Ansel Adams

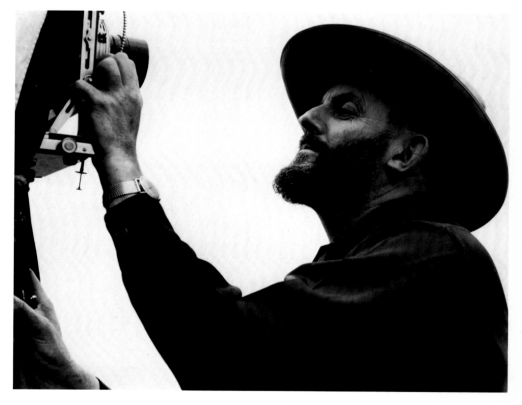

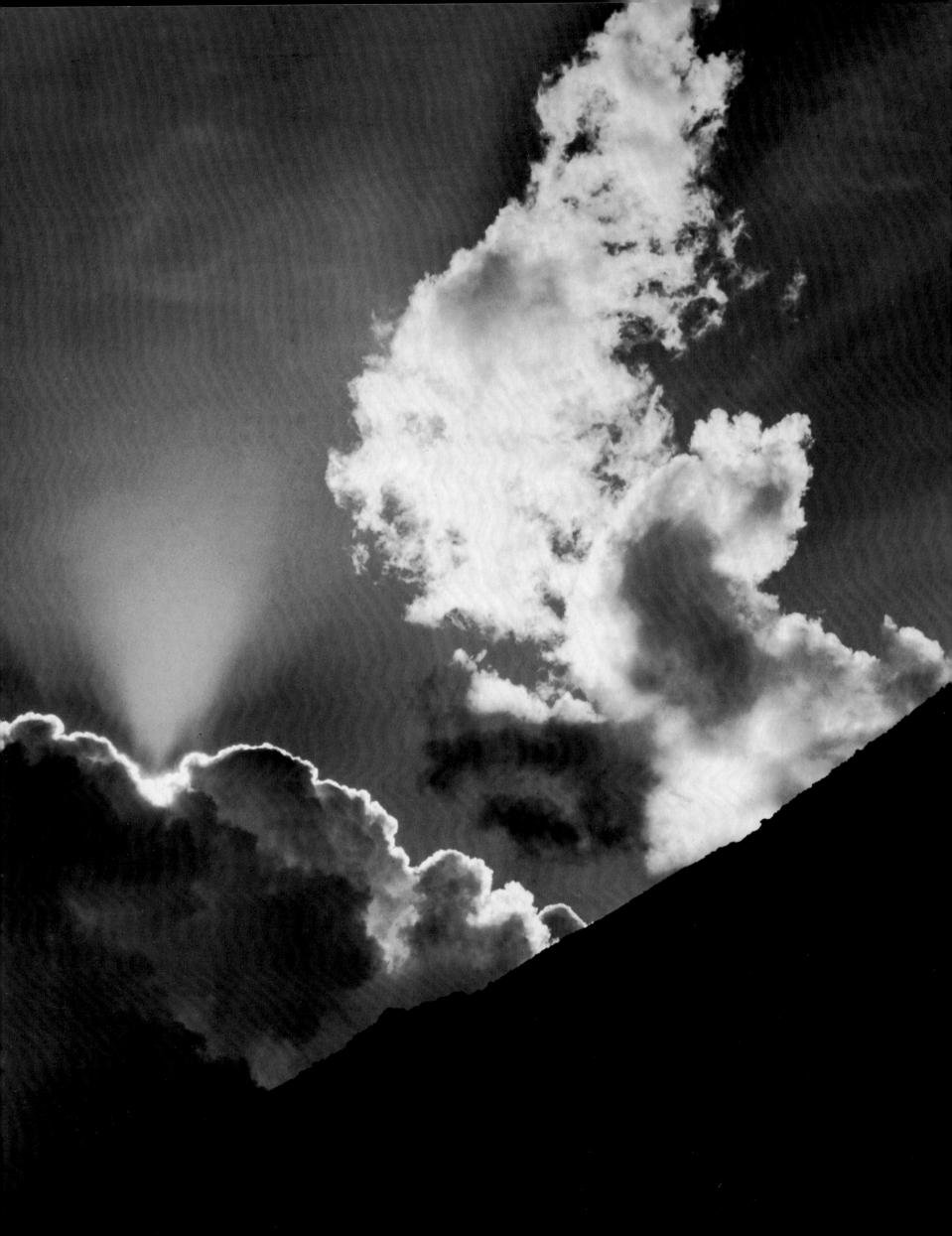

Ansel Adams *The Eloquent Light*

HIS PHOTOGRAPHS AND

THE CLASSIC BIOGRAPHY

BY NANCY NEWHALL

An Aperture Book

Library of Congress Card Catalogue No. 80-68714.

ISBN: 0-89381-066-5.

Manufactured in the United States of America. Revised edition.

Book design by David Brower and Nancy Newhall. Jacket design by Malcolm Grear Associates. This book was set in Centaur and Arraghi by Mackenzie & Harris, Inc., San Francisco. It was printed by Pacific Lithograph Company, San Francisco, and bound by Kingsport Press, Kingsport, Tennessee.

Published by Aperture, Inc. Distributed in the United States by Harper & Row, Publishers, Inc.; in the United Kingdom, Commonwealth, and other world markets by Phaidon Press Limited, Oxford; in Canada by Van Nostrand Reinhold, Ltd., Toronto, Ontario; and in Italy by Idea Books, Milan.

Aperture, Inc., publishes a periodical, portfolios, and books to communicate with serious photographers and creative people everywhere. A complete catalogue will be mailed upon request. Address: Elm Street, Millerton, New York 12546.

FOREWORD

This book is an unusual biography, for it was written by a close friend and colleague of Ansel Adams's while she was working with him. My late wife Nancy Newhall was a keen observer, a persevering researcher, and master of a writing style that combined exact exposition with the sensitivity of a poet. Over the decades that Nancy produced the texts and edited four books of Ansel Adams's beautiful photographs she came to a deep spiritual resonance with the grandeur and beauty of the American West: its deserts and mountains, its rivers and the Pacific, its flora and fauna. To this love she brought a rare understanding of photography. She shared with Ansel the conviction that this medium, especially when accompanied by a lyric text, can express, as can no other medium, the beauty and significance of the natural world. It was their desire to share with others the experiences that they had in common which led to the now-classic series of books upon which they collaborated.

Both Nancy and Ansel believed that text and photograph can reinforce one another to produce in symbiotic fashion a whole that is greater than its parts. It is seldom that two artists, using different media, can collaborate with the sympathy and mutual understanding that the realization of such a belief requires. It is a tribute to them both that they succeeded. Another of their fine collaborations, *This Is the American Earth* (1960)—printed by the Sierra Club in a folio-sized volume—is also distinguished both for its photographic and literary quality. So firm was Nancy's faith in the union of words and images that, although asked more than once to do so, she never allowed her poetic text to be published separately. It is, at once, an exposition of the ecological problems our generation faces, a cry to humanity to respect the world of nature, and a dramatic, vivid presentation of our inheritance.

As Nancy points out in the Preface to *The Eloquent Light*, the concept of this work goes back to 1944,

when Ansel told her of his desire to write an autobiography. She at once began to collect material for him to use. But the pressure of other work prevented Ansel from undertaking the project at that time. As the years of their collaboration passed Nancy continued to gather a vast quantity of documents, forgotten photographs reaching back to his earliest work, and correspondence. She made extensive notes of interviews with family members and friends and of the many conversations she had with Ansel. "Gradually," she writes, "it came to be assumed that I would write a monograph on Ansel."

When she began working on the book she soon came to realize that Ansel's rich, full life and his career as musician, mountaineer, conservationist, writer, teacher, and photographer could not be contained in one volume. By 1963 she had produced a manuscript covering the years 1902 to 1938. She and Ansel were asked by the Sierra Club to publish it as *Ansel Adams; Volume I, The Eloquent Light* (1963), the first of a projected series.

Nancy did not cease working on what she affectionately called the "Anselography" while collaborating with Ansel on *Fiat Lux* (1967), a description in images and words of the many campuses, research stations, and activities of the University of California, and *The Tetons and the Yellowstone* (1970).

I had never seen the area of the Rocky Mountains that Ansel portrayed so dramatically and Nancy described so vividly in what was to be their last book together. In July, 1974, Nancy proposed that we vacation in the Tetons. One day we took a river trip. As we floated down the Snake and Nancy named the plants and peaks, suddenly a huge tree—uprooted by unusually high waters—fell upon the raft. So severe were her injuries that she died a few days later.

BEAUMONT NEWHALL

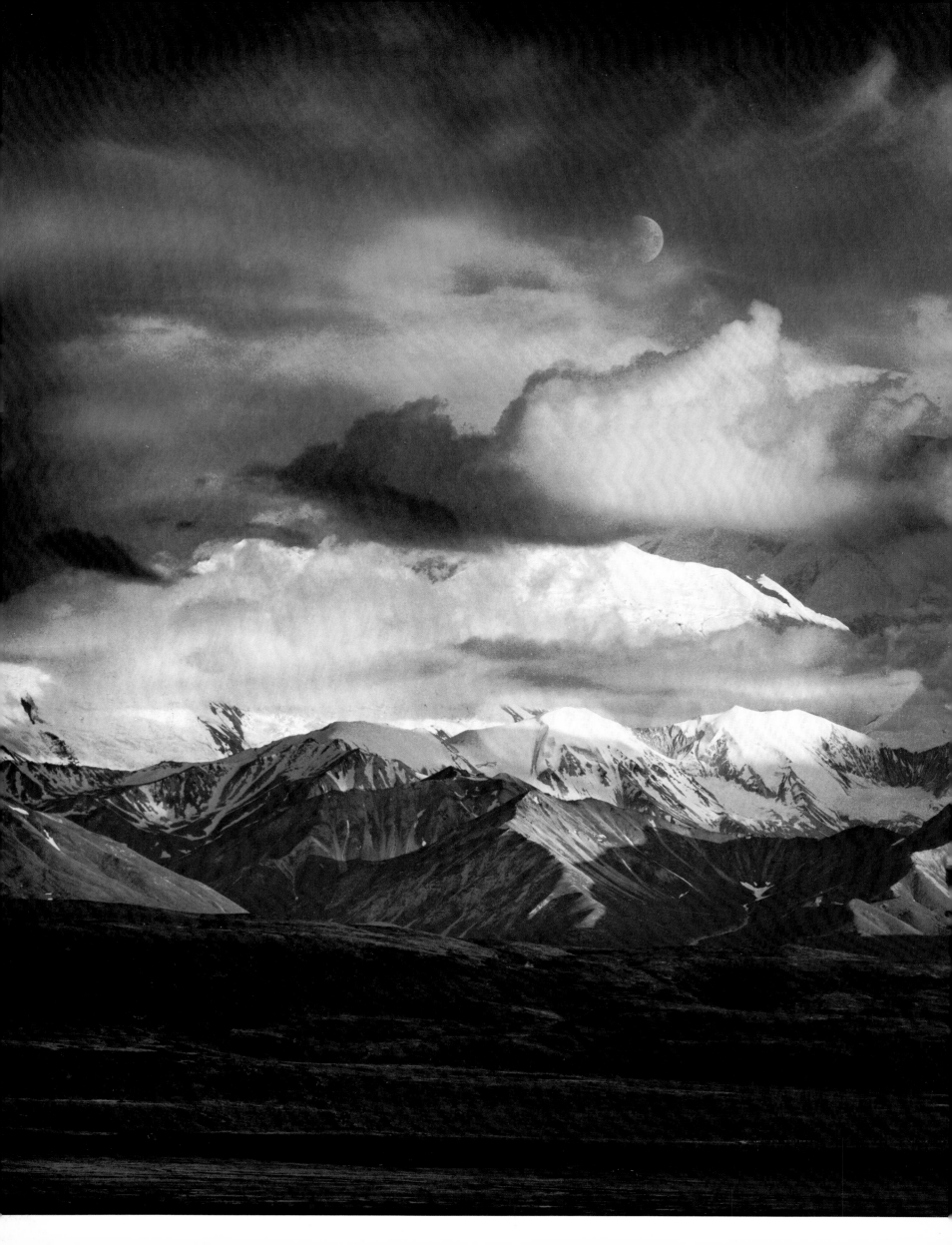

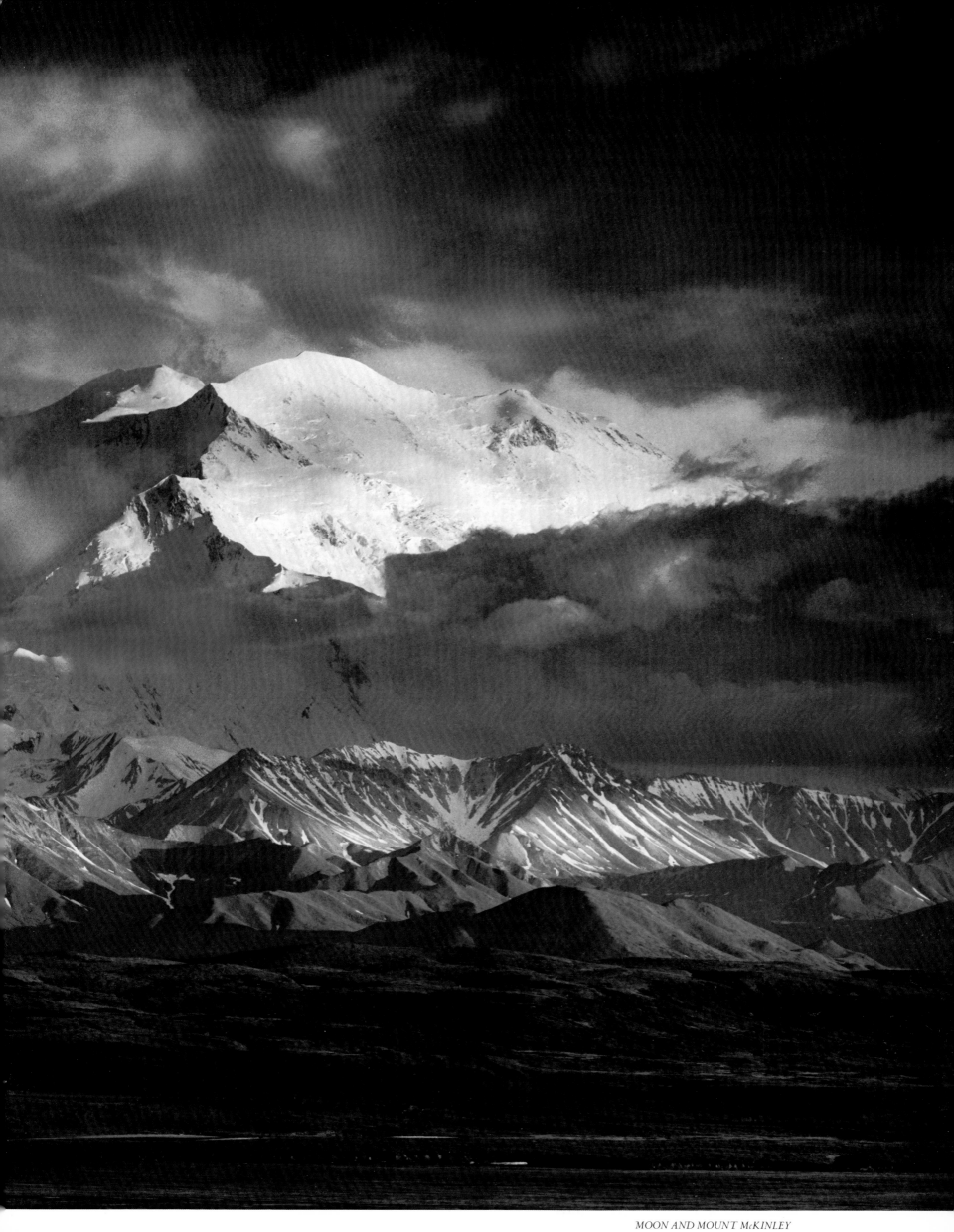

MOON AND MOUNT McKINLEY

PREFACE

This book began in 1944 as an autobiography, but Ansel Adams had too little time for retrospection. He was already a close friend and colleague. In 1940 he had helped Beaumont Newhall, my husband, establish at the Museum of Modern Art the first department of photography as a fine art. As vice-chairman of the department's advisory committee, he came to New York as often as he could to work with us on all aspects of the program and policy of the department.

In the spring of 1944, Beaumont was a photo-interpreter with the Army Air Corps in Italy. I was carrying on in his stead as acting curator of photography, and Ansel was in town to give a lecture course at the Museum and to help me plan the next year's program. Perhaps the most fascinating of my duties as curator was to add to the biographical files we kept on photographers of any importance or promise. It suddenly occurred to me that while we knew Ansel as photographer, musician, mountaineer, teacher, writer, friend, and "constructive belligerent," to use his own phrase, we knew little of why he was all these things. So I began asking. Not even the extraordinary stories of Alfred Stieglitz, to which I had listened almost daily during the two years I spent working on a biography of him, had quite prepared me for what Adams had to say and how he said it. Brilliant, poetic, witty, his spontaneous summaries of crucial moments in his life evoked poignant and compelling images. I found I wanted to see on paper both his word pictures, with their clash of sonorities and wry humor, and the photographs that were their visual equivalents. I could see a book and so could Ansel

To help him when he came to write, I began jotting down notes and keeping a special file of letters, interviews, articles, and lectures. Then Adams undertook simultaneously such projects as founding the first department of photography at the California School of Fine Arts, writing a series of technical manuals, photographing the National Parks, and bringing out many books and portfolios. Meanwhile I directed the retrospective exhibitions of Paul Strand and Edward Weston, and with Strand made from original documents the text for a book about New England. Gradually it came to be assumed that I would write a monograph on Adams.

He himself hoped for something "naked and brutal as the Arizona desert, wherein one can see vast distances." So he and Virginia, his wife, blew the dust off old files of letters, piles of manuscript, snapshot albums, bales of clippings and brochures, and handed them to me unsorted. Whenever, while clearing up family papers or some recess in attic or basement, they came upon more documents, they sent them on to me. Friends gave me access to their correspondence and their memories. The first little sketch was completed in 1951, but the publisher who originally commissioned it was in merger and others were timid about backing a monograph on a man not quite fifty and a photographer to boot. So I shelved that manuscript and began collaborating with Adams on a number of books, articles, and exhibitions.

It was a horizon-shattering experience. Up till then, my interest had centered in Adams the artist, who refused to follow intellectual fashions in the arts, stood forth as an independent, and produced in various media, works of startling beauty, technical excellence, and emotional power. I had understood something of what music and mountains mean to him; but not until we were working together did I realize that both had converged for him into an intense vision and purpose, and that the ideals to which conservation is dedicated have informed his life.

Over the years my early exasperation with his disdain for dates has gradually diminished, but I struggled long with fragments of fantasies indentifiable only by the make of typewriter; with photographs which could be dated only approximately by calculations based on postmarks, negative numbers, size of camera, type of developer, and, as a limiting reference point, their appearance in books, exhibitions, and periodicals; and with letters dated "Sunday night" or "Whothehellcareswhatdateitis—it's *now!*" For Adams the moment is *now*. His production in all forms is prodigious and incessant. In his photographs he seeks the instant of revelation—of timelessness.

In the book I have tried to keep a close relation between the thoughts and the photographs of each succeeding stage of his growth. So far as possible, the words are his own or those of his family, friends, colleagues, and critics. The first volume, 1902-1938, traces the development of an unusual man in a direction unusual in this century and ends with the crystallization of his aims and ideals in the early achievements which catapulted him into national renown. As his battles for his ideals have increased in scope, so has his power to express his huge themes. The words are witnesses, clarifying and extending. The important statements are in the photographs of Ansel Adams.

N. N.

Carmel, California, October 17, 1963

CONTENTS

1. The Latent Image 13

2. Golden Gate 22

3. Sierra Nevada 31

4. Sangre de Cristo 47

5. *f*/64 65

6. Diogenes 82

7. Making a Photograph 100

8. The Vital Thread of Perfection 114

9. Avenue of Sphinxes 129

10. The Range of Light 150

Photographs 176

ACKNOWLEDGMENTS

First of all, to Virginia Adams for her perceptions, her patience, and her sense of documentation, and to Beaumont Newhall for his strong support, his historian's acumen, and his quick response to details of research. To George Marshall for his helpful comments on the text. To David Brower for his ardent advocacy and heroic persistence in bringing this book to press and also for allowing notes he intended as his foreword to become part of the text. To Lewis Ellingham for assistance in a time of pressure. To the friends, family, and colleagues of Ansel Adams, who have helped in this first volume to define its protagonist and his work: the late Alfred Stieglitz, Edward Weston, John Marin, Albert Bender, Cedric Wright, and Charles Hitchcock Adams; to Henry Cowell, Francis Farquhar, Frances Kehrlein, Dorothea Lange, David McAlpin, Dick McGraw, Dorothy Minty, Eldridge and Jeannette Dyer Spencer, Willard Van Dyke, William Zorach, and many others—my deep appreciation. To Georgia O'Keeffe for permission to quote letters in the Stieglitz Archive in Yale University; Charis Wilson Weston Harris and Charles Halliwell Duell for permission to quote from *California and the West*; Witter Bynner for permission to quote his poem, "To a Guest Called Ansel." To the following, for their courtesy in allowing me to use photographs and writings by Ansel Adams and also reviews and comments by others which first appeared in their publications: the Sierra Club, the Book Club of California, Wells Fargo Bank, Studio Publications, Inc., Houghton-Mifflin Company, *Camera Craft*, and the *American Magazine of Art*. N. N.

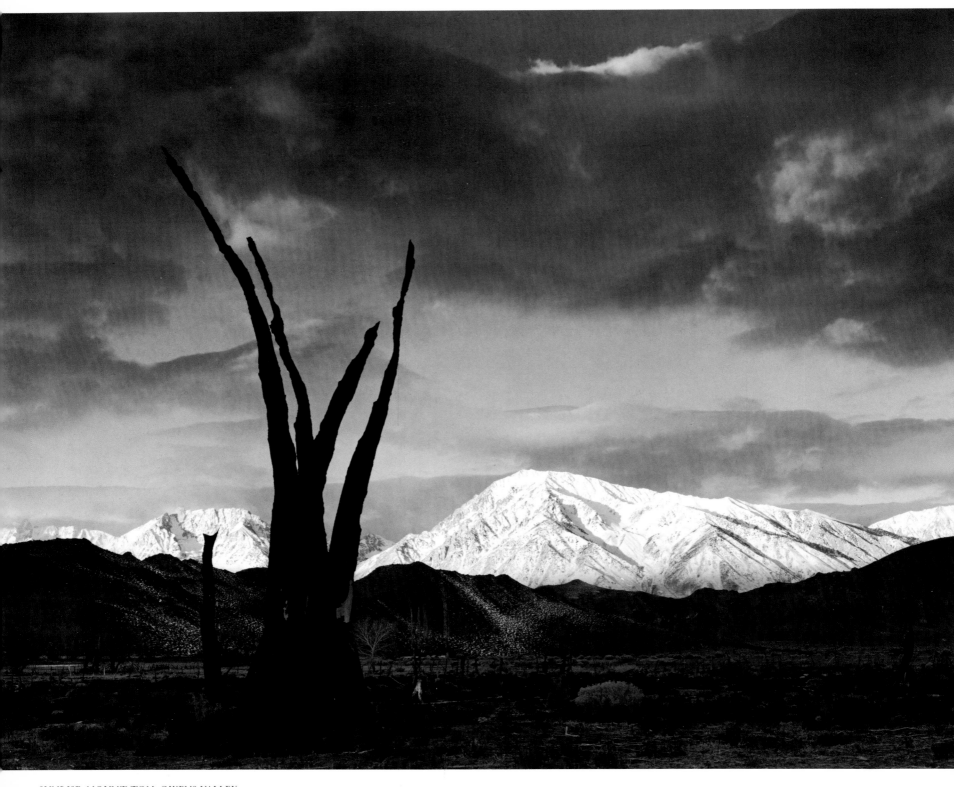

SUNRISE, MOUNT TOM, OWENS VALLEY

1. The Latent Image

If you work with Ansel Adams, you get up before dawn.

Maybe you wake in a sleeping bag on the edge of a canyon, with immensity at your elbow, or in a ghostly shimmer of cholla cactus, under the monstrous columns and candelabra of saguaros. Maybe what wakes you is the fume and sizzle of steaks frying, or coffee, handed you scalding in a hot tin cup with cool wire handles and SIERRA CLUB stamped in the bottom. But if the stars are paling and the rim of the world is already visible, the bray of a donkey or the yap of a coyote, rendered with heart-breaking and ear-splitting accuracy, will bring you up standing.

Maybe you steal out of a friend's house in the dark, assembling in a comedy of whispers and a minimum of lights, the precious lenses, small cameras, and light meters taken inside for safe keeping, the color films stored in the icebox overnight, and personal effects such as toothbrushes and half-dry laundry. Into the old Cadillac, dwarfed, huge as it is, by the platform on top, goes all the gear; the back seat and wide tonneau get filled to the window level, the last briefcase, jacket, or old boot is thrown in on top.

If the moon is still in the sky, you cruise the streets, or street, of some sleeping town, looking for the lonely glare and steamy windows of an all-night cafe. Inside, the pale counterman droops over the morning paper, the bored cook dozes at his little window, weary men hunch over mugs of coffee, the neon lights fizz and flicker and the fans drone.

Into this pallid atmosphere Adams comes like a whirl-wind, laughing, stamping. The hunchers look up; who on earth has that much energy at four in the morning? The silhouette — beard, boots, Stetson — is familiar enough in the West; every man in the cafe, cowpuncher, rancher, miner, uranium prospector, milkman, truck-driver, reporter or sandhog, with the possible exception of the cook and counterman, is wearing much the same.

It is the man inside the silhouette they try not to keep staring at—at least, not all of them at once. This is a test of true Western courtesy, for many of Adams's friends gave up long ago, and just gaze at him as if he were a Christmas tree. He glows, he sparkles; with the brilliant eyes under flaring brows, the bent beak of the nose, the torrent of black and silver beard, the fast and powerful hands with their delicate fingers, he looks like a portrait begun by El Greco and finished by Goya. He sings out, "You got a steak out there? Can I have it rare?"

The counterman straightens up—or, if female, pokes at her backhair—and hurries with menus, knives, forks, and the paper; the cook wakes up, slaps his hand on the shelf and looks fierce, ready to cook a tough slice of cow as never before. The order given, Adams may quizzically clink a spoon against the waterglass, the sugar bowl, the paper napkin holder, and suddenly beat out a little musical phrase. He looks as surprised and delighted as everybody else. The hunchers sit up, glance at each other—"We got a real live one here this morning"—and begin to smile. It is as if the sun had come up.

The steaks come on platters heaped high with fried potatoes. No lingering over coffee or paper; if the un-risen day calls forth herculean amounts of work, you may get two more breakfasts before noon, or, far from towns, and too busy to bother with the cookset, exist on laughter, a hunk of cheese, a can of fruit juice, and a couple of sacks of jellybeans till sundown.

Already the night is translucent and pierced by the glitter of the morning star. The road glimmers; you drive through a world slowly evolving out of darkness.

Snowlight, stormlight, foglight, rain that itself becomes drops of light, autumn leaves that become cascades of light, twilight and the rising moon—all these and many more are eloquent for Adams; but dawn, to him, is the greatest of all lights. He will get up at any hour, drive all night, or camp out on the spot if necessary in

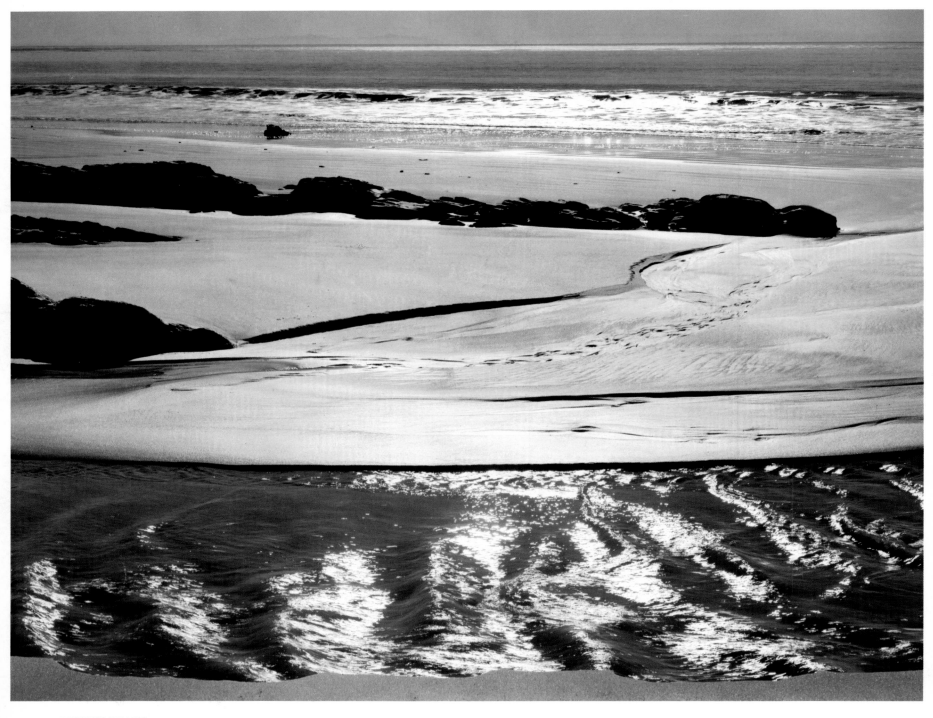

REFUGIO BEACH

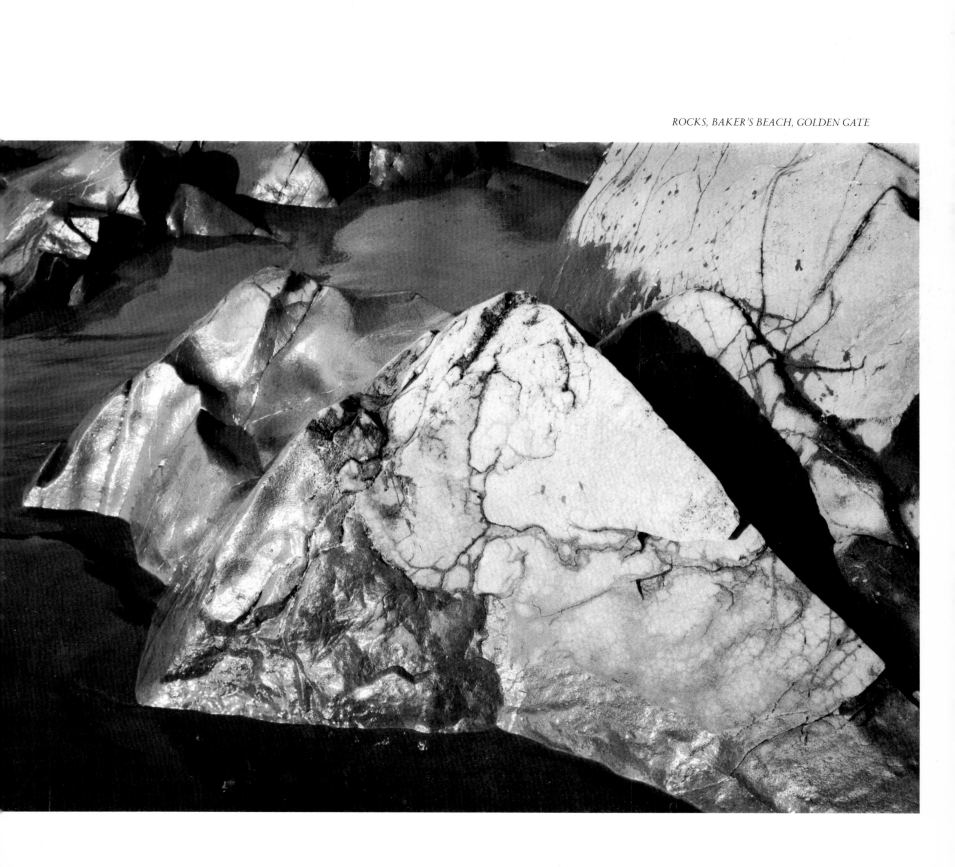

order to have cameras set up when the high snowpeaks turn ashen, then violet, then glow rose and red and suddenly, gold. At dawn, if ever, the air is clear and the wind still. The vivid light leaps almost level, penetrating, illuminating, rounding shapes against the deep sky. Shadows are alive; forms seem to soar.

Suddenly—always it is suddenly, no matter how well you know the road—you round a corner or top a rise, and some miraculous place lies before you. Perhaps the little road through the whisper and shimmer of pines and aspens bumps to an end at the North Rim of the Grand Canyon, and from that terrible edge, you look down on the island towers, already glowing like embers, shouldering up through mists and storms from the river running like quicksilver on the dark rocks far below. Perhaps the desert road, winding up through the black mountains, stops at the crest called Dante's View, and the unearthly incandescence of Death Valley spreads before you for one hundred and thirty miles. Next morning, a mile almost straight down under Dante's View, in the deepest sink in this hemisphere, you may be watching Badwater reflect, in its bitter pool, sunrise on Telescope Peak, eleven thousand feet above it. A few days later, threading the river road in Zion, you may look up through dark willows and cottonwoods at the Great White Throne looming in the first light. Perhaps you come, through sharp peaks steepled with saguaros, to the luminous domes and towers of San Xavier del Bac; or, from a boat standing on its beam-ends in the scour, look back under the huge, humming, red-gold structure of the Golden Gate Bridge to see the white city of San Francisco rising from the glittering tides of the morning bay. Or, up and up and up, through changing forests, each more beautiful than the last, past granite slopes still shining with glacier polish, you enter some of the most joyous places in the world, the exquisite mountains meadows of the Sierra Nevada, ringed with domes and spires where, in spring, snow burns bright against the deep blue sky, and the little river among the wild irises turns to an ecstasy of brilliance in the early sun.

Adams drives along, slowing down, speeding up again, composing with one foot on the brake. Are there clouds? Are the distances clear? How's the wind? What's the mood? Suddenly the Behemoth heads in beside a bank, or within inches of a precipice. Instantly Adams is out, and on the verge of nothing, or down by the water, or up on a crag, or, if nothing else is higher, the platform on the roof. Clearly, at such moments, he could do with wings. He frames his images with his hands. Then, if the prospect looks like most people's photographs, there is a long

moment of silence. Then he comes back with a shrug. "Bleak—maybe better late this afternoon." Maybe just: "Goofy." "But the clouds? They may look all right to the eye, but they'd look like hell to a camera. Fatigued shapes. Weak substance. Watery light." Or, with a groan, "Smog! Looks like pea soup down there." Smog, dust storms, or the persistent haze from distant forest fires—these he can only wait out. Often there is nothing to do but go back to town, take up the neglected manuscript of some long-promised book or article and work on it with one eye out the window, rattle off notes to a dozen people, ransack the drugstore for new magazines and science fiction against the wakeful watches of the night, visit the laundry, the grocery store, and, endlessly, the garage. Adams is an automobile hypochondriac, and with reason, for the loads he must ask a car to carry across deserts and dry washes, up mountains and through snow, and often cross-country without benefit of road, are appalling. What with cameras, film, lenses, food, sleeping bags, clothes, waterjug, whisky, extra gasoline, pickax, crowbar, rope, and people the weight is punishing. And something as slight mechanically as a flat tire could mean disaster.

Much more often, however, there is a happy caper on the rim, and Adams comes pelting back. "Yipe! Going to be just beautiful out there in a couple of minutes." Down from the roof, where they have been rattling rhythmically for miles, come the tripods, to be set up in a flash. Out from the back seat come the cameras, each in its case painted white for coolness. Up on its tripod goes his largest camera, the 8 x 10, a special duralumin model he got from an Arctic explorer, or the 5 x 7 Sinar, perhaps his favorite at the moment. Out of their flannel bags come the lenses. All good photographers are fast, but Adams is so fast it looks like sleight-of-hand. If the site is still some distance away, he shoulders the most important camera and the heaviest film case, while you, if you are the only lug available, follow behind like a prospector's burro, strung with meters, small cameras, filter book, notebook, gray card, Hasselblad, Polaroid, etc.

With Adams, there is no fumbling. Up goes each camera in the exact place and at the exact height where it will intercept the previsualized image. There is no backing or filling, no returning for a different lens, no indecision about filters. "Either it's there or it isn't. I don't fuss any more."

In the course of the past twenty years, on journeys through the West, the Southwest, and the East, I must have crawled under Adams's focusing cloth almost a thousand times. And still those images take my breath away. Beaumont Newhall once put it very well: emerging from

the folds, he looked around him and exclaimed, "Ansel, I can see better through your groundglass than through my own eyes!"

Then, with every camera steady on its vision, its back — even for landscapes — carefully leveled, the focus checked in all corners with a magnifier, the shutter anxiously tested by both eye and ear—then, ideally, there is a pause. Of course, for some of his most extraordinary images, such as *Moonrise, Hernandez, New Mexico*, jamming on the brakes, setting up camera and clicking the shutter were one continuous motion so instinctive he doesn't remember thinking at all. "If I'd fooled 30 seconds longer with those stumps down the Chama River, the light would have been gone from those crosses! Or—if I'd left ten minutes earlier, the image might not have been there to see at all." As for the marvelous *Sierra Nevada from Lone Pine*, "Another cup of coffee that cold morning—and that cloud shadow would have moved off the Alabama Hills. There might still have been a beautiful image, but it would have said something else. Sometimes I think I do get to places just when God's ready to have somebody click the shutter!"

But if the light, the clouds, the shadows, the mood, are not quite right yet, then the easy companion, the antic wit, the maker of hilarious noises and sonorous absurdities in rhyme, suddenly vanishes. In his stead appears a grave and stately personage, part mathematician, part chemist, part sensitometrist, and all photographer. Adams takes his SEI photometer out of its leather case, fits on the eye piece, and sights through it, like a navigator taking his bearings, or an astronomer checking his field. He may sight first at the gray card, which he has propped up on a rock or other convenient perch, then at very small and distant lights and darks impossible for most light meters to measure. Then, somewhat impeded by two pairs of spectacles strung around his neck, he finds the right pair by which to set his readings on the dials of its handle and read the resulting calibrations. Sometimes the Weston meter comes out now; its multi-celled eye can respond only to large areas of brightness or darkness, but its dial is still the fastest way to compute where, in the scale of the photographic negative, a certain crucial light will fall in relation to an equally crucial shadow.

Offhand, Adams can tell you the brightness reflected by any object far or near in any light, so accurately that if one of his meters disagrees with him, he suspects it is out of adjustment, and he is usually right. But for the fuzzy-headed trust many photographers, including some of the greatest, put in "feeling the light" and "the latitude of film," Adams has the greatest abhorrence. "It can fool

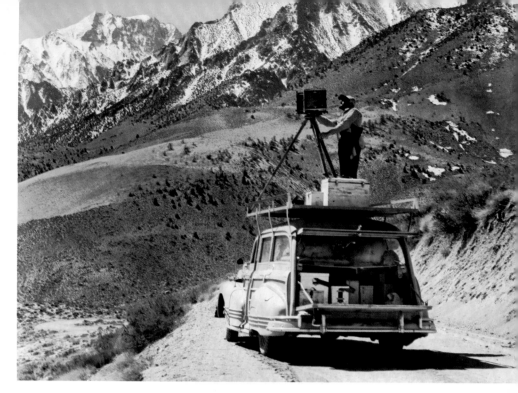

ANSEL ADAMS, ONION VALLEY ROAD BELOW KEARSARGE PASS

you out there!" he says, and continues, whenever there is time, to measure every passing nuance of light.

"Correct" exposure, with everything reckoned in— film speed, filter factor, flash factor if any, bellows extension, allowance for reciprocity failure, etc.,—is where most good photographers stop and click the shutter. It is where Adams begins. He is no more satisfied with a "correct" exposure in photography than, when he was a practicing musician, he was satisfied with a "correct" reading of a Mozart sonata. The values he is after are not literal but emotional. For him, "the negative is the score, the print is the performance." Right now he is composing his score, transposing the living scene before him into densities on the negative so precisely calculated that he *knows* that when he comes to print, he can voice the melody of the whites, bring out the exquisite counterpoint of textures, and sound the sonorous bass of blacks. By this time, a poet as well as a musician is visible through the mathematician, but since it is the mathematician who must calculate the basic and essential negative, it is he who begins to chant aloud all the mathematical calculations needed to transform the obvious setting into what he hopes may be a negative from which he can make a print conveying to others what he himself has felt.

Still chanting, he sets aperture and time, cocks the shutter, shoves in the holder, and, very gently, withdraws the slide, darts back to the cable release, and, shading the lens with the slide, watches with all his antennae out for the perfect instant, the moment of revelation.

Of course, not even the skill and experience of an Adams can save the photographer from "the perversity of the inanimate,"—or even the animate. Shutters do stick, sand does get through locked cars and closed cases

into film-holders, and dry air streaks of static electricity may be formed when the slide is drawn. Filters fall into canyons, and cable releases simply disappear. Mosquitoes can get inside the camera. Cattle can appear out of nowhere to gawk at the photographer, and so can people. And always it is the perfect moment that causes birds—especially gulls, hawks, and eagles—to take off at distances where they will appear in a negative as specks and blurs; apparently the same moment causes jet pilots to enter the stratosphere, leaving behind what Adams calls "sky worms" to linger for half an hour.

It is not easy to capture skywide immensities with a box, a bit of glass, and a few inches of sensitive emulsion. Even when the photographer is working with something close to him, at the perfect moment the winds begin to blow, or a cloud obscures the sun, or an unforeseeable shadow darts across the subject.

Where so much in front of the lens is unpredictable and uncontrollable, to control the lens and everything behind it, including himself, seems to Adams a necessity. Precision, speed, discipline, and exact knowledge are the foundations on which his extraordinary command of photographic technique is built. Before he purchases a lens, he wants to see it on an optical bench. He has his shutters tested frequently, and always before any long or crucial assignment; he has to know if the 1/500 is really 1/300, or the 1/10 really 1/8. He tests everything, not once, but continually. He runs exhaustive tests on any new film; he wants to know, not just the characteristic curve and color sensitivities as plotted by the manufacturer, but what he himself, with his equipment and darkroom procedures, can expect in the toe, the straight-line section, or the shoulder; what its normal developing time is and how it will respond to less than normal, or more. The scale of the newer high-speed films, for example, can be contracted successfully, but less effectively expanded, while the older and slower films respond to both expansion and contraction. What are the blacks like in a new batch of paper? What are the virtues and the faults of a new camera or other piece of equipment? Adams has to know, and the knowledge must be not only in his head but his fingertips. Just as, when he was a pianist, he practiced several hours a day, so even now, at least an hour or two of the most crowded day must be spent in either the practice or the

performance of photography. Only thus, when the huge challenges are flung before him, will he be able to respond instantly, and choose from his panoply of skills and tools the most effective combination.

As soon as the light has changed and the theme for now has lost its magic, cameras are stowed away, lenses sheathed again, tripods thrown back on the roof. Then Adams gets out his battered notebook, finds a convenient rock, stump, or fender to lean upon, and there is another moment of intense silence while he proceeds to write down, on printed forms he himself designed, the chain of decisions involved in making each photograph: what film and when loaded, what subject and what readings of the actual light reflected from it, and how, for his negative, he has "placed" these values; what lens was used, what filter, bellows extension, flash factor or pre-exposure, what aperture and shutter speed were given, and what development is indicated. As soon as possible, at night if necessary, if he can find a really dark closet or a friend with a darkroom, he will unload his holders, sort the negatives into boxes marked N, N—, N+, etc., seal them, and if the weather is so hot he fears for the deterioration of the latent image, or if he has doubts about some subject to which return may be difficult, if not impossible, he will ship the boxes airmail and special delivery to some student or helper. Any careful darkroom worker who knows his system and formulae can develop his negatives as well as he can. In case of any failure he can turn to the notebook. There, written in what only long familiarity can distinguish from Arabic, is the record.

The spectres of originality or of stereotype do not bother Adams. He approaches the weariest subject of the postcard makers as if only the wind had passed that way before. He knows his power. He knows he can make the commonplace, the stereotyped into what only poetry and perhaps religion can explain.

He claims no special privilege. He says: "What happens out there is far more important than what happens in here," pointing to himself, "and far more important than any image I or anybody can make of it!" And returns as humbly to his huge themes as he once returned to Bach, Beethoven, Mozart; as humbly as artists have always returned to beloved themes—Cézanne his apples, Roualt his clowns, Utrillo his walls, Marin his sea.

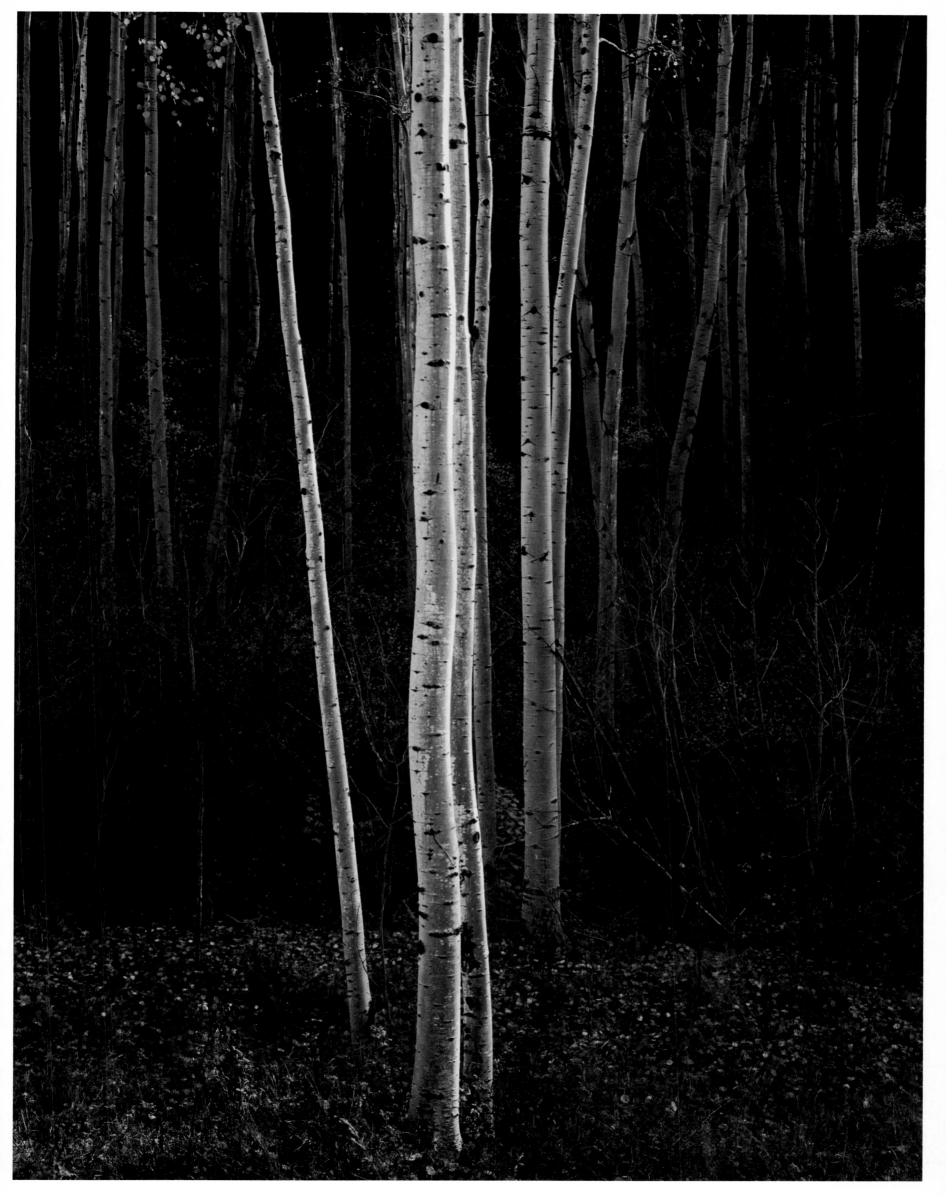

ASPENS, NEW MEXICO, 1958

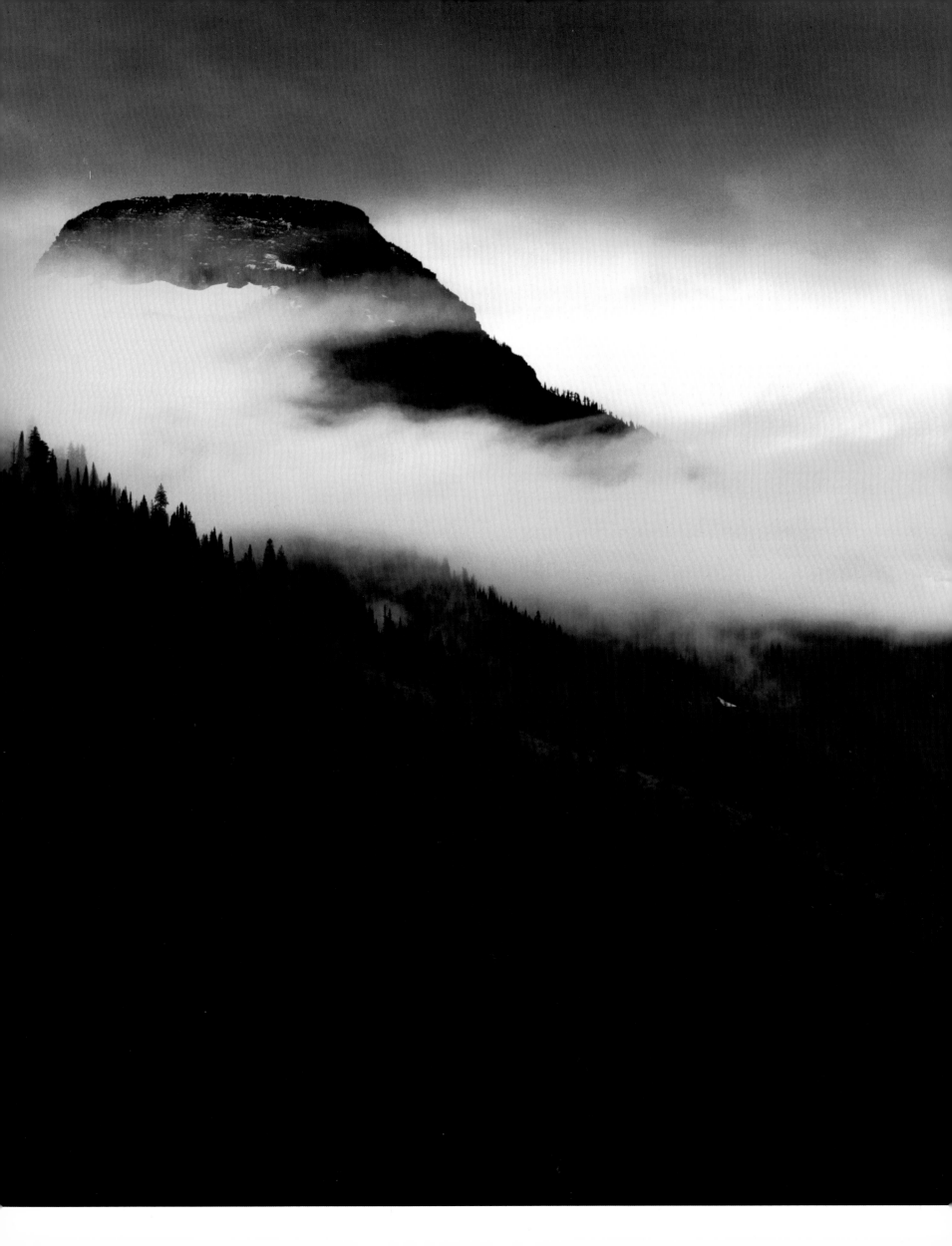

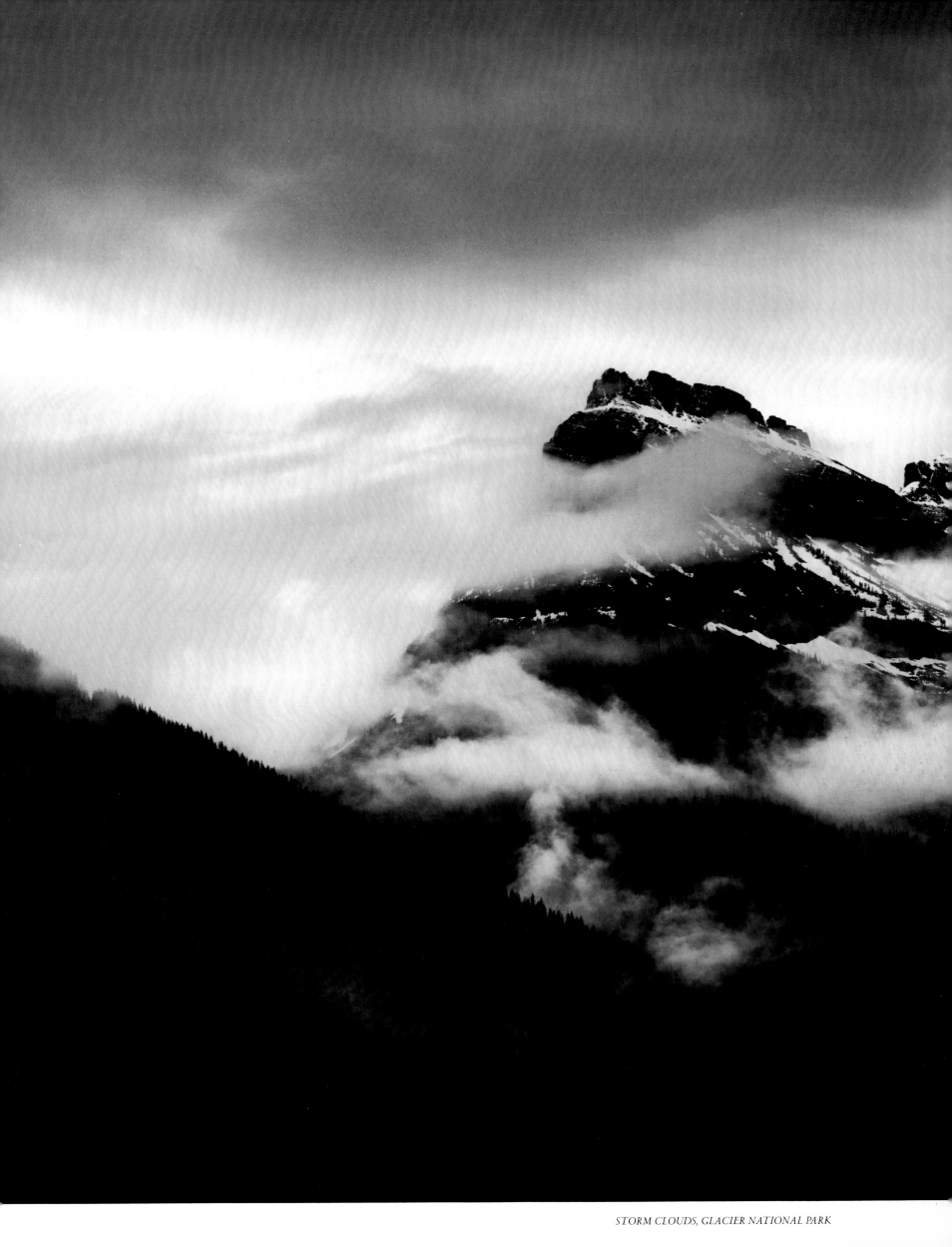

STORM CLOUDS, GLACIER NATIONAL PARK

2. Golden Gate

At fifteen, William James Adams ran away from his home in Thomaston, Maine, and shipped on a schooner bound out of the nearby port of Rockland.

Seafaring, however, was already part of the family tradition. Pure Scots and strict Presbyterians, the brothers William and James Adams quitted Londonderry, Northern Ireland, early in the eighteenth century, and came to help found Londonderry, now Derry, New Hampshire. Most of their descendants were farmers and deacons, with occasionally a preacher or a soldier—a lieutenant in the Indian wars, a captain in the Revolution—among them. Yet the sea called as well as the land. In the family chronicles, opposite the birth dates of two great-uncles and a brother, there stands only that stark epitaph which recurs in New England genealogies like a litany: *Lost at Sea.*

For Herman Melville and Richard Henry Dana, Jr., life before the mast was an escape into adventure. For W. J. Adams, an equally incurable romantic, it was the first step to fortune. He was able and responsible; he could command men and make shrewd and successful guesses on what cargoes to load for the next port. At New Orleans, he fell in love with the Mississippi. He was pilot on a steamboat when news came of the discovery of gold in California. As soon as he could, he took ship for the Isthmus of Panama, got through its miasmic swamps and bandit-infested trails unharmed, and took ship again for San Francisco. This was 1850; he was not quite twenty-one.

He tried gold mining, up in the foothills of the Sierra Nevada; he dug by the dry creek beds in the parching heat of those shadeless canyons. He was too bright not to notice that few miners, even those who made rich strikes, were able to keep their gold. In Sacramento, where most men stocked up before returning to the mines, he set up a grocery store and prospered. From retail the store became wholesale; in 1856 he sold it, and with a fortune went back to Thomaston, to see his family and to find a wife.

The whole town rejoiced; he was living proof of the adventurous legend of the west. And he won as wife a spirited beauty whom he had last seen as a little girl of eight. Cassandra Hills was the daughter of a country doctor; her mother was a relative of the Earl of Rosse, and her cousin, the present Earl, was one of the leading astronomers of the century. At sixteen Cassandra had married an ailing sea captain; widowed a year later, she was now at twenty eager for such a life in the west as W. J. Adams promised her. Immediately after their wedding, they sailed for Panama. Here the bride caught Chagres fever and lost all her black glossy curls; when her hair grew back again, it was straight and mouse-colored, with a high hairline which distressed her and which she tried always to conceal.

Back in San Francisco, W. J. Adams started another grocery store and was twice burned out in the frequent fires which had ravaged the city. He did not believe in insurance; each time disaster struck, he set his jaw and made another fortune. Then he went into the lumber business. Up in Washington, he bought tracts of timberland, built a chain of sawmills, and acquired a fleet of ships to carry the cut lumber down the steep and rugged coast to the fast-growing cities of California.

For his expanding family he bought, one after another, what he called "farms" in San Francisco. Mission and 7th, Market Street and Montgomery, Harrison and 1st, 2nd and Brannan—if he had held onto them, the story of his descendants would be different. Instead, he sold each of them for a good profit, and then, deciding San Francisco was too foggy and windy, bought fifty-four sunny, oak-shaded acres down the Peninsula. No fences, nothing one could honestly call a road, just a happy countryside where his children could roam with their horses and dogs and play with the children of other magnates who had similar inspirations.

The twenty-three room white house he built at Menlo Park was singularly chaste and restrained for that period of exuberant architectural fantasy. An indulgent father, he held certain strict New England notions about the rearing of children which caused Cassandra, now "Mamette," to tap her foot when he disciplined a child who was late for meals or who refused to eat.

In one way, all five children disappointed him. None of them seemed to care for the empire he was building or have the drive and acumen to carry it on. William Louis,

his eldest, was a linguist, a bibliophile, and a brilliant physician with a natural distaste for submitting bills. His three daughters, Cassandra, Louise, and Olive, married well, but though their husbands were the sons of men like himself, they too tended to have other interests. In despair, he turned to his youngest, Charles Hitchcock Adams, who passionately loved nature and science, and wanted more than anything else to be an astronomer. Charles—"Carlie"—did have two months in Europe with his adored brother Will, and he did have two years at the University of California, but after that, his father insisted he learn the family business. Dutifully, Carlie learned about lumber and ships and how to be prompt, exact, and scrupulously honest in administration.

A niece of his, Frances Kehrlein, daughter of his sister Cassie, observed in a family memoir, that Charles "lived a life of complete frustration. . . . For sixty years he served his time in business and for recreation was secretary of the Astronomical Society of the Pacific. Under his management the W. J. Adams estate dwindled down to nothing, but the Astronomical Society waxed big and strong and successful."

In 1896, when he was twenty-eight, Carlie married Olive Bray, daughter of a livery stable owner in Carson City, Nevada. She was six years older than he, but she drove a dashing team, played the piano, loved amateur theatricals, and painted china.

Ansel Easton Adams was born on February 20, 1902, in San Francisco. The next April, 1903, his family moved from the city out to what were then the wild and lonely dunes beyond the Golden Gate. Doubtless on one of their bicycle trips to collect wildflowers for Ollie to paint on china, they found the steep hillside above the thickets of Lobos Creek from which they could look down over the dunes to the tumultuous surf on Baker's Beach; from the casement windows of their simple chalet-like house, they could see the great bare hills of Marin County across the strait and watch the ships, some of which still belonged to them, passing through the Golden Gate.

They planted Ansel's first Christmas tree, a little Norfolk Island pine in a pot, out on the bare slope which, through the years, became an astonishing garden, its

ANSEL ADAMS, 1905 (TINTYPE, CLIFF PHOTO GALLERIES)

fuschia reds, cineraria blues, and nasturtium golds glowing in the foglight—a brilliant foreground for the often sombre majesty of the country. For this side of the fist-like promontory of San Francisco belongs to the Pacific, lashed in winter by the fury of its gales, haunted in summer by the fog that sweeps in every afternoon to break over the hills in the late sunlight "like a second sea," as one of Drake's men wrote. From the city by the Bay, the fog usually lifts with morning; out here, it may linger, sometimes low, sometimes high, all day for days.

Ansel's first memory is of lying in his carriage and watching low fog scud across the sky. Always he was, as he wrote himself many years later, "more responsive to wild environments than to urban . . . to the surf and dunes, the storms and fogs of the Golden Gate," rather than to civilization. When they took him to visit his grandfather and grandmother Bray in Carson City, the excitement for him as for any child born on the West Coast, was the novelty of "playing in the crisp winter snow." When they took him down the Peninsula to his grandfather and grandmother Adams, it was less the great white house at Menlo Park, with its lawns and verandas that he remembered than "the stately oaks of Atherton on the hot brittle fields sweeping toward the San Mateo Hills and beyond, to the madrone-lush folds of the Santa Cruz Mountains." And when, later, they took him up the coast to Hadlock, Washington, center of the family's lumber mills, "a few months among the beaches and rain forests of Puget Sound . . . made indelible the scents of sea and spruce, tar and sawdust. Such early images are often as clear and compelling in memory as the actual vistas of today." (Ansel Adams, "Introduction" to *Yosemite and the High Sierra,* by John Muir, 1948)

He was four when, early one April morning, he was awakened by a frightful, cracking roar that seemed to be shaking the world apart. His nurse was trying to shield

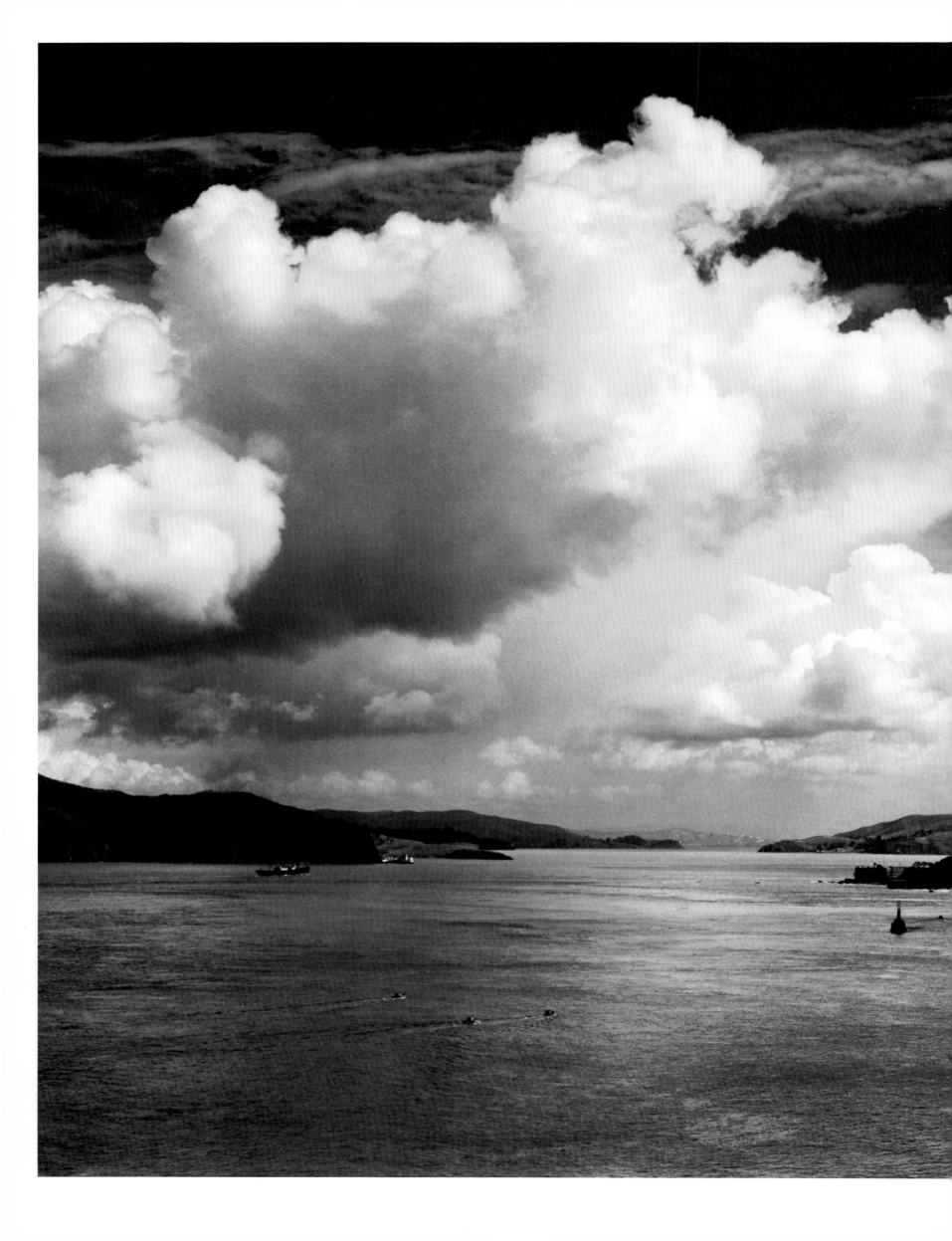

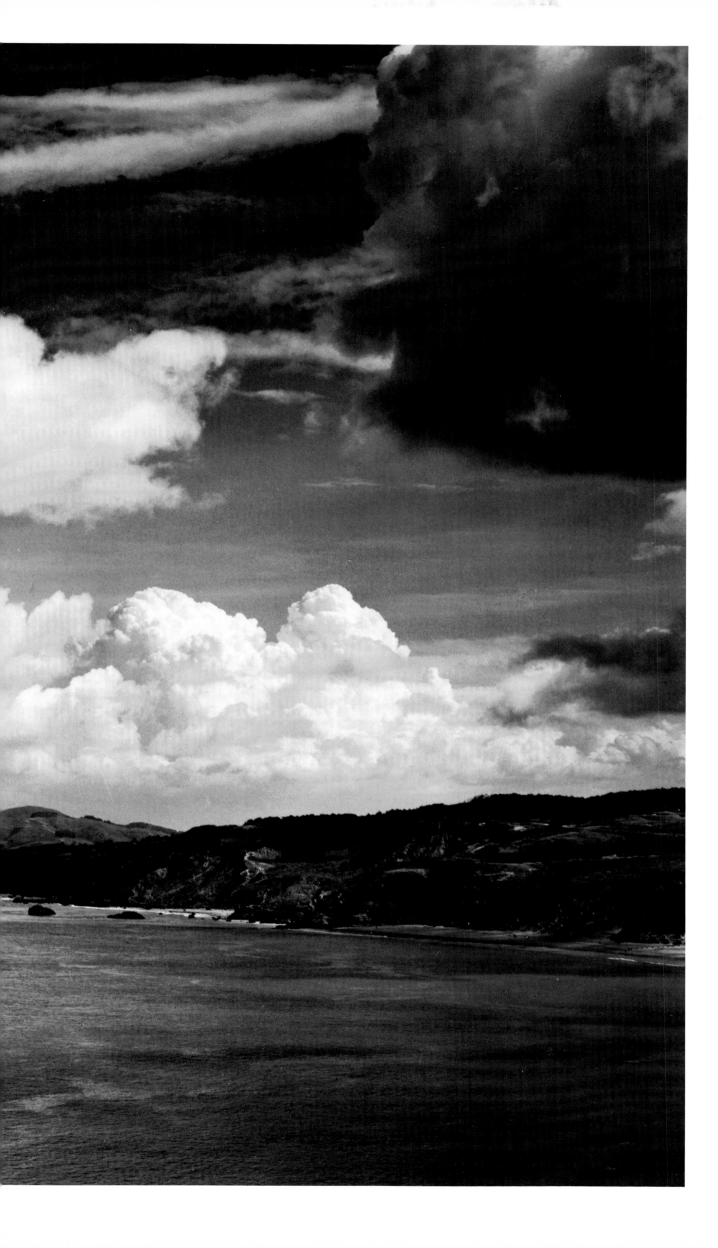

GOLDEN GATE, 1932

him with her body as both of them, together with the furniture, were catapulted across the room. A shadow crossed the window, and the chimney fell into the greenhouse, its crash almost inaudible in this deep mutter of the earth that voiced all the breaking, creaking, and screaming of the crust of houses and humanity upon it. Then, the roar ceased; the earth became, for a while, stable again.

Charles Adams was in Washington, D.C., and they were alone except for the little boy and the Chinese cook. Surprisingly, everyone was alive and none was seriously hurt. Apart from the chimney and the greenhouse, a few cracks, some wrenched woodwork and scarred furniture, and much broken glass and china, the house was intact. Then the Chinese cook, still dazed by being battered around his little basement room, started to light a fire in the kitchen stove with its ruined chimney; Ollie stopped him just in time. From similar causes, though out here on the dunes they did not know it, fires were breaking out downtown.

CHARLES H. ADAMS

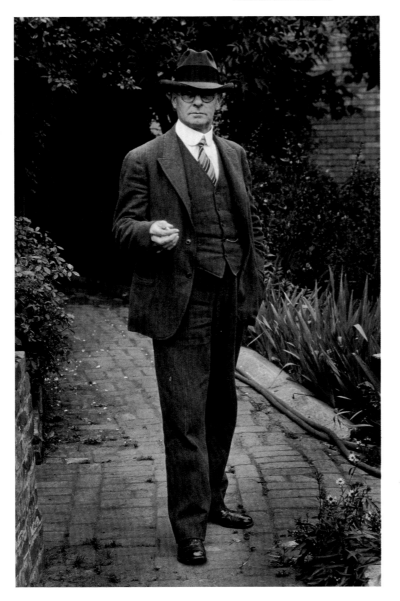

They sent Ansel out to play while they tried to clear up. A later quake threw him face down on the brick path. It was then, he thinks, that his nose was broken. But to him it was just more of this tremendous and catastrophic experience: damage to young cartilage is difficult to detect, and nobody noticed. From the flaming horror downtown refugees began to arrive, friends and family who overflowed the house and camped out on the dunes. For several nights the light from the burning city was so great that even out here one could have read a newspaper in the garden, had there been newspapers to read.

In Washington, the morning was hot and breathless when over the wires came news of some terrible disaster in San Francisco. Then silence; all means of communication had been broken. Charles Adams stood and sweltered with others from the West Coast who had come to attend a Congressional hearing. Soon rumors began to come through, each worse than the last: the city had been totally destroyed by an earthquake. It was burning. It had been engulfed by a tidal wave. Frantic men got on trains—any trains, so long as they were headed west. The journey across the continent was a slow nightmare punctuated by bulletins. By the time Charles Adams reached Chicago, the fact that an earthquake of unusual magnitude had been followed by the worst fire in all San Francisco's history of fires was fairly established. To communicate with individuals was still impossible. When at last he reached Oakland, makeshift ferries were running across the Bay. Smoke was still rising; the city was almost unrecognizable. The Ferry Building stood, but Market Street was a chaos overhung by ruins. The cable car tracks snaked crazily. People were living in tents in the squares, lining up for soup at emergency kitchens, poking about in the still hot embers, making fun of their hand-to-mouth existence, and already planning their new city.

Dynamiting was in progress. Charles obtained from the martial-law authorities the passes necessary to cross the fire lines and started to walk home, past steps and doorways that a few days ago had led to the houses of friends but now led nowhere. The streets were choked with rubble. A road mender offered half his lunch; Charles Adams sat down and gratefully accepted.

The cataclysm had in a few instants bound together people of all ages, races, classes; afterwards they could never quite forget that they had glimpsed apocalypse and that survival hangs by a single miraculous thread.

But for the Adamses the earthquake and the fire were only one in a series of disasters. Between 1897 and 1907 they lost six mills by fire, and twenty-seven ships by fire and shipwreck.

Trying to recoup the family fortunes, Charles Adams leased the American rights to a process for converting sawdust into methyl alcohol, set up a company, and built a plant at Hadlock. Against his own better judgment Charles was persuaded by a brother-in-law, the Ansel Easton after whom he had named his son, to sell a large block of shares to the sugar interests, who also produced alcohol. Then Ansel Easton sold his own—and controlling—shares on the streets of Seattle; the sugar trust, now in command, promptly ruined the plant and abandoned it. Charles Adams felt he had been betrayed by one he admired and loved, which hurt him even more than this final collapse of the Adams fortune. Yet, years later, when Ansel Easton needed help, Charles Adams forgave and came to his rescue.

The long years of recurring shock and loss were too much for Olive Adams. She would break down and weep; her sister Mary, who now lived with them, wept with her. Ansel was only eleven, too young to understand all that was involved, but he did know that weeping women were reproaching his father. Charles Adams, as tenderly devoted as ever, bore their complaints patiently; indeed, he agreed, "I have been a katydid . . . a grand and glorious failure in every way." He sought solace from the telescope he had set up in the garden, in spite of nights of dense fog. He liked the company of astronomers. "They were men of humility. When they could go no further, they stopped talking." (Interview, 1950)

For Ansel, the doleful voices of the women became part of the fog, of those nights when the horns and whistles of the ships and lighthouses wail and groan around the Golden Gate, with those mornings when low fog catches among gables and telephone poles, those noons when the staring light of a high fog turns the white city spectral. And the voices, endlessly recalling the past, telling the same old stories, made the past for him an unbearable boredom. School and the interminable histories became a continuation of the same dismal mood.

He was a strange, intense, and thorough child. Whatever he began, he saw through to its finish. As a baby, building castles and cathedrals with the marvelous architectural German blocks of the time, he carefully completed his great structures through several days, and then, just as carefully, put all the blocks back in their box in precisely their original positions. He was an odd-looking boy, very thin, as fast and nimble as a squirrel. Indeed, with the wide dark eyes, the swollen nose and slightly open mouth—for years he had difficulty breathing—he resembled a squirrel. Obviously he possessed a vivid imagination: he suffered from nightmares, delighted in

comedy and fantasy, and was profoundly moved by beauty. When excited by an idea or a project, he could not rest until he made it a reality. "In grammar school, as a kid, I was considered 'unusual'—not in my right mind, so to speak. The fact that I could do many things deftly and never was 'a bad little boy' was not sufficient to overcome the stronger fact that I was 'different.' . . . Then, I lived 'north of Lake Street,' which automatically made me an aristocrat in relation to those who lived 'south of Lake.' This distinction seemed to be based on two hideous pylons which the real estate company set up to mark a perfectly ordinary area as 'exclusive;' the only sad gap in their logic is that the pylons were built about eight years after my father 'moved out there in the country.' Hence, my snootiness was thrust upon me. But I went through hell at that time." (AA to Nancy Newhall, July 15, 1945)

Like his father, Ansel sought refuge among the eternities, "long days in a world of sea-grass, and bright sand, the roar and tang of the Ocean, and the cry of gulls." Whenever he could escape from house or school, he fled down the hill to the path "following the little creek until it sighed into the sand under the surf. I stopped by the old dam and looked long into the dark green waters. Dragonflies flashed in the sombre light, and the runnel sang over the black sand under the willows. At the ends of the long beach were solemn cliffs of sandstone, carved and hollowed by the winds and waters, intricate at the tidelines with growth of shells and seaweed.

"Northward across the channel lay the remote hills, which seemed to my young spirit of another world. Occasionally, great and little ships would pass before them; never would the vessels stop—they were bound for harbor or horizon, their destiny unknown to me. The distant hills and my own shores remained unstirred by the majestic traffic of the sea . . . I would wonder at the sun, the unfailing sea, the land, and the great winds." (Fragment, no date)

He describes himself as a "repellent little brat with a talent for involving everybody in vast enterprises of absolutely no consequence"—such as the time he and a friend stripped the long needle-clusters from the lowest branches of the Norfolk Island pine and sold them to indulgent neighbors as lighters for Christmas fires. (That was the only time Ansel ever saw his father angry.) Or the huge flag, eight by twelve feet, of artificial flowers— "Nobody could persuade me it wasn't useful!" Or the fireworks display he organized for the whole neighborhood on a Fourth of July night so foggy that the rockets, when he could get them to rise at all, vanished into the

mist, the Catherine wheels sputtered and died, and even the sparklers fizzled. "Everybody said they'd had a lovely time."

Impelled by an enormous curiosity and a restless intelligence, he was drawn to any precise or complicated instrument. He listened intently while his father explained the immensities of the universe and the telescope showed him the moon, a planet, a comet, or the bright cluster of the Pleiades. He tagged along after the surveyors who came to break up the nearby dunes into house lots; in the West Clay Park real estate office, he hung over the architects' drafting tables, and played with the accountants' machines. He took to the typewriter very young, and at eleven brought out several issues of a newspaper, *The Record*.

Of course he could not resist the family piano. "Ansel has developed quite a taste for music lately," wrote Carlie to his mother and sister (May 17, 1914). "He started a few months ago to play on the piano and heaven knows where it comes from but he can read almost anything put before him at sight. Four months ago he didn't know a note and of course has never taken lessons so I can't quite understand it. Mrs. Cowell, a singer, who lives here in West Clay Park, has had Ansel play for her and says he surely has genius, and her stepson, who is a sort of musical wonder and who, though only 16 years old, is giving public concerts on the piano and who composes orchestra music, has taken a great interest in Ansel and is going to give him lessons."

As Henry Cowell remembered, he was in bed with a cold when downstairs someone began to play the piano. "I sat right up in bed to listen. Whoever was playing really understood about music. I called out, 'Who's that? He's good!' And mother called back, 'It's a boy from down the street. His name is Ansel Adams and he's twelve years old.' " (Interview, 1961)

Carlie also remembered Ansel's "development of a full orchestral equipment: a piano, drum, harmonica, two feet and two hands. You struck great chords and thrilling trills on the piano with the right hand, hammered on the drum with your left foot, held the harmonica to your lips with your left hand, and put on full pedal with your right foot. It produced a real symphony and my poor mother—Grandmother Adams—sat by and *had* to listen to you. She showed a great appreciation and a sympathetic and understanding reaction, but she had a broad twinkle in her eye." (CHA to AA, March 25, 1944)

One of those who listened gravely to his playing—even to the one-man band—was Miss Marie Butler, a teacher of piano who had studied at the New England Conservatory of Music. She gave it as her opinion that he had extraordinary talent, and if he were not to acquire habits almost impossible to break later, must begin with a regular teacher at once. If he would start learning the Bach Inventions, she would take him herself. So for three years Ansel scrambled over the hill to her little cottage while she helped him perfect the melodic, rippling touch she said he would never lose. Then she announced she had taught him all she knew and he must now go to a better teacher.

Public schools in those days were not equipped to handle gifted children. Dissatisfied, Carlie took his son out and had him taught at home. Later, Ansel could remember little or nothing of all this and asked his father if he could recall any details. "I know I gave you mathematics and French," Carlie answered, "and you *did fine*. We went through French twice thoroughly so you ought to have stored in your head somewhere a full knowledge of everything including irregular verbs. . . . After quite a while at this home teaching and home reading, you went to private schools and in spare time you took up Greek with old Doctor Harriot . . . wherever you went, you seemed to absorb knowledge. You were a very original and unusual youngster. You read *good* books, kept up on all kinds of things, and sort of grabbed knowledge out of the air." (CHA to AA, March 25, 1944)

In 1915 his father did something that even today would be considered unusual. He bought Ansel a season pass to the newly opened Panama-Pacific World's Fair. Every morning, on his way downtown to the insurance office he now ran, he left Ansel at the gates of the Fair, and every evening, on his way back, collected him. All day long for a year, the thirteen-year-old wandered past the statues, lagoons, and fountains, through the colonnades and arches, into the huge domed buildings and whatever exhibit seized his fancy that day. He became known all over the Fair; any man would lend him a quarter for lunch if he happened to need it, knowing it would be faithfully reported to his father that evening and promptly repaid. Ansel discovered various outlets for his abilities, such as demonstrating an adding machine, to the delight of the exhibitor, and experimenting with a pipe organ. He found a piano in a lounge where sightseers could rest their feet; soon people were gathering to hear him play. His father reported there was standing room only.

In the vast international art exhibition which had been assembled for the Fair, Ansel passed through gallery after gallery where the influence of Sargent and Whistler still dominated. Here and there a few vivid canvasses appeared bearing names like Renoir, Van Gogh, Degas, Pissarro,

Maurer, and Marin. Two little galleries were devoted, rather surprisingly, to the work of the Italian Futurists. Their attempts to convey complex rhythms, forces, and even sounds shocked and stimulated Ansel; so did their titles, such as *Nude: Complementary Dynamism, Sea Dancer, Development of a Bottle in Space*. Over a sculpture by Boccioni, which he remembers as looking like a gutter, he got into an argument during which he maintained there were no straight lines in nature. When he got home that evening, he produced in crayon his own satiric variation on these themes. Coming across them many years later, he was highly entertained: "I had forgotten my first trauma in Modern Art! . . . What a profound loss to the world. Had I progressed I would probably have gone to Paris! Or Paris come to me.

"What verve, what dynamic hyperthyroidism! 'Sand Fleas' is a revelation of the inner itch transfigured to the outer spiritual and egocentric cuticle. A broad passage of a questionable color domination suspending quasi-biologic form impinges on a positive merging of traditional introspective allergy." (AA to NN February 13, 1951)

In the spring of 1916, a friend urged Charles Adams to take a vacation. For years, as Ansel saw it, "Papa wouldn't go anywhere without Mama, Mama wouldn't go anywhere without Aunt Mary, and Aunt Mary couldn't leave the cat." This time, however, the friend won out and the Adamses were booked for two weeks in May in Yosemite Valley. Ansel, who happened to be in bed with a cold, was given Hutchings' *In the Heart of the Sierras* to read. This account so fired his imagination that, for him, "the days became prisons of expectancy. Finally, the train at Oakland! All day long we rode, over the Coast Range, through Niles and Livermore, down across the heat-shimmering San Joaquin Valley, up through the even hotter foothills

to the threshold of Yosemite. I can still feel the furnace blasts of air buffeting through the coaches, and hear the pounding, roaring exhaust of the locomotive re-echoing from the steep walls of the Merced Canyon. Then arrival at El Portal, and a night spent in an oven of a hotel, with the roar of the river beating through the sleepless hours till dawn. And finally, in the bright morning, the grand, dusty, jolting ride in an open motor bus up the deepening, greening gorge to Yosemite.

"That first impression of the Valley—white water, azaleas, cool fir caverns, tall pines and stolid oaks, cliffs rising to undreamed-of heights, the poignant sounds and smells of the Sierra, the whirling flourish of the stage stop at Camp Curry with its bewildering activities of porters, tourists, desk clerks, and mountain jays, and the dark green-bright mood of our tent—was a culmination of experience so intense as to be almost painful. From that day in 1916, my life has been colored and modulated by the great earth-gesture of the Sierra." (Adams, "Introduction" to Muir, *op. cit.*)

They gave him a No. 1 Box Brownie in a leather case with a strap. After learning the simple needs of the little camera, Ansel took off. It seemed to his parents that he was everywhere at once—up on the domes, down in the meadows, jumping from rock to rock for a better view of a waterfall. At one point, trying to photograph Half Dome, he fell off a stump and heard the shutter click on the way down. When this roll was developed at Pillsbury's, the local photographic shop, it contained one picture so upside down it was level.

Endlessly Ansel tried to pour into the magic little box his wonder and his ecstasy. Somehow he must capture this beauty, somehow convey this opening before him of a new heaven and a new earth.

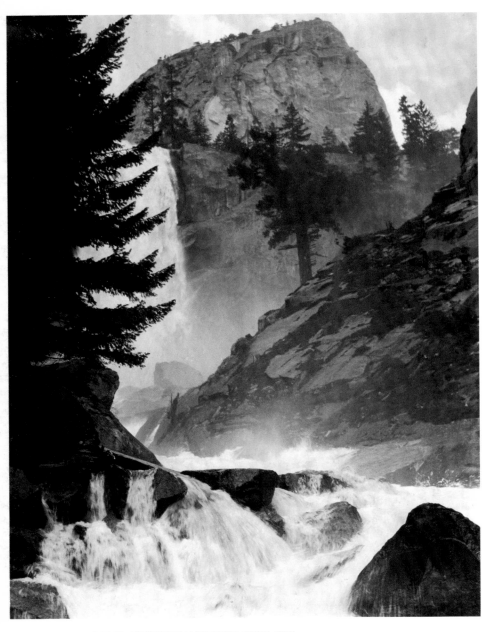

VERNAL FALL, YOSEMITE NATIONAL PARK, 1920

CASCADE, 1920

3. Sierra Nevada

The first small dim prints were disappointing. Why did they reflect so little of what he had seen and felt at the moment of exposure? A consuming desire to know all about photography seized Ansel. Characteristically he went—not to a camera club or some hobbyist acquaintance—but two blocks up 24th Avenue and around the corner of California Street to Frank Dittman, whose photo-finishing plant turned out thousands of prints a day. "Please, Mr. Dittman, may I work for you? I don't want any money. I just want to learn photography!"

Something about his eagerness touched Mr. Dittman. He took Ansel and his latest Brownie rolls into the darkroom and himself began to teach the process. Nevertheless, to him as to his three printers and his six delivery boys, this lanky, beaky youngster with his long words, poetry, and enthusiasm for Yosemite, was a funny one. They called him "Ansel Yosemite Adams," and they enjoyed teasing him. But Mr. Dittman noticed that he "never got mad," seemed to think the pranks played on him were funny himself, and "picked up cussing real fast." He also noted that Ansel often played hooky to work in his darkroom, and was of the opinion that the music lessons were just some more of the coddling the poor boy got at home. As for photography, "It come natural to him. I could see right off he was good. Whatever the kid done was done thorough." (Interview, 1950)

Camera stores, with their seemingly endless array of all kinds of ingenious instruments for making pictures, their rows of glittering lenses, devices for calculating exposure, and panoplies for developing and printing, became a never-ending source of interest to Ansel. How did all these things work and why? He began to devour photographic magazines and such handbooks as he could find. He attended one or two camera club meetings, but found them boring and the photographs dreadful. At one of them, however, he met W. E. Dassonville and saw the exquisite papers he sensitized for photographers to print on. Dassonville, he learned, was a neighbor. Dropping in to see him now and then, Ansel absorbed the idea that photography could be an art.

Whatever careful little photographs he might make around San Francisco, Ansel's real interest lay in getting ready to photograph Yosemite again. Every year since 1916, Ansel has returned to Yosemite. In 1917, Carlie could not come; Ollie reported: ". . . Ansel has his own ideas to carry out and I tell you he is busy already. He got up before seven—went to Pillsbury's, came back, had a swim, went to Happy Isles and *incidentally* to Vernal Falls—came back for lunch and now he and a boy he met on the train have gone for a *short walk*. . . . Ansel could not load his plates in the tent, too much light from the outside: he got under the bed but that wouldn't do, so he went to Pillsbury's."

Ansel himself wrote: "I would have written you sooner but I have not had time. I have walked to North Dome, Little Yosemite, Yosemite Falls, and other places making a total of fifty-five miles. When I got to the top of North Dome I found I had exposed all my plates. . . ." (AA to CHA, June, 1917)

The next year, 1918, he went by himself, under the guardianship of Francis Holman, a retired mining engineer whose interests were mountains, glaciers, and ornithology. "I started out at five o'clock this morning with Mr. Holman for Mount Starr King. There is no trail and it is one of the hardest trips I have ever taken—perfectly safe however. I should not have taken such a trying one the first day but I was surprised how little tired I got. We got to the base of the peak after a long tramp through big snow fields and began to look for a place to start the ascent. The only [approach] was on the north side . . . [we intended] to follow the line of snow over the summit. It was almost perpendicular for 500 feet, and appeared so dangerous that I resolved to turn back. Mr. Holman cut steps in the snow and reached the top, I guess the first man ever to do so, as it has been considered unclimbable. If he had slipped once he would surely have been killed. As soon as he got started I went back to some meadows about a mile away and watched him. I could just see him, and it took 2 hours to reach the end of the snowbank. But he said he couldn't rest until he reached the top." (AA to Olive Bray Adams, May 26, 1918)

Mr. Holman also took the boy on his first camping trip: "we started out one cloudy dawn from Yosemite on the Merced Lake Trail . . . on a day of storm and low

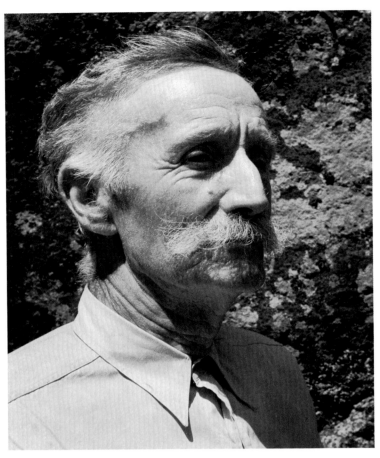

cloud we saw little of the high mountains. On the following morning I crawled out of a very damp and cold sleeping bag and scrambled up the long granite shoulder defining the bend of the Canyon at this point. From there I saw, in the cold dawn wind, the flaming sunrise light in the crags below Mount Clark. Intoxicated by my first intimate glimpse of the high mountains I returned to camp and found Uncle Frank busy with breakfast. He gave me a knowing smile and said, 'Pretty fine, my boy, isn't it?' The mood of that moment was continued for many years—many miles together on the trails. . . ." (*Sierra Club Bulletin*, 1944, "Francis Holman," pp. 47-48)

From Uncle Frank, who was a member of the Sierra Club and of the California Academy of Sciences, Ansel learned much about the mountains. He also learned the techniques and disciplines of wandering in the wilderness, of trail, camp, fire, of packing and managing mules and burros. Together, Uncle Frank in pursuit of birds and Ansel in pursuit of photographs, they led each other on into remote wild places.

These trips were not without their moments. One evening Uncle Frank was happily treating some rare bird skins with arsenic while Ansel, on the other side of the fire, stirred the supper. He was about to throw in some salt when its color caught his eye. "Uncle Frank, the salt's *green!*" After that ornithology and cooking were kept rigidly separate.

Another night, Uncle Frank, announcing he was going to bed like a civilized being for once, hung his clothes on a willow, put on a long nightgown and retired to his sleeping bag. During the night a cold weight began to trouble the sleepers. They awoke in a snowstorm, and found the clothes on the willow frozen stiff. Dry wood was scarce, but Ansel somehow kept a blaze going until the clothes thawed enough for Uncle Frank to struggle into them and lead a brisk retreat.

Ansel's Aunt Beth, widow of his Uncle Will, joined one of these expeditions. She was a woman of courage and perseverance, but she began to be a little perturbed that Uncle Frank, who had "only one eye he could see out of," and couldn't read maps very well, was sometimes uncertain about trails. Then a burro ran away and led them merrily down the canyon for three hours, until they caught him on the brink of a waterfall. Next, Aunt Beth, modestly sleeping alone, awoke to find herself the center of a ring of coyotes.

From one of these trips Ansel emerged with a riotous black beard. His mother nearly fainted, and he considerately shaved it off, though he clung for a while to a treasured wisp of moustache. But the beard is a hardy perennial, which always flourishes in the mountains, and in later years its appearance was greeted with such joy that he began to wear it now and then as a kind of banner.

Much of the time, however, Ansel went off alone with his camera, "seeking my own world in the vast bright intricacies of the mountains," wandering in "translucent unity with the world of mountain and of sky." There is no greater joy nor, often, a more arduous labor for the photographer than this solitary wandering, this meditation and communion. He returns physically exhausted, perhaps, but spiritually refreshed, and cannot wait to develop his negatives.

Of course Ansel observed the mountain rules of always telling some responsible person where one is going and for how long, and, if possible, taking a companion. But the photographer must be there when the great lights and moments occur. At dawn and sunset even mountaineers are cooking and eating, and by moonrise the weary crew is usually inert in sleeping bags. Then too when the trail leads through magnificent country, the photographer often needs to be up on a crag or down by the water, waiting for the wind to stop or a cloud to move, while the other marchers disappear around the mountain. And not everyone braves a storm in order to photograph the visions of its clearing.

Once in early April Ansel went off alone to Merced Lake and was caught in a sudden snowsquall. He groped

his way to a lean-to, holed in, and was bending over to stir his beans when a sudden pain jabbed him in the abdomen. Food poisoning, he thought. In agony, with what he felt must be a high fever, he started down to the Valley, tried to cross a raging creek, failed, and crawled back to the lean-to. There he drank water until the pain lessened, and waited for the creek to go down. It was a night and a day before he could return to the Valley. Not until several years later, when the same pain struck again and he was operated on for a ruptured appendix, did he realize how close he had come to dying alone in the lean-to.

Charles Adams remembered that during these years he and Ansel went off to the dunes to consider his future. Ansel was not sure that music, for him, could fill a lifetime, and he was worried about the certain expense and the uncertain returns of a musical education. Charles Adams told him to take twenty-five years, if necessary, to find out what he wanted to do; he was not going to allow this strange and gifted son of his to be caged by business, as he had seen many others of great promise be—and as, indeed, he himself had been. Ansel was fully aware of what this generous attitude implied for his family's now-limited means and to his father. "He was always a gentleman and a kind spirit . . . a sort of rock of patience."

Somehow, in the romantic haze through which Californians see their pioneers, the myth had arisen that Grandfather Adams belonged to the same family as John, and John Quincy, Adams. An uncanny physical resemblance lent credence to this legend. Charles Francis Adams, catching sight of Carlie at some crowded gathering, exclaimed, "Why, there's an Adams!" and came over to meet him. Thereafter they called each other cousin. And a comparison of portraits reveals the same shape of skull, eye, brow, and hand in Abigail, John Quincy, and Henry as in Ansel Adams. *The Education of Henry Adams,* appearing in 1918, seemed to Charles to sound the knell of a dynasty and intensified his concern for his son.

Toward thus being regarded as possibly the last spark of the century-long splendor of the Adamses, Ansel himself had a different attitude: "It has been one of the major problems of my life to control the spiritual inertia. Henry Adams wrote something about his Education, and it has always impressed me that if he had not tried to get that education he might have been educated. I pondered over that book a lot, and came to the conclusion that there was a direct relationship between the influx of 'Education' and the 'outflux' of Spirit. That conclusion once stated to my family put me in the Dog-House. I was not patriotic to the illusions of intellectual dynastic grandeur." (AA to Alfred Stieglitz, October 9, 1933)

Through Uncle Frank, Ansel began meeting other members of the Sierra Club, including such leaders as Stephen L. Mather, first Director of the newly created National Park Service, and a young man named Francis P. Farquhar, then acting as Mather's financial adviser, who was to become one of the Club's most distinguished mountaineers and historians.

Nevertheless, the illusion of belonging to a tradition of such scope and stature had its influence on Ansel. Whatever he was to do in this world, it was not to be petty or mean in aspect or intention; whatever his beliefs, he would have the courage to fight for them, and stand unmoved by criticism. Nor would he be one to accept any commonly held opinion without question.

In 1919, Ansel got himself a summer job as custodian of the Sierra Club's headquarters in the Valley, the LeConte Memorial Lodge. Before there was a National Park Service, or any rangers or museums to explain to people what they had come so far to see, the Sierra Club had sprung up from among those who had sat in the meadows or perched on the talus slopes to hear what John Muir or Joseph LeConte had to say about the mountains—Muir the naturalist who was fighting the battles of conservation in the national press, LeConte the geologist who with his brother formed the entire science

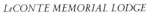

LeCONTE MEMORIAL LODGE

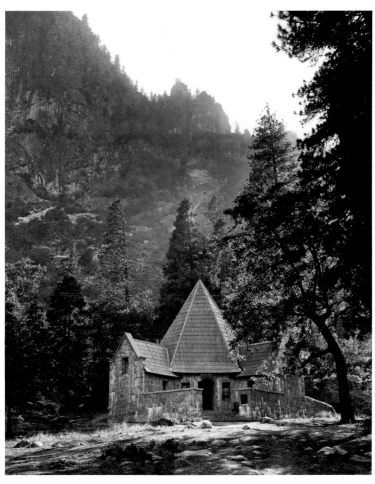

department at the young University of California. LeConte rode the trails of the High Sierra in a tall hat, a black frock coat, and a white shirt he himself washed nightly. He died in Yosemite in 1901. Two years later the Sierra Club built in his memory a little octagonal hut with deep stone walls and a high peaked roof. In the well before its huge fireplace some twenty people could warm themselves; in the room behind a hundred more could crowd in for lectures, receptions, exhibitions. The little hut had already welcomed kings and presidents.

Ansel at eighteen approached with reverence his simple duties of sweeping out, building fires, looking after the collections of wildflowers, rocks, stumps, and cones, collating the latest information about the high country, and running errands in the Club's already ancient Model T Ford. Shyly he received the members of this extraordinary band of conservationists, who came from all kinds of backgrounds, professions, and trades, and were united only by their love of great wildernesses. During the four summers he looked after the Lodge, he met hundreds who were to be life-long friends, frequent companions on the trails, and fellow fighters in the cause of conservation.

Notable among them was the towering figure of William E. Colby, a brilliant mining lawyer whom Muir had inspired to become one of the most sagacious and successful fighters for conservation. Since 1901 Colby had led the annual expeditions into the high wilderness. Then there were LeConte's son, Joseph N. LeConte—"Little Joe"—and his family of whom Ansel grew increasingly fond. One summer a telegram arrived at the Lodge for the LeContes, who were camping at Porcupine Flat. Since it reported that their home had escaped damage in the 1923 Berkeley fire, Ansel decided he must deliver it at once. He scrambled up steep Indian Canyon, through chaparral and forest where there were no trails, and onto the Tioga Road. Finally, brushing through the pines, he delicately approached the family campfire. As he bent to deliver the telegram, Mrs. LeConte reached up: "Ansel, how did you get this?" and took from his hat a baby woodpecker that was clinging there.

At eighteen Ansel decided to make music his career. He was studying piano with Frederick Zech, Greek with Dr. Harriot, and business methods and principles with his father, with whom he agreed that an artist should know how to keep his accounts in order. Perhaps it was this combination of musical notation, Greek alphabet, and Arabic numerals that caused Ansel to form his extraordinary handwriting. It is strange, strong, and exquisite, and, at this period of his life, so minute that it almost requires a magnifying glass to read.

After such rigorous and confining winters, the summers at LeConte Lodge were even more magical. He slept in a tent in the meadow. He was free to go out before dawn with his camera before the Lodge opened; he was free again in the late afternoon. And there were the nearby cliffs to scale. He became an ardent climber, less for the glory of achieving some difficult ascent than for the pure pleasure of exploring the great rocks, climbing handhold by toehold close to the scintillant granite, the veins of quartz crystal, the moss and lichen, to rest on narrow ledges among bay and pine and delicate alpine ferns and flowers and look out—perhaps to photograph—what only the birds and other climbers had seen before.

In the summer of 1920 he had for a few months a companion on the trails who was as excited and exalted by the great rocks and waterfalls as himself. William Zorach was turning from cubist painting to something more solid and monumental, which for him was eventually sculpture. Ansel guided him to high places where the force and mass of water and granite could be best seen. Zorach sketched and Ansel photographed. Once, on the way back, Zorach stumbled and went tumbling down a slope toward a precipice. Dropping his sketches, he clawed at the stone and managed to brake himself just in time. Ansel rescued him, but by mutual consent they left the sketches behind.

For all the adventure and the beauty, Ansel in Yosemite

WILLIAM E. COLBY

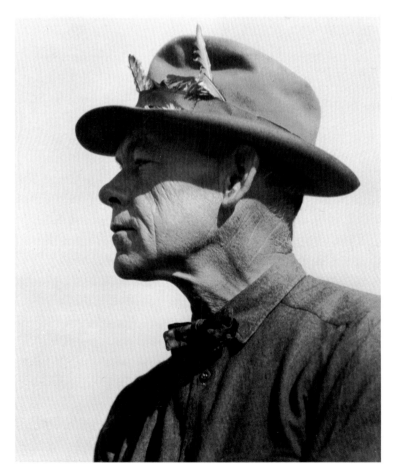

missed his piano, not only because he could say through music something soaring that he could not yet express otherwise, but because of a physical need to stay in practice. He has what he calls "fiddle fingers" instead of the padded fingertips of most pianists and to play for several hours, when out of practice, causes him actual pain.

One of the park rangers, Ansel Hall, solved this problem. In Best's Studio, in the Village, there was an old square piano. Harry Cassie Best had been a violinist before the beauty of Mount Shasta turned him to painting, and his daughter Virginia had a rich contralto voice. "Here's a namesake of mine," said Ansel Hall, introducing Adams, "and he'd like to play your piano."

The Bests made this tall, gangling young man welcome. Of course he could come play any time. Listening to him, Mr. Best commented, was like listening to the rippling waters at Happy Isles.

Virginia had long fair hair, a delicate face, and very blue eyes. There was about her a warm simplicity and an affectionate radiance. Ansel came more and more often to the Studio; he was deeply appreciative of the privilege.

In September 1921, after the Lodge was closed for the season, Ansel and Uncle Frank loaded up the burro, Mistletoe, and went off to the high country. Ansel wrote Virginia from camp above Merced Lake. "This lofty valley and the grandeur of Rodgers Peak, the ascent of which is our main objective, cannot be described. If only I had a piano along! The absurdity of the idea does not prevent me from wishing, however. I certainly do miss the keyboard; as soon as I am back in Yosemite, I shall make a bee-line for Best's Studio, and bother your good father with uproarious scales and Debussian dissonances!" (AA to Virginia Best, September 5, 1921)

From Lake Merced Ansel and Uncle Frank pushed on into increasingly magnificent country. They camped high on the slopes of Mount Florence, near the rim of the Merced Canyon, and looked down two thousand feet to Lake Washburn. They climbed Mount Florence easily and from its peak beheld much of Yosemite Park. Then they reached the Lyell Fork of the Merced, left the Isberg Trail, maneuvered the burro around windfalls through a rough canyon, and suddenly emerged into a fine level meadow ringed with high peaks, one of which had a curiously haunting and compelling shape. Ansel tried to photograph "the extraordinary beauty of the scene. The great rock tower bears no name and is undoubtedly inaccessible. The two peaks to the left of the tower are also unnamed," he wrote in a mountaineering note accompanying this first of hundreds of his photographs to be published by the *Sierra Club Bulletin* (1922). He and Uncle Frank "at-

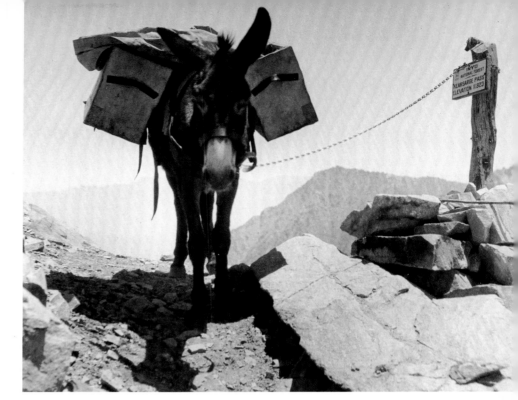

BURRO, PHOTOGRAPHER'S EQUIPMENT

tempted the ascent of Rodgers Peak, but were turned back when only two hundred feet from the summit by the perpendicular cliffs which guard this approach to the mountain's crest. The views we secured from this point, however, were truly grand and well repaid all our efforts."

During the winter Ansel and Virginia exchanged a few letters. A great blizzard caused much damage in the Valley, including the collapse of the roof of Best's Studio. Ansel wrote: "I am glad the piano was not damaged . . . how all the furniture was not totally demolished by a snow-weighted roof tumbling down upon it is more than I can see. I can be up there only three months next season, for I cannot let the piano go as long as I did last year. If it had not been for Best's Studio I might have forgotten the location of Middle C. You know . . . if you do not do anything more than *play* you won't get ahead much; it takes the grind at the mechanics, and the latter I could not inflict on you and yours last summer. Practice is frightful torture on anyone who happens to be within earshot. I am working now on the same Beethoven sonata and the last movement with the chord scales is certainly appalling even to the one playing it. It is a very beautiful thing when it goes at its proper tempo, but the grind of playing it slow over and over again until the proper flexibility of the wrist is attained could be catalogued as a fit punishment for musical sinners in the Hereafter." (AA to VB, January 16, 1922)

In the spring he inquires if her father really does want some of his "parchment" prints to sell in the Studio this coming season? And: "I am still working with the Greek and can read a little of Euripides. Literature should be studied with music, and the Greek Classics are the most musical writings of all languages and nations. The gentle-

man with whom I study Greek is a minister, lawyer, doctor, and linguist, all in one, but painfully religious. He believes to the letter that Adam called all the animals to him and gave them their names; that Jonah swallowed the whale (or the other way round). He denounced me as a very unruly young man for owning a copy of Shelley and daring to read *The Age of Reason* by Thomas Paine. . . ." (AA to VB, March 1, 1922)

Next summer Ansel and Virginia were in love. They knew they could not be married for years; neither of their families could help enough. Ansel urged Virginia not to tell her father immediately: "No, Virginia, we are young. He will surely guess it in a little while, and then at a suitable moment, you might tell him. It is a very delicate thing to do—*you mean the world to him,* you know."

In the summers they could be together; in the winters, Virginia stayed with the Adamses now and then, for a holiday or on her way to or from San Diego, where she and her father often spent the winter. Ansel's letters were full of the concerts he had heard, the musical personalities he had met, the qualities—or lack of them—of various soloists, of new recordings for the phonograph; of the grand piano given him by a friend of his mother's, the widow of an ex-Governor of Nevada. He explained the difference between "programmatic" and real music and urged Virginia not to waste time on "brass bands," and above all, to work on her music and her voice. Two great astronomical photographs, made with the new 100-inch reflector at Mount Wilson, inspired him to a little lecture on the Universe, Man, and the Atom—there has always been a touch of the New England preacher about Ansel—and always there was photography and the mountains. "I am writing this in 40-second intervals, as I am in the midst of some of Dad's pictures, and turn on the light for that length of time every print I make. So this should take just 40 x 50 (the number of prints I will make) seconds. There now, I have spent over three minutes telling you how long it will take. You must forgive the looks of this letter, for I am writing in a darkroom and it is an even chance that I hit or miss the keys I strike out for. . . . the desire to get into the mountains has grown very strong in me lately and the Yosemite *is* so very wonderful. But the crowds—how often I wish that the Valley could be now like it was forty years ago,—a pure wilderness, with only a wagon road through it, and no automobiles nor mobs. I long for the high places—they are so clean and pure and untouched."

A month or so later, up in the high country with a friend, he came to Thousand Island Lake late one afternoon in a clearing storm. The low light glittered on the wet rocks and shone upward on the clouds rising above Banner Peak. Ansel set up on the shore and made glass plate after glass plate of the lifting clouds and the changing light. Glass plates were fragile; of those that survived this journey—Ansel sat on one of them—one in particular emerged as unforgettable. *Thousand Island Lake and Banner Peak* has the upward movement, the feeling for the inevitable completion of line or form, the singing light later so characteristic of Adams's work. It is a place, a mood, a moment—and it is something beyond all these.

That summer, by arranging with Uncle Frank to look after the LeConte Lodge for a week, Ansel joined a Sierra Club High Trip for the first time: ". . . the days of dusty toil, the weary miles of laborious climbing and descent, the obstinate resistance of two opinionated burros, the rising before dawn and the camp-founding after dark. After five days I was tired, dirty, footsore, and thoroughly disgusted, in spite of the thrilling beauty of the ever-changing environment. However, on the sixth day, our march was short, and early camp was made . . . I retired to my blankets in a stupor. . . . I awakened, opening my eyes on a gigantic glittering dome of stars. The Galaxy, a vaporous plume of white fire, poured down the southern sky, extinguished by the black incisive spires of the forest. The stars loomed with terrifying brilliance, the darkness beyond them throbbed with unseen light. A cold wind passed between me and the remote splendor of the night, drawing sound after it through the groves of evergreen and aspen. The wordless meaning trembled on the mind's edge and passed on, while with almost hypnotic persistence, I watched the stars slowly stream over the earth. A short spell of sleep, and the white tower of dawn had reared out of the east. I walked toward the knife-sharp forest with the cold burning of the morning star glinting above me. I thought, as I ploughed through the dew-dampened grass, that there could be nothing so complete in its glassy splendor as the sequence of star-light and dawn-light, with the crystalline chaotic murmur of the stream, and the hollow movement of wind. There was no sentimental precedent, there was no imaginative experience with which to compare this magic actuality. My reactions spared neither my emotions nor my body; I dreamed that for a moment time stood quietly, and the vision of this actuality became but the shadow of an infinitely greater world, that I had within the grasp of consciousness a transcendental experience.

"Another time . . . I was climbing the long ridge west of Mount Clark. It was one of those mornings when the sunlight is burnished with a keen wind and long feathers of cloud move in a lofty sky. The silver light turned every

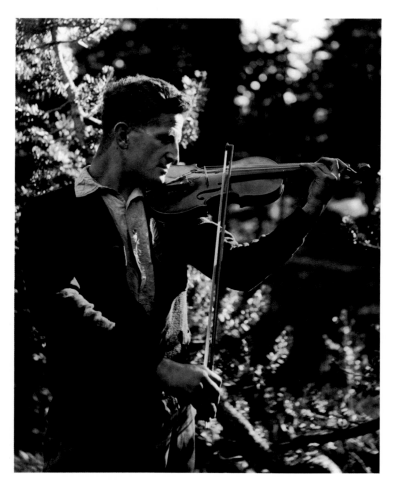

CEDRIC WRIGHT, 1927

blade of grass and every particle of sand into a luminous metallic splendor; there was nothing, however small, that did not clash in the bright wind, that did not send arrows of light through the glassy air. I was suddenly arrested in the long crunching path up the ridge by an exceedingly pointed awareness of the *light*. The moment I paused, the full impact of the mood was upon me; I saw more clearly than I have ever seen before or since the minute detail of the grasses, the clusters of sand shifting in the wind, the small flotsam of the forest, the motion of the high clouds streaming above the peaks. There are no words to convey the moods of those moments." (Fragment, no date)

On that first High Trip, Ansel found himself drawn to one Cedric Wright, a violinist, who could fiddle by the fire deep into the night and still be among the first up, making a little fire of twigs to heat cans of hot water for the cups and basins of fellow risers in the cold dawns; who could then help with breakfast and breaking camp, tramp all day, help set up camp in the afternoons, help dig the burlaps (as the latrines were dubbed), help with supper, and again bring out his violin in the firelight.

Cedric, a dozen years older, was not at first attracted to this thin eager youth with a camera on his back like a perpetual hump and who jittered about so. Eventually, he sensed what was going on inside Ansel—the music,

the poetry, the searching—and found the man who until his death thirty-five years later was his closest friend.

Ansel went back to music and photography that autumn working at a furious pace. He wrote Virginia: "I honestly declare I never had so much to think of, and do, before . . . lots of music, lots of pictures, lots of Sierra Club, lots and lots of little odds and ends to attend to. Yesterday I got up early—practiced all morning, had a hasty lunch, mounted 45 pictures in an album for the Sierra Club exhibit, made out a list of the pictures therein, printed your orders, practiced some more, went down town, took pictures to the Club, took lens to Kahn & Co. to be fitted, had some cake sent to Aunt Beth, took a book back to the Library, met Pop and came home with him, had dinner, mounted 12 pictures, called on some neighbors, took a bath and *went to bed*—that's how it has been going for the last three weeks."

Virginia, understandably, was worried by this incessant activity. Certainly his photographs were already a modest source of income, and bringing "The Day" closer. But photography—even of Yosemite, even those who, like Watkins, Muybridge, Tabor, Fiske, and Vroman, belong to the proud tradition of photography—had so far not succeeded in conveying much of the real moods and magic of the Valley. Best's Studio sold both paintings and photographs, but photographs had lost the wonder they once held for the public and were now classed as souvenirs. Virginia urged Ansel to forget photography and concentrate on his music. He replied on September 28: "My dearest Virginia . . . I have been anything but lazy this summer after my return from Yosemite. I am now doing a little *teaching*. I will continue my photographic work as a means of material income until I find my music is filling my time; thereafter the photography will become a hobby only. From now on, I will do only special work—that is, work of the highest quality that I am capable of. I want to establish a reputation for artistic work, and I have not the time to devote to lesser production. That means that the finest of my negatives will be used without exception; that the finest materials I can get will be put into my work; that I will use the utmost care in the making of prints, and that my photography will always be purely photographic."

This letter is embroidered with footnotes: "Must show you the framed picture of Banner Peak!" "Don't tell Dad that I don't like colored photographs. I like either a painting or a straight monotone photograph. Monotone is the domain of photography!"

Five days later: ". . . Yes, my dear, it is entirely right that I should concentrate on my music. It is too serious

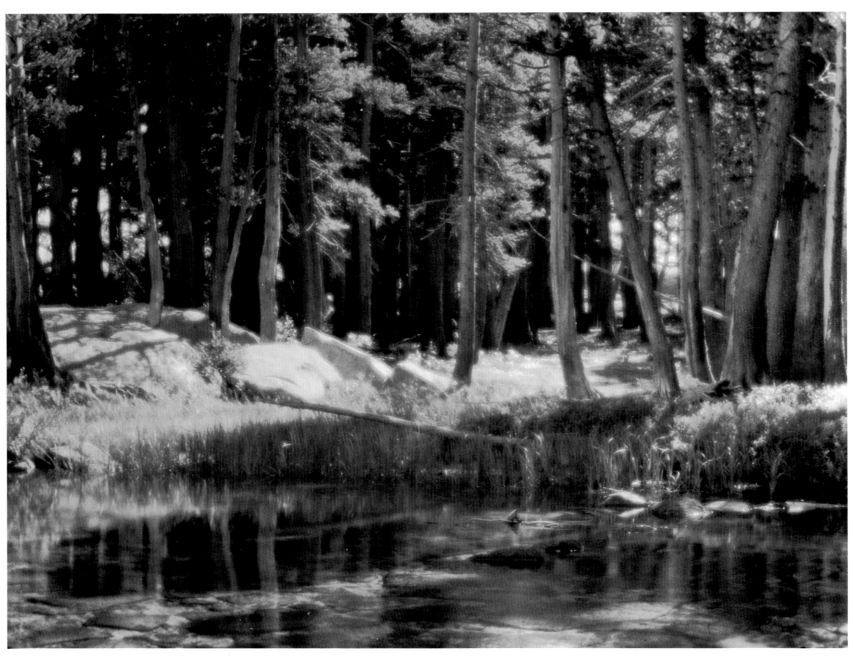

GROVE, LYELL FORK OF THE MERCED RIVER, 1921

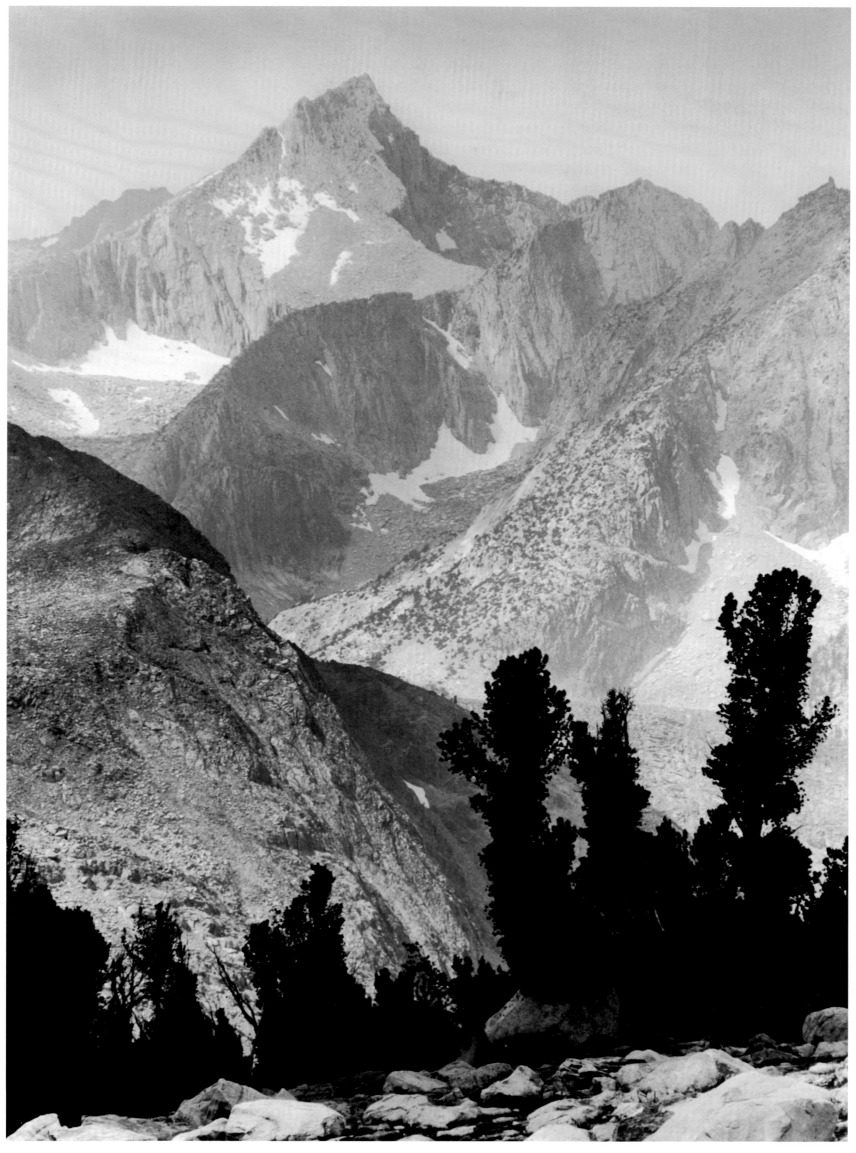

MOUNT CLARENCE KING, 1924

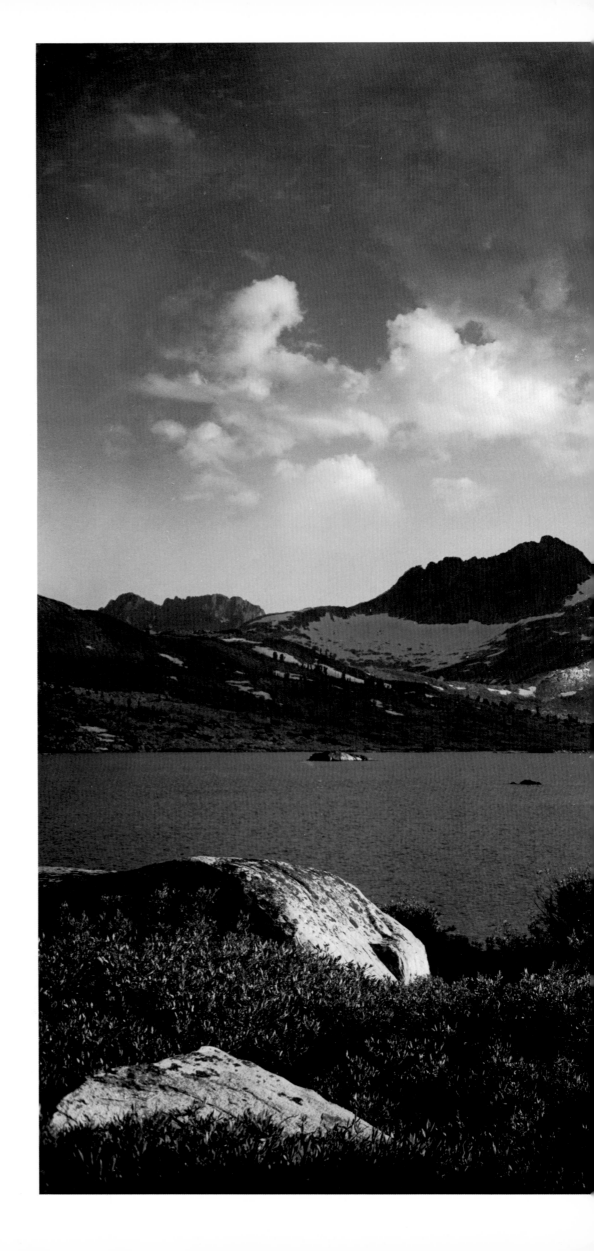

CLEARING STORM,

BANNER PEAK AND THOUSAND ISLAND LAKE, 1923

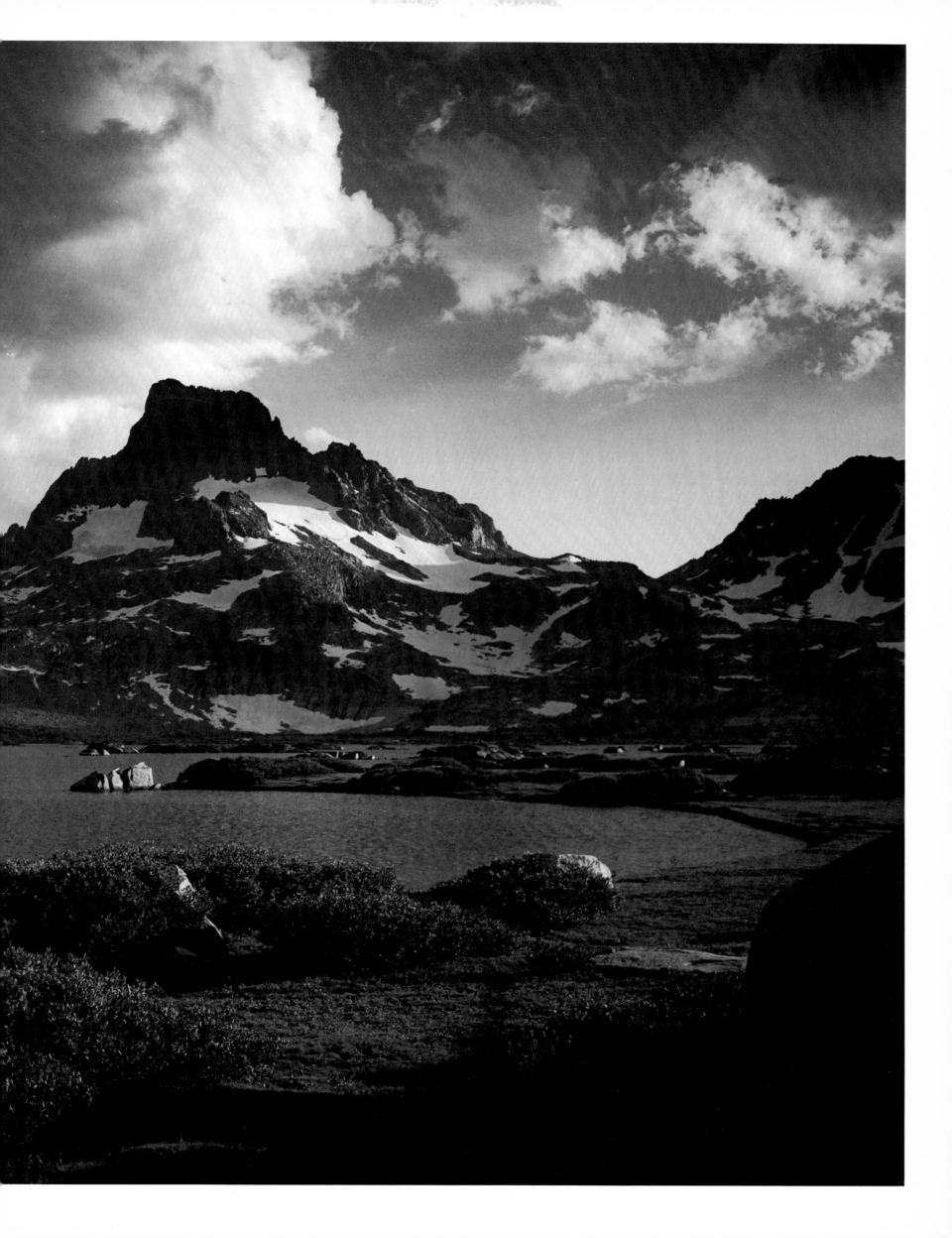

a thing to let any other work interfere with it. But in my times of recreation I shall do a little photography, conforming to the best standards of the art—for photography *is* an Art. My prices are now: "Approx. 6 x 8 *Artistically Mounted* $2.50. No more plain matte prints of the large size unless party wishes same framed. Then *I* will choose the frame. I want each picture to be *individual*." The prices he had decided upon for his Bromoils were much higher. "Bromoil," he said, "is the most magnificent photographic process I have ever seen. It *is* mussy—but more than worthwhile." A few of these bromoils he showed to Mr. Dittman, who spoke so violently of one that it stuck Ansel like a barb; not long thereafter Ansel began to suspect that Mr. Dittman was right, and soon left bromoil behind forever.

Meanwhile in Cedric Wright's house among the redwoods in Berkeley, Ansel was finding a warm welcome, a gentle humor, a dedication to the emotional and intuitive, a freedom from the severe New England codes at home. "Cedric Wright gave me confidence and support in many aspects of life, love, and the pursuit of individualism. He never 'influenced' people in the ordinary sense of the term; he affirmed and clarified all valid experience. He firmly believed that 'to know all is to forgive all.' He had an uncanny awareness and distrust of the futilities, degenerations, and opportunisms encountered so frequently in contemporary music, graphic arts, literature, and photography . . . he always found it difficult to adapt himself to the configurations of formal and academic procedures. Nevertheless, he was an excellent teacher, imparting a sense of structure and intense content, rather than expositions of conventional concepts and style." (AA, Foreword to *Words of the Earth,* by Cedric Wright, Sierra Club, 1960)

Something of his student days in Munich and Vienna lingered with Cedric always, in his spontaneity and fun, his mastery of German and Jewish dialect, his feeling for *Gemütlichkeit.* In his house there was music for violin and piano; there was poetry, especially Whitman; there were evenings in the big barn where a swing hung from the peak of the roof and the walls were lined with low couches and many cushions. Together he and Ansel went on long walks—twenty or thirty miles—up Mount Tamalpais for instance, and down to the sea and back through Mill Valley. It was a headier atmosphere than Ansel had breathed before, and he was moved to experiment with what he describes later as "intolerably stuffy sonnets" and then "interminable dull verse." Cedric once sent on a batch of these to prove his contention that Ansel was a better poet than musician or photographer. Ansel, on

receipt of this news, immediately begged: "For God's sake, keep them on ice!" Nevertheless there are lines in these youthful effusions that foreshadow what he would later develop visually:

". . . far quiet mountains notching the shrill skies . . ."
"Still slopes of ageless stone, immense in silence . . ."
"The clouds are the cool voices of the sky and winds."
Years later, in a discussion with an Eastern editor over the greatness of Robinson Jeffers, Ansel found himself quoting in support of Jeffers:

"O moon, you stare as a white cave from the cold stone of the sky
And the long mesas flow far under your silence. . . ."
"Pretty good," said the editor. "Funny I don't remember those lines. What are they from?" Ansel suddenly remembered what they *were* from—an early elegy of his own—and shut up in a welter of embarrassment.

Adams as teacher began dismally enough in music. He was ruffling through some scores in a music store when a girl came up to him. "Oh—you are a pianist? I want so much to learn to play the piano!" Getting to the young lady's house involved most of the transportation systems in San Francisco; Ansel was very late. Her fingernails were so long they clicked on the keys; when he suggested she cut them—"Oh no! I couldn't do that!" Then, trying to annotate some simple music for her, he upset a bottle of ink all over the piano and the girl. Her mother called the next day and said that she didn't think her daughter was suited to music.

Soon he began attracting a few more serious students. But, as he wrote Virginia, "A pupil a day won't keep the wolf away," and even when he was giving three or four lessons a day, his music and photography together didn't add up to enough to marry on. As his first gesture of independence from his family—and also to relieve their long-suffering eardrums—he hired a little shack in Mill Valley to which he retired for several days at a time. Here he practiced on an old upright piano hour after hour. The shack was cold. If he lit the stove to warm his hands, it was soon so hot he had to open the windows, and then it was cold again. He worked on until he was cramped and then, often enough, sought refuge in a tramp through the Marin hills.

In 1924, and again in 1925, the LeContes asked him to come on their expeditions into the wild and beautiful Kings Canyon Sierra, then accessible only to dedicated mountaineers. He accepted with excitement and a resolve to make the finest photographs that were in him. He wrote Virginia: "I gave lots of lessons, and gathered everything together for the coming trip—a plate-changing

bag, two red filters, a box made to fit the pack-box which is to hold my plates and film. I will have three cameras, five lenses, six filters, etc., etc., so, if I do not get results, it will not be the fault of the outfit."

In a fragment of manuscript, characteristically undated, Ansel described the photographer "burning with impatience to apply his precise craft to the huge and inexhaustible task of the photography of mountains.

"He carries on his back his camera for general use and his lenses and other devices. He has in his hand a tripod—rather heavy—for it must do for all cameras. On his pack animal he has secured his large view camera with its holders, and a generous supply of plates, films, and whatnots that could not be left behind without serious misgivings . . . two focusing cloths and a tape measure. I forgot to mention he also carries a small speed camera ($2\frac{1}{4}$ x $4\frac{1}{4}$ Speedkodak) 'just for incidentals.'

"It is a brilliant day and he is in immense good spirits. The heavy pack is shouldered, the mule untied. He is to go ten miles before lunch, and climb a small summit in the afternoon. The first four miles yield nothing. Then suddenly there appears an immense view: a mountain looms strong-shadowed out of the canyon. A white river roars in the near foreground, and there are sombre masses of pine scattered just right within the frame of view. (This is simply a bald and typical case.) He thrills and ties up the mule. What to do? Shall he throw the immense peak against a pure black sky? Impossible—for the exposure would mess up the rushing water. To catch the water would require at least a fiftieth of a second. That can be done with a Panchromatic Plate and a three times filter. Out comes the large View Camera. It is set up with the Goerz 8 inch [lens], laboriously adjusted on uneven ground. The view will not contain itself on the screen. Down comes the large one and up goes the small. Still, with the 5 inch, the view is unruly and will not stay in bounds. Down goes the small and up goes the large with the wide-angle. The view at last consents to crowd itself within the groundglass. But it is observed that the wide-angle lens has for its largest stop $f/16$. Only the weakest filter can then be used. But alas! the lens has no shutter, it is used with cap for time exposure. Despair. The day progresses. What to do? The speed camera offers the only solution. An exposure is made at $1/100$ of a second on film pack without filter. (Final result is magnificent.)

"The cameras are gathered together and the march continued. The photographer is a bit tired but still eager. When he arrives at the end of the morning's work he is weary unto death, exasperated, and dreads the toil of the afternoon ahead. He has to his score for the forenoon one

picture with the large camera, two with the small, and fifteen with the speed camera. Almost every attempt has entailed the same trial of apparatus as the very first.

"That afternoon he ascends the mountain with the small camera, the telephoto attachments, and the speed camera . . . and does a very great deal—with the speed camera. He returns to camp completely exhausted and with an already depleted stock of film. . . .

"He has much food for thought. . . . What should he have provided himself with in order to make his work an assured success?" (AA, manuscript, no date)

Ansel had taken along in his knapsack a copy of Edward Carpenter's *Toward Democracy*. He read it in the halts and twilights while resting from his photographic labors. From Marion Lake, the most beautiful he had ever seen, he sent out, through some knapsackers that August, a postcard to Virginia: "I have never felt that I would find a *religion*: but I have done so. The Carpenter book has established a real religion within me. Reading it, as I have been, in the Mountains, has greatly aided my understanding of it, and I cannot tell you of the great joy and peace it has given me. It is so broad, so inclusive, so reasonable, and so magnificently written!"

In San Francisco, he found himself in a strange state of mind: "I think nothing can be compared to the Hills for the elevation of spirit and peace of mind. How could I ever describe what the Mountains meant to me this summer; what they did for me? . . . My Dear, I am an entirely different person. It is almost a rebirth; I sense another and much deeper personality within me, a greatly extended perception and appreciation. The world has suddenly opened up to me with tremendous and dazzling effect, and I am having the very deuce of a time trying to realize it all. New personalities, new outlooks, new ideas, new possibilities all crowding into my consciousness, and above all the nameless dread of having to continue under this life, and the dread also of separating myself from it. The world distracts me from my purpose; I know I am not understood. The thousand little things compel me into a tension, mental and physical, as if I were threatened with myriads of relentless darts, which would torture me were I to dare a single motion while surrounded by them. 'Freedom, the Deep Breath!!'"

A week later, Virginia received a most exquisitely written and painful little letter: ". . . I have arrived at some rather tremendous conclusions. Here they are:—

"I. It will require six to ten years to complete my musical education, or rather, to bring it to a point where I may call myself an *Artist*. I am just beginning to realize this. . . .

"II. If I come forward at this time as a *teacher* and enter into the work with the seriousness required to handle responsibilities, my musical study will be almost entirely arrested . . . I would earn a precarious and uncertain living, and I would be filled with sorrow and bitterness that I had not perfected my Art to the limit of my ability. And this condition of heart and finances would bring naught but misery on those dependent on me. . . .

"III. I know that God has bestowed upon me a great gift, which in itself is a most tremendous responsibility. . . .

"IV. I realize now more than ever before my duty to my mother and father. They have given me everything—I have returned nothing. I must present them with *accomplishment* . . .

"I dedicate my life to my Art.

"I have taken the first step on the new road. I have purchased a Mason and Hamlin Grand Piano, the finest instrument that money can buy. So confident was I of the righteousness of my new resolve that I ordered the piano into the home with almost religious awe and reverence, as a symbol of my new life."

Virginia responded gallantly to this breaking of their engagement. Nevertheless she felt crushed by this rejection of her patient and undemanding devotion. Ansel, who had not wanted to hurt her—merely to face facts—was worried; so was Cedric, to whom she wrote a pathetic little plea for help, saying she did not want a career, or college, as Ansel and Carlie had urged—just a house and children.

For over a year Ansel persevered on his new course. He fell briefly under the spell of two of the beautiful young violinists among Cedric's pupils. Both were awed by his musical gifts and both found him too strange and nervous a phenomenon to love. During this year Ansel ventured on one of his earliest productions: with Mildred Johnson, a violinist, Vivienne Wall, a dancer, and himself at the piano, he set up the Milanvi Trio. When the announcements were printed—first of the many announcements in Adams's life—Ansel wrote Virginia: "I haven't been able to get my hat on since!" But the trio did not last long; Ansel was never intended to be an accompanist. Even when he tries, pianissimo, his extraordinary touch and sense of melodic structure come through like a command.

It was to Virginia that, early in 1927, Ansel wrote the wonderful news that Benjamin Moore had accepted him as a pupil. It was a rewarding relationship; years later, Ben Moore wrote: "You have no idea how many times I quote you and your touch which transforms everything into beauty. And of course the B♯ Major, Partita I, with its delicately traced *quasi flauto* air never fails to bring you vividly before me, and I wish that you could play it for the student and awaken that elusive intangibility."

Nevertheless, Ansel wrote Virginia, early in March 1927: "Music is wonderful—but the musical world is the *bunk!* So much petty doing—so much pose and insincerity and distorted values. Something in me revolts to all that . . . and it seems very clear to me now that unless I get more of the outdoors, I will blow up. I find myself looking back on the Golden Days in Yosemite with supreme envy. I think I came closer to really living then than at any other time in my life, because I was closer to elemental things—was not so introspective, so damned sensitive, so infernally discriminative. Now I long to get back to it all—to feel the contact of everyday, commonplace, material, primitive things—Rock—Water—Wood—and *unanalyzed* love and friendship (the only satisfactory kind). I want to write—I want to take pictures—I am tired of moving my fingers up and down under [word indecipherable] rules of past ages and evoking series of tones that are supposed to represent emotion. 1/100,000 of them do! There's something about *You* that is so refreshingly *natural* and *un*-complex—also in Cedric. I love you *immensely* at the moment . . . I am coming to Yosemite sometime in Spring—or Bust!"

Sometime in the next few weeks Ansel did return to the Valley and to Virginia. One spring day with Cedric and some others they climbed up to the Diving Board. Beside them towered the immense dark cliff of Half Dome, the snow on its crown and on the peaks beyond, brilliant against the deep sky. Ansel made a series of photographs, among them one that even then spoke to beholders like a trumpet. It first appeared, appallingly reproduced and garnished with bad sketches, on the feature page of the *Stockton Record* for April 16, 1927: *Monolith— The Face of Half Dome* is as crystal sharp as that vision long ago on the slopes of Mount Clark.

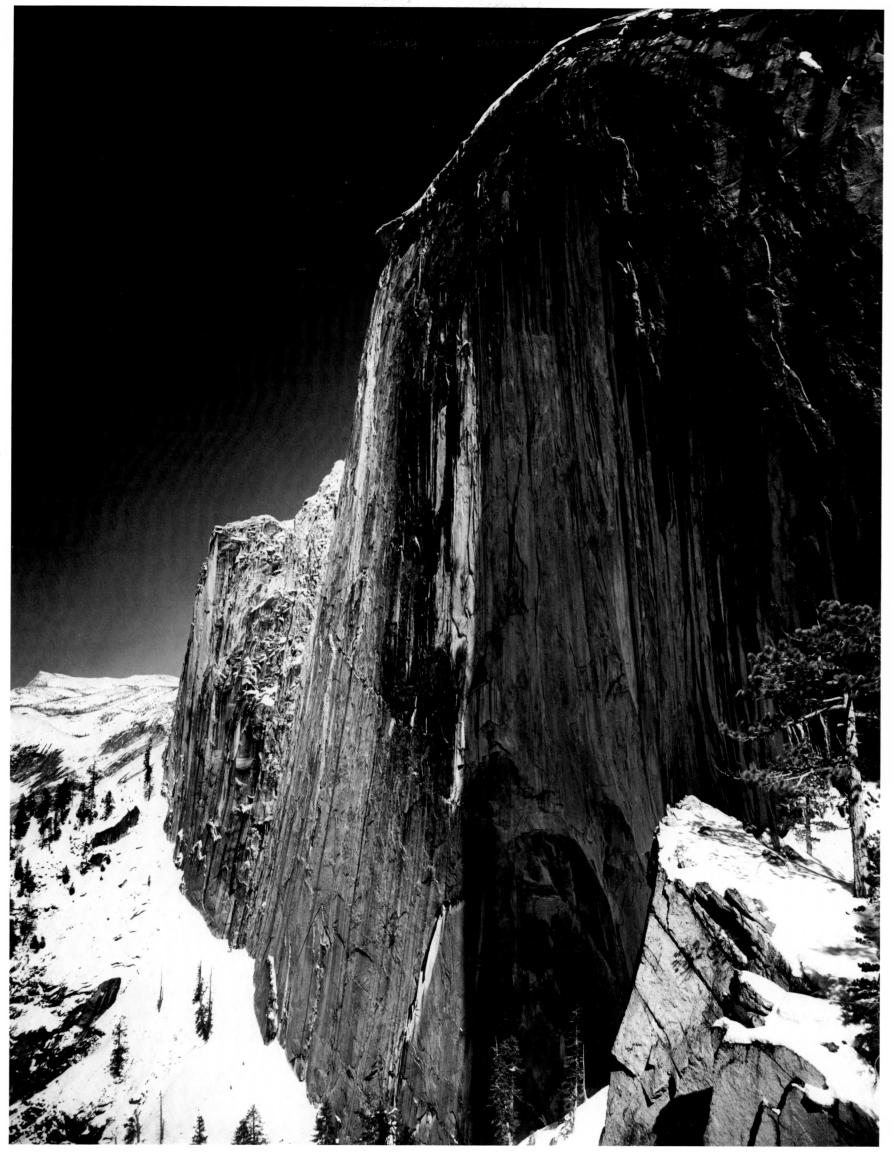

MONOLITH — THE FACE OF HALF DOME, 1927

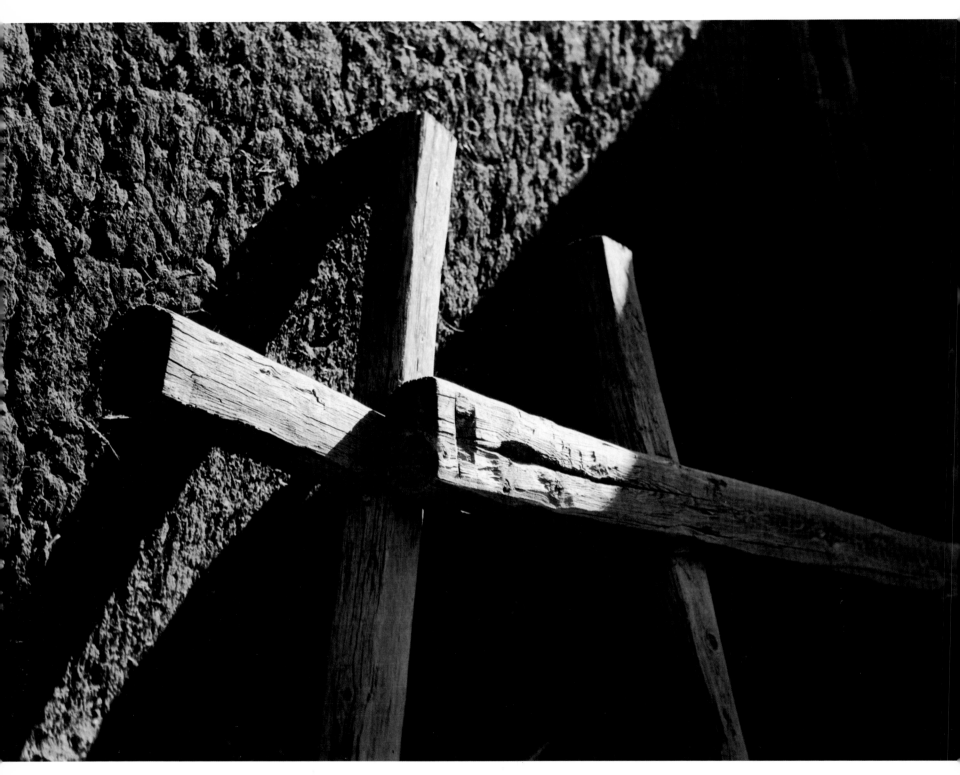

CROSSES AGAINST WALL OF PENITENTE MORADA, NEW MEXICO

4. Sangre de Cristo

At Cedric Wright's, the evening of April 10, 1927, Ansel met "a little man with a mighty heart and a luminous spirit"—Albert Bender. Born in Dublin, Albert had come to this country a poor Jewish boy, entered the insurance business, and made a modest fortune which he continuously distributed to people in need, particularly artists. His effect on the art world of San Francisco was such that he astounded people into generosity. "Albert," said Eldridge Spencer, architect and friend of both Ansel and Albert, "stimulated people beyond his own capacity to understand. In the midst of the unbelievers . . . he gave you reassurance that humanity—and beauty—come first."

Albert, as Ansel later discovered, with undiminished affection, "had no interest at all in nature unless it was decorated with celebrities like a Christmas tree," and very little interest in music as such, but he looked at these mountain photographs by a young pianist and said, "Can you come see me tomorrow morning?" On the morrow, he proposed that they issue, in princely style, a portfolio of photographs of the High Sierra. He then began calling various friends, for instance Mrs. Sigmund Stern, long a staunch patron of the arts and a frequent partner in Albert's projects. Ansel reports that the conversation at Albert's end went something like this, "Rosalie!—I have here in the office a young man who is both a wonderful musician and a wonderful photographer! His name is Ansel Adams and we're planning to get out a portfolio of his photographs of the High Sierra—probably fifteen fine prints. Grabhorn will do the typography. It's going to be stunning, Rosalie!—Seventy-five copies at fifty dollars each. I'm taking ten. What about you?" Mrs. Stern took ten, so did her son-in-law, Walter Haas. By the end of the afternoon, fifty-six copies had been sold, sight unseen, and the portfolio was assured.

Albert's pockets were full of gifts for his friends—and also of his latest Buddha or piece of jade in its velvet case; he was an ardent collector of Chinese art. He loved parties, and the one he always gave on St. Patrick's Day, which he celebrated as his birthday, was famous.

In Ansel he discovered a genius, a son, and an enchanting companion, and could hardly wait to introduce him around. Ansel was still very shy, and trod lightly while being led to the lions. But the lions, after the first few awful moments, didn't seem to think he was strange at all; they seemed to recognize in him, not a lamb or a fawn to slaughter, but another lion—a cub, anyway—and welcomed him. If he clowned, they roared with laughter; when he played, they were moved and exalted.

A few days after they met, Albert proposed to Ansel that they drive to Carmel together to see Robinson Jeffers, Lincoln Steffens, John O'Shea, and others. The road to Carmel was at that time a full day's drive. Carmel in the 1920s still retained much of its early Homeric quality. It was a simple and hospitable life the poets and painters lived among pines and cypresses. Their shacks were seldom beyond the sound of surf and the sight of the ocean, turquoise, emerald, and ultramarine on clear days, and a shining pearl under the fogs. Beside the beach, Jeffers had built himself a tower of sea-worn rocks from which he could look at Point Lobos and the eternal horizon.

On this journey Ansel made a portrait of Jeffers which Una Jeffers, his wife, described as having "indeed the quality of bronze." The poetry of Jeffers, with its feeling for the Pacific, the West Coast, and the Greek tragedies, made a deep impression on Ansel; here was a poet working in the great tradition with the earth on which Ansel himself stood, the same visions he saw, the life being lived today in these hills.

"My excursions into experience have brought me to stern realization of fact," Ansel wrote Virginia, "and, to be frank, I find the world more solidly beautiful than when clothed in glittering fancy. I want a little studio, acoustically correct, and with wall space for my prints. And a suitable workroom as well. And you must have your own room—as you want it—and it will be yours in every way. And I want friends about me and green things —and the air of the hills.

"My photographs have now reached a stage where they are worthy of the world's critical examination. . . . I will try to combine the two processes of photography and the press." (AA to VB, postmarked April 25, 1927)

They were scarcely back from Carmel when Albert proposed they drive to Santa Fe, New Mexico, and take with them the writer Bertha Damon. Bertha was brilliant and witty, and the trip was definitely an adventure—in an open touring car, on dirt roads that led over boulders and

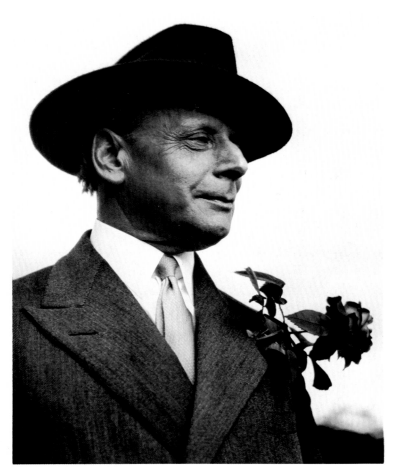

ALBERT BENDER

ROBINSON JEFFERS

down into washes, in dust and mud; they could probably have done it more easily with mules. Ansel had not met the desert or the Indian country before, but he got them to Santa Fe.

Ansel was deeply moved by Santa Fe. It was late April; the willows in the washes were in leaf, and the plum thickets white with blossoms, but there was still snow on the peaks of the Sangre de Cristo. One wandered up the lanes between adobes that through the centuries had settled into forms like living flesh, in the exquisite fragrance of piñon smoke, with the peaks glowing high above.

He met Frank Applegate, a painter full of enthusiasm for the strange and intense religious folk art of the Penitentes, who had brought their faith and its symbols from Spain to these high, remote valleys more than three centuries before. He met Mary Austin, whose *Land of Little Rain* is a searching, poetic summary of the different lives being lived in the great arid valleys of the West. Albert, with his extraordinary combination of insight and instinct, proposed that Mary, as "the greatest writer in the West," and Ansel, as "the greatest photographer," should get together and produce a book. Ansel was to acquire an affectionate respect for Mary Austin, but just then he found her not a little terrifying—"three feet wide with a Spanish comb," as she appears in one of his irreverent fantasies some years later. Then they drove north to Taos. Ansel scribbled hastily to Virginia: "This is the most completely beautiful place I have ever seen. A marvelous snowy range of mountains rises from a spacious emerald plain and this little Old World village nestles close to the hills. Adobe—bells—color beyond imagination—and today, the heavens are filled with clouds."

In Taos they went to see Mable Dodge, who, after a hectic experience of life and love in the East and in Europe, had come to so deep an appreciation of Pueblo wisdom that she married a full-blooded Taos Indian, Antonio Luhan. Her house, to which in the Spanish tradition she was continually adding more rooms, eventually surrounded a plaza of its own. Here she welcomed, with what Ansel once described as "talons for talent," the most brilliant painters and writers she could gather from two continents.

In such creative atmospheres, Ansel was like a half-frozen bird thawing out. All the charm, wit, and fantasy, so long latent, began to appear, still hesitantly.

They came back by way of the Grand Canyon. Ansel wrote Virginia: "It is a terrific thing, but for some reason, I was not moved at all. Mere vastness does not indicate beauty. There is no sense of depth or distance, it is immense, barren and forlorn. . . . My chief impres-

sion was that I confronted an absolutely unworldly vision without form or life—probably a mile—perhaps ten thousand miles in extent, and lonely and desolate. I thought of the moon. . . .

"The most remarkable spot I ever expect to see was the Pueblo Acoma—an Indian village of great antiquity set on a lofty mesa in a wild desert landscape . . . impossible to tell of the beauty of the place and the effect of color— the cream rocks and earth—the green blue desert and the brilliant reds and yellows and blacks of the Indian costumes. We *must* see it. . . .

"Our meter will read over 3,000 miles. It has been a marvelous trip in every way. Albert Bender is wonderful in his kindness."

That summer the Sierra Club High Trip went from Giant Forest, past Little Five Lakes, through the Kern-Kaweah region to Mount Whitney. Virginia came along; it was her first trip with the Club. Ansel brought one of his piano students, Jules Eichorn, later to prove one of the Club's most skillful and daring rock climbers, and Cedric brought one of his gifted pupils, Dorothy Minty, who was mildly astonished to find herself outfitted from top to toe in Cedric's clothes.

FRANK APPLEGATE

MARY AUSTIN

She and Cedric had their violins; their playing, and Virginia's singing, in the evenings while light faded from the crags and the campfire grew brighter, intensified for Ansel the experience he was trying to photograph by day. Much of what he felt he still expressed most easily through the soft shimmering play of lights loved by the Pictorialists. But he was struggling to attain that "world more solidly beautiful" of which his "Monolith" was the herald. Through close-ups he was trying to convey that "contact of everyday, commonplace, material, primitive things —Rock—Water—Wood," for which he longed. Jessie Whitehead, daughter of the philosopher Alfred Whitehead, was trip historian that year. A novice in the high country, she found it "hard to believe that no saints walked in those hills and angels descended on them never." In the midst of cloud and storm and peak, "the legend of Ansel Adams's mules acquired a quality of unrestrained lyricism. Electra was an animal who could not behave as other mules; her mind was ever alert to impart a humorous or poetic twist to the occasion, and she systematically exploited her own personality. She had a subversive intellect and a perverted mind, and seemliness was not in her." (*Sierra Club Bulletin,* 1928.)

His training in Mr. Dittman's darkroom stood him in good stead when he began printing for the High Sierra Portfolio. So did his training as a musician, playing the same phrase over and over until its voicing was in his

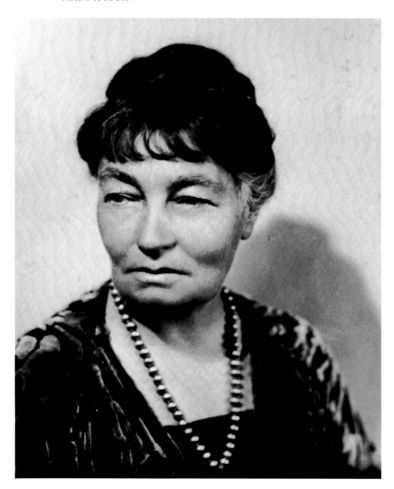

hands as well as in his head. Once he achieved the quality he wanted, it was easy for him to make a hundred more so close to the original that the differences were below the threshold of perception. For this Portfolio, he printed eighteen delicate and sensitive little landscapes. Each print was enclosed in a folder of handmade paper, the title page was illuminated in gold and blue. The case was of black grosgrain lined with gold satin. The publisher, Jeanne Chambers Moore, objected to the bald word, "photographs," so "Parmelian Print" was found instead. When it appeared, in the fall of 1927, *Parmelian Prints of the High Sierras* was a spectacular production. It was a success and has become a collector's item.

Joseph N. LeConte, reviewing it for the *Sierra Club Bulletin* (1928), found each print "of exquisite composition, each as technically perfect as it is possible to be produced. The fact that they are the handiwork of Ansel Adams is sufficient to guarantee their artistic perfection to members of our club. The artist has attempted, and with great success, to suggest the scenery of the Sierra Nevada in a more pictorial sense than by literal representation. By keeping to a simple and rather austere style, the prints assume a dignity and beauty which is not generally conveyed by photography."

Ansel now had actually some money to bank, instead of the sparse savings of earlier years. Just before Christmas he wrote Virginia: "If I come up on the 26th and bring Ernst Bacon the composer and two sleeping bags and a promise to eat at the Cafeteria, can I sleep on your porch or under your piano or down the chimney, and play for you and walk to some dear old places. . . . [Mr. Pantaleiff] said, 'Belief me, Mr. Adams, Mees Best has a very fine voice—will be fine singer; not beeg voice, but *bootiful*.' There now, how's that! . . . I have some new Ideas:—wait until the 27th."

Cedric came along too and brought Dorothy Minty. Ansel's ideas turned out to be 1. that Virginia should take three years to perfect her voice, and 2. that he and she should be married immediately. A minister was summoned, a license obtained from Mariposa. Five days later, on her wedding morning, January 2, 1928, Virginia finished sweeping out the studio just as the minister came to the door. Clothes were a problem. The best dress in Virginia's closet was black, though it came from Paris, and Ollie wept over the bad omen. Ansel had a pair of plus fours to put on, but Cedric, Ernst, and Dorothy were limited to winter hiking clothes. Dorothy on her violin, with Ernst at the piano, gave the bridal pair the second movement of the Cesar Franck sonata.

Ansel wrote Albert: "You opened up the world to me and made for me many precious friends—established my work and reputation. You gave me the foundation on which I hope to build a beautiful and useful life. Whatever I do, I will always feel, with true gratitude, that you are at the bottom of it all, having provided courage and inspiration and material support, when I was in dire need of such things. . . . So, Albert, we want you to know that if it had not been for you, we could not have married, we could not look into a radiant future—we would not be planning a home. . . . Within a week we will be settled down in Berkeley. . . . And do not fail to tell me if there is any way I can help you." (AA to AB, January 1928)

Planning a home was of the utmost importance. Immediately after the wedding they drove with Cedric to Berkeley to consult the architect Bernard Maybeck, among whose achievements were the Palace of Fine Arts at the Panama-Pacific World's Fair, where Ansel spent that wonderful wandering year, and many other buildings of rich and simple mood, among them Cedric's own house. Cedric wrote Maybeck a little note "to break the ice for Ansel Adams." The following is pure Cedric, *verbatim et sic* "This is one of my very special friends. You should have a picnic together. He wants a nice house cheap so I send him to you. For heavens sake don't make the house like HIM, as you claim to do. He will probably shave three times before his first visit to you but you will begin to find him out after a while. He will be too bashful to say so, but he has two donkeys and will want a stall at one end of his music saloon, and a campfire in the middle under a hood."

Maybeck, listening to Ansel's plans for Virginia and to her voice, was inspired to design a house around a woman who was both housewife and singer. The kitchen, in his opinion, should have the best view, since an American wife must spend so many hours there. For the studio, he worked out a beautiful staircase which should present the singer and conceal her accompanist and his piano. Ansel's needs for light, wall space for prints, and an efficient darkroom were minimized by Maybeck in his enthusiasm. Nevertheless, Ansel and Virginia thought his sketches glorious, and Maybeck gave them to a contractor to estimate. A day or so later, Ansel received a phone call; a distressed voice announced, "Mr. Adams, we are only two-thirds through the big studio, and we've already exceeded your limit of eight thousand dollars." So, for a few years, Ansel and Virginia had no home of their own; sometimes they lived with Cedric or with Papa Best in Yosemite, but most of the time they stayed with Carlie and Ollie.

WITTER BYNNER

BYNNER'S HOUSE IN SNOW

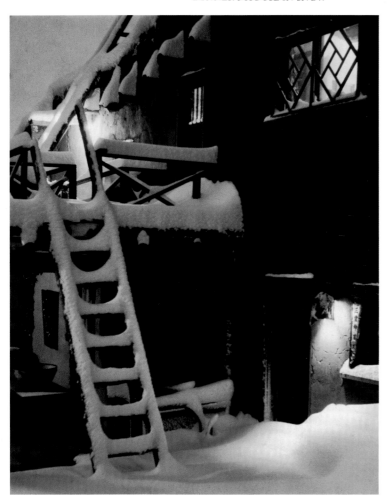

In April, Ansel went back to Santa Fe to pursue Albert's proposal that he collaborate with Mary Austin on a Southwest portfolio. Witter Bynner, the poet, welcomed him to his remarkable house, crowded with Chinese, Pueblo, and Spanish American treasures, which stood on a steep hillside within a walled garden and looked out through poplars at Santa Fe. Bynner was enchanted by his guest, and in a poem expressed something of Ansel's quality:

TO A GUEST CALLED ANSEL

Whenever a bird lands he sings
And brings
A bit of heaven down or preens
His wings like little evergreens
Of upward earth, combining so
The light that shines and things that grow
And all the best of all the weathers
Into a single ball of feathers.
You, sir, are personal and long
Far too large to make a song.
Combining rightly like a bird
Only the things good to be heard—
And yet you touch a floor or a chair
Or the indoors or the outdoors air
With just the presence that can float
Away upon a perfect note.

Nearly every night, to celebrate his guest and share him with Santa Fe, Witter Bynner gave parties which tended to continue into the dawn. Bynner himself, Ansel observed, benignly withdrew around one o'clock into an eyrie at the top of the house where he wrote for several hours. The nights of a poet and a pianist left scarcely time for a snooze before the days of a photographer began—a stiff pace even for the energy and vitality of an Ansel.

Nevertheless, he explored, looked, thought, and consulted with Mary Austin. He wrote Albert: "We have finally decided on the subject of the Portfolio. It will be the Pueblo of Taos. Through Tony Luhan, the Governor of Taos was approached . . . in a week or so a Council meeting was held, and the next morning I was granted permission to photograph the Pueblo. It is a stunning thing—the great pile of adobe five stories high, with the Taos Peaks rising in a tremendous way behind. With Mary Austin writing the text . . . I have a grand time to come up with the pictures. But I am sure I can do it."

That summer Adams went as official photographer with the Sierra Club High Trip expedition to Jasper National Park in the Canadian Rockies. His photographs

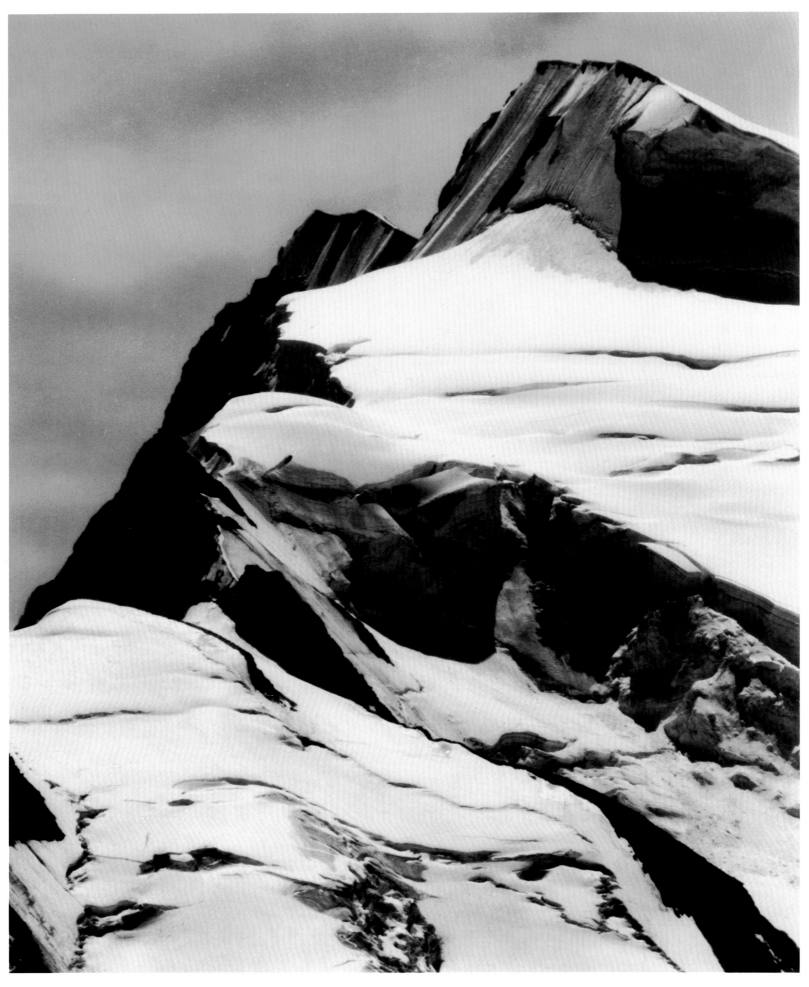

MOUNT RESPLENDENT, JASPER NATIONAL PARK, CANADA

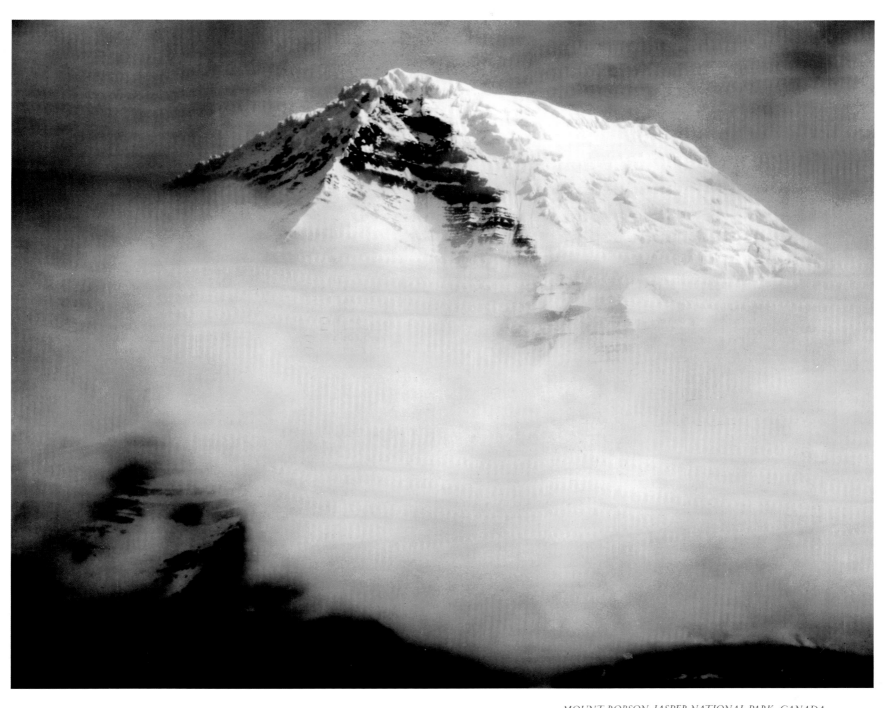

MOUNT ROBSON, JASPER NATIONAL PARK, CANADA

achieve a space and splendor such as perhaps only the great Italian alpine photographer, Vittorio Sella, had previously expressed.

Adams himself, however, came close to making no more photographs at all. On a difficult traverse, where only photographers were allowed off the rope, his enthusiasm landed him far off on a glacier. He was picking his way back, impeded as usual by his photographic impedimenta, when something absolutely compelled him to stop. He recognized the same chilling compulsion which once halted him on a sidewalk in San Francisco the second before a cornice crashed in front of him. Now, having no ice ax, he jabbed with his tripod at the snow ahead. Tons of snow fell into a crevasse that had been hidden.

During the descent from Mount Resplendent, "we looked back to see our photographer friend far up on the mountain, entranced by the view and handicapped by his pack. The guides fully understood his position, and in a tone of affection one remarked to the other, 'I go back and get dat Hansel.' From that time on, the guides took such friendly interest in him he had difficulty in keeping his equipment sufficiently concentrated for use, so eager were they to help him carry his burden." When the expedition got back to the Coast, and "embarked on the steamer, *Prince George,* our photographer friend stowed his cameras away, and held the attention of everyone on board with wonderful piano concerts," Walter L. Huber wrote in the *Sierra Club Bulletin.*

Music and photography. Could he say in music what he could in photography? Could he say in photography what he could in music? In October Ansel wrote Albert:

"We were discussing the communicative element of music, [A. R.] Orage [psychologist and philosopher] maintaining that ideas, visual and abstract, and the emotions, could be conveyed in their essences from the musician to the auditor through the medium of tone.

"We made an experiment. I played a certain short composition (Scriabin Prelude, Op. 17, No. 3, in G♭ major) which presented a definite programmatic quality to me, the basis of which was obtained through contact with a person who had studied with the composer. Indicating nothing whatever of this to Orage, I asked him, following the playing, these three questions: first, what was the dominant mood or idea that entered his mind during the playing; second, whether or not it referred to a personal experience of mine; third, what was his ideovisual impression.

"His replies: first, he sensed the escape from tragedy; second, that it was personal only in the sense that I was the observer of the moods and action . . . third, he visualized as from a wooded shore the sea—lots of sea—with ships upon it. I then revealed to him the following programmatic idea on which I understood the playing of the composition was based. It depicts abstractly an episode of the ancient Greek legend of the ships of Ulysses passing the deadly Siren rocks; the quiet unimpassioned mood of the sea underlying the voluptuously enticing song of the Siren voices. Alternately with the increasing temptation of the song, the sea motive increases in volume and power; at the most irresistible moment the thunder of the surge obscures the voices, the ships safely pass; the voices are heard again, but remotely, and the sea motif is resumed in tranquil chords quietly closing in a serene resolution. Three abstract impressions, correctly received, preclude coincidence, and would point convincingly to the fact that definite ideas and moods can be communicated through music."

Unquestionably ideas and moods could be communicated through photography. Ansel went to Santa Fe, again, in November. He wrote Albert: "Every day has been an experience of a new place or a new person. I am convinced this is the greatest place in the world to work. . . . I have taken several portraits, bought great quantities of pottery, visited many of the marvelous Mexican towns (Cordova, Santa Cruz, Chimayo, and four Pueblos). . . . Mary Austin is really a grand person, under her strange, stern manner. . . . She and Applegate and I are to do a work on the Old and modern (Spanish-American) Life and Art in New Mexico. She for the history and folklore, Applegate for the chapters on art, and I am set for the photography. It will take me months, and will be fascinating . . . the Indian Pueblo book meets her heartiest approval. And she has offered us her house and the use of the large studio. It is all too good to be true.

"Albert, I have a strong feeling that this land is offering me a tremendous opportunity; no one has really photographed it. And Virginia and I would have untrodden ground for music as well. . . . There *is* a glorious good time to be had, but there is also a wonderful mood for work, and a great vitality and beauty. Some of the Spanish-American towns, Cordova, for example, are unbelievably beautiful."

In the spring of 1929, Ansel and Virginia accepted Mary Austin's invitation to stay with her while completing the photographs of Taos. The portfolio was now to be a book, with Mary's monograph and Ansel's prints bound together. Mary's adobe was high on the Camino del Monte Sol, and looked across Santa Fe to the Sangre de Cristo. Mary, they observed, worked within a shell of intense concentration. Even while making bread or weed-

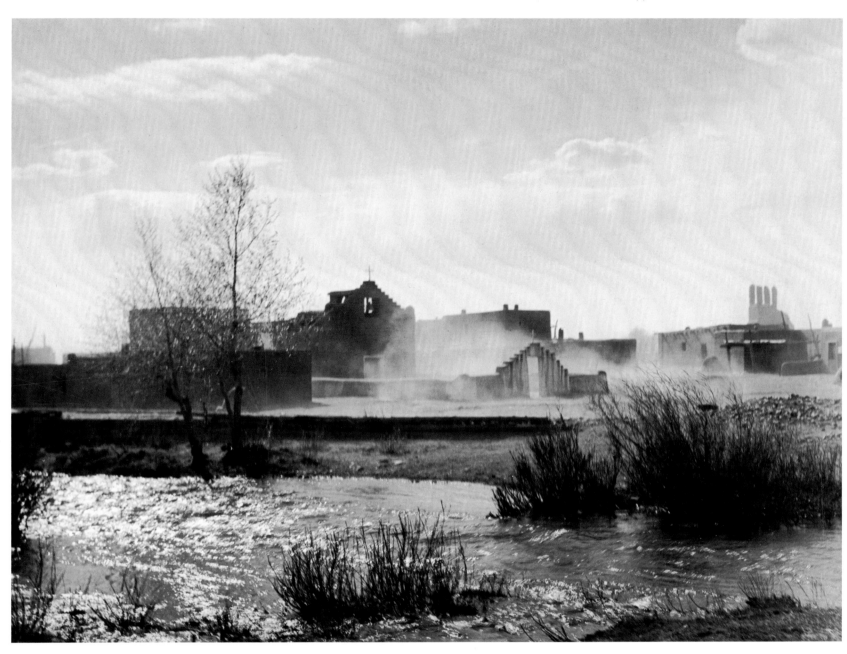

DUST STORM, TAOS, NEW MEXICO

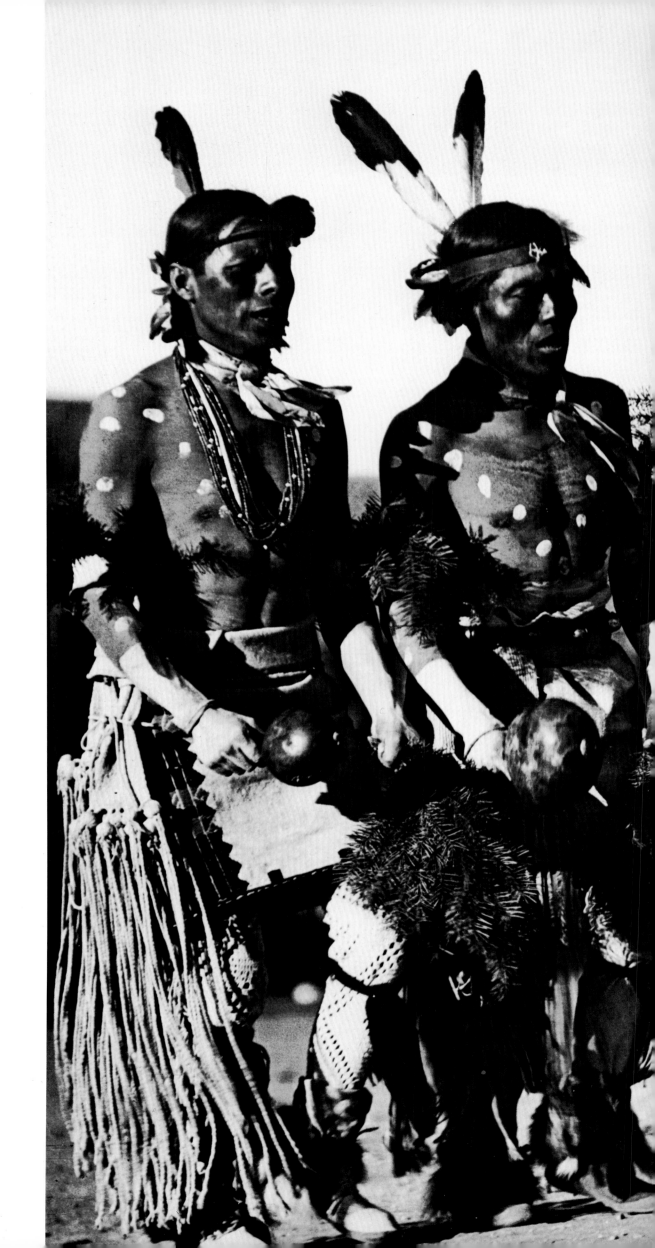

RAIN DANCE, SAN ILDEFONSO, NEW MEXICO

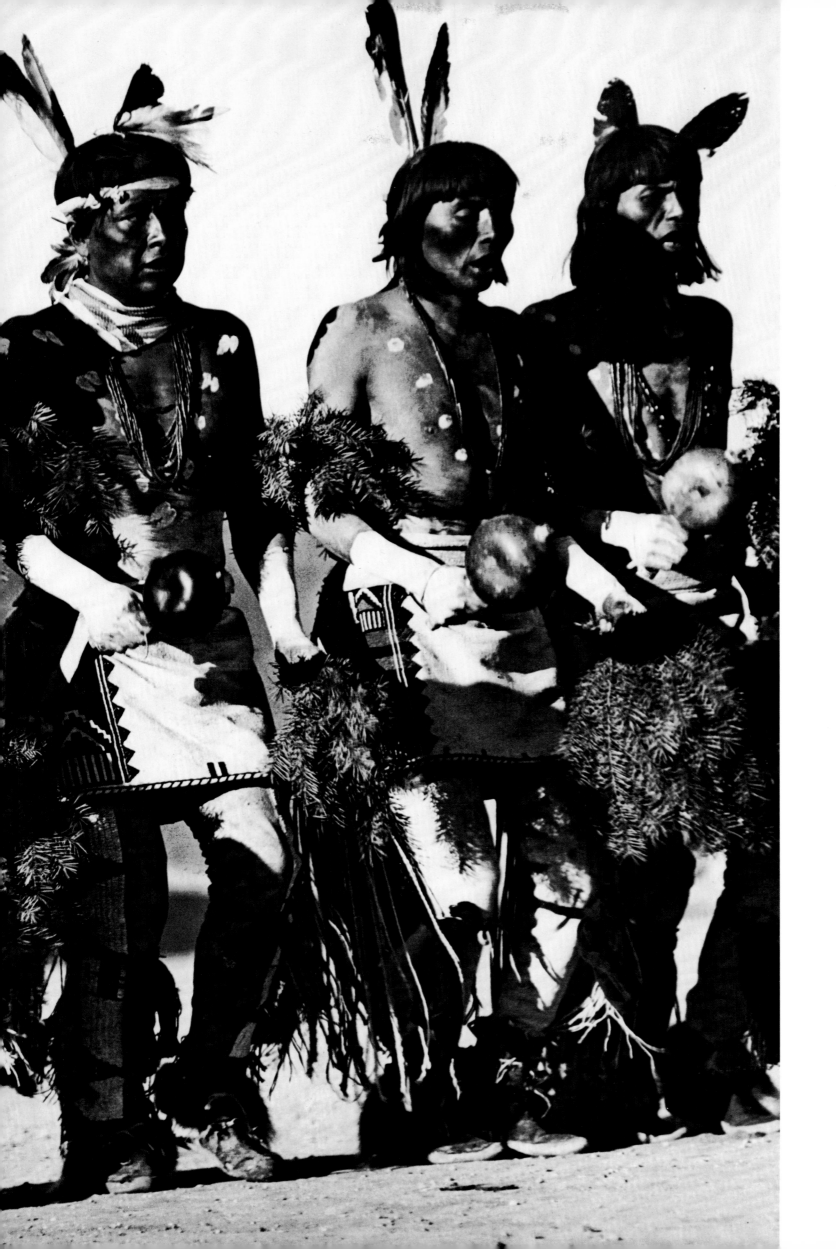

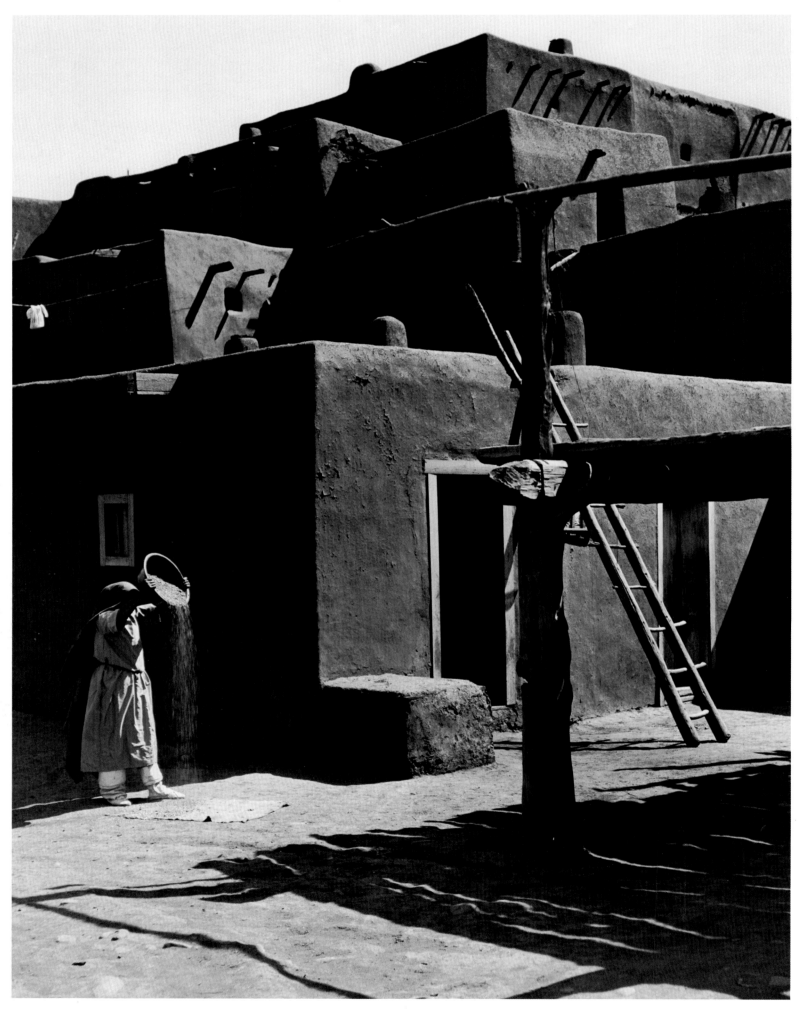

WOMAN WINNOWING GRAIN, TAOS, NEW MEXICO

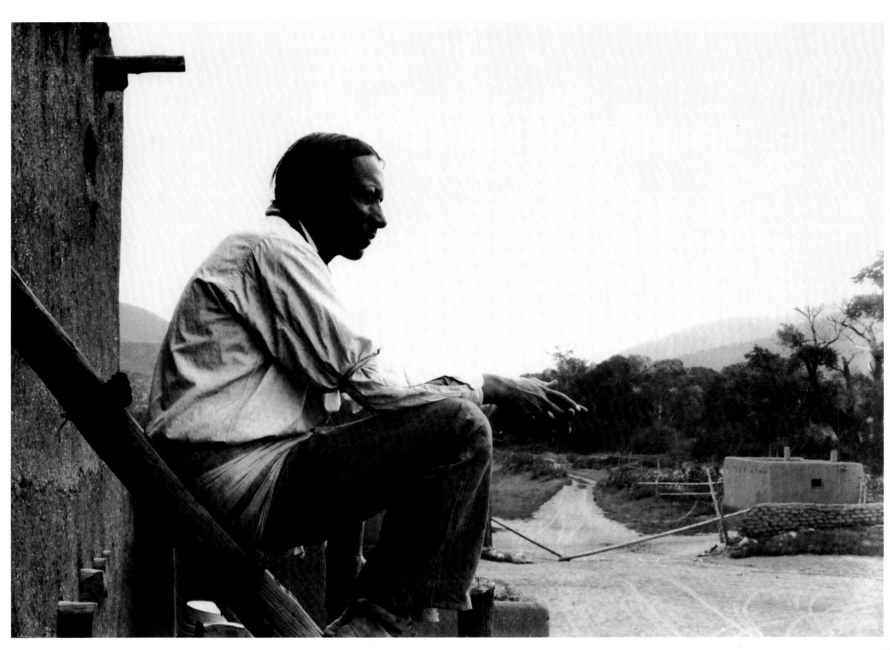

INDIAN, TAOS PUEBLO, NEW MEXICO

ing her garden, Mary was writing, and must not be spoken to or disturbed in any way, until she herself gave the signal for talk, laughter, and music to begin.

Ansel went again and again to Taos, photographing its tiered houses, its churches and strong people in many moods and lights—a calm day with a woman winnowing; thunder clouds above the sharp ladder from the underground kiva. In other pueblos, too, he photographed the dancers issuing from the kiva to perform their ancient magic ceremonials on the plaza before the church. With Frank Applegate, bumping over ruts and down arroyos in an old flivver, he went to the Spanish villages in the mountains, photographing for the proposed Spanish Arts book the Penitente shrines and chapels, festooned with lace and paper roses, the santos, always vivid and intense, the hand-painted chests, the Chimayo blankets on bed or floor, the smoke-blackened fangs of adobe holding simmering pots of chile, the adobes fitting into the hills. His photographs constitute an invaluable record of New Mexico before the moment of inevitable change; they have rarely been seen or published. The Spanish Arts book almost alone among Adams's cherished projects never materialized. The sudden death of Frank Applegate in 1931 was a severe shock both to Ansel and to Mary Austin, herself battling valiantly against age, illness, and blindness to get her work done. "I would like a little time to love the world before I leave it," she wrote, but there was no time. Five days before she died in 1934, she read five new poems to Santa Fe. At her request, her ashes were scattered among the hills by a friend on horseback.

For Adams in those days, Taos and Santa Fe were his Rome and his Paris. In Taos, on an earlier visit, he met Ella Young, the fey Irish poetess with the face of a sibyl, who often saw visions and watched the Little People. In New Mexico, she declared, they resembled the Kachinas and ceremonial masks of the Pueblo. Ella made Ansel work hard at his poetry; he must, she insisted, master many different intricate metrical forms as well as a greater compression and intensity of image. Curiously, Ansel never met D. H. Lawrence; after Lawrence's death, Ansel had an eerie experience. Entering Mabel Luhan's house one morning with the sun behind him, he was greeted by several startled people scrambling to their feet believing Lawrence had risen from the dead.

In Taos, too, in 1929, he and Virginia met for the first time members of the extraordinary group of artists championed by the great photographer Alfred Stieglitz, who had already been fighting for half a century for pure art regardless of medium. They met the severely beautiful Georgia O'Keeffe, his wife; they were deeply moved by the directness and clarity of her painting. They met John Marin, a spry and wrinkled little man with a haircut like a wilted dahlia, whose watercolors seemed to Adams, as to Stieglitz some twenty years earlier, among the most joyous and miraculous works of art in the world. "I shall never get out of my mind the thrill of seeing his things," Ansel was to write Stieglitz later. "It was the first great experience in Art I had." (AA to AS, October 9, 1931)

Marin remembered their meeting: "I was at Mabel's in Taos—guess it was around 1929—when in came a tall, thin man with a big black beard. Laughing, stamping, making a noise. All the other people crowded around him. Made even more noise. I said to myself, I don't like this man. I wish he'd go away. Then all the other people hauled him to the piano—and he sat down and struck one note. *One* note. And even before he began to play, I knew I didn't want him to go away. Anybody who could make a sound like that I wanted for my friend always." (Interview, 1945)

Adams was photographing Taos in a sandstorm when an old Indian ventured out to advise him: "East wind very bad. Bring trouble. You go home now." Ansel thanked him and went on with his pictures. A few hours later he was seized with pain. A ruptured appendix was the diagnosis. Ice packs were applied. It was three days before he could be moved to Albuquerque for an operation. He came very near death for a while, and the experience was one he never quite forgot—the sudden agony, the utter helplessness, the white-clad doctors, the white-clad nuns of the Catholic hospital. Death in the mountains was another matter; it was a chance you took, a deliberate risk. This being struck from within, without defense, was far more terrifying.

Much as he loved Taos and Santa Fe and the Sangre de Cristo, always in the back of his consciousness towered the Sierra Nevada. And now it could be seen in its hitherto unapproachable winter beauty. An all-weather road, which the new power plows could clear in a few hours, was being built into the Valley. Skiing, a skill little known in the Sierra, was being introduced; it opened up the possibility of exploring the high country no matter how deep the drifts.

To most Californians in those days the magical transformations and tingling excitements of snow and ice were tales told by their ancestors. Now, on the new road into the Valley, they could leave the rains and greening hills below and in a few hours be experiencing winter themselves. To accommodate guests all year, a new hotel, The Ahwahnee, capable of accommodating two hundred guests in all seasons, opened in 1927. To dramatize its first

Christmas dinner, a pageant based on Washington Irving's story of Christmas at Bracebridge Hall was staged. Adams was the first Lord of Misrule, undoubtedly the most hilarious jester ever to perform in the Bracebridge. One bit of business his successors do not always dare attempt was to climb block by huge block up the walls of the dining room and then leap down before the Squire's table.

In 1928 Adams was invited to direct the music for this pageant, and Jeanette Dyer Spencer, the designer and decorator, asked to continue with its staging and costuming. Together she and Ansel worked to raise the festival above the usual amateurish performance. Essentially the Bracebridge Dinner is a series of choral processions: one by one, the Fish, the Baron of Beef, the Peacock Pie, the Pudding, and the Wassail Bowl are borne on sumptuous litters down the aisle for the Squire's approval. Outside, through the tall windows, the waits and villagers are seen coming with their lanterns through the snow (when there is any).

Ansel searched for rare and beautiful old carols and bound the show together with a brief metrical text. Jeannette found traditional bits of buffoonery and haunting folk customs, such as the Welsh Hodening Horse: the jawbones of a horse, borne on a pole by a tall man in white, as a symbol of common mortality and a plea for largesse. This pallid figure was added to the villagers; so was the Yosemite Bear. Other characters were invented to circulate among the guests: the Cheese Men, gaily offering their wares; the Minstrel wandering with a lute from table to table, singing old ballads.

Trumpets summoned the five hundred guests. In early years, it was Virginia, as the Housekeeper, who welcomed them singing with the chorus. The Squire was the tall and charming Don Tresidder, then the president of the Yosemite Park and Curry Co. and later president of Stanford University. Ansel, however, to everyone's regret, soon assigned the Lord of Misrule to others; in the silent role of Major Domo he could more effectively check the assembly of the processions, time their entrances, signal the soloists. He paced before each marching, chanting group, and himself, until recently, carried the flaming Wassail Bowl. The Bracebridge is now one of the most brilliant of Christmas ceremonies in California; demand for reservations has become so great that it is given twice on Christmas Night.

Ansel and Virginia came to respect more and more the intelligence and perception of Jeannette and her husband, Eldridge T. ("Ted") Spencer, who worked together as architect and decorator with a sincerity and sympathy for client and place rare among the practitioners of these professions. There were hosts of other friends, new and old,

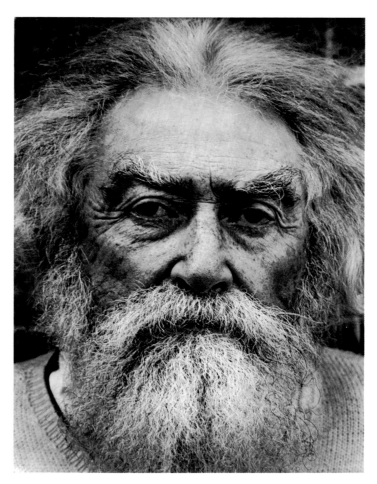

COLONEL CHARLES ERSKINE SCOTT WOOD

who became increasingly dear: Cedric Wright, of course, and Albert Bender, always helping, always involved in any project concerning artists, such as bringing the Mexican muralists Orozco and Rivera to the United States. Into his fresco at the California School of Fine Arts, Rivera painted himself, sitting in all his immensity, in the scaffolding. This double spectacle, while in progress, caused Emily Joseph, another friend in whose wit the Adamses delighted, to exclaim, "Diego, you are certainly doing a lot for posteriority!" Then there was Mrs. Stern, always surrounded by flowers, and unfailingly generous to artists, who supported their work, and requested the pleasure of their company in her box at the opera and at *al fresco* luncheons in her Atherton home. There were Colonel Charles Erskine Scott Wood and Sara Bard Field writing on their hilltop in Los Gatos. Ansel and Virginia were devoted to them. On February 20, 1932, when the Colonel was seventy and Ansel thirty, the birthday celebration became a house party that continued for days, with music in the grove day or night, whenever the spirit moved. There was the Sierra Club, to whose purposes and activities both Ansel and Virginia were dedicated. And there was the magnificent San Francisco tradition of fine printing, with such distinguished presses as those of the Grabhorns, John Henry Nash, Johnck and Seeger, and later, Lawton Ken-

nedy. In the end, Ansel and Virginia decided to build their house not in Taos or Santa Fe but in the San Francisco garden. With the help of an architect, Alfred Henry Jacobs, who was sympathetic to his ideas, Ansel achieved in the studio at 131 24th Avenue a lofty room with fine acoustics and beautiful light—morning, shining on the pine, through the great studio window above the piano, noon through the skylights high overhead—with a north window looking over the garden to the Golden Gate. On the cloth panels he hung his prints; on the shelves he and Virginia put their collection of books and Indian pottery.

On May 4, 1930, they lighted a fire in the tall fireplace with the inscription, O JOY DIVINE OF FRIENDS, and held their housewarming—first of hundreds of celebrations, frequently spontaneous, for which the word "parties" is inadequate. Witter Bynner conveyed their spirit: "THANKS for the best evening of all. . . . And you a bearded archangel, knocking St. Cecilia into a cocked hat. Boy, how you played, how you glowed, how you fed us, body and spirit. It was a rich and true happiness . . . !"

The new Studio was designed for both music and photography, but for Ansel the crisis of deciding between his two professions had now arrived. He went stale from over-practice at the piano, on top of general overwork, and was advised to rest. At this time Albert urged him to go wholly into photography. Ansel looked back. As individuals, many musicians had given him the accolade: Ernst Bloch, for example, after hearing him play at the opening of one of the art museums, said, "You know all I know." Yet apart from a few recitals here and there, the world of music was still closed and hostile. The world of

arts and letters, on the other hand, had welcomed him as a photographer freely and generously. He realized he had actually been a professional photographer for some three years. He was now twenty-eight; he had a wife, a house, and a responsibility toward his aging parents, who had given him so much, and might soon be dependent upon him.

While still undecided, he went to Taos. At Mabel Luhan's, he met still another member of the Stieglitz group, the photographer Paul Strand. Mabel's house appeared to be crowded, so Paul and Rebecca Strand asked Ansel to stay with them for a few nights. One morning, Paul was examining a fresh batch of his own New Mexico negatives, holding them one by one up to the light, grumbling a little at some, pleased with others. Ansel, looking over his shoulder, saw images such as he had not dreamed could be made in photography. Here light and substance were woven into an intense incandescence. Reality, faced without avoidance and with deep penetration and compassion, could be made music. "I have always had things happen to me—psychologically, even physically—when I have seen your things," Ansel wrote Strand a few years later. "I believe you have made the one perfect and complete definition of photography." (AA to Paul Strand, October 31, 1933)

Humbly, with such a revelation before him, Ansel decided to follow Albert's advice, and become a photographer, full time, and to the utmost that was in him. When he announced his decision to the family, his mother said, "Oh, you can't want to be *just* a photographer. Sit down now at the piano and play me something pretty."

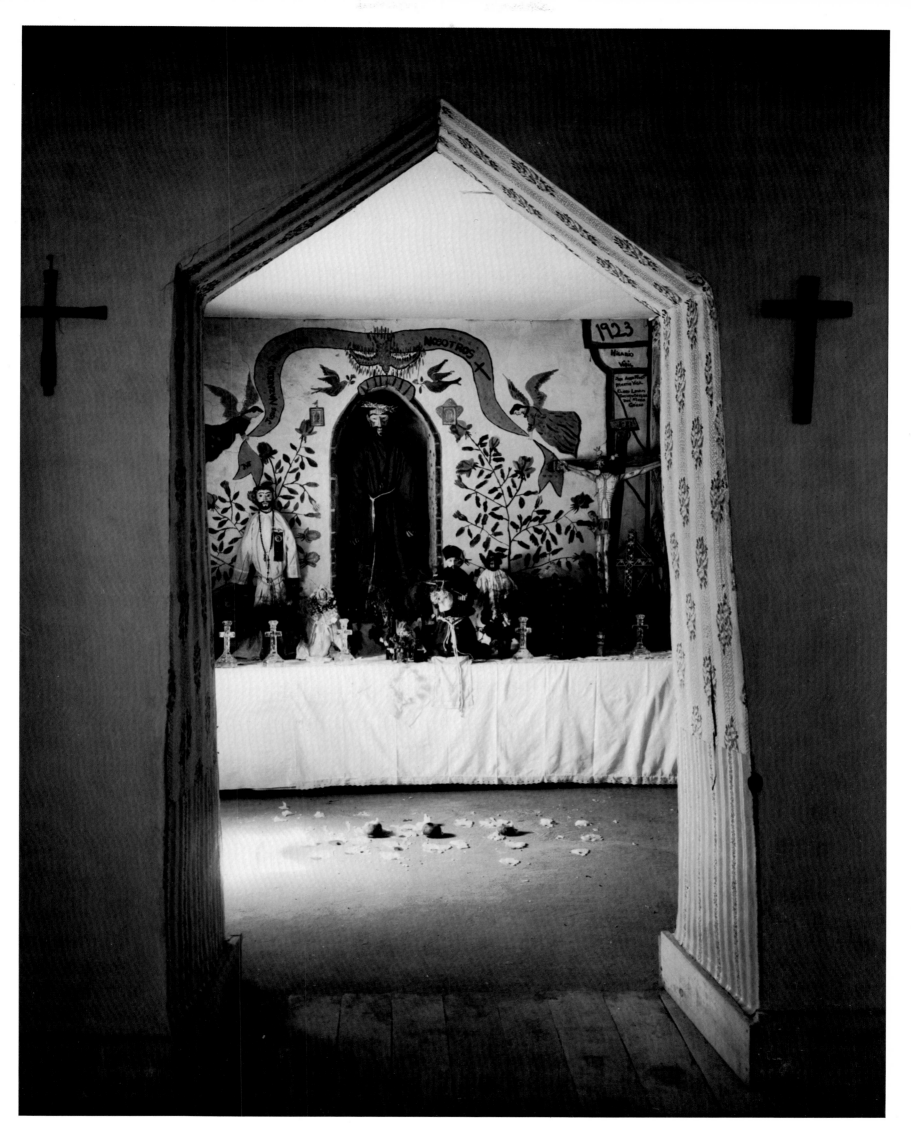

INTERIOR, PENITENTE MORADA, NEW MEXICO

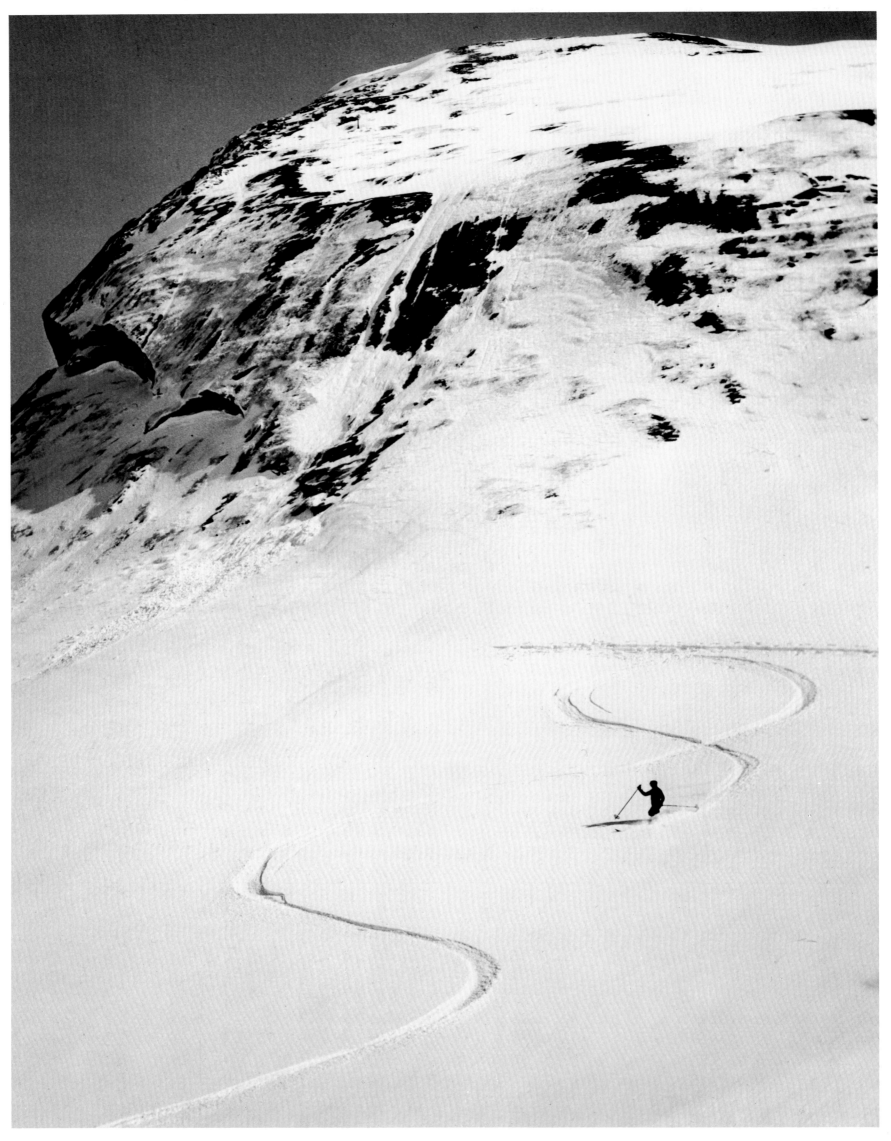

SKIING ON LEMBERT DOME, TUOLUMNE MEADOWS, 1930

5. ƒ/64

Late in 1930, *Taos Pueblo* finally appeared, "a splendid example of the modern art of book-making. It is a folio . . . and its format is so wholly satisfactory to fastidious tastes as to stir the acquisitive instinct of many collectors, which will do them very little good, since the edition is limited to one hundred and eight copies, of which one hundred are for sale.

"The most scrupulous pains have been expended on each element that enters into the production of an artistic book. The binding by Hazel Dreis is henna linen with Niger ends, tooled in blind, while the paper, which sets off to perfection the distinctive typography, has been especially made for this work by Crane and Company; furthermore, it has been sensitized for the photographic prints by W. E. Dassonville.

"These photographic studies are really a joy for the beholder. Ansel Easton Adams has had great success in showing the striking effects of the alternate blocks of light and shade shooting the buildings.

"Accompanying these prints is the text, a monograph by Mary Austin. Never has this accomplished lady done a finer piece of interpretation. Quite plainly it was a labor of love with her." (*California Arts and Architecture*)

Mary Austin's own reaction was one of surprise and excitement. Although in connection with the Spanish Arts book, she once wrote Ansel rather loftily: ". . . you must realize that the illustrator is always a secondary consideration with the publisher. The contract is made with the author, and then it is up to the author to use such influence as he may have to persuade the publisher to agree to a certain type and treatment of illustration." (MA to AA, August 30, 1929) And although she had praised Adam's photographs and even suggested he illustrate the Spanish Arts, she thought of him in the Taos book as merely "the prime mover in that enterprise." The writing of her essay would, she estimated, take her about a week. But with *Taos Pueblo* in her hands: "I was naturally much excited to receive it. I agree with you that it is a superb piece of workmanship. I think, however, that we can do a little better next time by getting together on the subject before we begin. I think I should see your photographs before writing the text, so that between us, nothing should be left out.

"Have you thought any more about the plan for having a less expensive edition made by my publisher?" (MA to AA, January 2, 1931)

The New York publishers subsequently were "much impressed, not only with the Taos book but with the fact that you could sell it at that price. Everyone says that the ordinary book market has never been so bad since book publishing began in this country." (MA to AA, March 13, 1931)

Yet in those years of the deepening Depression, *Taos Pueblo* at $75.00 a copy was soon completely sold out. Albert Bender, passing on a compliment from Ernst Bloch on the beauty of the photographs Adams made of Rivera's frescoes, added: "I note that the Stock Market reports only Ansel Adams photographs as the sole commodity that is on the rise." (AB to AA, August 17, 1931)

Nevertheless Adams himself was increasingly dissatisfied with his photographs. Something was missing. What it was he could not yet define.

On January 15, 1931—a day which marks an end and a beginning—he wrote Albert: "I promised you a letter and it seemed necessary to wait until I was in bed with a cold to write it.

"From the first evening that I knew you, when I showed you some miserable prints in Berkeley, until now, when I have the completed Taos Book before me, I have figuratively had my breath taken away by trying to keep even with my evolution. It is you that succored a poor artistic fish from the dry land of moronic isolation, it is you that cleared the way for the individualistic expression of a highly technical art. Perhaps the only fitting expression of my gratitude would be by a constant perfection and refinement of my work, to arrive sometime at a position, that will in part justify all that you have done for me."

And that same day—confinement in bed nearly always leads Ansel to incessant activity on the typewriter—he finished rewriting and polishing, for the *Sierra Club Bulletin*, an account he called "Ski-Experience." Like that moment of "exceedingly pointed awareness of the *light*" long ago on the slopes of Mount Clark, this was an intense memory, not only of breath-taking motion, silence, and sound, but of almost unbelievable light. "Ski-Experience" tells how, with three other skiers, all experienced mountaineers, he climbed out of the Valley, and glided along the rim three thousand feet above its floor, while Half Dome towered over them, and then receded. They went on up to Tenaya Lake, and with skis well-roped, to the top of Tenaya Peak, "the hub of a tremendous wheel of mountain grandeur. A hundred miles of

glittering peaks encircled our pinnacle of granite, and far below stretched the shadeless, dazzling plain of frozen Tenaya Lake." Instead of missing the intimate and endearing sights, smells, and sounds of summer, he found that "the grand contours of the range are clarified and embellished under the white splendor; the mountains are possessed of a new majesty and peace. There is no sound of streams in the valleys; in place of the far-off sigh of waters is heard the thunder-roar of avalanches, and the wind makes only faint and brittle whisper through the snowy forests. To us, four motes on an Earth-gesture of high stone, it appears that great mountain spirits have assumed white robes of devotion and are standing in silence before the intense sun.

"Frisch whips his skis on the snow and leaps down the long billowy slope; a cloud of powdery snow gleams in his wake. We follow; long spacious curves and direct plunges into the depths that take our breath with sheer speed and joy. Down and down through the crisp singing air, riding the white snow as birds ride the air, conscious only of unhampered free motion. Soon we are at the borders of icy Tenaya Lake—two thousand feet of altitude have vanished in a few moments. . . .

"Today we are moving on to the Tuolumne Meadows. All the bright morning we have been conscious of a deep stirring in the air . . . a remote, ominous sound, insistent as the murmur of a seashell held to the ear. Soon is this pulsing world-sound swelling to a deep and throbbing roar—the organ tone of storm-wind sweeping the skies with immeasurable power. A huge dragon of cloud crawls out of the southwest, and with it comes a horde of gray demons, darkening the sun and veiling the summits.

"We arrive at our cabin as the first snow is drifting down the wind. After several days, we emerge . . . the storm has piled a great splendor on the world, and peaks and forest gleam with frosty beauty.

"The morning is clear and cold, the last stars burn with diamond light as we cross the Meadows on our long run to the Merced Canyon. The new day lifts over the silent range, Mount Conness takes sudden fire, blood-red and golden light flames on the long Sierra Crest, and the crisp snow at our skis sparkles in the first sun." They returned "under cobalt skies, peak and crags flaunting long banners of wind-driven snow . . . we glide over the glistening dome of the world and launch our long descent to the Merced River. Down we rush, cutting the sharp air with meteor motion. Above us towers the noble Merced Range, wave upon wave of lofty stone glittering in the low winter sun. The mountains soar higher and higher into the flam-ing sky, and the blue depths rise to enfold us as we skim down through the dusk to the shadowed Valley." (*Sierra Club Bulletin,* 1931)

John Muir called the Sierra Nevada "the Range of Light." Ansel had seen it in a splendor impossible even to Muir. He was acutely sensitive to every nuance, change, and facet of that light. "Gleam . . glitter . . fire . . flame . . glisten . . burn . . diamond light. . . ." He was searching, in the more facile medium of words, for what must be said in the difficult medium of light itself.

"It is seldom that an artist venturing into a new field attains the first ranks so rapidly as has Ansel Easton Adams," wrote Francis P. Farquhar, for *Touring Topics,* February 1931. "For ten years a musician of more than ordinary ability, he turned his full endeavors to the art of photography about four years ago. Before that time, he had taken photographs in and about Yosemite, but with results that seemed to him unsatisfactory. A sudden change came with the realization that photography required the same mastery of technique and correlation of media that constitutes the basis of all art. . . .

"In the series of mountain studies presented here the dominant characteristic is the way in which the structure of the mountain mass is expressed. The composition in each case shows an analysis of the thing itself. Stark, powerful, the direct lines of force are unmistakable. The result is a design, but it is a design inherent in the mountain, not an abstraction upon the surface of a sheet . . .

"Another characteristic . . . is the way in which the harmonies of the original object have been successfully transmitted to the printed page. It is here that the artist's knowledge of materials and processes is made evident. From the beginning he has closely associated photography with other graphic arts, especially with printing. It is the comprehension of the requirements of kindred arts that had made Ansel Adams so successful as an illustrator."

At the same time reports came from Washington of his first show there. The Smithsonian Institution was showing "Pictorial Photographs of the Sierra Nevada Mountains by Ansel Adams of California." It was the last time he allowed the word "Pictorial" to be associated with his name. The *Washington Post,* on January 11, 1931, hailed the show as ". . . a group of prints that is a real achievement. His photographs are like portraits of the giant peaks, which seem to be inhabited by mythical beings. . . .

"There are lovely things among these photographs which have caught the unusual and the impressive. There has been no juggling with mechanical processes to produce effects. Here there is straightforward impression on the

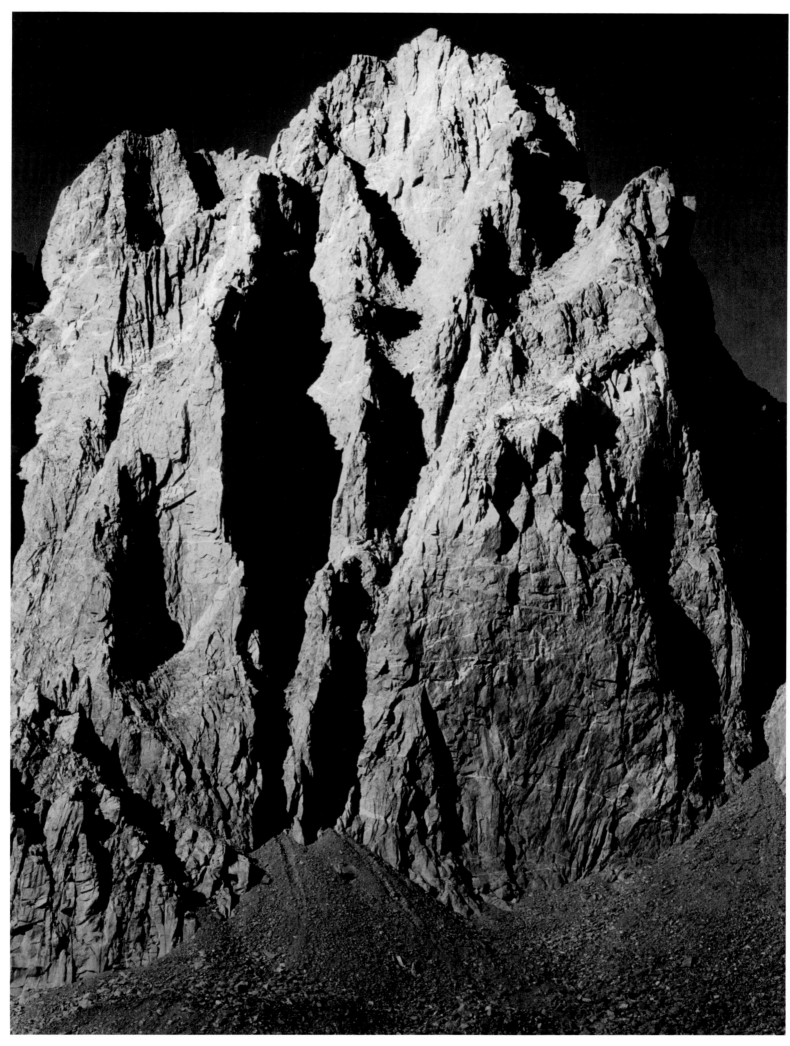

MOUNT WINCHELL, KINGS CANYON NATIONAL PARK

plate. Some of the snow scenes are wondrous in their whiteness. . . .''

But Adams felt that the tactile and the luminous still eluded him. He kept remembering the intense incandescence of Strand's negatives—he had not yet seen Strand's prints—and the cool clarity of the prints Edward Weston was now making on glossy paper.

At Albert's, sometime in 1927, he first met Edward Weston. ''An innocuous little man with some very literal photographs,'' was Ansel's impression. Edward, for his part, saw ''some promising but immature photographs,'' and heard a brilliant piano concert. ''The thought that in this young musician, with such a future before him, we'd have one of the greatest photographers we've ever had, never so much as crossed my mind.'' (Interview, 1950). Neither at the time meant anything to the other. The ''very literal photographs'' were platinum prints of the work Edward had been doing in Mexico: three black ollas, a heap of pottery dishes in a market, a few dramatic portraits, a section of palm trunk, and possibly one or two of his new series of nautilus shells. While in Mexico, Edward confessed in his Daybook that he preferred the proof prints he made on glossy paper to his finished prints on the expensive and delicately textured platinum or palladio papers. To Pictorialists, such as both Edward and Ansel had been, glossy paper represented the nadir of the cheap, slick, shiny, and commercial.

Edward wrote in his Daybook, on March 15, 1930: ''. . . habit is so strong that not until this last month did I actually start mounting glossy prints for my collection. It is but a logical step, this printing on glossy paper, in my desire for photographic beauty. Such prints retain most of the original negative quality. Subterfuge becomes impossible. Every defect is exposed, all weakness equally with strength. I want the stark beauty a lens can so exactly render.''

Later that year, the Mexican muralist, J. Clement Orozco, whom Edward had known slightly in Mexico, came to Carmel with Alma Reed, who ran the Delphic Studios in New York. Orozco's reactions to Edward's new work—massive close-ups of peppers, kelp, rocks, cypresses—and his stark prints was such that when Alma asked him for a one-man show in the fall, Edward decided to make all his prints on glossy paper, even his older work, such as the smoke-stacks photographed in Ohio in 1923.

Orozco hung that exhibition—the first Edward had in New York—with his own hands. Undoubtedly, Edward showed these prints to Albert, Ansel, and other patrons, collectors, and friends. Ansel's reaction was mixed. He could recognize Edward's stature as a photographer, but something in his approach to subject matter repelled him. What he felt was not unlike what Tina Modotti, Edward's love and disciple in Mexico, felt when she saw the first shells: ''Edward, they disturb me not only mentally but physically. They make me think of lilies and embryos. They are mystical and erotic.'' She reported that Diego Rivera, on seeing them, mopped his brow and asked, ''Is Weston very sensual?''

Ansel's reaction took the form of a poem:

PORTFOLIO

What curving insistencies
 Of these mute shells are
 Whirled from sun towards
 Dimness, whiteness toward darkness,
 Darkness to deathlessness,
 To the sound of pale porcelain?
The cypress squirms on a pale sky—
 Under the cypress, down
 In a little crevice lies
 What might have hoped to
 Be an echo of Mussolini,
 Were it not for prudence.
Involute crawlings of dark
 Pepper-thighs conflict the
 Urgency of chimney-shafts.
 Portraits stare at a whisper of
 Lint on my shoulder.
 I am not eager for regret.

Ansel soon regretted his reaction—a few words with Edward convinced him that Weston no more intended nor needed Freudian implications to be read into his work than Georgia O'Keeffe did in her paintings of huge flowers and clamshells. Both resented such misinterpretations; neither was sick, weak, nor frustrated, but they suspected such might be the case with critics who could see nothing else in their work.

Nevertheless, though Ansel believed Edward ''truly great,'' and though they became closer and closer friends through the years, there was a gulf between their approaches. Edward could write in his Daybook: ''How little subject matter counts in the ultimate reaction! I have had a back (before close inspection) taken for a pear, knees for shell forms, a squash for a flower, and rocks for almost everything imaginable.''

But Ansel wrote: ''If I have any *credo*, it may be this: if I choose to photograph a rock, I must present a rock . . . the print must augment and enlarge the experience of a rock . . . stress tone and texture . . . yet never, under any conditions, 'dramatize' the rock, nor suggest emotional

or symbolic connotations other than what is obviously associated with the rock." (Fragment, no date) In this passionate objectivity, he is much closer to Strand than to Weston.

The camera as an instrument of vision and photography, as an extension of experience have had incalculable effect on the arts, sciences, and communications. But ever since the first amazed eye-witness beheld an image not made by hands, there has raged debate as to whether art can be made by a machine. Those who wished to make not records but pictures became known as Pictorialists and quarrelled as to whether to mirror infinite depth and detail or to blur and isolate were the better approach. Through both, magnificent work has been produced by artists, and abominations by the ungifted. By the early 1900's the great creative photographers perceived that any attempt to evade reality usually ends in imitating the surface effects of other arts. One by one, they withdrew from the Pictorialists and began to work independently.

One morning in the spring of 1931, Ansel woke in a kind of vision. "It was like the Annunciation! Suddenly I saw what photography could be!" It was a severe and humbling vision. After music, photography had seemed to him a cramped and poor medium. Now he saw that only by accepting its limitations and applying them to their logical conclusions, could he achieve what he now realized was "a tremendously potent pure art form." Music was synthesis; photography was analysis. He saw it now in its stern and tender, its austere and blazing beauty. He felt as if he had been guilty of hiding from a burst of sunlight or of muddying a mountain spring.

He had no means of knowing then that other photographers had experienced the same world-changing revelation. It had sent Paul Strand down into the streets of Manhattan, to photograph the forms and forces of the City and the hurt, eroded faces of its people. It had caused Edward Weston to scrape the emulsion off old prize-winning negatives and use the glass for a new window. It had caused Alfred Stieglitz, while viewing an exhibition, to turn away from Pictorialism and its evasions, and later, when accused of hypnotizing his sitters, to turn his camera to the skies and make a series of cloud images which the composer Ernst Bloch recognized as music, even to identifying which lights and forms Stieglitz intended as visual "equivalents" to flutes, violins, and brasses.

Ansel's revulsion against his own Pictorialist phase was profound and lasting. A couple of years later, writing in the third person a biographical statement for his own first New York show, he accused himself: ". . . his first work was definitely *pictorial* in character; while he seldom manip-

ulated his negatives and prints, his production revealed an inert romanticism. His pleasure in textured papers and impressively expensive productions brought his work dangerously close to the decadent theatrics of the Pictorial Salon. Suddenly, in the spring of 1931, the realization of the expressive futility of his work caused him to break entirely from shallow and conventional standards. Almost overnight the fussy *accoutrements* of the Pictorialists were discarded for the simple dignity of the glossy print."

He found, as Weston had, that in a glossy print, "Every defect is exposed, all weakness equally with strength." And very few of his negatives passed this searching examination. "I had to begin all over again!" He set himself problems of extreme depth of focus and of extreme rendition of textures—and almost fell into the ground glass with excitement. No matter how common or insignificant his test subject might appear to the eye, the camera now revealed in it unforeseen qualities. An old board fence behind a patch of thistles could in sunlight become a brilliant clash of dissonant textures, a rose on driftwood, indoors on a dark day, could glow softly.

The moods of light could be voiced; textures used like different instruments. Through the photographic "illusions of light and substance" a limitlessly sharp image printed on a surface smooth as water could be as exquisite to the eye as music to the ear. Now clouds could float, waterfalls flash, snow hold its hidden light, grasses bend in infinite delicacy under dew.

Elated with this new eloquence, Ansel photographed the Golden Gate as sailors for centuries had hoped to find it, clear, with towering clouds in the sky and ships on the shining tide.

Through such photographs, Adams became acutely conscious of "the continuous beauty of the things that are." This is a line from his report to the Sierra Club on its High Trip that summer; as with "Ski-Experience," he worked hard to transform the usual watery, semi-humorous report into something closer to the real experience.

". . . a huge granite mountain cannot be denied—it speaks in silence to the very core of your being." For him the mountains are music: ". . . the jubilant lift of the Cathedral Range, of the great choral curves of ruddy Dana, of the processional summits of Kuna Crest."

It was a dry year, and after the steep climb down into Tuolumne Canyon, "there was much regret over the unprecedented low water . . . the Waterwheel Falls were only suggested by feeble jets from glassy cups of granite. An Oriental esthete would never question the exquisite charm of those pale threads of water patterned on shining stone. The American mode of appreciation is dominantly

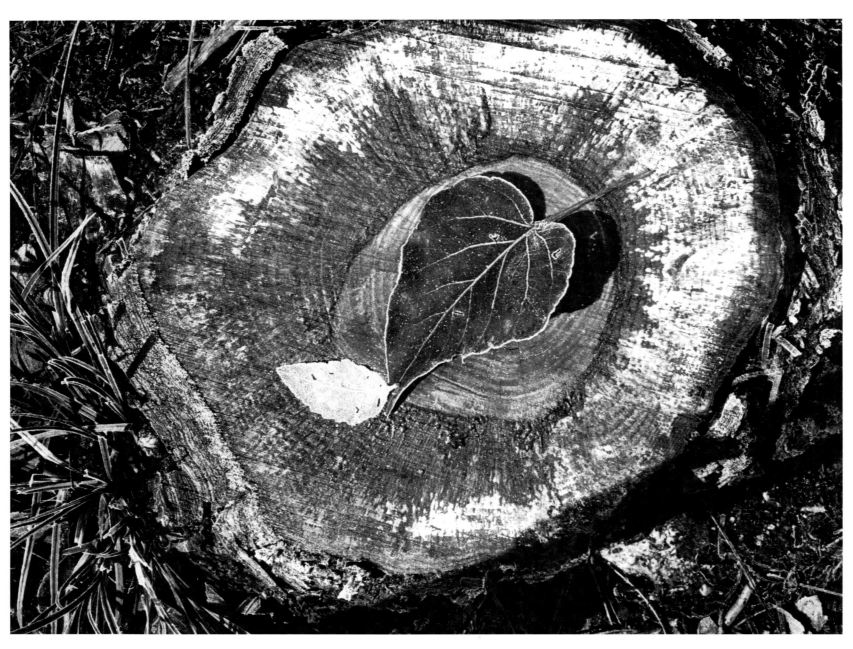

LEAF, FROST, STUMP—OCTOBER MORNING, YOSEMITE VALLEY

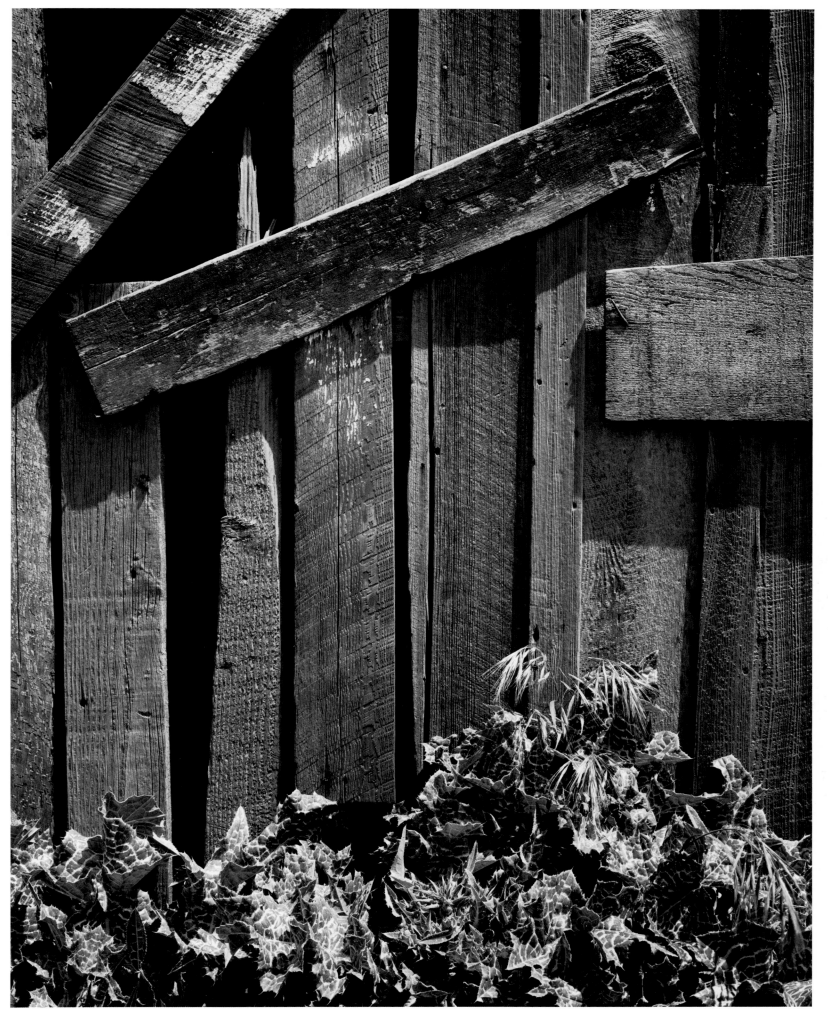

BOARDS AND THISTLES

MADRONE BARK

ROSE AND DRIFTWOOD

theatrical—often oblivious of the subtle beauty in quiet, uncomplex things. One can never assert the superiority of the vast decorations of the Sistine Chapel over some pure experience in line by Picasso, or of torrents swollen by the floods of Spring against the quiescent scintillations of an Autumn stream."

In Pate Valley, "confronted with relics of prehistoric culture *in situ* . . . vast ancient oaks, hoary granite cliffs blackened by time and sun, and, inscribed on the latter in red-brown pigment, puzzling and rather fantastic pictographs of indeterminate age . . . you project into the primitive isolation of this wild deep valley . . . the thought of aboriginal struggle and final extinction. For the moment, you forget mountains and remember men."

Of fire: "You are drawn, as early man was drawn, by the enchantment of dusk and flame to the council fire . . . we gathered on the rim of the world and watched the last fires of sun flare on the summits and the valleys fill with cool rivers of night. Stone, and hoary trees, and the bodies of our companions merged in translucent unity with the world of mountain and sky; our fire leaped and writhed into the night and clouds of querulous sparks soared high among the stars. A spirit of unearthly beauty moved in the darkness and spoke in terms of song and the frail music of violins. You were aware of the almost mystic peace that came over us all . . . the faces . . . of calm revelation . . . of adolescence, hushed and surprised by the world's sharp beauty. At the close of the music, we went quietly through the darkness to our beds, swaying and twinkling our lights among the trees and listening to the golden bells from our animals at pasture."

Of a thunderstorm: "It was good to feel the tiny flagellations of the rain—it was good to be buffeted by cool and fragrant air. And one must ever bow before the deep benediction of thunder. We sat for long under a rocky shelter while the storm moved over the pass and roared down canyon to westward. High summits were veiled in the massive clouds that swirled and blended above us. Clustering in the frontiers of the forest were pale shafts of long dead trees, posed in final quietness, enduring thunder and the lash of rain."

He recorded ". . . a rich day, full of the companionship of clouds and shining mountains." And: ". . . in the presence of moon-illuminated mountains . . . space became intimate: the world of fixed dimensions fades into patterns of exquisite delicacy." (*Sierra Club Bulletin*, 1932)

In the summer of 1931 Francis Farquhar brought Dr. Robert L. M. Underhill of the Appalachian Mountaineering Club, aided by the young Glen Dawson and Jules Eichorn, to introduce the use of rope in rock work in the Sierra Nevada. Adams hailed it as an art and "a thrilling means to a more important end," though he feared "an ascendency of acrobatics over esthetics." Then Ansel led the Sierra Club into his beloved Lyell Fork of the Merced, with its "great horseshoe of peaks . . . intimate and tranquil meadows . . . for me, after many years of Sierra experience, one of the most supremely exquisite regions of the range. You will recall one startling tower of greenish-black stone, banded with brighter rocks that dart over the dark rocks like bolts of lightning." Three years later, when Ansel again led the Club to the Lyell Meadows, the 1934 trip historian, Ruth Currier, reported: "One particularly impressive peak in the cirque above the camp was distinctive for its sculptured mass and for the way it responded to changing lights. It was glorious in the last rays of the setting sun, and when it was proposed to name it Mount Ansel Adams, for our leader of trail and campfire, the suggestion met with intense response." (*Sierra Club Bulletin*, February 1935) Three climbers managed to scale its difficult sides on July 11; a week later, a considerable party, including Ansel and Virginia, held dedication ceremonies on its summit. (Such names are usually not approved until the death of the individual honored.)

At Benson Lake in 1931, where the Club rested for several days, the irrepressible comic in Ansel produced the first of a series of mock Greek tragedies wherein he poked fun at the rigors and absurdities of life on the trail and in camp and filled his stately iambic pentameters with slang, puns, and outrageous metaphors. *Exhaustos* caused so much mirth and applause that for 1932 he wrote *The Trudgin' Women*, and for 1933, the *Oxides*. Costumes were improvised on the spot; "Clymenextra," swinging earrings, made of exploded flash bulbs, stalked regally before a sun-burned chanting Chorus. "The Privos Kouncellous" appeared in burlap, hung with forgotten tin cups. The Prompter was Virginia, with her head in a box. "The Spirit of the Itinerary," Adams himself, clad in a near-white blanket clutched by an uncertain safety-pin, twanged a lyre of a forked branch and string, while Cedric Wright, not always at the same time, twanged his violin behind a bush.

In San Francisco that fall, Ansel found his own excitement over photography being shared by many others; photography was in the air. The young new director of the M. H. DeYoung Museum, Lloyd Rollins, decided to devote several galleries to a series of exhibitions of photography. Most of the leading museums in the U.S. had occasional exhibitions of photography, but few, if any, had ever heretofore undertaken so long and intensive a study of photography as a medium. Rollins brought to

REFLECTION OF UNNAMED PEAK, LYELL FORK OF THE MERCED RIVER

THUNDERCLOUD, NORTH PALISADE, KINGS CANYON NATIONAL PARK

the West many photographers known previously only by name and a few reproductions in magazines; nevertheless "the great Ss"—Stieglitz, Strand, Steichen and Sheeler—refused for various reasons to send their work. This was to West Coast photographers a deep disappointment.

In time, the series became important chiefly because Rollins gave one-man shows to the leading West Coast photographers a chance to study closely, at length, the scope of what each had achieved so far. This, however, was not yet apparent when a new, and short-lived, review of the arts in Bay Region, *The Fortnightly,* asked Ansel to do a column on photography.

Ansel took his duties as a critic very seriously. He had begun to dream of a group of photographers who could show the public what the medium itself, uncluttered by either Pictorialism or Commercialism, could do. "One of the functions of criticism is to reveal the fundamental intentions of the artist in relation to his medium. Another is to consider the intensity and perfection of his expression. There is a fairly general comprehension of the aims and techniques of painting and etching. Photography, on the other hand, as a pure art form, possesses a minimum of precedent, and its present-day standards are painfully fuddled by the overwhelming amount of advertising, news, snapshot, and 'camera-art' productions that confront us in almost every phase of life." (*Fortnightly,* December 18, 1931)

He opened his column on November 6, 1931, with "a great pioneer of photography—E. Atget, of Paris." In the exhibition at the DeYoung Museum, he found "no superimposed symbolic motive, no tortured application of design, no intellectual axe to grind." Reviewing the monograph, *Atget Photographe de Paris* (Weyhe, 1930), "Atget's significant and lonely gesture in the direction of austere expression, is consummated in the use of clear images, smooth honest papers, and in the complete absence of affected imitation of other art forms. The 'Pictorialist' is on the wane: the blurred indefinite 'poetic' prints are slowly but surely passing into historic oblivion."

That same November came Weston's one-man show at the DeYoung—one hundred and fifty prints. Ansel in his second column recommended "all readers to visit the DeYoung and carefully study the remarkable prints of this really great photographer. May I suggest that you leave at home your 'painter's consciousness' and come prepared to see a profound expression in pure photography. I also suggest that you examine the prints at very close range as well as at the normal observational distance, so that you may observe the exquisite textures."

This advance notice he followed with a carefully considered review. "In Weston's work one never feels that the presentation is inferior to the 'seeing.' Photography is really perception—the analytic interpretation of things as they are. In a strict sense photography can never be abstract, for the camera is incapable of synthetic integration. Weston is a genius in his perception of simple essential form . . . but often he makes his objects *more* than they really are in the severe photographic sense. While succeeding there in the production of magnificent patterns of definitely emotional quality, he occasionally fails to convey the prime message of photography—absolute realism. In the main, his rocks are supremely successful, his vegetables less so, and the cross-sections of the latter I find least interesting of all. But I return with ever-growing delight to his rocks and tree-details, and to his superb conceptions of simple household utensils. . . . His portraits are of striking quality and worthy of most careful study and appreciation.

"He is often accused of direct symbolism—pathologic, phallic, and erotic. In discussion with Weston on this very point I became convinced that there is no conscious attempt to imply symbolism of any sort in his work: we must consider the mental processes of the spectator—the psychological *point of view* rather than the free imagination. While Freudian principles are too well known to invoke here, I feel that the accusation of symbolism may be explained thereby. Given even the faintest hint or lead, a certain type of mind will construct a most elaborate morbid interpretation of the simplest and most 'innocent' object of nature or of art. As an artist, Edward Weston rightfully resents any intrusion of morality into critical estimations of his work.

"It is a pleasure to observe in Weston's work the lack of affectation in his use of simple, almost frugal materials. His attachment to objects of nature rather than to the sophisticated subjects of modern life is in accord with his frankness and simplicity. . . . Finally, may I quote what Diego Rivera said as we were speaking of Edward Weston —'For me, he is a great artist'." (December 18, 1931)

For years, rising in the dark hours before dawn in order to be alone and to think, Edward in his Daybook had been trying to resolve for himself just such problems as Ansel here discussed: abstraction *vs.* realism, theory *vs.* instinct, seeing *vs.* perception, the eye as contrasted with the photograph. Now his need for isolation was dissolving; in his gifted second son, Brett, in his new pupil, Willard Van Dyke, and in this ardent young purist, Adams, he had photographers with whom he could talk and by whom he might be understood. He wrote on January 28, 1932:

"Your article I appreciated fully, it was an intelligent consideration, by far more so than most I get, because it was a subject close to your own heart.

"The discussion of phallic symbolism should at least clear me of intention, though the disciples of Freud will not be convinced—they are as fanatically religious as Methodists!

"The part you devoted to my vegetables provoked a trend of thought which I will try to put into words. You are not the first to object to them: my good friend Charlot, whose opinion I value highly, also cared less for them than my rocks, thought they resembled sculpture too much or held other implications. Others have had similar reactions.

"I think first of all we must understand that Whistler (or was it Wilde?) was wrong—that nature does not imitate art but the artist continually imitates nature *even when he thinks* he is being 'abstract.'

"No painter or sculptor can be wholly abstract. We cannot imagine forms not already existing in nature—we know nothing else. Actually, I have proved, through photography, that nature has all the 'abstract' (simplified) forms Brancusi or any other artist can imagine. With my camera I go direct to Brancusi's *source.* I find *ready to use,* select and isolate, what he has to '*create.*'

"Now I am not a missionary, I will not try to convert you into liking my peppers or cabbages! Please consider what I have to say as a broad discussion.

"Did you interchange the words 'seeing' and 'perception' in your analysis of photography? Well, no matter—I will use 'seeing' for further discussion. . . ."

"Photography as a creative expression—or what you will—must be seeing plus; seeing alone would mean factual recording,—the illustrator of catalogues does that. The 'plus' is the basis of all arguments on 'what is art.'

"But photography is not at all seeing in the sense that the eyes see. Our vision, a binocular one, is in a continuous state of flux, while the camera captures and fixes forever (unless the damn prints fade!) a single, isolated condition of the moment. Besides, we use lenses of various focal lengths to purposely exaggerate actual seeing, and we often 'overcorrect' color for the same reason. In printing we carry on our willful distortion of fact by using contrasty papers which give results quite different from the scene or object as it was in nature.

"This, we must agree, is all legitimate procedure; it is not 'seeing' literally, it is done with a reason, with creative imagination. . . ."

Then Edward tried to warn Ansel about ideological straitjackets—even pure photography. "But after all,

Ansel, I never try to limit myself by theories. I do not question right or wrong approach when I am interested or amazed—impelled to work. I do not fear logic, I dare to be irrational.

"I would say to any artist—don't be repressed in your work—dare to experiment—consider any urge—if in a new direction all the better—as a gift from the Gods not to be lightly denied by convention or *a priori* concepts.

"The great scientist dares to differ from accepted 'facts,'—to think irrationally—let the artist do likewise. And photographers, even those, or *especially* those, taking new or different paths should never become crystallized in the theories through which they advance. Let the eyes work from inside out.

"Has this sounded like a sermon? I despise sermons, preachers, so I hope not. Perhaps I am really talking to myself. I have done some dangerous reasoning at times, but fortunately something beyond reason steps in to save me."

Ansel's own one-man show was opening at the DeYoung Museum in San Francisco. In the statement requested of him, he tried to be as objective as possible.

"Pictorialist phase ended with publication of Taos book . . . last year has been devoted to experiments in pure photography." Of one series of experiments, he was rather proud. Off Land's End a ship had foundered, and steel, rusting in the fogs, hurled against sand and rock, was being battered and twisted by the sea into strange and stern sculptural forms. If the transmutations of this shipwreck held any personal symbolism for Adams, he deliberately avoided it. "I have attempted to keep all emotional 'amplifications' well within the rigorous limitations of the medium, and to suggest mood in strict relation to subject. The Shipwreck series is a collective experiment in that direction."

Cedric Wright, who had himself begun to photograph, was much moved by the show. "I wish I could figure out some complicated and super highbrow letter about the exhibit. All I can say is something like this—It was good. It was better than Imogen's and Weston's. I was surprised as hell. I thought you'd never have the pussinality to fill them rooms in the big house, and the band playing outside and all. . . . It seemed like a very good concert, the technic was forgotten in the message and the message seemed to be the propaganda to exhibit the intimate beauties of seashore things, the mountains and all the rest, made brilliant in light.

"If I remember a few favorite ones they are that cloud picture, the soft one, along the coast. The Echo Peak one, the granite one with the sun alive across it, the watercourse

between granite. I suppose the wreck and the sand and shells is better stuff technically and textually and compositionally but don't care for the subjects as much.

"It seems to me that in the last year your prints have improved like hell.

"This is the first time that your pictures seemed on a par with your best writing." (CW to AA, no date)

And Weston, looking back later at that short year since Ansel's "Annunciation," and remembering his own long and painful evolution from Pictorialism, commented, "Ansel's growth in so short a time was really astounding." (Interview, 1950)

Ansel continued to review the shows at the DeYoung and elsewhere as if he were St. George, and the Dragon was any departure from the highest standards of pure photography. "The Moholy-Nagy exhibit was the greatest perversion of serious photography that has come to my attention. The current show of foreign Commercial photography further deflates my opinions. I find their tricky manner highly disturbing, and the technical aspects of the prints are so vile that I feel almost as if I were duped."

". . . the San Diego International Salon . . . was hardly worthy of notice. Compared with this sentimental balderdash, a good ordinary commercial photograph is an achievement in its direct and honest presentation."

Willard Van Dyke, over in Oakland, was if possible, even more a crusader for pure photography than Ansel. Whenever he could leave his job at a filling station, he went to Carmel to work with Weston, to whom he was almost a second son.

Willard agreed with Ansel that photography in the Salons had sunk to "decadent theatrics," to, in Ansel's phrase, "a medium for floozy expression . . . rendered with a keen devotion for the imaginary essences of implied substances." (AA to WVD, November 26, 1932) Willard agreed further that, even with the DeYoung series running, "the few exhibitions of serious straight photography were submerged."

Willard was all for immediate action. They should form a group devoted to demonstrating the potentials of straight photography. They counted up possible members. Weston first, of course, but they were both aware that he would refuse to be involved in any formal organization. Brett, his son—but Brett was barely twenty, and even less likely to be lassoed into a movement. Sonya Noskowiak, Edward's love and partner in the Carmel studio—Sonya might be devoted to such a group, but she would certainly not come in if Edward didn't. There was Imogen Cunningham, peppery and delightful—"A solid worker, especially fluent in . . . flower and plant life and

sensitive portraiture," wrote Ansel a year or so later. There was John Paul Edwards, a man of charm and distinction, who had risen to Salon fame about the same time as Weston—"A Pictorialist of real renown who has investigated the trends of the new photography. . . ." There was Henry Swift—"a business man who is serious in his approach to photography. Quite unique in this respect. Pictorialism as a hobby has been very popular with weary brokers and professional men, and the standards achieved have been questionable." (Unpublished sketch, 1935?) There were others of course, including both knowns and the always exciting unknowns, who might later be added to the group. But counting in themselves, the group of seven was representative.

Then how should it function? And what to call it? They kept proposing names, and rejecting them.

Ansel was now the official photographer for the Sierra Club, on the Editorial Board of its *Bulletin*, and a member of its Outing Committee. This mild-sounding duty began in the winter, helping Francis Tappaan plan routes through the high country safe enough for two hundred people and a pack train bearing a five-ton load, with only occasional access to the outside world for new supplies. The people walked from camp to camp. There must be challenging and little-known peaks and valleys to explore, too. On this tribal migration, the duties of direction began at dawn: breaking camp, packing the animals. During the day Ansel not only climbed and hiked, but he also photographed. Arrival at the next campsite meant prompt decisions: where to pitch the men's camp, the women's camp, the married people's camp, where to dig facilities, pasture the animals, set up the commissary, build the campfire. After supper Ansel began rehearsals for the mock tragedies—"people really worked on them!" It was a strenuous life and Ansel loved it. But even he had to acknowledge it had its bad moments.

Once, after camp was made, he discovered he had left a lens somewhere. He started back in the bright moonlight, and found the lens sitting on a rock twelve miles back. When he loped into camp again, dawn was breaking and so was camp, with another twelve miles to go before he could really sit down.

Again, there was the time when, the night being chill, the ring around the fire was closer than usual. Ansel, with his jeans beginning to smoke, "issued his trail directions for the morrow on the trot," and then, remembering his lecture on proper deportment toward mules, paused to scold an unnamed photographer for stampeding a whole pack train with his beard and focusing cloth.

On that high trip in 1932, Ansel made some hauntingly beautiful and enduring photographs—a frozen lake, below Kaweah Gap, where bright ice melted on dark water below the fractured shadows of a cliff; the new moon before dawn in a dark sky over the peak of Mount Whitney, with first light over the Owens Valley below.

When Adams got back to San Francisco, "Willard suffered a stroke of genius—" Why not call the proposed group of "pure" photographers after one of the smaller lens stops, such as $f/64$, which implied clarity of image and depth of field?

In his Daybook for November 8, 1932, Weston noted: "While we were in San Francisco several weeks ago, a party was given, exclusively for photographers, at Willard's. Those who gathered and partook of wine and photo-technique, were Imogen, John Paul, Ansel, Sonya, Willard, and E. W. Others were present but the six above formed a group with the primary purpose of stimulating interest in real photography and encouraging new talent. Henry Swift was added to the above mentioned. The original plan was to rent a room in San Francisco and give a succession of exhibitions. This idea was abandoned out of consideration for Lloyd Rollins, who has done so much for photography during his directorship at the museum. Lloyd felt we would be directly in competition with him, and offered an alternative: to give us a group show, several galleries at the museum. This offer was accepted and 'Group $f/64$' will open November 15th.

"Some have expressed astonishment that I should join a group, having gone my own way for years. But I see it as purely educational. We are all friends, free from politics, and I have no desire to be the founder of a cult!"

Group $f/64$, as Ansel wrote a little later, had none of "the formal rituals of procedure, incorporations, or any of the limiting restrictions of artistic secret societies." They had neither a president nor a treasurer; they were just seven photographers who now and then exhibited together and nearly always asked two or three other photographers to show with them. Ansel wrote: "We have issued no stony manifesto (such as the Surrealists did some years ago); we have stated in works and words what we consider straight photography to be, and we expect and welcome any fresh point of view." (Unpublished statement, 1935?)

In both Europe and America, the movement toward pure photography was growing. But there still existed confusion about it. Was it merely a return to the factual approach of the last century? Could it rise to the stature of art? The time for a culminating statement, for clarification, had arrived. Group $f/64$ was the catalyst.

At that first show at the DeYoung, Sigismund Blumann, editor of *Camera Craft,* recognized the arrival of a new period. "We went with a determined and preconceived intention of being amused and, if need be, adversely critical. We came away with several ideals badly bent and not a few wholly destroyed. We were not amused, we could not criticize adversely. This was the line of thought:

"First, classic forms of beauty have been, to us, inalienable from the pursuit of art. The $f/64$ Group have shown that there is something to say in a 1933 way that may still react on the cultivated senses as expressive of the beautiful.

"Second, that these workers are not militantly adverse to the old order of things. They are not trying to forcibly revolutionize this, that, or anything whatever but are doing what it pleases them to do without thought of the past, the present or the future. Just doing things their own way.

"Third, that they are doing it darn well.

"To appreciate sharp focus, strong contrast, exaggerated high-lighting, and bizarre subjects one must attune oneself to the key and the motif. For a listener to enjoy Stravinsky he must dismiss the Chopin mood and prepare with a course of raw meat diet. The $f/64$ prints are like that. Black, oh, very black and white! Angular. The accents are stentorian. These pictures do not sing. They shout. Stay your deductions. What they shout is as appriately shouted as a tender ditty is lilted. The unities are preserved. . . .

"Sentimentalists that we are, we shall never forgive these fellows for shattering our pet traditions. On the other hand, we are grateful to them for chastening our over-sure spirit.

"The Group is creating a place for photographic freedom. They are in a position to do so for not one of them but has made a place for himself in the hitherto accepted Salon field. For us, the destruction of an older taste will be like unto a surgical operation." (May 1933)

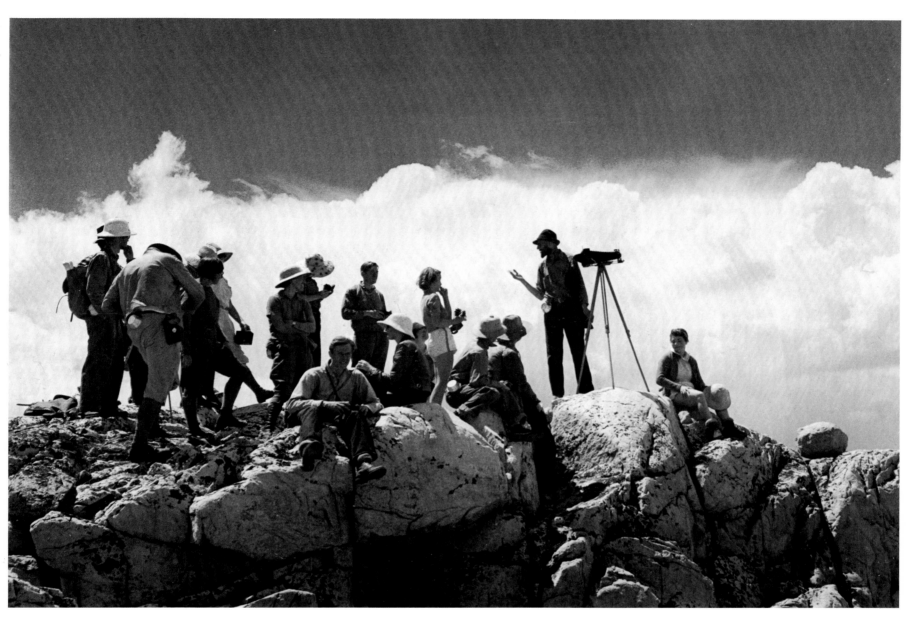

SERMON ON THE MOUNT (CEDRIC WRIGHT)

6. Diogenes

The Depression was at its blackest. Factories were shut down, banks closed, stores boarded up. Thousands wandered, homeless and jobless, through the streets, sleeping in doorways and on park benches, standing for hours in the breadlines.

Every day on her way to her studio in downtown San Francisco, a portrait photographer named Dorothea Lange passed these breadlines. The faces haunted her. One afternoon she could stand it no longer, and went down into the streets with her Graflex. She already knew her subject was people. Once, in the middle of a thunderstorm, "it came to me that what I had to do was to take pictures and concentrate on people, only people, all kinds of people, people who paid me and people who didn't." (Quoted by Daniel Dixon, in "Dorothea Lange," *Modern Photography*, December 1952)

But that afternoon in the streets came a further revelation, a sudden fusion between the inner desire and the outer reality. She photographed a lonely old man in a battered hat, leaning on a fence, with his hands knotted, an empty cup before him and a sea of turned backs behind him. "White Angel Breadline" still stirs beholders like a cry for help.

Her portraits had been soft and dateless: ". . . earlier, I would have thought it enough to take a picture of a man, no more. But now I wanted to take a picture of a man as he stood in his world." (*op. cit.*) Now she needed to see sharp and deep, to imply the place and the date, to produce an incontrovertible *document*. And straight photography, with the new and intense vision the purists had given it, could serve with a force greater than ever before in its old function of "the faithful witness."

Group *f*/64 welcomed her new work with excitement and deep emotion. Most of them had known Dorothea for years as a little soft-spoken woman, slightly lame, who with humor, insight, and simplicity, managed to look after her husband, the painter Maynard Dixon, her children, and a successful portrait studio simultaneously. No one had suspected her of suddenly opening up a vast potential use of the medium or of a power, no less than that of Goya or Daumier, to rouse pity and wrath. Dorothea herself made no such claim; she has always insisted she is just recording history as it passes before her lens. But Group *f*/64 recognized her quality as art and voted her a member.

Ansel hailed her: "An extraordinary phenomenon in photography. She is both a humanitarian and an artist. Her pictures of people show an uncanny perception, psychological and emotional, which is transmitted with immense impact on the spectator. To my mind, she presents the almost perfect balance between artist and human being. I am frankly critical of her technique in reference to the standards of purist photography, but I have nothing but admiration for the more important things—perception and intention. Her pictures are both records of actuality and exquisitely sensitive emotional documents. Her pictures tell you of many things; they tell you these things with conviction, directness, completeness. There is never propaganda. . . . If any documents of this turbulent age are justified to endure, the photographs of Dorothea Lange shall, most certainly." (Unpublished statement on Group *f*/64, 1934?)

For Willard Van Dyke, Dorothea's photographs pointed out the way he himself must go. Working with Edward Weston, he had forged a sharp tool. But art seemed so irrelevant, even trivial, in the face of vast human suffering. Now he saw how the straight photograph could serve a dynamic purpose. He observed Dorothea's approach, alone and unprotected, to situations where she might easily have been mobbed and even killed: "In an old Ford she drives to a place most likely to yield subjects consistent with her sympathies. She may park her car at the waterfront during a strike, perhaps at a meeting of unemployed, by sleepers in the city square, at transient shelters—breadlines, parades, or demonstrations. Here she waits with her camera open and unconcealed. She looks at no one directly and soon . . . her subjects become unaware of her presence. Her method, as she describes it, is to act as if she possessed the power to become invisible to those around her." This was to become the classic approach of the documentary and journalist photographer.

But Willard was beginning to feel that the single photograph was not enough: "It must make its record out of context, taking the individuals or incidents photographed as climaxes rather than as continuity." Even with Dorothea, "her individual shots cannot tell the whole story, nor has she any plan of sequence—it is only in the broad scope of her life's work that her commentary upon humanity is to be found." (Willard Van Dyke, "The

Photographs of Dorothea Lange," *Camera Craft,* October 1934) For some photographers, this gap was to be filled by words and picture sequences on the printed page; photo-journalism was fast rising into an important profession. For others, as for Paul Strand and Willard himself, the answer lay in cinematography.

As for Adams, his admiration for Dorothea and sympathy with her goals were such that he helped in any way he could, developing her negatives for her when she was away in the field, making special prints when she needed them, and coming along to assist whenever she felt some situation was beyond her technical skill. But the Photo-Document was not his way, any more than Weston's. Now, it seemed to Adams, it was imperative that he go east—imperative that he see the work of Stieglitz, Strand, Sheeler, Steichen, discover what his contemporaries were doing and thinking during these disastrous years, and learn where his own work stood in the sight of a larger world.

Early 1933 was not a propitious time to tour the United States. Daily the newspapers reported more industries shut down, more strikes led by Communist organizers, more Fascist parades, more banks stormed by such crowds of terrified depositors.

Nevertheless, Ansel and Virginia felt this was the time for them to go. She was expecting a child in August, and her father, Harry Best, had given them a thousand dollars so they could make the journey together now. With the thousand dollars in banking checks, and many notes of introduction from Albert Bender and Mrs. Stern, they started off.

Suddenly, on the day of his inauguration, President Roosevelt ordered all banks closed. Fortunately, Ansel and Virginia were in Santa Fe among friends. Their checks proved sound, but it was weeks before they could continue on their way.

First to Chicago, then to Detroit, where they stopped to see Rivera's murals. Finally on a rainy Monday morning they arrived in New York. Leaving Virginia at the hotel to rest, Ansel went to see Alfred Stieglitz.

The essence of that meeting Ansel later described in a fantasy in which he himself became "hoary Diogenes" bringing his new electric lantern "to that rather large and severe pile of commercial architecture known as 509 Madison Avenue" because he had heard that "there was a man somewhere in New York who *was* honest. He also was a bit fantastic, quite blunt, occasionally cruel, and thoroughly intelligent. He was said to be, underneath and after all, exceedingly kind. . . . The elevator soared to the seventeenth floor. As Diogenes wiped his feet on the mat

before the door lettered 'An American Place,' the lantern went out completely. He placed the lantern on the floor next to a pair of rubbers . . . straightened his beard and walked in. . . ."

The actual details of the first encounter are not in the fantasy. Adams saw a little white-haired man in a black cape talking to other visitors. He waited. Finally the little man swung toward him.

"Mr. Stieglitz?"

"Yes, I am Stieglitz."

"I am Ansel Adams, from San Francisco, and I have a letter for you from Mrs. Sigmund Stern." Stieglitz took the letter and crushed it, unopened, into his pocket.

"Oh yes, I know her. She has nothing but money, that woman, and if this Depression keeps up, she won't even have that soon."

Ansel gasped—this, of the kind and gracious Rosalie! He recollected just in time that this was an old man twice his age, half his size, and wearing glasses. While he was still wordless, Stieglitz pointed to the portfolio under his arm and said, "Come back at 2:30; I'm busy now," and turned away.

Ansel went out and walked the wet streets in fury. The legendary, the wonderful Stieglitz, indeed! The old -------! What could Marin and Strand have seen in him? How could Georgia O'Keeffe have married him?

He went back at 2:30.

"No one was in sight. A beautiful barren room filled with expectant space, enclosed by walls of indescribable tone on which a few paintings were hung thrusting like jewels into the cool light. Over the radiators on the window sill were a few piles of leaflets; four doorless apertures led to other spaces. Light came from windows looking west and north and ceiling troughs emitted a blue-white radiation. The radiators knocked twice and a rustle of papers was heard from one of the attached rooms. . . . He saw a small room stacked and littered with paintings, photographs, books, papers, frames, letters, pens, blotters, gumdrops, leaflets, a telephone. . . . Stieglitz looked up at him with piercing, tired eyes. Diogenes noticed the belligerent intelligence of the face, the frailness and the strength, the beautiful precise mouth. . . ."

Stieglitz took Ansel's portfolio without a word, untied it, looked at the first print a long time, replaced the tissue exactly, looked at the second print. Ansel sat on the radiator, there being no chair in the room except the camp chair Stieglitz was sitting in. The silence went on and on. Ansel noted "some photographs leaning against a stack of books. They were quiet and rich in tone and substance —a leafless poplar reaching into the sky as an arrested

ALFRED STIEGLITZ IN AN AMERICAN PLACE, NEW YORK CITY

fountain of pale light, an immeasurably tall building against the night, a roof corner of an old barn. Throbbing with life, they were cool and enduring as stone."

Stieglitz came to the last print, shaped the pile carefully together, closed the portfolio and tied the bows neatly. Ansel thought, "Well, that's that. I needn't have come," and started to rise from the radiator.

"Sit down, young man."

Ansel sat. Stieglitz untied the portfolio again, and still in silence, went back over every print. Finally he looked up at Ansel, who by this time was "as corrugated as a waffle," and said, "some of the finest photographs I've ever seen."

At that point, Ansel really met Stieglitz. Nothing so far had prepared him for that extraordinary experience. "I am perplexed, amazed, and touched at the impact of his force on my own spirit. I would not believe before I met him that a man could be so psychically and emotionally powerful." (AA to PS, September 12, 1933)

From that little gallery above Madison Avenue Stieglitz challenged the outside world. "He walked over to the windows and looked out on the towers of New York growing out of the invisible rock like the rectangular forms of a huge crystal. 'This mad-house,' he said, 'is the vortex of the human world. Everything comes here in its time. Even you.'"

The fantasy ends as Diogenes forgets his lantern and leaves it forever beside somebody's rubbers at the door of An American Place.

New York in 1933 was grimy and unswept. Central Park was worn and neglected. Soot fell incessantly. All night long lights glared, flashed, and winked, and the cacophony of wheels, horns, and voices never ceased. The breadlines were longer here, tailing around blocks. Thin men in thin clothes, sometimes in rags, with their feet wrapped in newspapers, waited shivering in the rains. In the streets and subways, every passing face seemed to have the yellow transparency and little frown of hunger. Yet New York was still "the vortex of the human world," still the center of power and finance, of art, music, books; of industry and even conservation.

Around the corner from An American Place rose the huge new shaft of the RCA Building, which pessimists had regarded during its erection as "the last skyscraper devouring the last great fortune." In the lobby Adams found Rivera, no less an example of "posteriority" than before, up on the scaffolding before the vast mural of science and industry into which he had introduced the heads of Marx and Lenin. The thundering controversy that resulted in the destruction of the fresco was already rumbling in the press.

Almost at the top of the tower, Adams was greeted by Horace Albright, who had recently resigned as Director of the National Park Service to become a vice-president of U.S. Potash and to advise John D. Rockefeller, Jr. on his manifold and world-wide conservation activities. Albright led Adams to his windows, which commanded a superb view of the then-new buildings of Rockefeller City rising from what had been a sea of brownstones sheltering speakeasies and cheap boarding houses. "This," said Albright, waving his hand, "is the summit of human endeavor!"

Edward Steichen, then at the apogee of his career as a commercial photographer, used as his studio a carriage house in the 60's. "Colonel Steichen is very, very busy," said the receptionist. "I doubt if he can see you. Of course you can wait if you like." Adams chose to wait. And watched. Frantic crews were scrambling up ladders to screw and unscrew various lights; elegant thin women adjusted the folds of a model's gown, or directed the placing of a prop; errand boys arrived breathlessly with packages of all sizes. Finally a horn honked outside; someone rushed to open the old carriage doors, and Steichen drove his car inside. "Mr. Adams has been waiting," said the receptionist. Steichen glared at the black beard and the portfolio. Ansel could feel "a personal chemistry at work," an antipathy as instinctive as it was mutual.

Steichen snapped, "Photographer?"

"Yes—my name is Ansel Adams—"

"Sorry. I'm too busy to look at photographs."

"Another day perhaps?"

"Impossible. Schedule's jammed for weeks. Goodbye!"

The studio of Anton Bruehl, in a skyscraper on Lexington Avenue, was equally hectic. But Bruehl, whose fame was then eclipsing Steichen's, came instantly out to greet Adams and ask him to lunch. He apologized for having no time until then, but, "Meanwhile, if you'd care to hang around here, feel free to do anything you like. Here's my library and here are some of my prints. And don't hesitate to ask questions if anything interests you." After lunch, Breuhl invited Ansel to spend the afternoon in the busy studio. Ansel liked the straightforward craftsmanship of Breuhl's photographs, and especially his subtle and sensitive work in color. And he liked a man who could so welcome a young unknown.

Ansel and Virginia found New York full of contrasts. They went to stately dinner parties in great rooms on upper Fifth and Park avenues and sat on the floor drinking wine in cold-water walk-ups in Greenwich Village. They heard concerts in Carnegie Hall and jazz in Harlem nightclubs. They saw the art of the past at the Metropolitan Museum and that of the present at the Museum of Mod-

ern Art. They visited many galleries, two or three of which, such as Julien Levy's and the Delphic Studios, occasionally showed photographs. At the Delphic Studios, Alma Reed asked Adams for a one-man show in the fall.

The art world, they soon saw, was divided into many violent factions. One leading group consisted of intellectuals for whom Europe was the sole source of art, thought, and civilization and America worthy only of cynical contempt. For these, two aspects of photography held a mild interest: imitations of abstract art such as the experiments of Man Ray and Moholy-Nagy and confirmations of Surrealism such as they found in Atget's documents of Paris and in Cartier-Bresson's uncanny split-second perceptions. Another group loudly and vociferously proclaimed that the Midwest was the one strong and undefiled source of life. From the prairies any man, be he corn chopper, hog butcher, doctor, lawyer, or newspaperman, tended to grow into the image of Abraham Lincoln. Grant Wood, John Stewart Curry, and Thomas Benton were the painters of this American scene. Carl Sandburg was its poet and his brother-in-law, Edward Steichen, its photographer. These were roused to enthusiasm by nostalgic snapshots and by glorifications of steel mills, corn fields, prairie towns, brawny men, and aproned women. On three things all factions appeared to agree: in villifying the New England tradition for its prurient Puritans and transparent Transcendentalists, in deriding the West, and in being baffled by Alfred Stieglitz.

In the talk ebbing and flowing around them, the Adamses heard Stieglitz called a crank, a mystic, a fascist, a Svengali, a prophet, a charlatan, a supersalesman. Even Albert Bender, who remembered Stieglitz as an "intellectual talking machine," warned Ansel: "It is far better for you to be independent instead of a protégé of his. Through being independent you will go further and develop yourself to rely on your own resources." (AB to AA, April 4, 1933) Ansel was born an independent, but he could not get the Marins out of his eyes, nor the O'Keeffes, nor the deep, rich Strands—the first prints he had seen— nor the penetrating tenderness and emotional power of the Stieglitzes. He went back again and again to the luminous quiet of the Place. He saw the tiny cubicle Stieglitz used as a darkroom—Stieglitz, whose technique was based on rigorous training by the photochemist, scientist, and teacher, Wilhelm Hermann Vogel, Stieglitz who had for years astonished the photographic world by making great photographs in rain, storm, night, by taming the crude flashlight and the rough young gravure process—Stieglitz was now, in his old age, using

the barest amateur equipment, the commonest ready-mixed chemicals. It was a darkroom even starker than Weston's. The hours with Stieglitz, Ansel wrote later, "touched and clarified many deep elements within me." Things he heard Stieglitz say struck a deep resonance in him:

"Wherever there is light one can photograph."
"When I make a photograph, I make love."
"Photography is my passion, the search for truth my obsession."
"Art is the affirmation of life."

Adams puzzled the intellectuals nearly as much as Stieglitz. Of his wit and intelligence they had no doubts, but how could any gifted young artist in the twentieth century still believe in "beauty" and "nature?" They tried to laugh him out of such naïve and worn-out notions. When he protested that "beauty" and "nature" were fairly outstanding facts in, say, the Sierra Nevada, and that the critics had better come see what they were missing, they became derisive. Mountains!—why photograph rocks when Man and Man only, Man Now, was the proper study of Man. Nature existed only as raw material for Man. In art, both "nature" and "beauty" were suspect. As for California, it was a joke, a promoter's hyperbole, a super-colossal backdrop for Hollywood. In art, the West Coast did not exist. Its so-called poets, painters, and photographers were shrugged off as barbarous, mystic, or theatrical.

Infuriated and challenged, Adams longed for a chance to reply in print. When Albert Boni asked him to review for the magazine *Creative Art* Edward Weston's first book, *The Art of Edward Weston,* Adams welcomed it as the perfect opportunity. This book, casually mentioned to Edward in July 1932 by the impresario and graphic designer Merle Armitage, was by November a finished production. Bold in its typography and bound in shiny black, with a series of hasty forewords preceding the handsome plates, it made Adams wince. Edward, he felt, should have had something as elemental and classic as the *Taos* book. He spoke up both for Weston and the West:

"The physical environment of the California Coast has left an impressive mark on Edward Weston. In the whirl and social vortices of the huge craters of civilization, it is easy to forget the simplicities of stone and growing things and the hard beauty of the implements of human relations with the primal forces. Weston has dared more than the legion of brittle sophisticates and polished romanticists ever dreamed. While much of modern art is documentary in the social sense—a record of the dynamic situations of the times—his photography is documentary in the sense of recording actualities of the natural

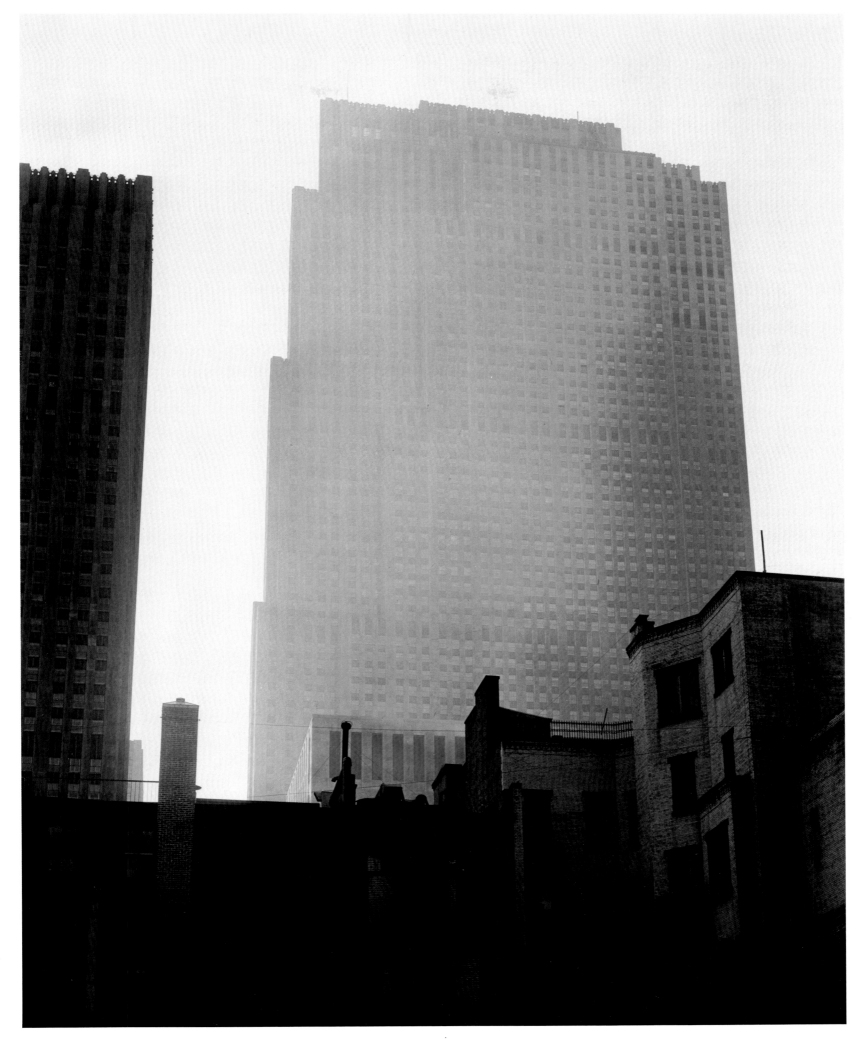

R.C.A. BUILDING, NEW YORK CITY

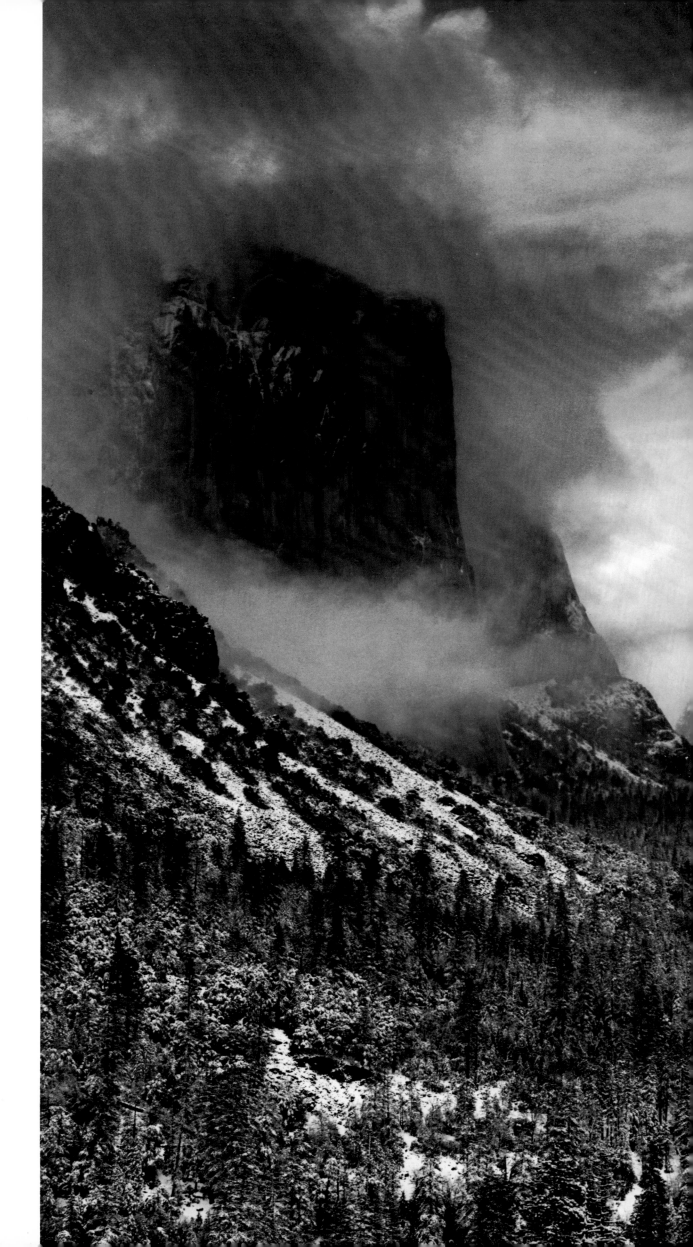

WINTER STORM, YOSEMITE VALLEY

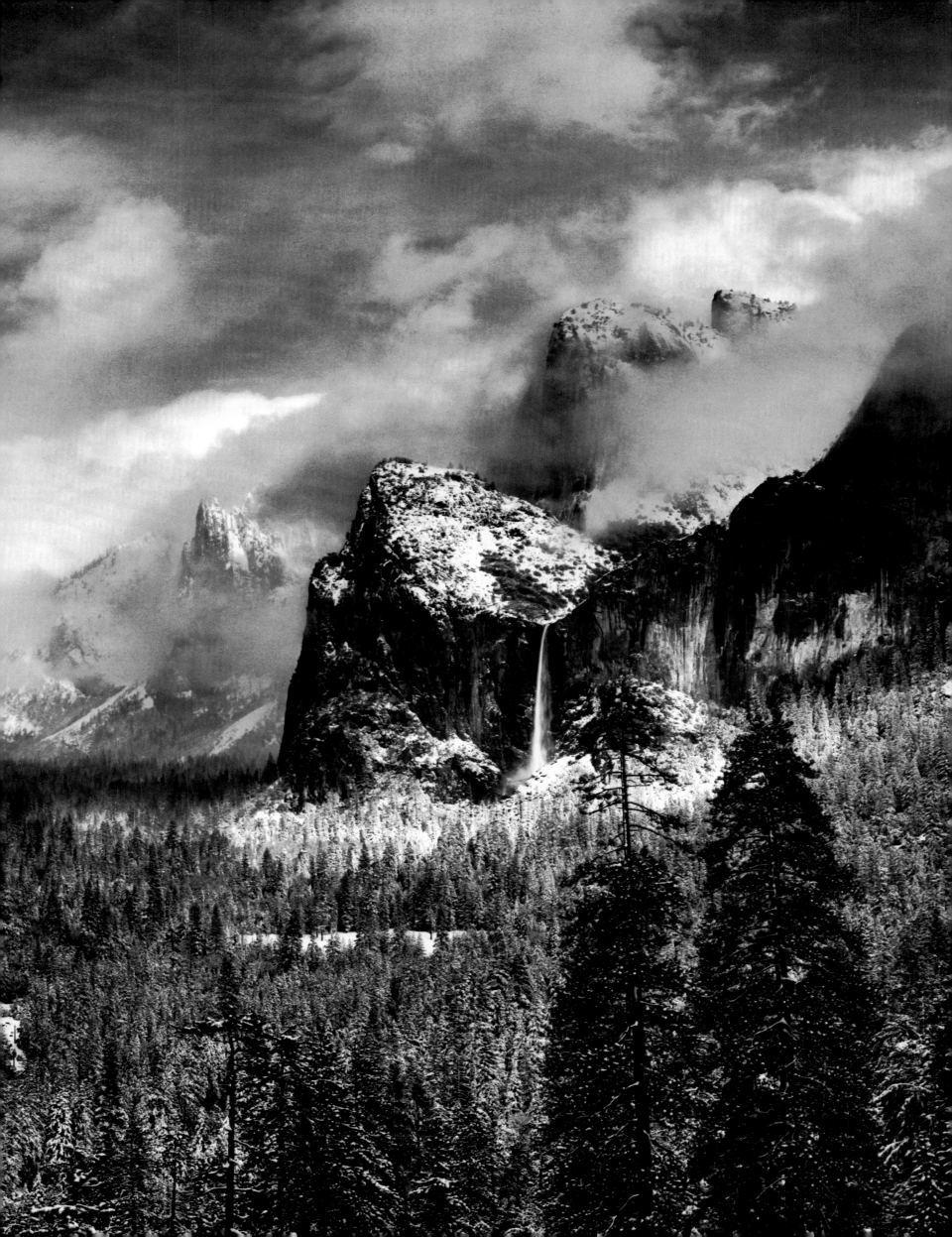

world . . . simple things which, through his presentation, assume the qualities of elemental necessities.

"I can find no relation between his work and chromium steel decoration, the frigid structure of modern cities, Fifth Avenue, and Hollywood. Unfortunately, this book implies such a relationship, but that is not Weston's fault. The editor of the volume has included rather tasteless adulatory texts of no actual critical worth and often savoring of the character of book-jacket blurbs.

"My first reaction to the book was a surge of pleasure at possessing a collection of reproductions of Weston's photographs. My second was one of regret that the vehicle was inferior to the subject. Mr. Armitage's gesture of self-conscious altruism might have been convincing had he permitted the photographs to speak for themselves.

"I strongly advise all who are interested in the art of photography to get this book; the magnificent work of Edward Weston triumphs over the manner of its presentation." (*Creative Art,* May 1933)

When, finally, Adams got back to San Francisco, he sent Weston a copy of this review. Edward received it with mixed feelings. He was packing to drive with Willard Van Dyke to New Mexico, and Ansel was shepherding his 8 x 10 through the repair shop so that it would be ready for the journey. Ansel's work had awakened an old love. Edward was beginning to see landscape again as he had seldom seen it since his boyhood in Chicago, and certainly not since Mexico. Ansel was becoming increasingly important to him. But so was Merle Armitage. Edward was very proud of his book and the praise it was receiving. So—would Ansel see that the camera was ready for Willard to pick up on his way to Carmel? Then ". . . you certainly eulogized my work, if you did pan Merle. I can understand, enjoy, believe in controversy—if it is *creative argument.* But when you label Merle with 'self-conscious altruism,' I take exception. For years others *talked* of an E. W. book; Merle *acted!*" (Edward Weston to AA, June 9, 1933) Yet later when the book was voted by the American Institute of Graphic Arts one of the Fifty Best Books of the Year, Edward did not crow; he stated the bald fact in a postscript to an affectionate Christmas letter.

Later, looking back on the whole trip East, Adams wrote Stieglitz on October 9:

"New Mexico—prostrated under Luhans, Sophisticates, and Tourists. The air is so clear there you can see and smell unpleasant things at a great distance. And what is between you and the Great Distance doesn't count, physically and racially. Once in a while a little island—a little moment of extraordinary beauty. And then a tour-

ist, or a bad artist, or—a little too much beauty. How often, when the Beautiful is boiled down and dried in the hot sun it turns into the Picturesque. Any island one makes for oneself there cannot withstand the tides. The people there think it is life on a Grand Stage, when it's only license in the Wings.

"The Chicago Fair:—Three-dimensional advertising posters in front of a picket fence of Mammon-Wood.

"Cape Cod: Drearily charmful—preserved sugar-houses, golf-green lawns, characters and people who are Aware of their Environment. Good Old New England! The most refreshing thing I saw in Boston was the way the Museum treated your prints—they had *not* put them in Golden Oak frames!!

"I remember New York: subtracting you and a few other people, your work and very little other work,—what is there in that memory but a vision of a slowly dissolving inferno. Migrain from looking up—Nausea from looking down—Total Jitters from looking side-wise. Noise, sweat, stink, more noise—this is the Center of Civilization (God help Civilization) . . . no Earth in sight—the City is sitting on its chest with a strangle-hold —even the clouds look [as if] they were intruding. Chicago, the same. Detroit, the same. San Francisco, not quite the same,—some stinks, some noise, but Earth is in sight—sand-dunes, hills, long moor-like solemn stretches of windy seafront, ocean, fortunate fog. And not very far away there is a land and sky that would be heroic if given a chance. Here, there is beauty within reach—in New York you have to stretch for it. This part of the earth cannot help it if they call it California."

In California, that June of 1933, the Depression seemed to be lifting a little. Plans for a huge new bridge to span the Golden Gate and for another to cross the Bay were announced. Up in Yosemite, a tunnel four thousand feet long had been drilled through the solid granite of Inspiration Point. From the lookout at its mouth, Adams photographed a rainbow arching up past El Capitan and over Half Dome. Both this and his earlier "Golden Gate" were featured on the front page of the *San Francisco Chronicle's* Sunday rotogravure section. Ansel took a bold step. Downtown, at 166 Geary Street, the Galerie Beaux Arts had just closed its doors. In spite of this omen, Ansel took over the space. He wrote Stieglitz: "I have secured an admirable location downtown in San Francisco as a studio for my work. In conjunction with this studio is a gallery— very simple, fairly spacious, and well lighted. I am planning to operate this gallery as a center for photography. There is nothing of its kind out here. My venture is not an attempt to imitate what you have done at An

American Place— that would be more than ridiculous to try.

"I am as it were, embarking on this experiment on a shoe-string. I am counting on my own work to pay the rent and expenses. I have raised a few hundred dollars with which to paint, clean up, buy glass for exhibits, etc. I am paying that money back in photographic work in the future. I expect to derive a little additional income from the sale of prints in the routine shows, and from lectures, etc."

Would Stieglitz send him twenty-five prints for the opening show on September 1? Ansel guaranteed all expenses, insurance, and would take no commission.

"I ask for a Stieglitz show—reverentially—in the hope that many people here who are unable to travel to New York will be offered the great experience of seeing your work and absorbing what they may of its extraordinary quality and spirit. If this request is refused, I will take it philosophically—knowing that your work is your life, and that no one must question the directions of the spirit." (AA to AS, June 22, 1933)

Stieglitz was up at Lake George and would remain there until the end of September. "But even if I were in town I don't know whether I could respond to your request. You see I am a stickler in the presentation of everything. The main thing is that of the things I'd want the world to see there are rarely duplicates and the firsts I keep together at home even if I never show them. It's just a feeling. . . . Someday I'd like to send you a good print of mine as a token of appreciation of your purpose. I know your experiment will be a good one—I know well it won't be an imitation of anything else. I wish you every success." (AS to AA, June 1933)

This was disappointing, but not unanticipated. Ansel decided to open with a Group f/64 show, to be followed by paintings and lithographs by Jean Charlot, photographs of Mexico by Anton Breuhl, water colors by William Zorach and his wife, Marguerite, photographs by Edward Weston and Peter Stackpole. He worked on improving the lighting for the Gallery and setting up a darkroom in which he could both work and teach. Then he had to go off with the Sierra Club—"no vacation, just toil with cameras and people." He did not get back to Yosemite until two days after Michael, his son, was born. He wrote Cedric, "it is a leetle boy, with long fiddle fingers for you to teach some day maybe."

In Oakland, Willard Van Dyke and Mary Jeanette Edwards were making "683 Brockhurst" into a charming little studio-gallery. On July 28 they opened the first retrospective show Edward Weston had ever had. Hung in chronological order, the prints were an astounding record of growth and change. The reviewer from *Camera Craft,* who appears to have known little of the work of Group f/64 as individuals, was "struck by the fact that some of Mr. Weston's latest things might almost be classified as landscapes. Landscapes have been something of a bugaboo to the 'new photography' and it will be exciting to see what Mr. Weston can do with this problem." Then the reviewer learned of Ansel's Gallery, and as a stop press item, ran the announcement with the comment: "The value of such a gallery as this, where fine photography is constantly on display, can hardly be exaggerated. Mr. Adams is to be congratulated." (*Camera Craft,* September 1933)

Ansel achieved a "few Spartan sales." But he could not achieve what he had hoped, "to bring things to San Francisco that should have come years ago." Strand was in Mexico, and dared not trust his unique platinum prints through the customs. Sheeler had done no photography for years, and felt that the same old prints would look like a memorial exhibition. Diego Rivera regretted he had no drawings or paintings with him in the United States.

And there were other problems; in one of his "safety-valve letters" to Stieglitz across "3,000 miles of Moronica Gigantica," he wrote in October, "I wish to issue a manifesto—a manifesto to you, 3,000 miles away, from me, 3,000 miles away from you. It's a manifesto in the form of a grouch. (A grouch is wrath without guts—I have to save the guts for things here.) It's this—I hereby object trying to support myself, my photography, my gallery with such a prostration of spirit as the following example indicates.

". . . A man who owns 3,000,000 $'s and has a Responsible Position in the Community tells me he likes my pictures and wants a portrait—tells me he wants me to avoid making his head look like a species of fruit—tells me to show only one ear—tells me to be sure and make him look at the camera—tells me, moreover, he understands ART and I am big enough jackass to try it, needing the cash then he didn't like it then I tell him for God's sake how can I get him to look at the camera and not show his two ears when he won't turn his eyes sidewise and he says never mind I don't know my business and I say, Right!! I don't know that part of it . . . and he sails out like a clipper ship in a rip tide (and I hope he flounders on a good muddy oyster-bed) and I am left Alone kicking myself in the pants every time I remember that I tried to make that picture, which was just a collapse of moral stamina. Hell!!!

"The high priest of commercialism bellows from the tower of necessity the call to prayer, and the faithful bend and sprawl and grovel at the ghost of the Almighty $......rents have to be paid, food bills have to be paid, shoeshines and clean shirts have to be bought,—so that the smirk of ideals compensating with existence is given a proper setting.

"I find myself brooding over rocks and clouds and Things of No Value that would make good pictures. I remember campfires, a few gigantic mountains to inflate my ego—and a few very long miles to deflate it again. It's funny—I have had lots of that kind of life; I didn't know what it was all about when I had it. Why is it that Things of No Value make the best pictures, and that a stomach ache becomes interesting when remembered. . . . I remember my mountains, my old clothes, my pack-donkeys, my first funny plate camera (6½ x 8½ with glass plates) that I animal-packed and back-packed over unimaginable miles of rocks and roughness and pointed at amazed landscapes. The results, photographically, were terrible, but the life bent and tempered something that I can never unbend and untemper in this existence—even if I wanted to. There is too much clear sky and clean rock in my memory to wholly fall into self-illusion. I wonder —as I pick this out on the typewriter to you—I wonder if I can bring anything of that absolute honesty into my work and into this experiment of a gallery?—if I can make something or show something that will be as inviolate as a piece of Sierra Granite? You have weathered storms that would put me on the bottom with the old bottles in a week, but I don't think the Public will beat me after all. You face the winds like a rock, and I have to streamline my front. But thank God, there are some people here who understand a little about it—who forget that it's Art and know it is for Something Said about Something Felt."

Later, when Ansel begged Stieglitz for a joint show of his photographs and O'Keeffe paintings, Stieglitz wearily replied: ". . . my dear man I understand only too well about the starved souls in San Francisco as well as elsewhere—But what you ask is absolutely impossible— physically impossible as well as otherwise impossible. The O'Keeffes are needed here. I dare not risk them out. She is not painting. May never paint again. . . . As for (my photographs) they hardly exist for me. No I cannot spare the energy to go through them and send you a lot for exhibition even at your place. You know I hate the very idea of all exhibitions for exhibitions as such are rarely true.—Have fundamental significance. Are entertainers and not enlighteners." (AS to AA, October 20, 1933)

Ansel did understand, though he wondered if Stieglitz's attitude had not become "an all-enfolding armor to the world . . . which protects and prohibits at the same time. After all, there is only a handful of souls that care and know—in all the world there is only a handful. But they, that handful . . . are hidden away in the vast pile of humanity, and we can't see in and can't always see out. If you bring a light close enough they may be able to see it and respond. And what is the function of great art but to do just that—to kindle something of a flame in the human material that is ready to burn? I think there is a small army of people who would hasten to support your standards were they only reached." (AA to AS, no date)

Stieglitz answered: ". . . You ask what my attitude is. Man can't you figure it out for yourself. I am trying to sustain life at its highest—to sustain a *Living* standard. To let every moment *actually live* without any ism or fashion or cult attached to it. Don't you realize I hate the very idea of what's called an Exhibition. Don't you know I hate the very idea of what's called a Picture. Of course you have tackled an impossible problem. You must realize that. But that doesn't mean that you must give up. No, it's your problem. You have a family to support. That's the rub. The clash of the ideal with the commercial—for you cannot escape the latter unless you are ready to starve and have your family starve. I chose my road years ago— and my road has become a jealous guardian of me. I cannot as yet move mountains by addressing them with beautiful words." (AS to AA, December 7, 1933)

Ansel did what he could at his Gallery. He offered what *Camera Craft* announced as "an exceptional opportunity to study under a master-craftsman," he gave lectures in which he traced "the development of photography with the idea of establishing an esthetic rationale," led discussion groups, and gave private instruction. *Camera Craft*, inspired by his teaching ability, asked him for a series of technical articles—his first. He got to work on these, between interruptions, and also, when he could, printed for his New York show, to be held at the Delphic Studios in November. In the fifty prints he finally selected, there is the unmistakable note John Marin heard, years ago in Taos. The matchless majesty and religious depth of his later work is only suggested, as yet, by the Monolith and the Golden Gate. But the power to arouse a profound and meditative emotion is already there, in the beautiful dark head, with its liquid eyes and its living skin, of the young journalist Carolyn Anspacher, in hoarfrost riming leaves on a stump among frozen grasses, in trees like fountains of snow, some dim in storm, others sparkling in

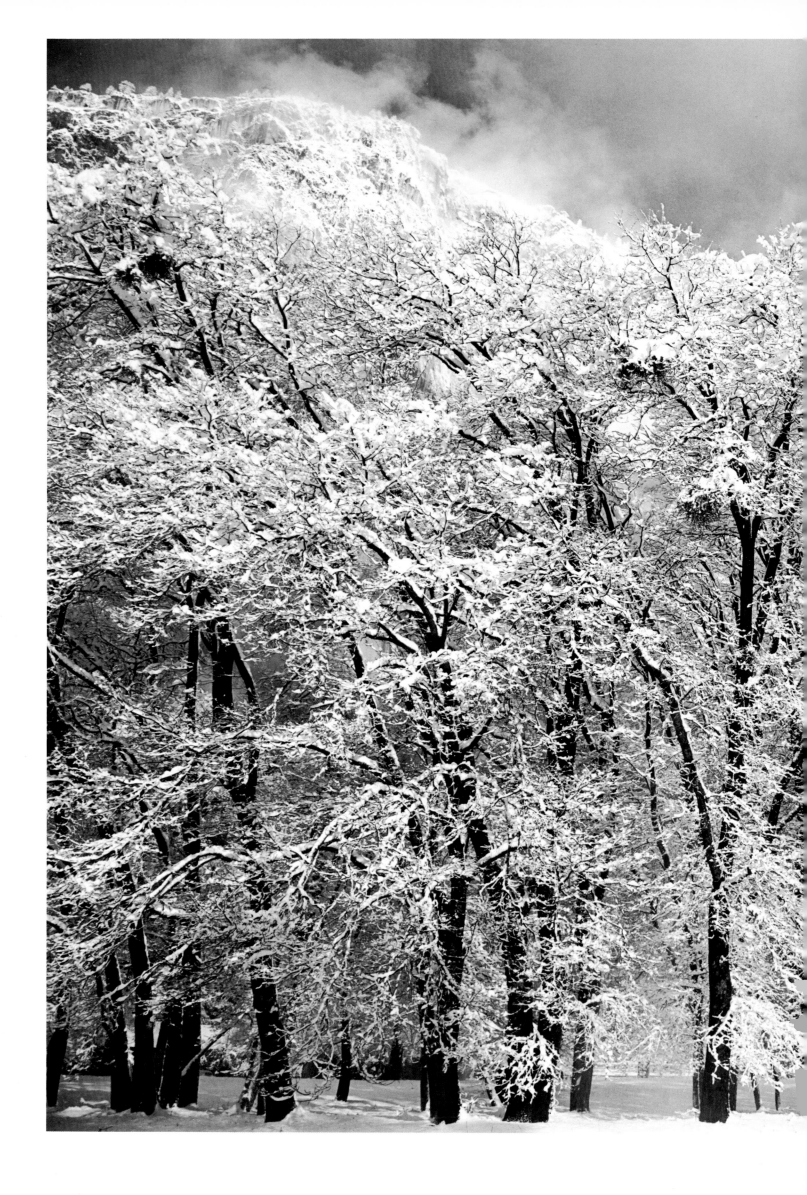

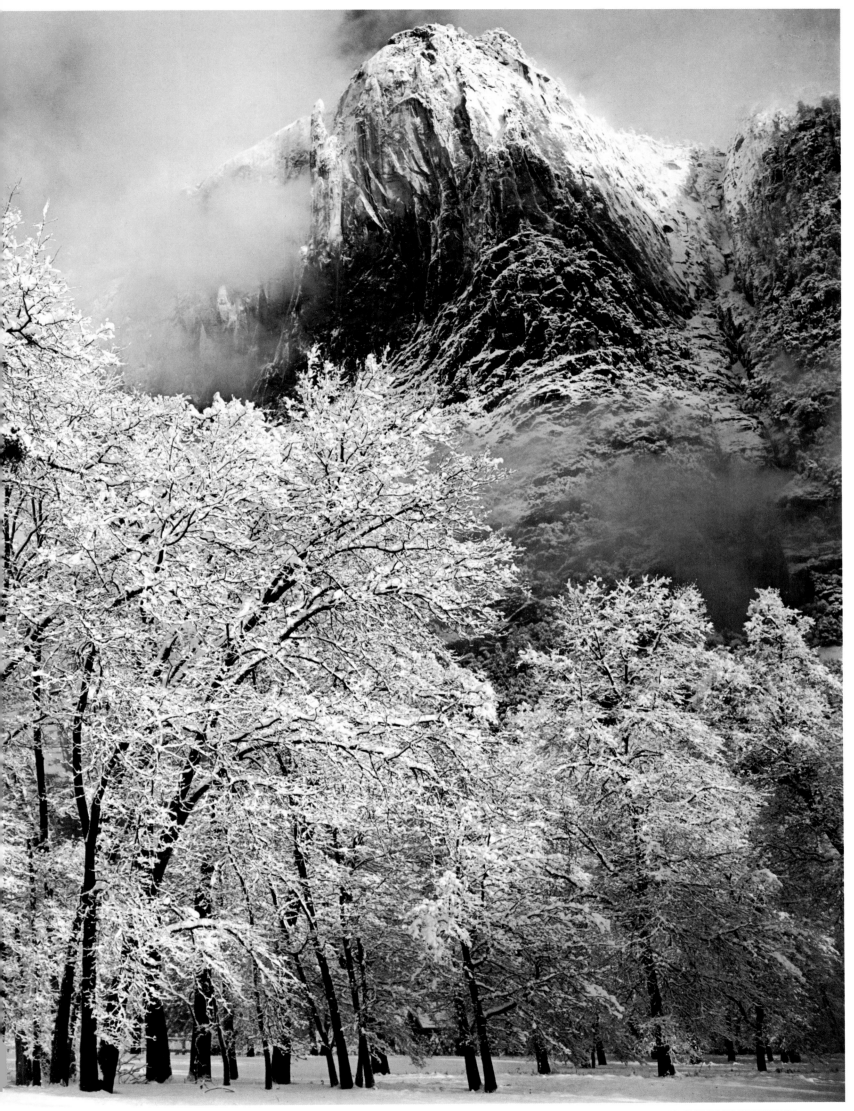

OAKS IN SNOW, YOSEMITE POINT

sunlight against vast shadowy precipices; in the statues Adolph Sutro set on the ramparts of the Pacific, mouldering and cracking in the storms and fogs.

For the one page wall-label to accompany this show, Ansel composed an ardent credo: "Robinson Jeffers has said: '. . . on the final Pacific . . . this old world's end is the gate of a world fire-new.' Out here, on the edge of the Pacific, [art] is burning with a fresh and revealing flame— a brave light eating into an old darkness. Our painters, sculptors, poets, and photographers reflect the qualities of a joyous relation with a young and vigorous civilization and rely more on the dynamic actualities of the present than on the sombre relics of past cultures. Here the land is so beautiful it cannot be denied. Photography finds an admirable environment in the West. It is a new art in a new land."

Then he waited, anxiously, for news of how his show was received. No word from Alma Reed. The first report was written by William Zorach November 16:

"I saw your photographs yesterday. You're certainly a marvelous photographer—I think your stuff is as good as Stieglitz in fact I think you're better—The only advantage he had on you is that he cum first. It's too bad you're stuck out in the sticks—are they making any use of you out there? Of course nobody takes a photographer seriously—That's what Stieglitz has been crying around here for years—but that's his fault. Sheeler certainly made a heap photographing and so did others—I guess it all comes down to salesmanship—in anything. People pay 99% for gab and 1% for art—So take a tip—If you find you're not a salesman—quit the gallery—Still may be a very valuable experience—I guess I've got the wrong technique. I heard a rich woman say at the Downtown Gallery she'd be glad to pay $600 for a John Marin watercolor Stieglitz asked $5,000 for—and she's one that lost all her money in Detroit banks—and is one of the weeping rich— Now if I'd ask $3,000 for my watercolors—maybe some one of San Francisco's weeping millionaires would stoop to offer me $300—We must live and learn. It's a cockeyed business anyway. Why don't you tell San Francisco and the lovely West to go bury themselves in oranges and grapes and come east. I can show you some pretty swell country up here in Maine."

Adams answered on November 20:

"I am touched by your letter. Really am. I agree with you about the terrible condition of ballyhoo in art; the money bags that gab a lot and then step aside when they could come through with an honest gesture and buy something. There is only this:—there are lots of people who are really hard up. Quite a few of my friends here have a genuine interest in art and did a lot and bought a lot when they could. But now they are panicky and lack the cash. I know I would have sold some of your things in better times.

"Yes, I am a bum salesman according to profitable salesmanship standards. I agree with you that most art is sold by gab; only the really good stuff lives through it and emerges secure after the artist is under the sod. To Hell with that, too. . . .

"My work is very serious and not at all spectacular in the surface sense. I have had doubts all along as to how it would hit the sensation-loving New Yorkese. I don't think my pictures have the least smell of trickery about them; I know they are not Freudian, and, thank God, they are not reeking with bloated contemporaneousism. I think the salvation of art is going to be in its detachment from the shallow fashions of surface-contemporaneous thought. There is a deeper thing to express—the return of humanity to some sort of balanced awareness of the natural things—some rocks and sky. We need a little earth to stand on and feel run through our fingers. Perhaps Photography can do this—I am going to try anyhow.

"Stieglitz has done a great work. But I think he is distracted with the game of galleryism. He has fought a tidal wave of metropolitanism all his life; it is a miracle that he has accomplished what he has. His work, and the work of Paul Strand, is supreme. . . .

"I am planning to turn this Gallery over to an organization here and withdraw into a sort of silence for awhile and do some good stuff. I have made only five decent things in the last five months."

Alma Reed reported: "The exhibition is magnificent. All of the photographers and a very large public have already been in. The public is most enthusiastic and the photographers simply rave. The exhibition looks beautiful . . . has drawn a magnificent audience—there were 432 persons attending the opening reception. All were thrilled with the photographs."

For some reason, Alma neglected to mail this report until December 10, at which time she mentioned that she had already sold four prints. Ansel replied immediately: "I confess I was getting a little worried. Am glad some were sold—but the reception to the work was the most important [response] to me. My curiosity is aroused; what did Steichen think (if he came)? I know Bruehl liked my work. Did Stieglitz come? Sheeler, Steiner, etc.? You see, I am very anxious to know the general opinion of my work. I had hoped for some analytic criticisms. . . ." These Ansel never received. Nor did he ever receive payment for the eight prints reported sold. Edward, he dis-

PINE BRANCH, SNOW, YOSEMITE

covered, had suffered the same kind of treatment by the Delphic Studios.

For the Christmas show at his own Gallery, Ansel hung some of his own Yosemite winter prints, and went up to the Valley as usual, to direct the Bracebridge and also a new pageant, originally titled *The Feast in the Hall of Heaven*, which he and Jeannette Spencer prepared for the dinner preceding the annual New Year's Ball at The Ahwahnee.

Nineteen thirty-four began dismally for photographers. Edward wrote Ansel, congratulating him on his snow-covered trees—"exquisite! When you come down, bring some in portfolio—I would see again."—and stating that since he had just completed what he believed to be his finest set of nudes, he couldn't really complain of 1933, but: "What has depressed me recently is of course indirectly due to economics. I have to spend too many hours waiting in my studio for possible sittings. Our case is something similar in that we are tired; only you are tired from overwork and I am restless from inaction. Believe me, I feel for you!"

In January, Ansel came to the conclusion, that, as he wrote Stieglitz (May 20, 1933): "I could not operate both my photography and an art gallery and do them both well. I was losing out painfully in the photography and wearing myself out in the bargain." He turned the operation of the Gallery over to Joseph Danysh, formerly art critic of *The Argonaut*, "who, by virtue of 15-hours-a-day hard work, will undoubtedly make it go."

The Adams-Danysh Gallery opened with Photo-Documents by Walker Evans and an exhibition of the sketches and models for Beniamino Bufano's controversial statue of St. Francis of Assisi.

Ansel went back to "the simple, photographic life" with relief. At least he was free again to work without interruption, free to undertake assignments anywhere, and he no longer had to make that long, dreary journey through the blighted areas of San Francisco twice a day.

About this time, a friend reproached Ansel for taking bread from the mouths of starving photographers; wealthy men in these dire times should not compete with those who had no other livelihood. Ansel, astounded and indignant, suddenly saw the irony between the outer image of the long-vanished Adams wealth, the studio in the beautiful garden at the end of now-exclusive West Clay Park, the sound of music, the big ancient Buick filled with friends, with the top down and the black beard flowing in the wind—and the inner image of want and worry. He got out his account books, showed the friend the meager and insufficient balance in the bank, and urged him to quash that myth wherever he heard it.

The Public Works of Art Project was being set up. Merle Armitage, as director for Southern California, managed to get Edward Weston on as a creative artist for the Northern section. But when Ansel went to inquire if he and Willard might be of use, he was told there were very explicit directions from Washington *not* to employ photographers. Adams cautioned his informant to say nothing that might upset what Armitage had arranged for Weston, and advised Willard: "If that other Service Station job is available, I would certainly take it for a while . . . if I did not have one small contract for the year, I would be in a hell of a fix and looking for some kind of janitorship. I have a heap of connections and strings and contacts—and I have only one small order since I came back from Yosemite on the 9th of January. You're a damned good photographer—one of the best going (I mean it) but for Krisesake don't put yourself in the bread-line on account of any impatience. Hell—wait until you try the commercial fields—a few phases are swell but most of it is absolute bunk."

He wrote to Steiglitz in May: "PWAP work here is fair—that in Los Angeles is much better. But all through it one can smell a self-conscious striving to be 'contemporary.' Soap-box art in the main. I am getting dreadfully tired of being used as a tool for radical interests—artists in the main are asked to do 'Proletarian' work, photographers are asked to photograph May Day Celebrations, old human derelicts in a dingy doorway, evictions, underpaid workers, etc. I grant that the times are portentous, but I'll be damned if I see the real *rightness* of being expected to mix political economy and emotion *for a purpose.* I am ready at any time to offer my services to any constructive government—Right or Left, but I do not like being *expected* to produce propaganda. Half of my friends have gone frantic Red and the other half have gone frantic NRA." [National Recovery Administration, one of the earliest New Deal economic agencies] "The artist occupies a sort of No-Man's Land. I can imagine it is much worse in New York."

CIGAR STORE, 1933

7. Making a Photograph

Adams's series of articles for *Camera Craft* was bringing a "very considerable response." He had avoided calling the series "straight photography," or "pure photography"; every purist he knew worked differently toward the same general ideal, and he did not presume to speak for Weston, Strand, or Stieglitz. He called it simply, "An Exposition of My Photographic Technique," frankly "an individualistic approach." The series ran from January to May, 1934. In the first article he sets forth the making of any photograph as one integrated sequence of decisions and actions. "In no other form of art is technique more closely interwoven than in photography. The photographer who thoroughly understands his medium visualizes his subject as a thing-in-itself. He visualizes, before operating the shutter, the completed photograph. In order to do this he must be aware of every phase of technique. From the time of exposure to the mounting of the print . . . every link in the chain of production is vital in its contribution to the completed picture."

He listed the equipment he was using at the time. "As a professional photographer, I am called upon to effect many types of work. I therefore require a more extensive apparatus than would one who concentrates on landscape or portraiture"—three cameras: an 8 x 10 view, a 4 x 5 view, a Speed Graphic; six lenses, all but one interchangeable on all three cameras; two tripods, one light enough to hike with, and one a heavy motion-picture tripod of great solidity and flexibility; lever, ruler, focusing magnifier, shutters, focusing cloth, two portable lights, filters, and filter holders. The list does not include an exposure meter, later so fundamental to his thinking; he was at the time using one of the extinction type, probably more to check his own extraordinary ability to estimate light than as an instrument for calculating a negative capable of yielding the previsualized final print. He urges a thorough knowledge of a few carefully chosen makes of film and paper. He uses ABC Pyro for negatives and Amidol for prints; he stresses the importance of absolute cleanliness, from checking lens, bellows, and film holders for dust to testing the washed prints for any last residue of hypo.

In the second article: "By Landscape I refer to . . . all Natural Objects photographed *in situ:* distant and near views of land and sea, clouds, rocks, and growing things (entire or in detail). Photographically speaking, landscape is possibly the most difficult subject material to work with; it offers the minimum control of point of view in reference to composition and confronts the photographer with extremes of light and shadow and the difficulties of atmospheric obscuration. I believe that the shallow presentation of the obvious in landscape subjects has restrained the artistic development of photography to a marked degree . . . what is done with the subject as an expression of emotional and esthetic ideas is of vastly greater importance than the mere recording of a scene or an object . . . an immense technical facility is required to command the problems of landscape photography."

He then discusses his own "Golden Gate—to illustrate the fact that a subject of obvious sentimental connotations can be managed in an objective and direct way." Instead of a literal rendition, he heightens the contrast to a "tonal 'key' which is rather deep and intense," so foreshortened in scale that the brilliant clouds and the shadowed headlands both retain "some indication of *substance* . . . it is in the control of this tonal foreshortening that the major technical problems lie. As in music, certain harmonies exist in various registers of the scale and these harmonies should persist in whatever 'key' is defined for the photograph. Literally, the photographer should think in 'chords' of tone."

Obviously, he is on his way to his famous "Zone System." He then describes what decisions he made and why—the KI filter, underexposure by about 30%, overdevelopment for 25% above normal time, with reduced carbonate. "I do not want to create any false illusions about the difficulty of tonal control; making this photograph was not as simple as it sounds. All of us fail in our objectives quite frequently, and I am certainly no exception. . . . The theory of negative development is one thing —the actual development of a given negative quite another."

Hurter and Driffield, in their pioneering research into the exposure-development relation—done in an attic, with a candle and a shutter rigged up on an old sewing machine, and destined to be the cornerstone of modern sensitometry—stated in 1890: "The making of the negative is a science; the making of the print is an art." But it is art that must decide what science is to do; Adams could not rest until he could accurately predict exactly what "chord" of whites, grays, and blacks he would have to work with when he came to print.

CAROLYN ANSPACHER

FOUJITA

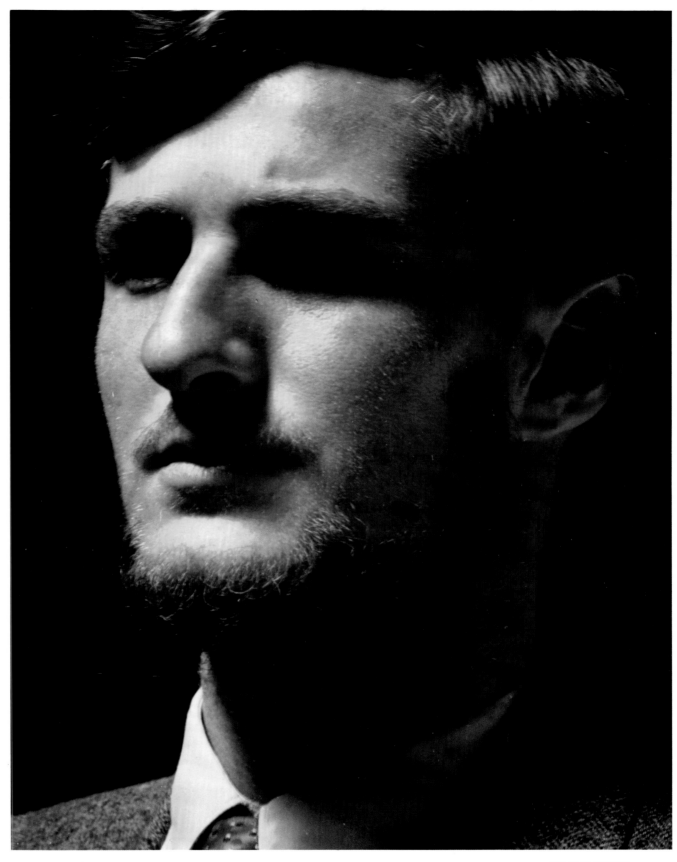

JULES EICHORN

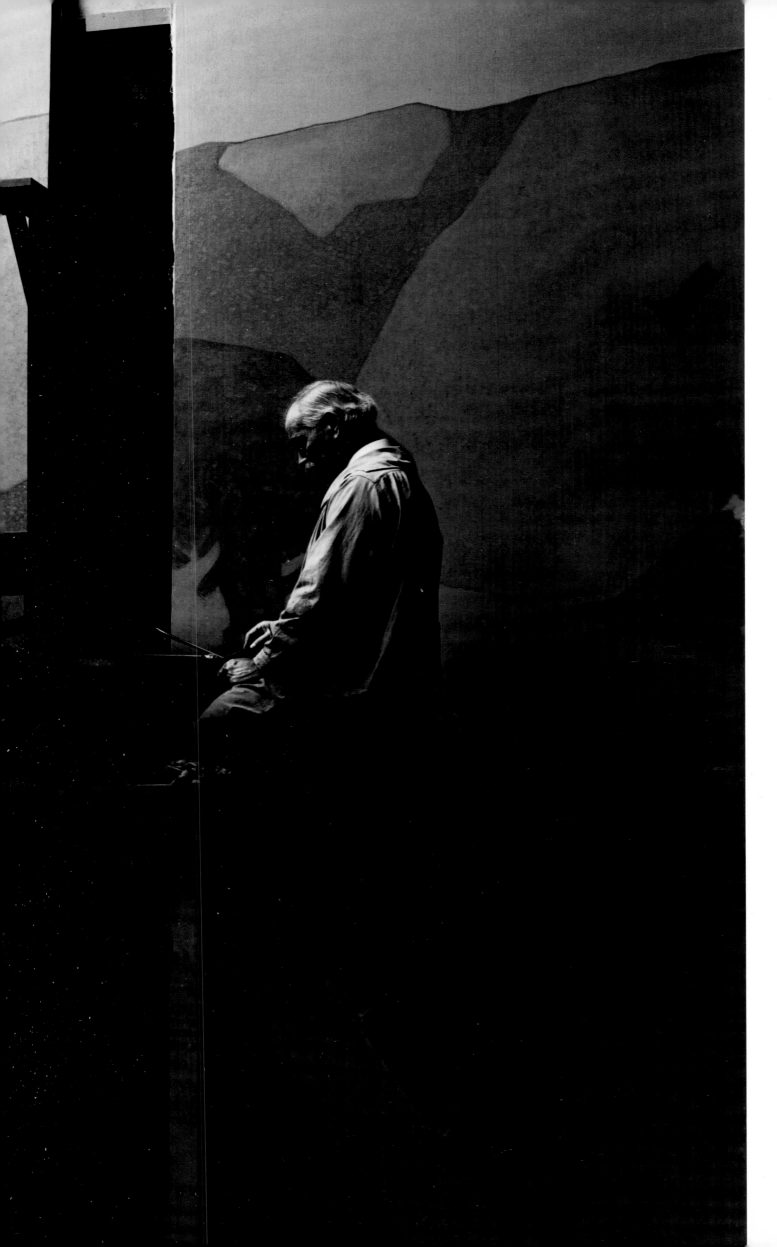

GOTTARDO PIAZZONI
IN HIS STUDIO

In the third article, *Portraiture,* he meets head-on the "barbed-wire entanglement of . . . wrinkles, lines, freckles, dimples, overweight, underweight . . . I will not compromise. I have a *battle royal* about once a month over a wrinkle." Most portrait photographers were still suffering over the retouching necessary to soothe human vanity: not even Edward Weston dared hang out a shingle proclaiming "Unretouched Portraits" until this same year, 1934. But Adams went further still, and proposed "static" portraiture, with an emphasis directed against the so-called "dynamic" approach of the current candid camera craze.

"Expression—the motion of the features through an interval of time—is logically beyond the power of the camera to record in a single exposure. For instance—a smile, no matter how 'literal' and pleasing it may be in a photograph at first sight, breaks down on prolonged examination, into a grimace—an unreal tension of the features . . . I am not confusing the cinema with the still picture in this discussion. The motion picture is entirely different in conception, rationale, and purpose. Staticism in the cinema is as false as movement in still photography."

"I photograph heads as I would photograph sculpture . . . the head or figure is clearly presented as an *object,* the edge, mass, texture of the skin, and the general architecture of the face and form is revealed with great intensity . . . the expression—many possible expressions—are implied." He sweeps out all the elaborate clutter of the portrait studio—the floods, arcs, spots, props, and fancy backgrounds. "There is no light as completely satisfactory in general photography as natural light—sun or open sky. Weston has done amazingly beautiful things in direct sunlight, the head or figure usually against the sky." Indoors, Adams uses a plain black screen several feet back of the sitter, or a pure white one at varying distances, and as for light: "I have been using the photo-flash for most of my portraits. One photo-flash globe, about three feet from the subject, is several times faster than sunlight. The motion of the head due to respiration or nerves and the 'blinking' of the eyelids is overcome." He has two rectangular light-boxes on adjustable tripods, each containing two 100-watt lamps, and a flash lamp, on a separate circuit. Thus the "finding" lights, which are left on throughout, have the same direction and balance as the flashlights, and he can see the exact lighting at the moment of exposure. "I use lighting only in reference to the sculpture of the head—there are no rules which can be applied in every case." Complete depth of field is essential. "There is nothing so disturbing as seeing a portrait with the eyes clear and the ears blurred."

Depth of tone is another essential. "Ordinary portrait photography attempts to obliterate skin textures by 'light' printing and retouching; I work for just the opposite—a deep printing and frank treatment of textures." Three of the illustrations for this article are flashlight portraits—the Carolyn Anspacher, the Holbein-like Beniamino Bufano, and one of an eighty-eight year-old woman, wise, humorous, and astonishingly beautiful.

In the last of the series, he discusses various forms of applied photography. "The term 'Commercial photography' has unfortunately become associated with cheap and inferior work. It is a serious situation, and every method should be made to enlighten the public that photography in any of its legitimate phases can be good—at least possess good craftsmanship. The work of such 'Commercial' photographers as Anton Bruehl clearly indicates that Advertising and Illustrative photography may express perfect technique and an aesthetic quality as well.

"One of the most functional phases of photography should be that of Advertising and Illustrating. It happens to be one of the most mistreated . . . the results are both brutal and shallow . . . and it is going to be a long up-hill grind to convince producers that their products might be more successful through more honest presentation."

He advises: "By all means, check on the method of reproduction . . . and make the print accordingly. Half-tone, Rotogravure, Lithography, Offset, etc., all the reproduction processes require, for best results, print values that are within their tonal scales."

He has sound advice on Architectural photography and the Copying of Paintings; he differentiates between Documentary photography (news, sport, records of production, etc.) and the Photo-Document. "I believe that an entirely new group is evolving which will develop the Photo-Document as one of the most important phases of photography. I hope also that Advertising and Illustrative photography will absorb some of the qualities of honest human realism which the Photo-Document possesses." Already he foresees, however: "One danger confronts the development of the Photo-Document—the danger of it becoming a tool of obvious propaganda."

Finally, in concluding these first outlines of what were to become a torrent of photographic articles, lectures, courses, and books: "I beg belatedly for the indulgence of the reader; I have not kept strictly to the title of the series. I have projected my discussion from the technicalities to . . . the intellectual and aesthetic. I discovered, in attempting to define technique, that technique does not exist in itself; it is only the substance of the creative machinery. Any technical idea does not exist apart from

application. Perfect technique is really more an *attitude* than a command of apparatus and chemicals.''

The Pictorialists soon counterattacked with, in Ansel's phrase, ''bullets of sentiment and smoke screens of ignorance.'' *Camera Craft* editors delighting in the potentials of controversy, chose as champion for the Pictorialists one William Mortensen, a former costume and makeup man escaped, apparently, from Hollywood, and now producing pictures best described as movie posters and calendars. His staple salon winners were coy nudes of the pin-up variety, often entitled in high thin letters, YOUTH. Next above them in accumulating salon stickers were portraits; Mortensen believed in retouching the sitter rather than the negative. Still more admired were his ''character studies'': some pliable and anonymous model transformed, complete with wens, whiskers, and leer into Mortensen's concept of Cesare Borgia, Henry the VIII, Fagin, Machiavelli, etc.

All these, however, pale beside his real theatricals such as ''Preparation for the Sabbath,'' a roguish nude romping with a broomstick in the firelight; ''The Mark of the Borgia,'' a nude bowed at the foot of the scaffold, with a halter around her neck and the skin flayed from one shoulder; and ''Fear,'' a nude shrinking from the embrace of a figure draped, apparently, in a focusing cloth and yards of gauze. Many of these were further improved by printing on a tipped easel—with ''projection control,'' as Mortensen called it, in which lines and especially legs got longer.

The members of Group $f/64$ failed to understand why Mr. Mortensen had hampered himself with a camera. Surely it would have been easier to learn to draw?

Mortensen titled his first series, ''Venus and Vulcan: An Essay on Creative Pictorialism.'' Venus, of course, is the Aesthetic Impulse, and Vulcan, Technique. Mortensen could not resist identifying Vulcan a little further: ''his black beard bristling,'' he storms at Venus, ''Why, I could take a picture of our back fence that would look almost as much like a back fence as our back fence does.'' (*Camera Craft*, June 1934)

His exposure of ''The Fallacies of Pure Photography'' began with a complaint of the ''well-meaning dullness'' of the Salons. Then he summed up ''the many sins committed with the aid of camera''—the snapshooter's banalities, ''the Fuzzy-Wuzzy artist . . . expressing himself in terms of cotton wool,'' the ''aimless dilettantism'' of the average amateur, and ''the quick and easy, cheap and nasty commercial aspects of photography.'' From this index he omitted the category described by Adams as ''decadent theatrics.''

''Here, surely, was opportunity for the reformer and his torch and a rousing 'bonfire of vanities.' Such a reformation was forthcoming in the work of the so-called purists. Their work is uniformly hard and brittle, shows technical competence, and consistently avoids any subjective interest. And, after the perennial fashion of reformers, they have duly erected their reforms into a code, and have chosen to regard a good clean contact print as the end of photography rather than its indispensable beginning. So great is the technical obsession revealed by some of the purists that it seems not illogical to suggest that they keep their prints at home and send their cameras to the salons.''

Choosing to ignore—possibly because he was incapable of feeling it—the evocative power of the purists' prints, which other critics did not attempt to deny, he reproves them sternly: ''A chemical fact can never become a picture unless an idea and an emotion are present; and these are qualities that cannot be added to the developer.'' He commends them for their ''series of excellent finger exercises in technique'' but feels they cannot be given ''artistic consideration . . . until they are through ostentatiously playing scales in the key of C.'' (*Camera Craft, ibid.*) He gave it as his verdict that, ''Tested by its results this school fluctuates between commendable sincerity and deplorable taste.'' (*Camera Craft*, March 1934)

By far the worst aspect of Mortensen's counterattack was having to look, even in passing, at his work. Ansel and Willard appointed themselves the ''Sanitation Commission.'' But they deliberately rewrote their hot reactions until they appeared merely mild elucidations; about the hottest they allowed was Ansel's request for ''a precise definition of Mr. Mortensen's conception of TASTE.''

The battle for pure photography has little of the wit, sparkle, and malice it had when Pictorialism was still a burning issue involving the leading creative photographers. The fire had died out of Pictorialism; it had sunk to mere imitation, it had become a hobby preferred to golf by thousands of well-meaning, kind, and decent people—doctors, dentists, mechanics, secretaries, shipping clerks, lawyers. The salons, like their illustrious predecessors in painting, had degenerated to the academic, and worse—the obvious, the cute, the sentimental, and the dull.

The editors of *Camera Craft* in their review of the *American Annual of Photography* for 1934, asked: ''Where is Edward Weston, Anton Bruehl, Ansel Adams, Imogen Cunningham, to mention only a few most easily called to mind? No one can truthfully state he knows what is going on in photography without having had an opportunity to see what these individuals are doing . . . the

tendency toward pure photography is becoming more evident each year."

Group $f/64$'s answer to this was to hold a Salon of Pure Photography, at "683," with Weston, Van Dyke, and Adams as judges. They also sent out traveling shows, as usual inviting others to show with them.

The "Sanitation Commission" was fighting on many other fronts: for good lighting, clean installation, and careful handling of photographs by museums, galleries, and exhibitors generally; for the rights of photographers in the publishing world to be given due credit and receive due fees, and to be represented by the whole photograph, uncropped, unretouched, and as faithfully reproduced as the process used by the publisher allowed.

As a Sanitary Commissioner, Ansel had been distressed to find a landscape by Weston reproduced in blue and a snowscene of his own in brown in the London Studio's annual, *Modern Photography 1933-1934*. Asked to send a print for the next annual, he answered that he would "be pleased to do so, if I can be assured that the reproduction will be in black-and-white . . . when a black-and-white print is reproduced in colored inks, it definitely loses its values. The Weston reproduction was the worst and I know Weston is quite upset about it.

"The 'new' photography has made astonishing strides in the last few years, and the Pictorial type of work is gradually passing out. I think your best bet would be to *anticipate* the development of photography and include a goodly number of contemporary photographers who are working in the purer phases of the medium." He suggests inviting, among others: Willard Van Dyke, Dorothea Lange, Consuela Kanaga, Clarence Kennedy, Ralph Steiner, Henwar Rodakiewicz, Walker Evans, and Berenice Abbott. He recommends "a few articles by leading contemporary workers." (AA to Studio, February 1934)

The Studio promptly asked if he would himself do the article on "The New Photography"—two thousand words, fee ten guineas—and get it to London by April 14. Ansel got his article off on April 5th. He wrote the editor, C. P. Holme: "As you will see, I have attempted to *suggest* a definition of contemporary photography, not as an isolated artistic experiment of the present, but as a natural development of the medium from the earliest periods . . . it is impossible to omit the progressive (and retrogressive) elements of its history from the aesthetic aspect." (AA to C. P. Holme, April 5, 1934)

To one reviewer, "The New Photography" was a clarion call. Beaumont Newhall was a young art historian a few years out of Harvard and its remarkable training school for the museum profession. The Depression, which caused many museums to dismiss the younger members of their staffs, had cost him both his first job at the Philadelphia Museum and his second at the Metropolitan. Now, back home in Lynn, Massachusetts, he was studying for a Ph.D. at Harvard and finding the little-known field of photography as a branch of art history daily more absorbing. Each new photographer, each fresh insight into the world, each vivid glimpse through photographs into the past filled him with a delight he rushed to share with his fiancée, Nancy Wynne Parker. My dedications heretofore had been to painting and poetry. Beaumont's enthusiasm added photography to the list.

When *Modern Photography 1934-1935* arrived for review, Beaumont was as excited by Adam's statement of the esthetic rationale of pure photography as by the brilliant photographs by Group $f/64$ and others which accompanied it. He had not seen Adams's work before nor met the quality of his mind, and he felt like an astronomer who has just discovered a new planet. Here was a gifted contemporary photographer who could write and who was interested in the history and esthetics of his medium. Newhall already knew enough of the history to comment that Adams's "suggested" periods, Experimental, Factual, Pictorial, and the Photographic Renaissance, were "categories by no means as defined as the author presents them," and he felt it imperative to challenge the purist rationale by pointing out that the ability of the camera "to bring out an object in sharp focus before a blurred background, thus giving it a special emphasis" was as remarkable and legitimate a function of straight photography as "the delineation of the most minute detail," which, Adams had insisted, "must be obtained in all parts of the picture." Nevertheless he agreed that: "Emphasis of texture in which [Adams] sees an enlargement of experience—'the experience of enriched detail'—is clearly one of the merits of the New Photography. In conclusion, he writes, 'Photography makes the *moment* enduring and eloquent.'" (*American Magazine of Art*, January 1935)

The Studio was delighted with *The New Photography*. On April 20, C. P. Holme, the editor, asked Adams if he would write *Making a Photograph* for the Studio's How-To-Do-It series. Ansel, who had been thinking of expanding his *Camera Craft* articles into a book, responded on May 5 with a prospectus; he proposed to fill a void: "there is no book which attempts to define the basic properties of the medium and relate them to aesthetic expression . . . no book which serves as a practical-logical-aesthetic foundation for the serious student. . . ." The text, as "simple and dynamic as possible," should be accompanied by a few simple line diagrams, a number of

photographs illustrating technical principles and problems, and, as climax, a portfolio of twelve fine reproductions of contemporary photographs such as:

> "The intense subjective photograph—Stieglitz
> The intense objective photograph—Strand
> The formal objective photograph—Sheeler
> The formal subjective photograph—Weston"

Fine reproductions—halftone on plate paper—are requisite throughout; he also includes specimens of the typography he considers would complement the photographs.

There were, even in this breathless sequence, the usual delays. The Studio had to inquire into costs; then Holme went away, and Ansel vanished into the wilderness for a month with the Sierra Club. Not until August could terms be discussed. The Studio proposed a book, related to the rest of the series: text not more than 16,000 words; fine halftones not more than 33; book not more than 96 pages. Advance against royalties fifty pounds (about $260 at the time); royalties, after the first 1350 copies were sold, 19¢ each. Delivery date, in London, for completed manuscript and illustrations, November; samples for salesmen by October 1.

It was a perfectly fair contract for the time, and Ansel already knew enough about publishing to sympathize. But the stringent deadline and the meager advance meant concentrated work with little opportunity to earn a living for two months. Ansel pleaded, but the Studio was adamant. He gave up his idea of a portfolio—he hoped it was just a postponement—except for one Photo-Document: Dorothea Lange's "White Angel Breadline, 1933." He asked Weston for a foreword: Edward sent a one-page statement condensed from a booklet he had recently written.

Within two months, Adams managed to make the illustrations for depth of field, perspective in relation to focal length, color as rendered by different films and filters, the use of swings and tilts, etc.; write and rewrite back down to size a basic handbook on technique (the *Camera Craft* articles are almost completely lost in the compression); get the line diagrams drawn, and send the whole manuscript off to London on October 22.

He gave it the subtitle, "An Introduction to Photography." He felt it was too brief and too elementary "to answer the demand for the ideal textbook," he wrote in the foreword. As he saw it: "the present state of photography is one of confusion. A multitude of clubs, groups, and salons add to, rather than diminish, the divergent uncertainties of the destiny of photography. The majority of photographic schools are mostly concerned with the commercial aspects of the art and stress the superficial and immediately productive applications rather than the fun-

damental aesthetic and technical principles. If the student turns to books, he meets with even greater confusion. The wealth of excellent texts available lacks a practical correlation, so that endless time and energy are consumed in extracting the vital facts of technique and style. *What is required above all else is a number of centralized institutions which combine competent instruction in theory and practice with library and museum features. Repositories of the most significant photography, past and contemporary, are sorely needed. The understanding of photography as a form of art implies much more than a knowledge of physics and chemistry and a superficial education in the aspects of painting and other media. It is necessary to study photography itself.*" (Introduction, *Making a Photograph,* italics supplied.)

Thinking still further in this direction, Adams applied for a Guggenheim Fellowship to study "the significance of photography in America as a medium of social and aesthetic expression." Deciding to omit "the technical aspects" from this study, he proposed to concentrate on:

"1. The aesthetic aspect. The history and development of photography as a form of art . . . the relation of the development of photography with the development of American art . . . the aesthetic rationale. . . .

"2. The social aspects. The communicative value of photography . . . news photography and its significance in relation to the history of the future . . . the Photo-Document . . . its influence on social [and] economic thought, and in its relation to *comment* and *propaganda* . . . Illustrative and advertising photography . . . how it has served to expand industry and how it has reacted on the reader and general spectator in relation to the support and profit of industry and distribution . . . to determine the *actual* value of photography in advertising through statistical investigations. . . ."

His ultimate plans were: "To publish the results of this study and research in book form; not necessarily for motives of profit. . . . To establish, or assist in establishing, a central institute of photography wherein instruction, library, and museum facilities will be available and where serious students of photography, both as an art and a craft, will be able to derive information, encouragement, and knowledge. This institution would also support traveling exhibits of the finest contemporary photography."

This project was several years ahead of its time. The Guggenheim Foundation had not yet awarded a fellowship to a photographer, let alone one for the study of photography, and doubtless saw no need for such a survey. In any case, Adams was not among the fortunate that year.

Meanwhile, Edward Weston, in Carmel, was suffering from difficulties, financial, emotional, and creative. He

had chafed under WPA "charity" and resigned the moment a sizable portrait commission turned up. Now, in the "no-man's-land" of the artist, he was being sniped at by both Right and Left. In addition, his new passion for landscape was causing great distress to his followers, fans, and collectors, who feared a return to "hearts and flowers."

Ansel, who was also suffering from much the same criticism, came across a tombstone bearing the name WESTON; an urn, shattered to the form of an egg, lay at its foot. This photograph he sent Edward, in deepest sympathy, together with a dirge:

"Lament, O Amidolphus, Form is dead!
The sea-weed, orchid and the rock and shell,
The egg, the turnip and the cabbage head
Have answered cruel Oblivion's doleful knell.
This monument is reared to him who dared
Reject convention for the shape elective.
Once Majestic in Bellows grandly fared
Until our Edward found himself objective."

But he went on worrying about Edward; and wrote him on November 29, 1934: "I gather that things are not entirely smooth in Carmel, and I have been intending to write you for several weeks and just think out loud. I may be presumptuous in writing you at all, but I know what just such letters have meant to me when I have been 'down' and in an indefinite state of mind and spirit.

"First, you have made a definite contribution to photography that puts you on the immortal shelf along with Hill, Atget, Stieglitz. Your influence is far-reaching. You have crystalized your work in Carmel; the sea, rocks, trees, and the mood of that coast have grown into you and you into it. You are *not* (thank God) a Metropolitan person. Commercial and advertising work as it is inflicted today is not your line. It isn't mine, either, and I suffer the pangs of Hell with some of it. But as long as I am here I will have to do it.

"You have had a slack period. But that doesn't mean it will always be so from now on. I have periods when I am scared to death—and then something always turns up to clear the air and the bills, and the mood is regained."

He had a number of excellent suggestions; some of them involved finding a manager—Ansel still thought in terms of the musical world—to arrange for exhibitions, sittings, and "master-classes" in various cities. Managers were and are still rare in the photographic world. Occasionally both Edward and Ansel found such an agent for a particular show or trip, but both remained, in the long run, their own most effective representatives. One sug-

gestion, however, eventually bore fruit: " . . . you should not give up Carmel as your headquarters; it has a glamor and character which is very favorable to your work and to the *presentation of your work.* Edward Weston, Carmel, California, is a very logical and incisive address. Edward Weston, San Francisco, Los Angeles, Chicago, etc., is something quite different. People will come to you at Carmel quicker than they will to their own city spots; I find they come to my house just as quickly and easily as they came to me downtown—and there is more flair in coming to my house than to 166 Geary Street. We all should keep alive by keeping just a little remote; by establishing an environment that is not of *everyday.*

"Both you and I are incapable of devoting ourselves to contemporary social significances in our work; Willard is gifted in this respect. I come to think of him more as a sociologist than a photographer. His photography seems to be turning into a means to a social end, rather than something in itself. I will regret it if it becomes that entirely, for he is too damn good a photographer to submerge it in anything else. I still believe there is a real social significance in a rock—a more important significance therein than in a line of unemployed. For that opinion I am charged with inhumanity, unawareness,— I am dead, through, finished, a social 'liability,' one who will be liquidated when the 'great day' comes. Let it come; I will try to adapt myself. But . . . I refuse to liquidate myself in advance!

"I think it is up to such as you and I to maintain our conception of art as expressed through our medium. You and I differ considerably in our theory of approach, but our objective is about the same—to express with our cameras what cannot be expressed in other ways—to trust our intuition in respect to what is beautiful and significant—to believe that humanity needs the purely aesthetic just as much as it needs the purely material."

Edward responded on December 3:

"What a grand letter you wrote me! Really, I am profoundly grateful, more so than I can easily express.

"I find nothing to disagree with in your philosophy, nor in your analysis of me,—my needs. I am not Metropolitan. Left San Francisco because I was unhappy, wanted to get my feet on the soil, to get away from canned people. I will never make money because I don't care enough about it; but I always keep one jump ahead of the wolf, and ask no more.

"You are absolutely right about keeping remote . . . our kind of work cannot be done on 'Main Street'." As for Carmel, "I still have hope that you will escape someday and find yourself here."

"I agree with you that there is just as much 'social significance in a rock' as in 'a line of unemployed.' All depends on the *seeing*. I must do the work that *I* am best suited for. If I have in some way awakened others to a broader conception of life—added significance and beauty to their lives—and I know that I have—then I have functioned and am satisfied. Not satisfied with my work as it is, understand. Thank the Gods we never achieve complete satisfaction. How terrible to contemplate Utopia. Contented Cows." (EW to AA, December 3, 1934)

Making a Photograph came out in April, and was hailed by photographers on both sides of the Atlantic like the sun after endless drizzle and fog: " . . . the pure and simple process of photography . . . enough to illustrate all the subtleties by which an artist photographer makes his camera say what he has seen," wrote a reviewer for *John O'London's Weekly* (August 1935). At home, the *San Francisco Chronicle* announced its publication, with a photograph of Adams which it titled, with unabashed pride in a native son, "Photographic Genius."

In Lynn, Massachusetts, Beaumont Newhall began his review optimistically:

"Photography is becoming increasingly appreciated by the art world," and congratulated the Studio on its new publication: ". . . the style is brief, thorough, and clear . . . the tipped-in glossy prints seem at first actual photographic prints, so well has the half-tone reproduction been done." But Newhall, for all his personal excitement, was no simple convert to any one philosophy; his training had been that of the historian and the critic. "Of Mr. Adams's mastery of photography, one has nothing but praise. His textural rendition is unbelievably fine. But it must be admitted that, like Stieglitz, Mr. Adams approaches his subjects as if they were still-lifes. Other fine camera work catches fleeting movement. The two are different approaches; both are valid." (*American Magazine of Art*, August 1935)

A few months later Newhall got a job at the Museum of Modern Art. Officially, he was librarian, but titles mattered little to that handful of excited young believers in modern art. He found himself helping Alfred Barr, then Director, mounting the Van Gogh show that broke attendance records, compiling a vast bibliography on Surrealism; and photographing the futurist sculpture the customs officials declared were not works of art, but hardware, or possibly scrap metal. When the Museum needed a photograph, Newhall made it—and developed it at night on a shelf in the men's room. His passion for everything to do with photography—he was an ardent afficionado of the cinema as well—amused and delighted the rest of the staff. In the back of his head he kept hearing Adams's words: *What is required above all else is a number of centralized institutions. . . . It is necessary to study photography itself."*

Making a Photograph sold out so fast that a second printing was rushed through in May 1935; a second edition, revised to include color and the miniature camera, appeared in 1939 and a third in 1948. As late as 1951, it was described as "probably the most lucid and information-packed 96-page how-to-do-it ever to appear in the field." (George Wright, *American Photography*, October 1951)

Stieglitz wrote: ". . . single-handed letter writing has become nearly impossible for me—But somehow I must let you know what a great pleasure your book has given me. It's so straight and intelligent. And heaven knows the world of photography isn't any too intelligent, nor straight either. But why single out photography? My congratulations to the book—I have bought a copy and recommend it." (AS to AA, May 13, 1935)

Ansel on May 16 sent him an inscribed copy and wrote: "Nothing could have made me happier than the letter I received from you today. Frankly, I was doubtful that you would like the book. I felt that you might react to it as just more *writing* and not enough doing."

And from Edward Weston: "I am continually recommending your book to photographers, advanced workers, and novices. I have just presented a copy each to Chan and Brett [his sons]. This may appear as indicative of a new affluence. Alas no, I've never been lower; the books were gotten on exchange.

"Well . . . I've always eaten and still expect to. . . ."

Edward continued: "Amusing gossip just came to me from a friend who got it from another friend,—a prominent San Francisco businessman whom you know; that he could not visit me any more because I was listed as a communist! This is too funny, except that it might seriously hurt me. Me a communist! The latter consider me practically a fascist, or a bourgeois liberal, which is about the most damning label a communist can give. However, I'm not blaming [him]. . . . If I am listed (where, how?) as a dangerous radical, he *can't* afford to keep my company. I wonder if I could bring suit for libel, for defamation of character? I could surely win, and retire on my winnings. The only thing funnier than me being called communist would be news that you had been so labeled or libeled." (EW to AA, postmarked August 27, 1935)

Ansel wrote back: "It may amuse you to know that I have no doubt whatsoever that I am listed as a bloody Red too; it seems that everyone who has even breathed the tainted air of liberal democracy (perhaps as exemplified in a gathering devoted to the discussion of pure photography)

is branded as anti-conservative and therefore dangerous,'' and recommended they both check to find out if such a list existed. "Safety in this world seems to be in direct relation to one's inability to think or create.

"But I have certainly lost my respect for the average artist on account of his gullibility and his inadequacy to express himself and his real environment. . . . Your print . . . of the shipbuilder is one of your very best things. I am crazy about it. Both it and the Ploughed Field are as emotional as anything I have ever seen. And how free they are from any goddamn connotations of the 'class struggle!'

"I am dreadfully sorry you did not tell me about wanting some of the books. You certainly deserve them on account of your contribution for one thing, and also on account of your interest and friendship. The book is apparently going over very well. There is little money in it but lots of satisfaction. . . .

"I am certain we will all continue to eat—although I would feel better if I had a cud." (AA to EW, postmarked September 4, 1935)

The Depression in the towns and cities was now widening to engulf refugees from still greater disasters. Drought in the Great Plains, dust storms darkening the sky for a thousand miles, floods in the South, clawing the hills, drowning the valleys—the terrible consequences of the reckless exploitation of the continent—uprooted multitudes of bewildered farm families. Piled into jaloppies, with their meager possessions roped on somehow, they wandered down the highways. Thousands headed West, to California and its winterless climate, and its vast valleys where miles of fruits and vegetables needed pickers. In the hollows, by the creeks, they camped in makeshift tents and shanties, drifting from harvest to harvest, hoping somewhere, somehow to find a job, a home, and some land.

Paul Taylor, asked by the State of California to survey the situation, made the then unusual request for a photographer as research assistant, and hired Dorothea Lange. He soon discovered that "her ear was as good as her eye," and began putting the bitter, simple things she heard people say beside their photographs. This proved an effective presentation; the State of California began building camps for the migrants and helping them find jobs and farms. To cope with the problem on a national scale, the Federal Government set up the Rural Resettlement Administration (later the Farm Security Administration). Roy Stryker, an economics professor from Columbia University, was appointed chief of the historical section of the photography department; the first photographers he hired were Arthur Rothstein, Dorothea Lange, and Walker Evans. Pare Lorentz was appointed chief of cinematography; two of his cameramen for his first film, *The Plow that Broke the Plains*, were Ralph Steiner and Paul Strand. One of those on his second, *The River*, was Willard Van Dyke.

John Paul Edwards, asked by *Camera Craft* to explain, as a respected Pictorialist, what he found important in Group *f*/64, responded with what is actually the Group's farewell address. He wrote a brief introduction: ". . . the greatest aesthetic beauty, the fullest power of expression, the real worth of the medium, lies in its pure form. . . . Witness the vogues which have in turn intrigued the worker: the soft-focus lens, carbon, carbro, gum, bromoil, bromoil transfer, faint gray monotone printing, or its counterpoint, stygian blackness . . . they seemed so important at the time, and are now almost forgotten."

Four members of the founding Group then speak for themselves. Edward Weston, condensing again from his booklet, pointed out that: "The rigid form of the sonnet has never circumscribed the poet. . . . The mechanical camera and indiscriminate lens-eye, by restricting too *personal interpretation*, directs the worker's course toward an *impersonal revealment* of the objective world. 'Self-expression' is an objectification of one's deficiencies and inhibitions."

Imogen Cunningham began with a quote from Lewis Mumford: " 'There are fewer good photographers than painters.' There is a reason. The machine does not do the whole thing."

Willard Van Dyke stated his credo: "I believe that art must be identified with contemporary life. I believe that photography can be a powerful instrument for the dissemination of ideas, social and personal. I believe that the Photo-Document is the most logical use of the medium."

Adams commented: "I consider the production of Group *f*/64 as definitely transitional in character . . . our work should now be taken from the laboratory . . . and functionally applied.

"One of our major achievements is the exposition of the fact that . . . pure photography is not a metier of rigid and restricted rule. It can interpret with beauty and power the wide spectrum of emotional experience." (*Camera Craft*, March 1935)

Quietly, its work done, Group *f*/64 dissolved. The battle for pure photography had been won, not in the salons, but in the open world.

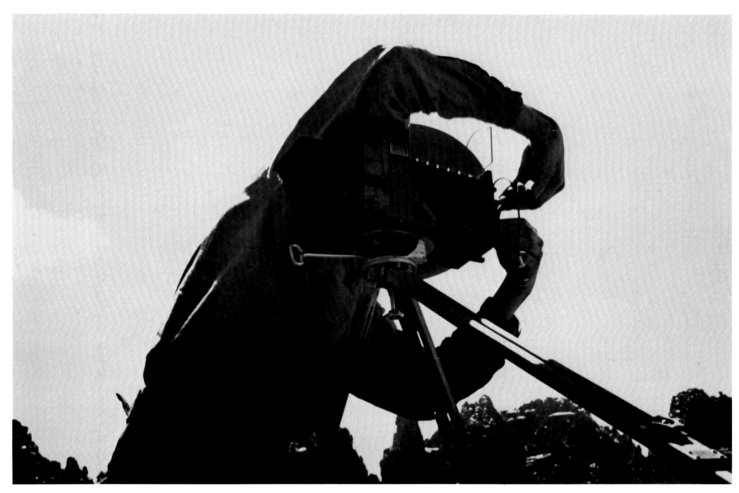

ANSEL ADAMS (RONDAL PARTRIDGE)

8. The Vital Thread of Perfection

High in the central Sierra, the summer of 1933, two young knapsackers encountered a man with a beard and a camera. "Ansel Adams was complaining about the clouds when I first met him," wrote David Brower, later Executive Director of the Sierra Club. "They weren't yet what they ought to be, but he thought they would get better. Then he continued on up toward Pilot Knob . . . and my friend and I continued down to the Sierra Club High Trip camp at Hutchinson Meadow, lingered for dinner to stretch our own very limited rations"—they were down to cornmeal and bacon grease—"and then worked our way up to a high bench where only knapsackers could camp." Dave was already an eager climber who liked to go fast and light, "far from the madding mules," and for whom a good day might include "a moonlight ascent of Mount Tyndall, breakfast after sunrise on Mount Williamson, lunch on Mount Barnard, a second lunch at Wales Lake, and a ten-mile walk back to camp." (David Brower, *Sierra Club Bulletin* 1935) Nevertheless he liked meeting the Sierra Club on its slower and vaster tribal migrations. And he liked that man who complained of clouds. Neither beards nor cameras are uncommon on High Trips. "I don't remember how I knew it was Ansel when I stepped up to him to ask if he was, but I knew," continues Dave. "He was thirty-one and I ten years younger. I joined the Sierra Club that fall, and before many years would learn what Ansel was confronted with in helping lead the Club's High Trips. The following spring, when he ran for the Club's Board of Directors, I voted for him. It became a habit." (Manuscript notes, 1963)

For three years—1932-1934—Virginia had served on the Board of Directors. Then someone nominated Ansel, and precipitated a domestic comedy. Neither would allow the other to withdraw, Ansel insisting she had done such a fine job she should continue and Virginia insisting he would do better still and anyway she was too busy looking after their baby Michael to attend meetings. They campaigned for each other. An amused newspaper reporter headlined the story of Ansel's election with: "He Won—Or Maybe She Did!"

Adams proved so stimulating and valuable a member that he has been continuously re-elected ever since. He is instantly ready to act in any capacity where he may be useful—write a strong letter to a politician or a news-paper, give an eloquent address to a conference, dissolve an embattled meeting with a funny story, provide photographs for a campaign, or map out a future project or a program as though he were looking at it from the summit of Mount Whitney. On anything to do with conservation, as in anything else that interests him, he is a fountainhead of ideas. These, when in spate, issue with such speed and dazzling profusion as sometimes to bewilder colleagues who prefer to move slowly and with caution.

The winter of 1933-1934 brought deep snow to the High Sierra. In spring the waterfalls would rise to tremendous power, the whole Valley be full of the flash and voices of water, and wildflowers shine through forests and meadows. Wildflowers, vanishing from every part of the country, were then the symbol of conservation to which people were rallying to pass protective laws and establish sanctuaries.

Even within the parks, overuse, carelessness, and ignorance of ecological balances were destroying many delicate living things. Outside the parks not merely wild-flowers and wildlife but whole landscapes were being ruthlessly and needlessly destroyed. In California the mountains were being sliced and the coastal cliffs scarred by brutal highways. Once-lovely roadsides were being obliterated by garish stands, billboards, junkyards, dumps, and litter. Cheap housing developments were marching solidly over the hills and dunes of San Francisco, breaking up the sunny peace of the rural countrysides, invading the vast inland valleys once filled with blossoming orchards.

To dramatize this destruction by showing what values were being lost, Adams as Chairman called a Yosemite Wildflower Festival for the spring of 1934. The program consisted of talks, movies, and exploratory walks and tours through the extraordinary variety of spring loveliness to be found in many different places in the Valley and high above it in the melting snows. The response of many people was to recall the threatened beauty of other regions they knew and loved.

Adams decided to call a conference the next year; this time it would be not only a Wildflower Festival but a Conservation Forum. In the folder announcing this for June 1935 he wrote:

"Two points were self-evident to everyone who attended the recent Yosemite Wildflower Festival: 1st, that

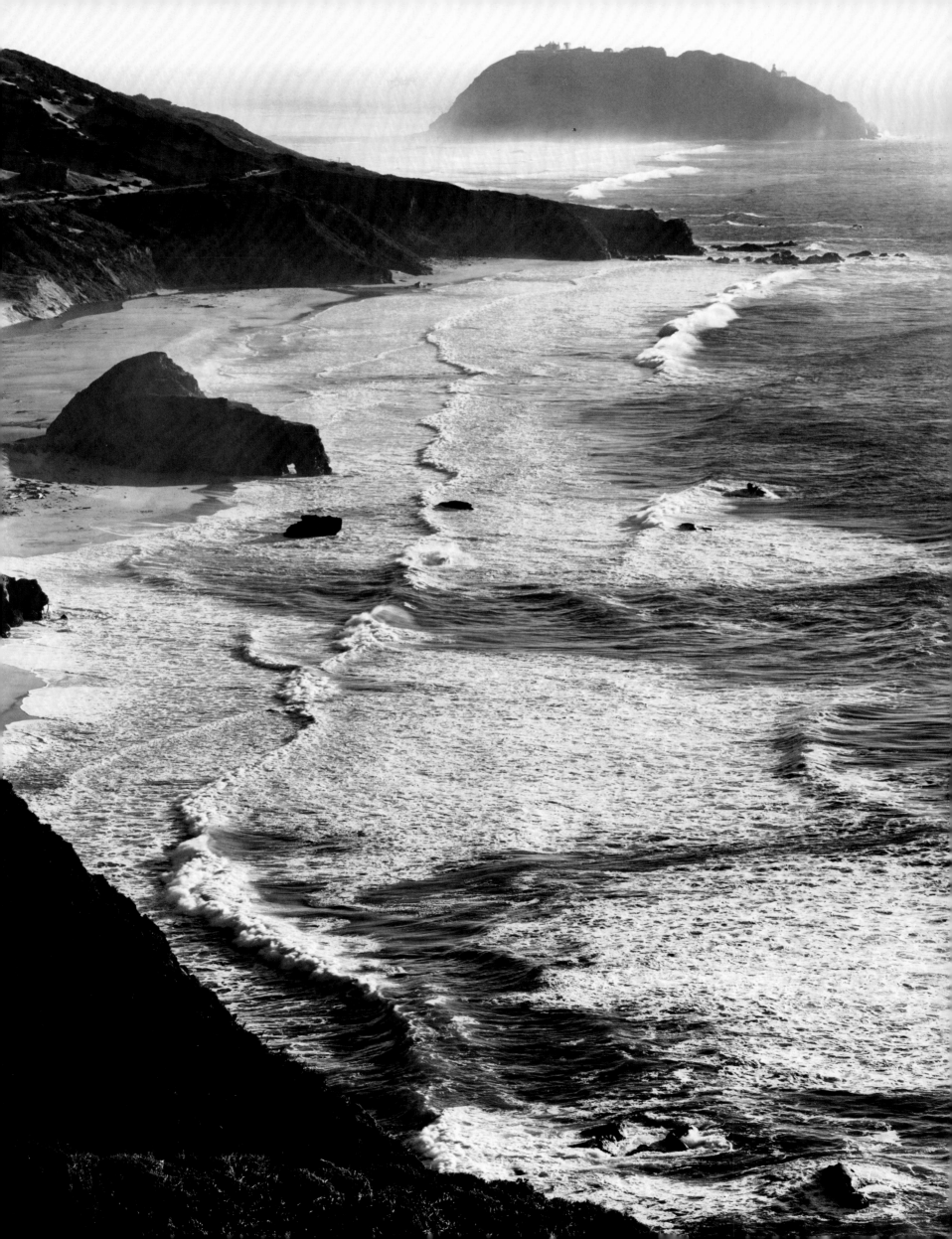

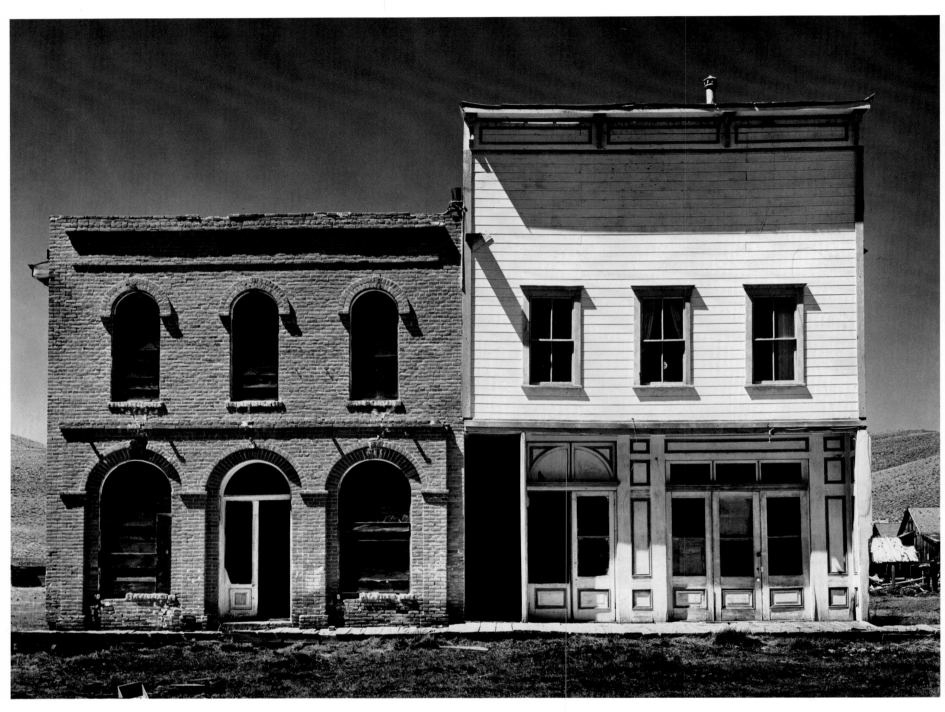

GHOST TOWN—BODIE

the Natural Scenic Treasures of California should be made more available to all the world; and 2nd, that in our intense desire for 'more efficiency' we have been wantonly destroying a heritage that it has taken thousands of years to build up.

"Hence it was the consensus . . . that all conservation-minded persons and organizations should assemble and formulate plans for the preservation of California's Landscape Values.

"This can be accomplished only by the unified action of these scattered organizations which have been actively waging war against this despoliation."

On the sponsoring committee for the Forum were the Director of the National Park Service, the presidents of Stanford University and the University of California, representatives of the Forest Service, the State Parks, the Federal and State Highway commissions, the California Conservation League, the Save-the-Redwoods League, the Garden Club of America, and others, including the Boy and Girl Scouts. The program, embracing prospects far beyond wildflowers, was divided into five sections: Legislation, Education, Landscape, Highways, and a Pacific Crest Trail conference to discuss a timberline route that should run from Alaska to Mexico.

Both Francis Farquhar, then President of the Sierra Club, and Colonel Charles G. Thomson, then Superintendent of Yosemite, expressed a certain skepticism about this bold project. How could so many differences of opinion be reconciled?

But Adams was full of faith and enthusiasm. Not only did he hope that the conservation societies, on beholding the large view, would perceive that the goals they had in common were more important than their differences, he hoped also that the old rift between the volunteer societies and the professional services might be bridged. The professionals, beset by park logistics, often find that a solution dictated by expediency brings an angry hive of conservationists about their ears. They are aware that without the conservationists there would be neither parks, forests, waters, wildlife, nor services to protect them. They appreciate these dedicated groups, but step warily in their presence.

On this occasion, however, speeches by several conservationists caused Colonel Thomson to interrupt rudely and jocosely; members of his staff thereafter were noticeably shy and cool until an appeal by Adams warmed the atmosphere.

Another rift he had hoped to bridge was that between the Park Service and the Operator, in this case, Don Tresidder, president of the Yosemite Park and Curry Co.,

main concessionaire of food, lodging, and transportation in the Park. Tresidder, distinguished, urbane, and a warm personal friend, would, so Adams believed, convince the Forum that an enterprise necessarily commercial could serve as a conservation force. Tresidder's speech therefore came as a shock. He declared that the "intangible values" of wilderness were not only negligible, since they could be appreciated only by a few thousand nature lovers and mountaineers, but actually negative, since insistence upon them barred the Sierra to millions who wanted more tangible pleasures when on holiday. Consider also, he urged, the plight of the operators of such public service companies as his own; hedged in by government restrictions on one side and barred by "intangible values" on the other, the operators could not expand or improve their facilities, and such of them as were unwilling or unable to run philanthropic institutions continually risked bankruptcy. And since the parks belonged to the people, why not make their magnificent landscape values available to the world? A road need not be a desecration; indeed, a road had probably brought most members of this conference to Yosemite. Roads skillfully engineered would not hurt the mountains and would enhance the enjoyment of millions who might otherwise never see the High Sierra. The lodges necessary to serve them would have spectacular views, and the ski slopes outrival the Alps.

Adams was aghast. Tresidder, of all people, to make use of the old "greatest good for the largest number in the longest run" sheepskin under which so many profit-scenting wolves had been detected! Could this idealistic man really mean it or was he joking? The Colonel had no such doubts; he was furious. To the conservationists, however, both the Colonel's outburst and Tresidder's speech were merely old attitudes assumed by new actors, and had the salutary effect of bringing them closer together instead of falling out, as all too often happened, over whose cause deserved priority.

Adams might have failed this time in achieving two of his all-but-impossible goals but it was such a good try that veteran fighters in the Sierra Club, recognizing not only his brilliance and integrity but the scope of his thinking, regarded him affectionately as a possible comer to the ranks of what Adams himself once called "The Saint George of Conservation."

Adams went on thinking about how to preserve landscape values. It seemed to him that the only way lay through public appreciation, and this, in turn, depended on the image formed through the manner of presentation. In Yosemite, for example, thousands of little details jarred his photographer's eye. What distortions did they

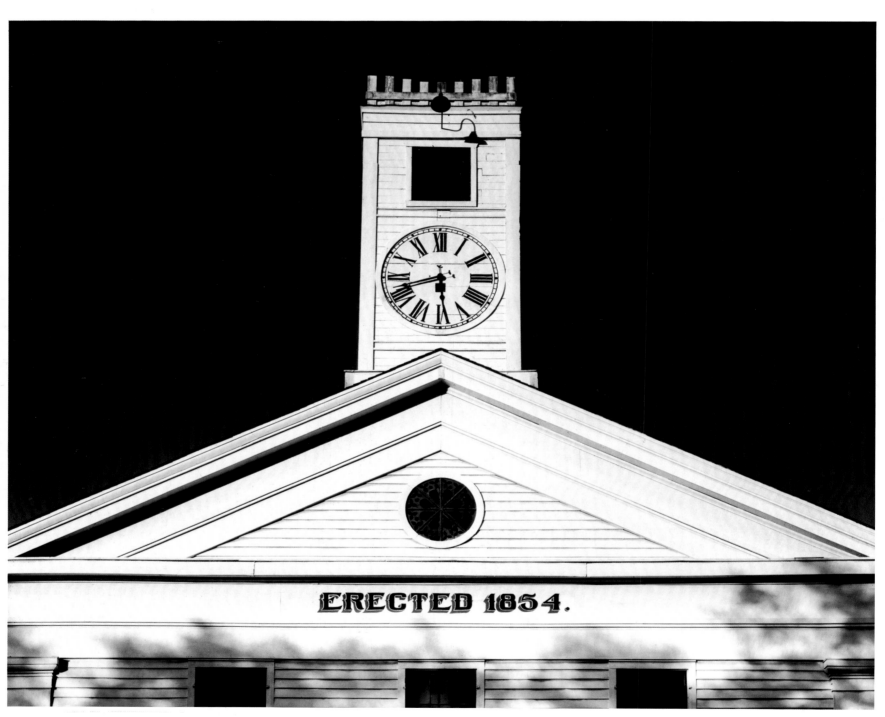

ERECTED 1854.

COURTHOUSE, MARIPOSA

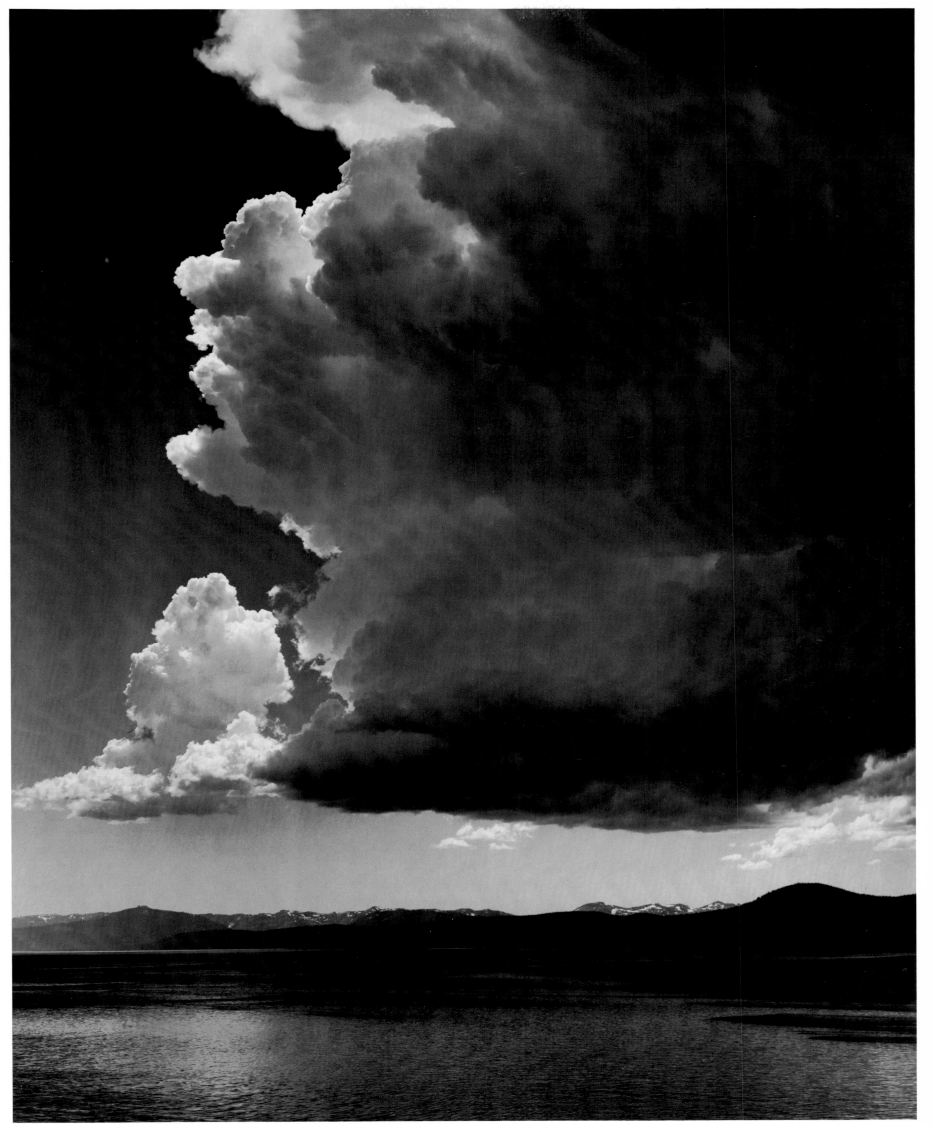

THUNDERCLOUD, LAKE TAHOE

project, consciously or unconsciously, into the impressions received by millions of visitors?

Some were the fault of the Government; the Colonel, probably, didn't even see them and wouldn't care if he did. Others were the fault of the Company, which, led by a man of Tresidder's cultivation, could hardly be condoned for anything but profit. Tresidder and the Colonel had attitudes which were persuasive in the parks. One first result of these considerations was a little think-piece entitled, "The Aesthetic Factor in Relation to Presentation of the National Parks."

In his preamble, Adams explained that he used the term "Presentation" to signify the complex subjects of advertisement, information, sales of art, literature, illustrations, and 'curios,' and the general aspect of Governmental and Operative activities."

He continued: "General Argument: The quality of the National Parks themselves, and the spirit and intention on which they were created predicates a high level of taste in their operation. The National Park Service has effected a remarkable achievement in the protection, development, and administration of the Parks. As yet, the Operators, with a few exceptions, have not attained the level of quality which is obvious in the Park Service Administration. In a few instances, however, the private operators have exceeded the Governmental standards; the most recent architecture, a stylized use of early California forms by Eldridge Spencer, that the Yosemite Park and Curry Co. has chosen, is one example. On the other hand, the quality of the inexpensive pictures and curios sold in Yosemite is very low and most certainly out of relation with National Park standards. I cite these two examples within one organization merely to point the argument: there is no basic pattern of taste on which to build every phase of Operation. Considering the Governmental administration, permit me to mention one or two inconsistencies (again relating to the Yosemite). The roads are magnificently maintained, and the trails run a close second in structure and upkeep. Yet, with all this perfect machinery for the movement of the public throughout the Park, there is lacking a subtle and hard-to-define element: the awareness of detail. A few examples: At Rocky Point the grand view of the Upper Valley is marred by the poles and wires. Along the trails many of the best views are cut by a glistening telephone wire. Signs are placed about without any consideration other than utility. . . .

"The few examples stated above should serve to indicate the actual basis of the argument. They are little things, it is true, but they signify a very important thing. They break the vital thread of perfection; they destroy the mood, which after all, is the most precious factor in the relation of man to nature. It is true that most people would scoff at these words, but that would be due to a misunderstanding of the words. Through my connection with the Sierra Club, my work with the Yosemite Company—photographic and musical—and my association with thousands of people of all kinds during nearly twenty years of outdoor interests, I have yet to observe a definite case which would refute the statement that the *mood*—you may call it the spirit—is of supreme importance.

"Most people are unendowed with the power of expressing the more subtle elements of thought. They may even discard anything that savors of subtlety but that really stems from an attitude of defense. The fact remains that people are drawn, in spite of their surface selves, to the great reservoirs of natural beauty, the National Parks. It is not necessary that they be called upon to explain why they are drawn thereto; the huge attendance of the Parks is sufficient testimony of their worth. Is it not logical, therefore, to assume that a careful attention to detail in presentation is of great importance? It is in this devotion to the rightness of detail that the Aesthetic Factor exists as an element of control." (Fragment, no date)

In this sensitivity to "rightness of detail" and in finding solutions to the practical problems involved, Ansel found in Ted and Jeannette Spencer stimulating collaborators. They were gradually replacing the clutter of buildings which "an arbitrary insistence on rustic modes" had imposed on the Valley. They preferred the simple elegance of early California forms. They were also thinking ahead of the dynamics and the ecology of Yosemite itself. For instance, should all human habitation be built up on the talus slopes where trees would hide them from view and where the interiors formed by huge mossy boulders, ancient oaks, and tall pines suggested exciting spatial concepts to any imaginative architect? Or should all habitation be moved from the Valley, and loop roads, running along the edge of the meadows, bear the ever-increasing traffic smoothly around the great Valley to parking spaces and essential services hidden among trees at the base of the trails? In every great primeval park, the problems of overuse and overcrowding demand solutions as different as their ecologies.

There were many who concerned themselves with national park politics and economics, but none who could comprehend park esthetics better than Adams. His insistence on the primacy of the natural beauty of the parks had profound influence upon action the Sierra Club took in December 1936 when it "urged that the Department of

the Interior maintain high national park standards, and suggested that a division of the National Park Service be set up to concern itself with the great primeval parks alone." (David Brower, editor: *The Sierra Club: A Handbook*, 1960)

In the advertising aspect of presentation, Adams had long been trying to persuade the Yosemite Park and Curry Co. that the Valley was more than a backdrop to a resort. In this he was successful to the limited extent that they frequently used, and even featured some of his more spectacular photographs. He went on campaigning for no resort overtones at all. In the spring of 1935, shortly before the Forum, they gave him a large and challenging commission: to make photo-murals for their exhibit at the forthcoming San Diego Fair. Photo-murals were a craze of the day; banks, corporations, travel bureaus, and so forth were ordering huge blowups and montages with which to paper their walls. Most of them were excruciatingly bad in concept and in technique.

Adams found the problem fascinating, both technically and esthetically. He fitted up the darkroom in the basement of 129 24th Avenue with tanks large enough to handle rolls of mural paper and installed mine-rail tracks for an 11 x 14 enlarger camera to run upon. The first problem was sharpness; this resolved itself into grain— the apparent size of the silver particles which form the photographic image—versus tone. He discovered: "I would rather have richness of tone and a *little* grain than no grain and an unsatisfactory tonal image." The second problem, of course, was design, and here his imagination and exquisite taste suggested compositions that filled the given panel with empathetic movement and light, whether the subject was a landscape in deep space or a closeup decorative as a tapestry.

At this point, embarked on the vast, Ansel suddenly tumbled to the other extreme. The miniature camera was another craze of the time. Ansel "saw quantities of inferior work, heard impossible claims, and sensed the 'hobby' quality to an alarming degree." He feared that "the miniature camera would make superficial photography too easy; that standards would be lowered."

At one of the last Group $f/64$ shows, he observed Peter Stackpole, a gifted young photographer recently elected a full member of the Group, comparing the prints on the wall with a print in his hand. This was an enlargement from a 35mm negative. Ansel conceded that: "The print *was* quite sharp, but perhaps rather thin in tonal quality." About a year later, Peter showed Ansel some of the photographs he was making on the building of the Golden Gate bridge. Ansel congratulated him on acquiring a 5 x 7 camera, and carrying it on that high and perilous assignment. Peter had then the pleasure of informing him that a Leica was the only camera he carried. Ansel was overcome with "emotions and conviction, astonishment and apology. Stackpole's prints were splendid from every point of view. They were clean, direct, precise,—and they had something else besides—something alive and immediate." (From first draft, "My First Ten Weeks with a Contax," *Camera Craft*, January 1936)

Ansel "saw the indication of a powerful new field of photographic expression—and I capitulated to a Zeiss Contax with Tessar $f/3.5$. I was aware of the element of humor that existed in the fact of my installing a darkroom for 4 x 6 *foot* prints a few weeks prior to acquiring the tiny miracle of precision that had entered my photographic life."

He used the little camera on a Sierra Club High Trip that summer. "The Contax 'took' things perfectly— everything from clouds to water-bubbles, people, mules, flowers. I returned to my darkroom in a state of jubilant expectancy; tried a dozen different developers on more than two dozen rolls of film, and emerged with considerable mileage of squirmy celluloid. Net result: some fine pictures and the realization of an immense new world of photography to explore, aesthetically and technically and in relation to human significances . . . undoubtedly the most important field for the miniature camera—the camera is for life and for people, the swift and intense moments of existence. These are perhaps the most precious revealments after all."

He who had championed static portraiture now found himself photographing a baby's wonder at the world— his little daughter Anne, born to him and Virginia in March 1935, raising a tiny exquisite hand; Cedric Wright standing like a redwood tree in Sierra sunlight; a skier, breathless and exhilirated, against the winter sky; a ripple of amusement among four old people. Through such moments, Adams set himself "to find the 'rightness' of subjects in relation to the apparatus; not to imitate the production of larger cameras, but to speak the specific language of the medium employed, or rather in a particular dialect of the language of photography." (*Camera Craft*. January 1936) Nevertheless, for him the miniature remained a "dialect"—an instrument useful but limited in its range.

A campaign calling for some of his most powerful landscapes now arose. A conference on the national and state parks was to be held in Washington in January 1936. The Secretaries, Wallace, of Agriculture, and Ickes, of the Interior, Horace Albright, Conrad Wirth, later

LEAVES (SCREEN SUBJECT)

Director of the Park Service himself, and many others were to attend. The Sierra Club decided to send Adams as its representative. His task, a delicate one, was to endorse in general the master plan the Forest Service had worked out for the Kings River Canyon while urging the Club's proposal that the high country above it should become a national park. In this, as the Club knew, his photographs would be more effective than a six-volume report. They knew that photographs by Carleton Watkins had helped Congress decide in 1864 that Yosemite Valley should be the first state park set aside for the nation; and eight years later photographs by William Henry Jackson helped convince Congress in 1872 that Yellowstone should be the first national park as such. Adams could help now.

Willard Van Dyke was also going east. He and Ansel boarded the train together. Willard was suffering from the change in his ideals—from the simple independence of a photographer to the complex teamwork of the movies, from art for art's sake, to art for propaganda's sake. For Willard, Weston symbolized the one and Paul Strand the other. He was torn between his filial love of Weston and his steadily rising admiration for the genius and dedication of Strand. Compared to either, he felt his own gifts insignificant. Ansel, who freely and gladly acknowledged the greatness of both men as artists, tried to assure Willard of his own faith in Willard's potentials. Willard, however, believed that the greater the artist the more imperative it became that he serve humbly in the cause of humanity; what did the creation of beauty matter when people were fighting injustice, dying for freedom?

On arrival in New York Ansel went to see a movie in a theater on Union Square—with unexpected results. David McAlpin, escorting Georgia O'Keeffe out of a movie, saw a black-bearded figure get up out of an aisle seat and clutch her. McAlpin summoned up his Navy training and stepped up to intervene forcefully. Georgia, to his amazement, turned to him in delight. "Dave, this is Ansel Adams!" Ansel went with them uptown to the Shelton Hotel, where Stieglitz and O'Keeffe were then living, produced the portfolio of new prints he had brought with him, and showed, to an increasingly moved audience of three, exquisite and lyrical close-ups of snow and water and leaves, powerful images of storm and light on distant mountains, compelling presentations of architecture, and a few of the recent "swift and intense moments of existence."

The reactions to these prints on all sides were heart-warming. Ansel wrote Virginia: "Everything seems to come to him who waits!!! The net result of two full days in New York is as follows:

"1. I am to have a show at Stieglitz' in the Fall. . . . He is exceedingly pleased with the pictures.

"2. Have made a wonderful contact with Zeiss . . . I emerge with another lens for the Contax, a new case, a new developing tank, *and* believe it or not, a Zeiss Juwell 3¼ x 4¼ with a real Zeiss Double Protar lens. It's the best in the world."

These he would not accept as gifts; Zeiss proposed he write a series of articles on technique for their magazine, and he joyfully agreed. He wanted to share this wonderful contact with other photographers, Peter Stackpole, for instance, who had just joined the staff of the new-born magazine *Life* and Stieglitz, who had been longing for a Protar to use on his 8 x 10. Adams urged Zeiss to present Stieglitz with this lens, "the best in the world," in honor of his life-long contributions to photography. Zeiss at first demurred; few medals were as expensive as a Protar.

Then Adams met Paul Strand again and had the great experience of seeing a number of his prints. Deep, rich, intricate, subtle, and austere, the images glowed and glittered. Strand's use of toners—to make his whites shine pearl against deep bronze blacks when the subject called for warmth—had its effect on Ansel, who thereafter frequently used toners to deepen his blacks and enhance the delicacy and tenderness of luminous passages. Ansel, writing to Virginia of Strand's photographs, observed: "While not as completely sensitive as Stieglitz', as prints they exceed anything I could ever imagine. He is a swell guy, too."

With his portfolio of photographs of the Kings River Sierra, Ansel visited the various conservation and mountaineering societies whose headquarters are in New York. Most of them promised their support; so did Horace Albright. "I hope I can do a really good job in Washington," Ansel wrote Virginia. "I have been working constantly on the Kings project; while I am to get a lot of immediate data in Washington, I feel I have a full knowledge of the Sierra Club's past in relation to the matter. Tell Francis [Farquhar] and William E. [Colby] that I will do my durndest to put it over right."

In Washington he took his portfolio to the offices of various senators, services, and cabinet officers. In the middle of this he took time to go see Roy Stryker, chief of the photographic division of the Farm Security Administration, at the urgent request of Dorothea Lange, who found sending her negatives to Washington for development a handicap and a frustration. How could she tell what she had achieved or missed unless she could check on the negatives as soon as possible? Often, when in the field, she shipped her negatives to Ansel, who de-

veloped them and returned proofs to her immediately if the subjects were crucial or were unlikely to recur. With centralized laboratories, such as not only the FSA but also magazines like *Life* were setting up, it might be months before photographers could see what they had done. This "blind shooting," this "spinning film out of one's self like a silkworm," as Cartier-Bresson once put it, led photographers to shoot more and more in the hope of getting something, and this, in turn often led to a lessening of intensity in their seeing. The responsibility of the artist for his ultimate image was passing from the hands of documentary and journalistic photographers into the control of editors and layout men.

Ansel reported to Dorothea on his visit with Stryker, whom he persuaded to let her develop her negatives in San Francisco, make three prints of each and send the prints and negatives to him. He would return one print and allow her "to keep control of the aspect of the prints and indicate to the lab here what you want."

"I saw lots of the work," Adams said, "and there is some grand stuff being done.

"I think I got you something; I wish I had gotten more. Washington is a madhouse . . . I only arrived here two days ago and have been going like a windmill."

At the Washington Arts Club, Adams arranged for a show of his national parks pictures in the spring. Then he attended the conference, gave his speech on the Kings, and took the train back to San Francisco.

One result, entirely unanticipated of his Washington activities was a letter from the office of the Secretary of the Interior: the next time Mr. Adams was in Washington, would he come discuss with the Secretary the possibility of doing a photo-mural for the new Interior Department building?

His Arts Club show appeared in May, demonstrating ". . . that there is beauty in the sometimes forgotten and neglected art of photography. The pictures are principally taken in the national parks, but are not merely scenic. They are lovely things, beautiful lights and shadows playing through all of them. There are a series of pictures of Yosemite Valley made at different periods of the day . . . and night, when a rainbow crosses the sky and when a storm hits the precipices and the Valley. . . . He has also taken a picture of a plain, ordinary factory and made it look like a work of art." (*Washington Times,* May 9, 1936)

This transformation of the commonplace into the beautiful without in the least altering its significance was by now as distinguishing a characteristic of Adams's work as his increasing ability to render beauty itself. He wrote Stieglitz: "I have done one good photograph since my return which I think you will like. It is a rather static picture of a fence—the pickets covered with moss—and dark rolling hills moving beyond it. The Protar lens has an amazing quality—I seem to get more light—more glow—in the images although I feel it is not quite as hard and sharp as a Tessar. My visit with you provoked a sort of revolution in my point of view—perhaps the word simplification would be better.

"As I sit writing you I see out of my window the two enormous towers of the Golden Gate Bridge and I can visualize the still larger Bay Bridge going up to the east. I am wondering what these bridges will do to our local civilization. They will open up a vast territory in which all the miserable fungus of 'development' will flourish. And yet the bridges are magnificent in themselves; they are potential instruments for good but they won't be used that way. And the funny thing is that I don't want to photograph them—I would rather work on an old fence with moss on it. Do I live in the past—or in the future?" (AA to AS, March 15, 1936)

Thinking over his visits with Stieglitz, Strand, and other photographers, he dashed off a series of his impressions to Willard Van Dyke, including one of Willard himself—"Brilliant bewildered backwash with a strong tide coming in . . . extremely talented . . . swell guy who will get a second helping of destiny. . . .

"Strand: Print-quality, print-intensity, print-beauty . . . Must have Rock-of-Reason-Why. Great artist who takes it out in making most beautiful prints in the world. But 'Blind Girl' and 'The White Fence' click sharper than later and more perfect prints. . . .

"Stieglitz: Continuous transformer-hum translating God-knows-what voltages into directional and non-directional activities chiefly intellectual and egocentrically charitable. Supreme artist who knows something is wrong but can't see it due to smokescreen of convictions (which are denied in the flesh). I remember photographs where I do not have to remember print-quality, style, social significance, form, and composition,—for all these qualities merge, without pushing into a very simple and aggravating perfection of thought and feeling which, after all, may be the essential surface of the personality. Stieglitz never goes beyond human things, neither do any of us, but we try to out-complicate the breath and the coursing of the blood. Stieglitz gets fresh air at Lake George.

"Weston: Fresh air, earthy things, sunlight—hot or cold—simple but never frail, not afraid of natural things, lens is corrected for sex. Remembered like a swell thunderstorm on a granite mountain a long ways from New York."

Willard thought these sketches showed Ansel to be "a

very facile and brilliant judge of people. I don't quite understand how you do it but you do." He could not quite agree about Strand's earlier prints, nor about Stieglitz as "supreme artist." As to himself, he doubted if he were talented. "If you were to say 'imitative,' then I should agree." But why must Ansel place such emphasis on fresh air? There were much more important human goals to work for. (WVD to AA, March 2, 1936)

In his reply Ansel tried to define why he himself refused to photograph for propaganda purposes: "My training has been introspective and intensely lonely. I have been trained with the dominating thought of art as something almost religious in quality. As I look back on it now I realize a certain 'unworldly' quality about the point of view that was drilled and dynamited into me; I existed only for the quality of art in relation to itself; the production of beauty without other motivation. I have not achieved anything comparable to what my training implied, but again—that's my fault. This training has become part of the physical and emotional body, and it is hard to manage it in relation to other directions of thought. However, for quite a few years, I have been fully aware that something was missing—something of supreme importance. The 'contact with life' you may call it. . . .

"I am not a sociologist any more than I am a Roman Catholic . . . I distrust the power of Propaganda as Art, or the power of Art as Propaganda (in the obvious sense, of course). But I don't distrust the power of Propaganda as Propaganda. And more power to those who are working for a betterment of the social order . . . the extreme propagandists mix a little of the grime of industrial alleys in their developers. And I freely admit that the 'purists' work in an icebox and get their beards frosty."

FENCE, MARIN COUNTY

WHITE TOMBSTONE, LAUREL HILL, SAN FRANCISCO

9. Avenue of Sphinxes

The missing "contact with life" came upon Adams like a thunderstorm in the mountains. The peaks sing with a warning resonance that send most mountaineers scuttling for shelter; only poets, scientists, and photographers, who must see what happens if they are ever to express it, linger on the perilous stone. Adams was struck as by lightning—a love so intense that during its illumination he saw the world charged with a new and profound significance.

The capacity to convey emotion through the visible, tangible fact, latent in his work since the earliest snapshots, now attained an aching beauty, a tragic depth and tenderness that so transcended the subject before his lens that often he felt the images came from something far beyond himself. Quiet subjects—a white tombstone in an old cemetery, a weathered picket fence against the sky —quiet and terrible images. There are no words for such images. They are too close to us. And the prints Adams was making for Stieglitz of such negatives, though he now considers them inferior to his later work, still glow with an inner fire that causes the beholder to catch his breath.

Few of his friends would have hesitated to follow such a love, no matter what the cost to others or to themselves. He was at once too imaginative and too practical not to foresee what suffering his departure to set up a new household would cause not only Virginia but also their children Michael and Anne, now just beginning to emerge from the chrysalis of babyhood. He had observed what was happening to the children of divorced friends. Nor could he bear the thought of what new burden of distress such a severance would impose upon his father. Ansel remembered an evening when he brought Ella Young to dinner with Carlie, Ollie, and Mary. "Their words are like little hammers of pain," said Ella of the two women, as Ansel escorted her down the steep path to the gate. "Your father is a saint."

Ansel had no intention of becoming "a three-dimensional martyr" like his father, but neither could he contemplate for long leaving Virginia and the children. Yet to what dark perspectives of loss and loneliness would the dismissal of this love condemn him!

The decision might be inevitable, but the agony of making it was such that both he and Virginia became ill. Then Harry Best, Virginia's father, came to visit them.

He was helping Virginia put his granddaughter to bed when suddenly he fell across the little cot, slid to the floor, and died. Trying to cope with this emergency, to comfort Virginia in her shock and grief, to help her solve the problems thus precipitated, Ansel was simultaneously trying to complete the printing for two one-man shows, finish a handsome photo-mural screen with a leaf motif, and write a foreword for Stieglitz to use in the catalogue.

He *must* go east, he thought. The show at An American Place was opening October 27. In Chicago, Katharine Kuh was opening the show at her gallery on November 2, and had already arranged several meetings with possible clients, publishers, editors, and other patrons. There was also the photo-mural for the Department of the Interior to discuss. And the most effective way to find out if Virginia could continue the Best's Studio concession in Yosemite was to talk with the new Director of the National Park Service, Arthur Demeray.

Ansel wrote Virginia, on November 11, "It seems that Katharine Kuh has really done a very great amount of work in my behalf. The show looks very fine and the screen is a knockout." Things were happening fast. Meetings, commissions, portrait sittings, a lecture, receptions, dinners, parties. "I have not been to bed before 3 a.m. since I arrived. . . . The city is so huge and solid and endless that I feel like an ant on the great plains. . . . This trip is going at a terrible pace. . . ."

Later in November Ansel wrote Virginia:

"The show at Stieglitz' is extraordinary—not only are they hung with the utmost style and selection, but the relation of prints to room, and the combination in relation to Stieglitz himself, are things which only happen once in a lifetime. He has already sold seven of them—one (The White Tombstone) for $100.00. The others for an average of over $30.00 each. He is more than pleased with the show. I am now definitely one of the Stieglitz Group. You can imagine what this means to me. The number of people that have visited the Place and the type of response is gratifying.

"I have seen about 100 other people and am going from morning to midnight steadily. . . .

"Today we go to Mrs. Leibman's (Mrs. Stern's sister). I am seeing Albright for lunch. Had a swell dinner with Stieglitz and O'Keeffe last night. She has a very beautiful

new studio in which Stieglitz wanders around like a lost sheep. Her things are wonderful.

"But what is probably the most impressive thing that has happened here for many years is the Marin exhibit at the Museum of Modern Art. It cannot be described in any fashion. I am photographing the walls and arrangements this afternoon for Stieglitz."

From Washington on November 20:

"I had a splendid talk with Mr. Demaray this morning, and he is extremely favorable to the renewal of the operating permit. They seem to feel it's good for the Yosemite for us to be in it!" And the photo-mural for the Department of the Interior was now a real possibility.

From Chicago, to which he had returned to finish up various commissions, he sent the screen on to Secretary Harold Ickes as an example of what he could do with photo-murals. Ickes was so pleased that he eventually bought it for the Department and had it placed in his office. In the midst of frenetic activity, Adams went on thinking about the Yosemite concession and wrote Virginia:

"We have a real responsibility in the Yosemite thing. Demaray granted the extension immediately—before I had any chance to present the plans. They feel that we can contribute something grand to the Parks. I told them decisively that you were the operator—that I was only 'on hand,' as it were, to help you. They look at it in the right way—that something fine should be done, and they trust us to do it."

From New Mexico, where, in addition to a series on the potash industry for Horace Albright, he was to photograph the Carlsbad Caverns:

"I feel like a bat. I have just been 700 feet underground in the most exquisite apotheosis of Touristiana I have witnessed. The caves are spectacular—but they were conceived and were intended to exist in complete darkness, and the lighting—undoubtedly necessary and adequate—is Wagnerian, to say the least. I hope I can get some sort of photographs out of it—but pray for me. . . .

"I am temporarily installed at White's City. It is an Auto Camp—the very essence of all cheap auto camps . . . curios, misinformation, beckoning signs for miles on either side along the road, and the most extraordinary collection of middle-western auto-trailers and people I have ever seen. The tourist quality of Yosemite is nothing compared to this. This has been a wild month, all right, with an appalling variety of scenes and situations." (AA to VA, Saturday night, no date.)

Back in California, Ansel fought off collapse but it was a losing battle and he ended in the hospital. Letters came from Stieglitz, enclosing more checks for the sale of prints: "I hope you are pleased as well as surprised. I am. It's all too wonderful. But Lord you deserve it. I know your head won't be turned—and remember just go on your own way. Well, Adams, it has been a great experience for me to have your prints here and to have you here—a great one truly." (AS to AA, December 16, 1936)

"I enclose another pleasant missive [a check]. . . . The Protar. [Adams had at last persuaded Zeiss to give Stieglitz that double Protar lens.] My dear man it hasn't been touched, nor has any of my photography. Barkus is willing, but the damned heart says Nay, Nay. I'd love to get at some printing and maybe make a negative or two with the Protar. Just to see what it feels like. You know I always jokingly said if I ever get a Zeiss lens it will be as a tombstone.—But that won't deter me from making a stab as soon as I find an opening—'Running' the Place looks simple enough, as simple as making a swell photograph." (AS to AA, December 21, 1936)

For Ansel, emerging shakily from the hospital, Stieglitz' letters and the checks enclosed were "an incredible horn blast from the Milky Way—it's too good to be true. I know it has given you great joy to have things come to pass like this in your Place and I am glad for you and very proud to have had anything to do with it. I wonder if you can ever know what your showing of my work has done for my whole direction in life? And I am only one of thousands; with a little closer touch perhaps through the exhibit." (AA to AS, December 22, 1936)

In the same letter he tried to explain what, at the moment, he thought was happening to him: ". . . there is something about a hospital that might be good for the body but it's hell on the mind. Everything goes dead and the expense is terrible.

"Anyway, what happened to me is very hard to describe. For years I have been driving myself beyond reason, assuming responsibilities which, in the light of common sense, I never should have undertaken. The gradual nervous and physical pile-up of exhaustion had to be accounted for. The last trip to New York was a frantic attempt to keep the wheels spinning—and when I arrived home I felt at the breaking-point. And add to this an extremely intense emotional experience developing over the last five months—it is little wonder to me now that when I contracted a chest infection I went under in a big way. I have the doctor literally on my neck now and have made a series of uncomfortable, irrevocable, and expensive promises to him. I fully realize how important it is to return to full health and how very far I am from it now. I cannot do any work for several months." He dreamed

of a long boat trip with Virginia, to New York, then to Europe and back, and of ceasing "Commercial" work. "I am going to concentrate on honest things—a book on San Francisco, fine Industrial work, etc. for the bread-and-butter. That will give me time to do some of the things I really want to do . . . I would like to say with Robinson Jeffers:

'A little too abstract, a little too wise,
It is time for us to kiss the earth again. . . .'

The beauty of Yosemite, rest, a little photography, and a few climbs usually restore Adams to full vigor; this time they did not. Wearily, he dragged himself back to San Francisco and the misery of enforced inactivity. Stieglitz, with still another check, wrote him on January 7, 1937: "I know how you feel not being able to photograph. It's an awful feeling. So you can imagine my plight. . . ."

The same mail that brought this, brought a letter from the Museum of Modern Art, outlining the comprehensive scope of an exhibition entitled "Photography 1839-1937" and inviting Adams to participate. Usually photographers were asked to make their own selections, but in this case, three prints, "Boards and Thistles," "The Golden Gate," and "Pine Cone and Eucalyptus," had been offered by Mrs. Charles Liebman from her own collection. Did Adams approve? and would he also send three more prints, preferably of his recent miniature camera work? The letter was signed by the Exhibition's Director, Beaumont Newhall.

Adams was exhilarated by the clarity and challenge of the idea, which was to show the full extent and power of photography as a medium; and he liked the letter. He responded immediately, and had no sooner posted his reply than he had another inspiration. Would Newhall want a remarkable old album he possessed? "It is a collection of original prints, chiefly by a man named O'Sullivan, taken in the Southwest about 1870. A few of the photographs are extraordinary—as fine as anything I have ever seen." (AA to BN, January 12, 1937) And would Newhall also like the screen Secretary Ickes was purchasing for his office in the Interior Building? Ickes would certainly consent to loan it to such an exhibition.

Newhall declined the screen, owing to space, but enthusiastically accepted the album. Was it by the same O'Sullivan who was one of Brady's assistants in the Civil War? Would Adams send it and what was the valuation?

Adams responded that it was worth, at least to him, $250, and added that through Jeannette Spencer, local representative of the Museum of Modern Art, he had just signed up as a member.

He was puzzled not to find Stieglitz listed among the advisors to the show; Steichen was there, and C. E. Kenneth Mees, the brilliant director of research at Eastman Kodak; so was Moholy-Nagy, a couple of editors, and one documentary film director. Thinking Stieglitz must be quietly behind the whole thing, he was writing to thank him for being included when some instinct, or some vague memory of Stieglitz talking, warned him that in spite of the Marin show, relations between the Museum and the Place might not be entirely cordial.

What he recalled was probably some half-hearted reference to "the man from the Museum of Modern Art." "The man," when present, served as target for Stieglitz' exasperation with that institution, and, when absent, as an example of how academic and institutional training hobbled and blinded people. "The man," who suffered this abuse, who had to swallow his hurt and summon all his courage to return, was Beaumont Newhall.

How could he stay away from the Place? With the great photographs he knew it contained? The immense documentation, the letters, clippings, books? Stieglitz was old and frail; questions unanswered now might endure like an avenue of sphinxes among which the history of photography as an art might flounder from error to error forever. "I went back again and again because I believed in photography. What I wanted above anything else was to write the history of photography."

Aware of this desire, Alfred Barr, then the Director of the Museum of Modern Art, had asked Newhall to direct an exhibition on photography that should equal in size and scope such epochal and iconoclastic shows as Barr's own "Cubism and Abstract Art" and "Dada and Surrealism." Like these, the exhibition would occupy all four floors of the 1900 mansion the Museum then inhabited, and the accompanying catalogue would include a brief scholarly history of the subject. The moment this opportunity was confirmed, Beaumont wired me that we were getting married in three weeks, and then immediately went to ask Stieglitz to serve as chief advisor to the exhibition. Stieglitz refused. It was years before Newhall realized that Stieglitz expressly had founded An American Place to counteract, so far as he could, the intellectual exhibitionism of the Museum of Modern Art.

Stieglitz answered Ansel's inquiry "on a dreary wet Sunday" while waiting for his brother the doctor to come examine him. "How we all burn the candle at both ends . . . You must get well and work without killing yourself. That's a job hard for high-tensioned temperaments to learn. As for sending anything to the Museum of Modern Art show, I think you should be represented. There could

PICKET FENCE, SIERRA FOOTHILLS

CEMETERY PATH, CHARLESTON, SOUTH CAROLINA

be loans so that you would be spared.—No, I haven't anything to do with the show. Of course, 'the man' was in to see me last spring and a few days ago again.—A nice person I forget his name—I refused to show my own work. There are many valid reasons. I haven't the time, energy, money, or interest to get my things ready. Besides I hate the exhibition passion as evidenced in our country. I'll explain it to you when I see you.—Of course, 'the man' was much disappointed. It is difficult for me to say 'no' to any one. But in this instance I had no choice." (AS to AA, January 17, 1937)

By the time this letter arrived, Ansel was feeling desperately ill. When a routine medical check revealed nothing wrong, he insisted on a thorough examination. An hour later, the doctor called and told him to go directly to the hospital: he had infectious mononucleosis. What this dread disease might be, Ansel had no idea, but he dutifully went to the hospital. Here he had no peace; bevvies of doctors and interns kept bursting in to examine him.

Mononucleosis is a debilitating increase of white corpuscles in the blood. The afflicted have no energy, their brains seem full of fog, and the recovery is slow. Adams groped around and around in his mind as futilely as he paced around and around the bleak little hospital room. There was, for him, no way out of his responsibilities. His emotional situation was at crisis; he faced it and made the decision he had foreseen as inescapable. In this desolation of spirit, he recorded a nightmare:

"There was never any sound there but the low rumble of one's own thoughts traversing the rolling planes of memory. There was never any wind, or any rush of water or movement of leaves, either in light or darkness—only a low imagery of form and space. Metallic hills pressed on wooden skies; the world was large with solitude.

"Into this vault of the world's death came many beautiful ghosts—a white horse with mane blowing ever in a strange wind—the face of a young woman with wide plaintive eyes and cruel lips that stared reproachfully into your spirit—a great flower that curled and blossomed and returned into the bud over and over again. And there were sounds of deep music and weary wailing and the hard tireless pounding of machines. But the sounds were not audible to the ear. I saw a pillar of glass rise out of sea rocks with the cold green waters striving at its base. I saw a vast sphere of another world soar above the night edge of the hills. I saw men and women and many children standing and waiting for something never to occur. . . ."

Adams set himself to pick up his life again. He must escape this nightmare emptiness. The two houses in the San Francisco garden seemed to him shells of futility, echoing with the loneliness of his childhood, the old voices, the old moods of fog, of loss and grief. He and Virginia decided to rent the Studio at 131 for a while, and look for a different atmosphere, a new light and air. He wrote Stieglitz on February 10 of "an uncertain period for one Ansel Adams. I have just emerged from the hospital in a rather thankful state of mind. I had something called infectious mononucleosis which had everyone perplexed and scared the daylights out of me as I anticipated an operation.

"I am convinced I am on the up-and-up now. We are moving across the Bay to Berkeley in order to live a simpler and sunnier life. The house we are renting is up on a hill with lots of eucalyptus and laurel trees and canyons and hilltops all around it. It is a swell place for children to grow up in . . . San Francisco is a cold and depressing place in many ways.

"The trip is off—there have been too many hospital bills and other depreciations of income. My greatest loss is not to see you again, but I know I will be back East soon—possibly very soon to talk about the photo-mural in Washington. I sent off a print to The Modern Museum—'Miners'—and asked Mr. Newhall to pick up the other two—'Family Portrait' and 'Mexican Woman' from you. I specified that the above three be exhibited courtesy of 'An American Place.'

"I have not done any work since I returned—but . . . a gentleman has offered to subsidize a fine book on the Sierra Nevada—fifty plates and appropriate text—which will give me ample chance to present my best pictures of the mountains in a fine way."

This offer came from Walter Starr, a member of the Sierra Club since its earliest years, and a pioneer in the mapping and photographing of the Sierra Nevada between Yosemite and Kings Canyon. The book was to be a memorial to his son, Walter, Jr., who "ardently, passionately loved the High Sierra. He could not rest until he had seen it all. And then he wanted others to see it, to enjoy it, and to be inspired by it as he had been. So he made notes of practical directions, then formulated a clear articulate plan for presenting them." (Francis P. Farquhar, Introduction to *Starr's Guide*, 1934) Young Starr was a lawyer who devoted most of his weekends and all his vacations making a guide to the High Sierra, and especially the John Muir Trail, which winds beside blue lakes high along the crest from Yosemite to Mount Whitney. Like Muir, young Starr loved solitude in the mountains. No companion marred his joy in them or slowed him up when, working by moonlight, and all

through the day to dusk again, measuring distances, altitudes, and elevations, noting the availability of water, firewood, and pasturage, describing beloved places in words that seem to cry for photographs beside them, he achieved records of speed and endurance twice those of most mountaineers. He was thirty, the summer of 1933, and his book was well along toward completion when he camped beside Lake Ediza, in a region he considered perhaps the most magnificent in all the Sierra. From across the lake he photographed the Minarets.

"This group," he wrote, "is a tremendous wall of sheer rock, with numerous jagged spires and pinnacles crowning its crest and dazzling snow fields reposing beneath." He had climbed nearly to the summit of Michael's Minaret when a huge rock slab toppled out under his weight and flung him down the precipice to a ledge several hundred feet below. When, after weeks of anxious search—Francis Farquhar directing the survey from the air, his father directing it from below—one of the climbers finally found him, he was entombed there on the ledge. His father gave his ice-axe, crampons, rope, and that photograph of the Minarets, the last found in his camera, to the LeConte Memorial in Yosemite Valley.

Then he completed his son's book. *Starr's Guide to the John Muir Trail and the High Sierra Region,* was published by the Sierra Club in 1934. A light little book, designed to be carried in knapsacks, thumbed by campfires, stained with smoke, sweat, and rain, it served the purpose young Starr had intended. His father, however, wanted a monument more beautiful and enduring. What could be more appropriate than a book of Adams's photographs of the high places? A book, moreover, that might serve in the battle to save Kings River Sierra as a national park?

What a book this could be!—Ansel could envision it complete, and sketched it out there at the luncheon table, together with estimates of costs. Walter Starr, for his part, had absolute faith in Ansel's integrity and ability; he told him to go ahead and make the finest possible book. He himself would stand back of all costs incurred. Adams insisted that all income from the book should go to Starr until his generous subsidy should be repaid.

The book was an inspiring challenge from the first. Ansel, looking over his negatives, decided that although he had already had quite a number that might be worthy of inclusion in the final fifty, he would have to go up to the high country again and make more. Book production, however, was another matter. The market for fine books had declined during the Depression. Craftsmen were scattered, materials hard to obtain. To find the right paper, type face, binding, and engraver was to take Adams

months. At every point disappointments and delays impeded him. But to be making such a beautiful thing was in itself rewarding, and the search for perfection exhilarated him.

The "simpler and sunnier life," however, still eluded him. The house on the hilltop in Berkeley was peaceful. Yet even to this refuge nightmares pursued him: "It happens to be raining like the devil," Ansel wrote Stieglitz on March 21, 1937, "and the water is coming in through the cracks the last earthquake caused.

"Our present house happens to be on what is known as the Hayward Fault. The other night it slipped a bit right under us and caused the most God-awful roaring sound anyone could imagine. I thought our gas furnace had exploded. . . . Following the shock, an amazing sound came out of the city below us—fire-bells, burglar alarms, dogs yelping, and a great coming on of lights. I have felt a lot of earthquakes but nothing that had such a mood about it; something that could be best described as a sense of inevitable, impending disaster. Seismographically it was a minor shock, but I am not a seismograph.

"Let me turn to more stable things than earthquakes. I do not know if the show at the Modern Museum can be called stable but I would certainly like your opinion on it. I trust they came for the prints in due time, and that An American Place is given due credit in the catalogue. I sent them an album of old prints—originals, made from negatives of 1870-73 and I would like you to see it. There are some extraordinary pictures in it. While the museum undoubtedly displays the album open in the case at a picture of the Canyon de Chelly, I wish you would ask them to show you the print of Inscription Rock with the Measuring Rule. There is something in that print that out-surs the sur-realists, to say nothing of its magnificent tonal scale. These pictures make me think we are not always wise to use the extra fast and extra sensitive panchromatic emulsions. Especially in sky treatment—the old types of negative material registered blue as white, and the skies sometimes had a grand feeling of light that we can't seem to get today."

Newhall's catalogue for *Photography 1839-1937,* written and published between Thanksgiving Day, 1936, and St. Patrick's Day, 1937, sent Adams to his typewriter on April 8: "I am anxious to compliment you on what looks to be (at a distance, at least) the best show of photography on record.

"I was especially interested in your text and feel that it is a major contribution to the literature of photography. With certain slight additions and amendments to augment its already comprehensive qualities (especially in the

contemporary section), and the addition of a few more plates, it could well be published separately as a work for photographer and layman alike. It is a very fine job. The entire catalogue presents a true 'museum' attitude toward the subject.

"It is a matter of regret that I cannot see the exhibit in New York. But I earnestly hope that it will come out West—and that it will not be reduced in scope or size."

The success of the show he had not helped must have saddened Stieglitz. He wrote Ansel on May 9: "The 'load' heavier—and I not growing any younger. The 'season' has been a most difficult one. Somehow the more supreme the integrity of the Place the more removed it seems to become from the world. . . . I didn't go to the Great Photographic Show. Maybe I don't have to explain why."

"The Great Photographic Show," when it came to San Francisco in a somewhat abbreviated traveling version, impelled Adams to begin an article on "The Expanding Photographic Universe" with what is less a review than a proclamation:

"Whoever saw the recent Exhibition of Photography 1839-1937 at the Museum of Modern Art in New York could not fail to realize the true meaning and attainments of the art. A personal disagreement on certain prints, a social-aesthetic opinion at variance with certain trends of contemporary work, a nostalgic regret over the absence of misty romanticism—all are overpowered by the stark vital reality of the fact crashing from the walls of this exhibit: Photography is the most potent, the most direct, the most stimulating medium of human expression in this day. Call it Art, term it Craft, place with journalism, science, physics or self-expression, it is not to be denied. Never in all history has such an instrument of Kaleido-scopic powers been placed in the hands of men for the dissemination of thought, fact, and emotion. Things and events must be accurately recorded; thoughts and emotions must be crystalized. The facile magic of the camera is supported and amplified by the duplicative powers of the printing press; wires and wireless send pictures to the far corners of the earth; news is now a combination of statement in words and proofs in pictures. Photography is doing for the modern age what the early printing presses did for the post-Renaissance social expansion." (Manuscript version, dated August 9, 1937, of "The Expanding Photographic Universe" for *Miniature Camera Work*, New York, Morgan and Lester, 1938)

Further recognition of the power of photography as an art came in the joyful news that the Guggenheim Foundation had at last awarded one of its Fellowships to a photographer: Edward Weston. Ansel could not have been more pleased if he had received the Fellowship himself. For Edward it meant a year away from his hated portrait studio, a year in which he would be free to wander through the west and work with landscape. Charis Wilson planned the two thousand dollars down to the last penny to cover a maximum of photography and travel. Luxury, they discovered, was out; no hotels, restaurants, not even auto camps or hotdog stands for them. With Ansel's help they achieved a solution as simple as a mountaineer's—sleeping bags, cookset, canned goods, munchables. They would live in the open and cook after dark. They would follow where the seasons led—Death Valley and the desert in April, before the dread heat and thunderstorms of summer; the coast in May and June; the Sierra in July. When, they asked Ansel, would the high country be open, and would he—could he—be with them then? The snow was deep that year. Ansel estimated that by late July it would have melted enough to allow access to the ten-thousand foot altitudes. Why not come to Yosemite in mid-July, explore the Valley for a few days, and then come with him up to Lake Ediza?

Plans for Best's Studio were going forward. "Possibly the most interesting problem confronting me from a practical point of view," Ansel wrote Dave McAlpin (April 9, 1937), "is the development of a photographic concession in Yosemite which has come to my wife through the death of her father last fall. It will offer the opportunity to do a certain type of 'commercial' work which is not out of line with what I am basically interested in—the photography of the natural scene."

Best's Studio had originally been just that—a studio where Harry Best could paint and a shop where he could sell his pictures. Books, photographs, photo-finishing, and curios were added over the years. The curios were a profitable sideline, and those stocked by Harry Best were less objectionable than most, being merely mass-produced pots and similar Indian items from the Southwest. Ansel and Virginia considered them unworthy of Yosemite and sold the whole lot off immediately. The bookstore became excellent, and the camera shop, though small, one of the finest anywhere. The darkroom up on the slope behind was improved and made into a compact and efficient unit capable of handling photo-finishing of the highest quality in volume. Throughout the Studio, walls were painted white; the skylight of the painting room was closed in and gallery lighting installed. Here in the high white room, Ansel could hang fine prints, display screens and photo-murals, and, after hours when the shop was closed, play the piano.

In May, when certain necessary alterations in the living

quarters had been completed, Ansel and Virginia moved there with the children. The Studio, so close to Yosemite Falls that in spring its thunder resounds through the house, became their home.

To handle the photo-finishing they hired Rondal Partridge, the gifted, redheaded son of two old friends, Roi and Imogen Cunningham Partridge. Ron was also to help Ansel with the publicity needs of the Yosemite Park and Curry Co. For years Ansel had been on contract to the Company, at ten dollars a day plus expenses, to photograph their accommodations, activities, conferences, notable guests, and so forth. He also offered them the opportunity to use his creative work. David Brower, that eager young mountaineer and member of the Sierra Club, was now the Company's publicity manager. For Dave: "one of my greatest pleasures in work became that of keeping up to date the Company's file of Ansel Adams's prints, to be used for any promotional ideas that might occur to us. The echelon above me gave definite instructions, the essence of which was: we are going to sell Yosemite as an all-year playground and we're going to do it until we are stopped.

"Perhaps I knew intuitively at that time that this was not quite the purpose of a national park; if so, then Ansel Adams was my intuition. Whenever I had a chance to rearrange the file of prints, I was far less interested in the playground than in the sheer beauty of the proof prints in the Adams's album. 'Scenics,' they were dismissed as. The pressure was on to get photographs, instead, of Mrs. Whoever-She-Was from Topeka, with a readily identifiable Yosemite background, prints of which were to be sent to the Topeka papers as evidence that this was what the better Topeka people were doing this year. So I would order more scenics. Before I lost my job to someone willing to order fewer, I got to know Ansel reasonably well, and he got to know my problems better than I did. Best's Studio was my haven. And the darkroom on the hill behind the studio became my conservation classroom.

"The pupil was apt enough that Ansel, seeing that my days as a publicity man were probably numbered, set about trying to have me put to work as executive secretary of the Sierra Club. By the summer of 1937 there had been many long talks in the darkroom, many evenings of music and conversation in the studio after the shop was closed, hours of philosophy on a camping trip in the Yosemite High Sierra and on another to Lake Ediza, when I was lucky enough to be along with Edward Weston and Charis Wilson." (Manuscript notes, 1963)

Moonlight shone on the pale granite of the cliffs that July night when Edward and Charis came to the Valley, and were "enthusiastically welcomed, nobly housed and fed." After the privations and frustrations of their initiation into expeditionary photography, the warmth of Ansel's and Virginia's hospitality was the more welcome. The night before the departure to Lake Ediza there was such a celebration in the studio that the six members of the expedition—Ansel, Edward, Charis, Ron, Dave, and Morgan Harris, a young zoölogist with a passion for rock-climbing—barely made the 6 a.m. control—one way traffic—out of the Valley. Then began that magic journey —up through the changing forests, over the old Tioga Road as it twisted among the trees and boulders and came down to the massive granite slopes and the brilliant lake at Tenaya, on and through the exquisite meadows at Tuolumne, on up through peaks and lakes, and down over Tioga Pass as it plunges to Mono Lake and the desert. Then south toward the gap in the great wall of the Sierra Nevada, the volcanic Mammoth Lakes country and well back into the mountains along the primitive road to Agnew Meadow, where mules were waiting to be packed with gear, film, and food. Then up by trail to ten thousand feet and timberline. Ansel and the young rock climbers capered ahead, Edward, who had been complaining of his heart, sailed up serenely, but Charis needed a push now and then from Ron.

At last, the beautiful lake, the towering black spires of the Minarets, deep snow gleaming on Mount Ritter and Banner Peak. Everything was as Ansel had foretold it— wildflowers blooming among snowbanks, floating ice on the lakes and tarns—everything, that is, except the mosquitoes. Ansel offered successive hopes—the mosquitoes who greeted them so enthusiastically on the trail could not follow them up to ten thousand feet; the afternoon shower would dispel them; they would vanish before the smoke of the campfire; they would freeze at night.

Camp was made on a grassy terrace laced with little streams. The mules appeared, were unpacked and dismissed with their packer. A large campfire was built before the tent and a small cookfire built nearby. With the smoke the mosquitoes seemed to increase, though the chill of night dispelled them. Dinner was eaten by the glow of the great fire, with what Charis regarded as "an impossibly beautiful moonrise lighting dark peaks and snowbanks above us. The stream moved slowly past our camp, then went leaping down to the lake in a wild cascade that made music like wind rushing through branches. On the little hill behind us the polished rocks shone white as snow in the moonlight. . . .

"Next morning Ansel admitted he was beaten. There the mosquitoes were, and it was most unusual," Charis

wrote in *California and the West*. Edward found a pair of gloves and draped a bandanna from his hat brim; Charis swathed her head in a scarf, covered the last exposed few inches of skin with lemon juice, and refused to wash. Ansel, with a philosophic tolerance relieved by occasional profanity, merely tried to keep ahead of the swarm, and flapped his focusing cloth well before settling under it.

Mosquitoes or not, Edward found the High Sierra dazzling. For the first time on any trip, he exposed all the film in his holders—twenty-four 8 x 10 negatives. But lying prone in the tent at night and trying to replace exposed 8 x 10 films with fresh ones in a tiny changing bag he found baffling and infuriating; Ansel volunteered to help as an old hand at this and thereafter changed both Edward's holders and his own every night, while Edward solicitiously brushed the mosquitoes from his brow and Charis teased him with abstruse intellectual questions.

"Mornings clear and sparkling; noons of gathering clouds; afternoons of thunder, lightning, and showers; evenings clear with clouds retreating over the peaks in wild sunset colors. Edward made at least twenty negatives a day: details of trees and stumps, rocks and snow, waterfalls cascading down the lightly forested slopes; pre-storm clouds and clearing clouds; Lake Ediza at sunset and sunrise, soft light reflecting from the dark cliffs around it."

Those days and nights among the peaks expanded the horizons for them all. For Ansel, Edward's instant and intense response to the same beauty he had loved so long was healing and exhilarating. The very differences be-

EDWARD WESTON, TENAYA LAKE

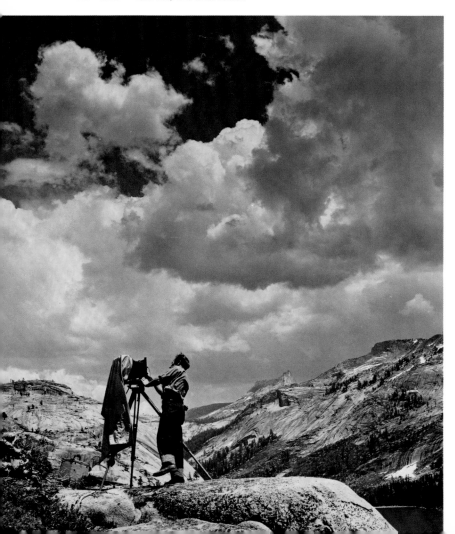

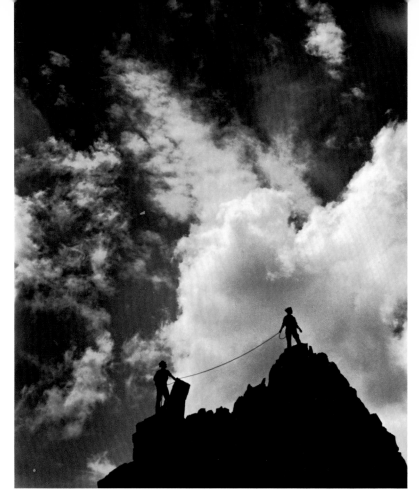

DAVID BROWER AND MORGAN HARRIS, THE MINARETS

tween their visions stimulated him. He photographed the Minarets, and the young climbers achieving their summits, with a feeling of renewal. Charis's vital young loveliness might be hidden by boots, pants, and mosquito-rigging, but nothing, not even the tenderfoot's tendency to sleep at high altitudes, could dim her challenging wit nor her utter devotion to Edward. Ron's unpredictable and humorous reactions enlivened any situation. For Dave Brower and Morgan Harris, descending chilled and wet from stormy heights, what a privilege and delight it was to crawl into a tent designed for two, curl around camera cases, and have hot toddies with four such wonderful people while rain beat on the canvas. When the storm passed they crawled out into truly "a sparkling world, every blade bent under a load of silver. . . ."

The last morning the photographers worked around the Devil's Postpile, that strange basaltic formation of pentagonal columns, and on an abandoned cabin nearby. Then down to the Owens Valley again, and north to Mono Lake, tragic and enchanted, with clouds rising over its black volcanic islands and white willow skeletons, bleached by its alkali waters, along its shore. Ansel photographed the strange, meditative reflections of the lake; Edward found driftwood on the beach. Then they caught the last control over the Tioga Road, arrived back at Best's Studio around ten o'clock, and fell upon two cold roast chickens provided by Virginia.

"Swept on by the wild hilarity fatigue produces, we were all talking at once, all laughing. Suddenly a white face appeared at the window, a frightened voice shrieked, 'The darkroom's on fire!' Out the back door we dashed to see a red glow around the darkroom, clouds of smoke pouring out. Ansel yelled, 'Negatives!,' ran toward the building, Edward after him. . . ." The blaze was promptly extinguished. "But our work had just begun. The bathtub was filled with water; boxes, files, handfuls of wet and partly burned negatives were dumped in. Other negatives, not yet wet, were transferred to new envelopes. Midnight came and went, the salvage crew, disposed about the bathroom and the hall beyond, worked grimly on. Not until it was all over did we recall that dinner had been interrupted and trail out to invade the icebox. Of the group, Ansel looked least like a ruined man. When we had had a well-earned drink he became positively gay, sat down at the piano and rendered an extensive Bach concert."

Fire, consuming so many early negatives, seemed to have consumed with them a period of his life.

He wrote Cedric Wright on July 30, 1937:

"Worst loss is about 5,000 negatives of Yosemite. I have to start all over again with pictures for [Yosemite Park and Curry] Co., self, and studio. Insurance ample in one way and very inadequate in others. I'll get 5 x 7 Juwell [camera] and go after Yosemite again with a new point of view. I have to do it for ethical reasons, but I would like to live far, far away, with a few friends, on milk and crackers, and try to get myself more into the essence of things, and say some of the things I feel way down deep I have to say."

The caprice of fire remained astonishing: why devour the fine negative of the pine branch in snow and leave still usable, in the same envelope, its less successful duplicate? Why skip over hundreds of unimportant negatives to damage ones like *Winter Storm, Yosemite* just enough to cause endless trouble in the future? Sometimes Adams found himself wishing the fire had destroyed everything so that he would have to begin afresh.

Checking over what was left of the negatives he proposed for the Sierra Nevada book, he decided he needed one of the east face of Mount Whitney. This meant a journey of several hundred miles, over Tioga Pass and down the Owens Valley to Lone Pine. Edward and Charis, transfixed by their glimpses of the sculptural splendor of Tenaya—the shining granite slopes and domes, the clear icy lake, the ancient, storm-twisted junipers—had returned there to camp. At last they left this Eden, and as soon as Edward had developed his negatives, joined Ansel in his dash down the tremendous and tragic valley.

Now for the first time they saw the great towering east wall of the Sierra Nevada, rising abruptly from desert to snow peaks thousands of feet high, and stretching on south more than a hundred miles into the distances. Parallel to the Sierra, and no more than a few miles away, rises the Inyo Range, almost equally high, desert mountains glowing with strange hot-metal colors. From this valley, one of the most magnificent in the world, nearly all water is drained by the city of Los Angeles. In those days, abandoned ranches, charred ruins, and dying trees still bore witness to one of the worst defeats and disasters in the history of conservation. This had been Mary Austin's *Land of Little Rain:* she had been in the fight to save it, insisting that the question be carried up to President Theodore Roosevelt. But quietly, secretly, over the years, all controlling rights had been bought up by agents of the Los Angeles water and power interests. Mary's trenchant eloquence came too late.

The highway led between immensities, endlessly past sagebrush and boulders, through a few baked little desert towns, beside the Alabama Hills, the low, dark remains of an ancient mountain range. All the way down that day, Charis noted with amusement, "Ansel kept pointing out Mount Whitney and changing his mind; hardly a peak in the Sierra but had held the title briefly when at last we came to Lone Pine. . . ." By then it was dark; they camped at Hunters Flat, and "didn't see the peak until next morning, when, ambling around with our mugs of coffee, we looked up through a gap in the trees to the high white granite spire shining in the sunrise." (*California and the West*)

They photographed the Alabama Hills in storm, at one moment "a sooty menace of silhouette, at the next dazzling in a downpour of blinding light. . . . Between negatives the photographers wring out their focusing cloths like wet towels." They worked with the rusty abandoned soda works at the edge of what had once been Owens Lake and was now mostly an alkali plain where the wind raised a choking dust. On the journey back they passed through "forests of skeleton trees. Dead white or burned black the tree trunks stand beside the shiny new power standards; the shiny parallels of the power wires cut through the delicate lacing of dead twigs and branches like the lines of a musical score. And over all this fantastic forest of death and civilization, towers the grim east wall of the Sierra."

Edward and Charis were becoming very important to Ansel; the simplicity of their life, their mutual devotion and complete concentration on Edward's creative work was to him at once a challenge and an ideal he was hopeless

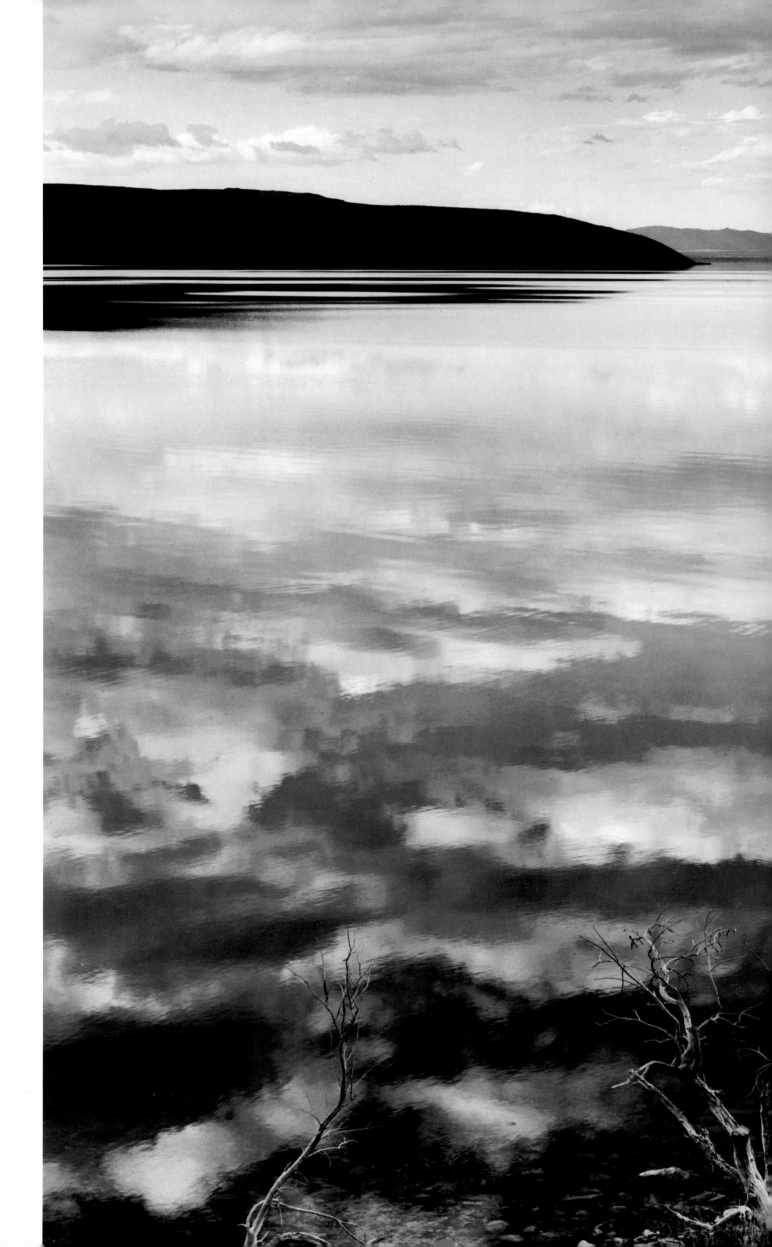

MONO LAKE

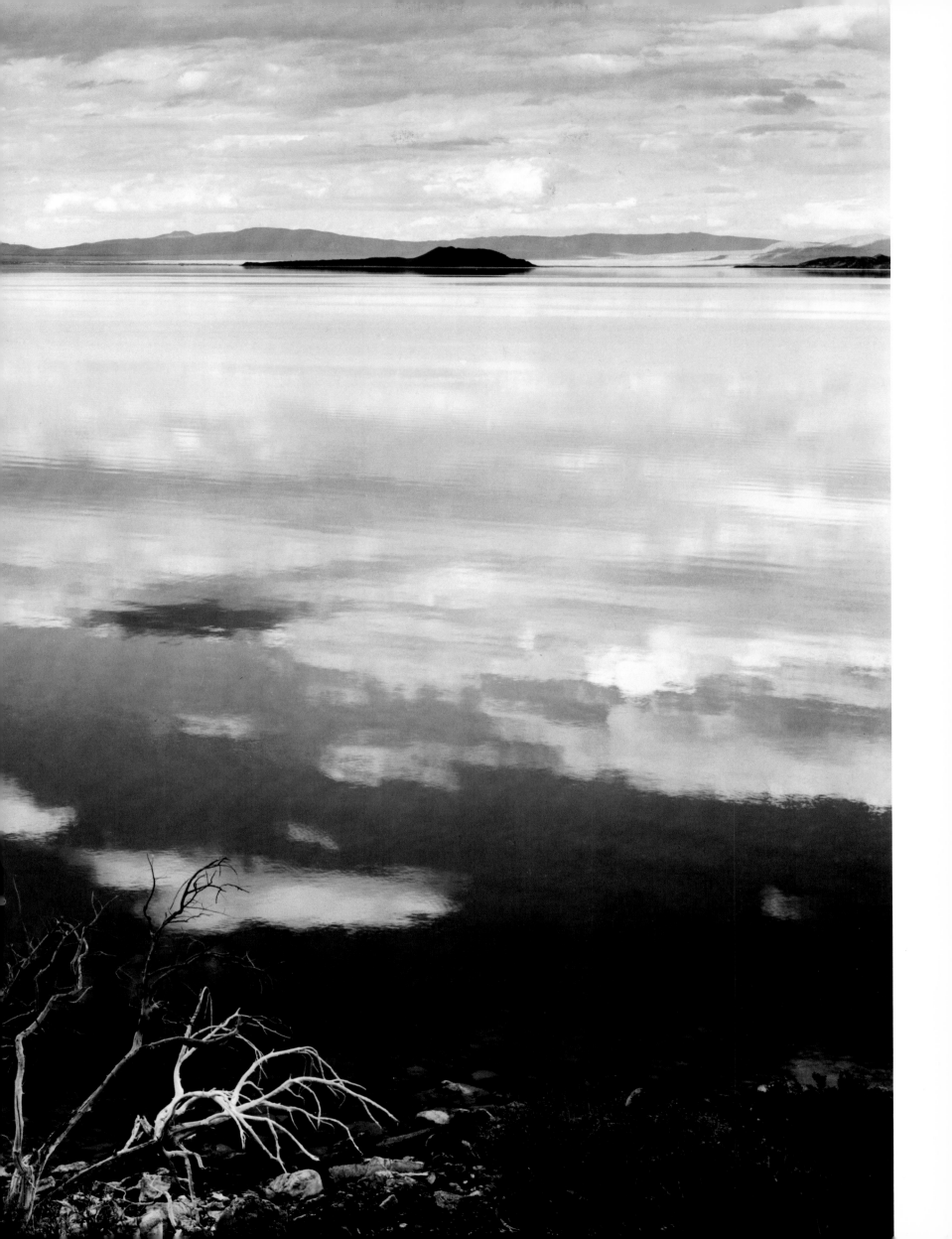

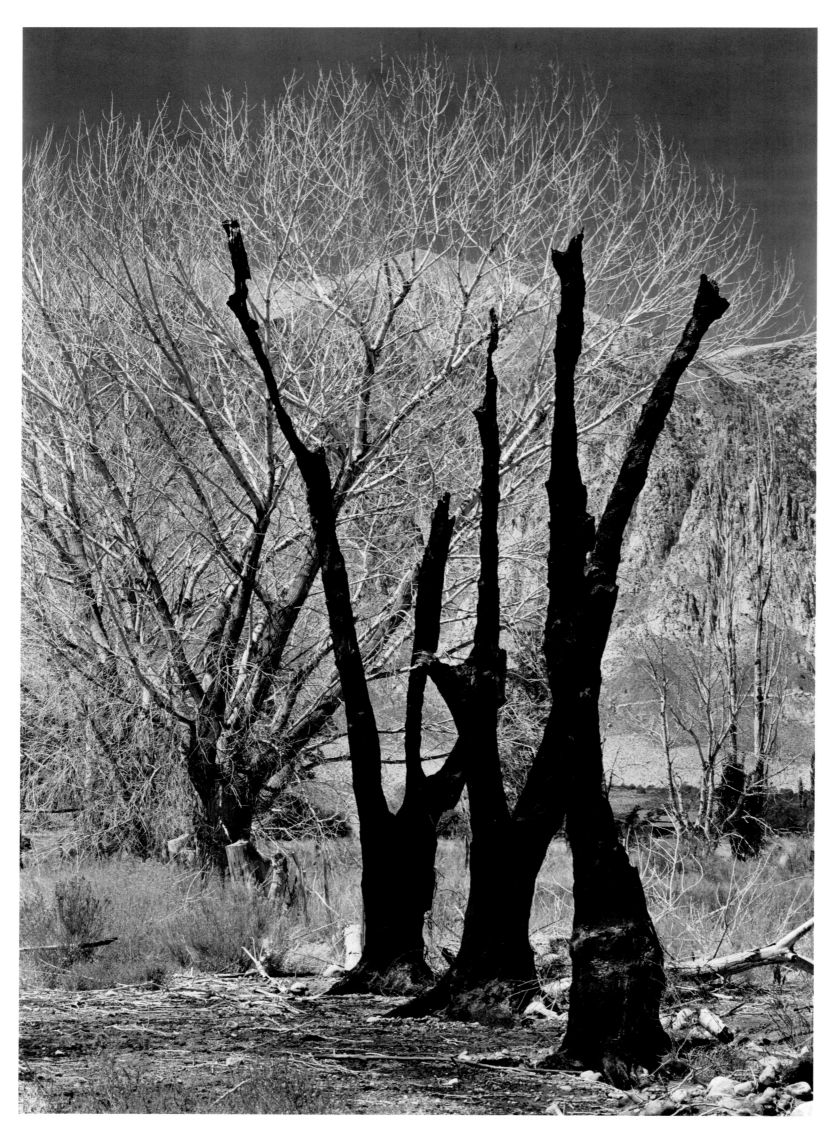

OWENS VALLEY

of ever achieving for himself. He wrote Cedric Wright, who had been invited to join both expeditions and had not been able to arrive at either rendezvous: "I looked all over the Owens Valley for you. We had a wonderful trip . . . and I got some of the best pictures of my life.

"I do regret not being out with you for some little time in the hills. Life is very complex; we are all in a kind of box with cast-iron sides which prevents us from touching the essences of real living. But perhaps 'real' living is just trying to make the inside of the box as rich as possible. On the other hand, Weston seems to achieve a Real Swell Life by eliminating everything that is not essential and going ahead with his creative work. He is a grand person—one of the best in the world. The work he is doing is truly great; he lives, sleeps, and eats with the greatest simplicity; needs practically nothing in the way of luxuries and fussings, avoids complex tie-ups with people and things, and gets the most out of the world and the big and the little things in it. We live in a complexity that appalls me—and I do not know a way to escape without doing a lot of damage.

"I gotta see you . . . you are one of the people that have a wide-angle and long-focus point of view all at once."

In September Adams went off to join Georgia O'Keeffe, David McAlpin and his cousins Godfrey and Helen Rockefeller, on an autumn tour of the Southwest. Heretofore Ansel's explorations in New Mexico had centered around Taos, Santa Fe, and the Sangre de Cristo, now he went with Dave and his cousins up the Chama Valley, the river running swift and shallow among cottonwoods deep in its canyon, through humble little Spanish villages—Hernandez, for example, a church, a few huts, and a graveyard, lying small on the vast sagebrush-dotted plain; and Abiquiu, a church, a cross, and a plaza on the verge of a cliff. They went to the Ghost Ranch, where O'Keeffe now spent her summers. O'Keeffe was, in Ansel's opinion, doing "some extraordinary painting," and was working on several canvasses she was loathe to interrupt. So for a week or so, Adams, McAlpin, and the Rockefellers explored with their cameras the ghostly mudhills and the remote little towns where the earth was so red the adobes seemed to glow perpetually with sunrise or sunset, with that strange mountain shape, the Pedernal, a pyramid with its top sliced aslant, haunting the horizon. It was an autumn of wonderful skies, with storms and lights sweeping across the mesas. Ansel wrote Virginia that the Ghost Ranch country "beats anything I have seen anywhere for complete beauty. . . . It's the first real rest I have had in God knows when. . . . McAlpin is very enthusiastic about my work . . . wants to see me do books on all parts of the country . . . a series of books from Maine to California. What do you think of that?"

Finally, O'Keeffe was ready and they set off, up to the old mining towns of Colorado—Silverton, Durango, Ouray. Here the aspens on the mountains were already gold and Ansel began to think he might really do something satisfying with color photography. But it was in black and white that he photographed, before dawn one cold morning, a fugue of leafless aspens spectral in the frosty stillness. Then off to the Indian country—Laguna, Zuni, back through Rainbow Bridge, Monument Valley, Shiprock. Again, with O'Keeffe as with Weston, the stimulus of another strong creative vision, different from his own, yet close enough to respond to the same country, exhilarated Adams. But before him on this journey went an older vision, that of Timothy O'Sullivan, more than half a century earlier, who now and then, in the midst of the geological records required of him, suddenly felt what Adams was to call "presence." Here, in the soft stone of Inscription Rock, was the same record left by the Conquistadors which O'Sullivan had photographed with the dark ruler; there, in the Canyon de Chelly, was the same little white ruin, built by a vanished race of Indians centuries before, in a river-eroded hollow of the enormous cliff. It was only one of hundreds of cliff-dwellings in similar hollows scattered among the walls and pinnacles of that eddying canyon. Adams and the others rode up the canyon bed to see them all that first afternoon. "The next day it started to rain and today we are expecting a real flood!" Ansel wrote Virginia (Chinle, September 28, 1937) "We will be here until the roads dry up enough to permit travel. The worst rain and electrical storms I have seen. The Canyon de Chelly exceeds anything I have imagined at any time!"

Then Adams had to leave, for a job at the Grand Canyon and another working with aspens in Yosemite. There, problems awaited him. The Sierra Nevada book had to be postponed because, he wrote McAlpin, of "too much print control on the part of the engravers." And a rather poor booklet of his photographs had been published without his knowledge or consent by the Company. He wrote Stieglitz: "Adams is in a hell of a state. I am blowing up in a style that befits a hot-water geyser in Yellowstone Park. Advertising tells the artist 'We want your interpretation, we want Good Stuff' and then proceeds to take your interpretation and rape it. You protest—but you are advised that you do not know anything of Advertising. Besides, you have a *contract.* And then the artist, who is also a human being, has to think of his family and the high cost of Grape-nuts, and grin and bear it.

"The picture here is amusing—if it weren't tragic. Yosemite is one of the great gestures of the Earth. It isn't that it is merely big—it is also beautiful, with a beauty that is as solid and apparent as the granite rock in which it is carved. The U.S. owns and administers it; a Public Service Company makes it possible for you and me to eat and sleep in it. This Company with the steam-roller momentum of Big Business, needs to bring people to it. . . . It is just like jazzing up the *Poeme de l'Extase* of Scriabin a little hot rhythm, and there you are.

"Adams remembers how his prints looked on your walls and he is very humble before you and those walls. Adams has had to make a living. He has tried to make it with what he had to offer—which was considerable in this place. It is the same old story. You can expect anything to happen to Adams in the near future—except Homicide, Suicide, Grand Larceny, and Arson. Please forgive this growling letter. I have to let off steam to someone." (AA to AS, November 12, 1937)

There was some solace in proofing the new negatives for McAlpin and in writing him on November 27: "The Book idea interests me profoundly. Do you know of any industry which needs a fine presentation via the lens? Polaroid, Steel? etc.? . . . Seriously, there might be a wonderful chance for interpretative advertising with a product such as Polaroid—treating of the manufacture and the various uses of the material. A series of fine photographs in a well-designed booklet might have quite a functional value." This was several years before Edwin Land began to think about the "picture-in-a-minute" process.

"I happen to be rather full of ideas at present, for I think 1938 will be a highly productive year for me, and I have to make some drastic changes in my set-up. I do not feel senile (Adams was thirty-five!), but I am not getting younger, and I should hit things quite hard during the next five or ten years, so that there will be sufficient momentum to keep me busy during the following twenty-five years. After that I expect to retire to a fine-grained photographic heaven where the temperatures are always consistent."

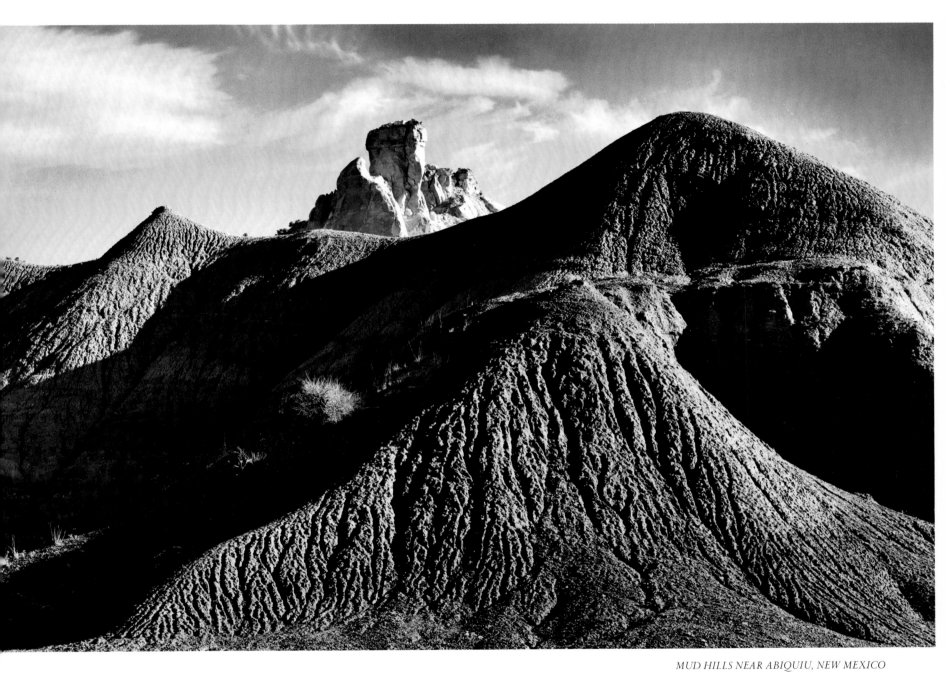

MUD HILLS NEAR ABIQUIU, NEW MEXICO

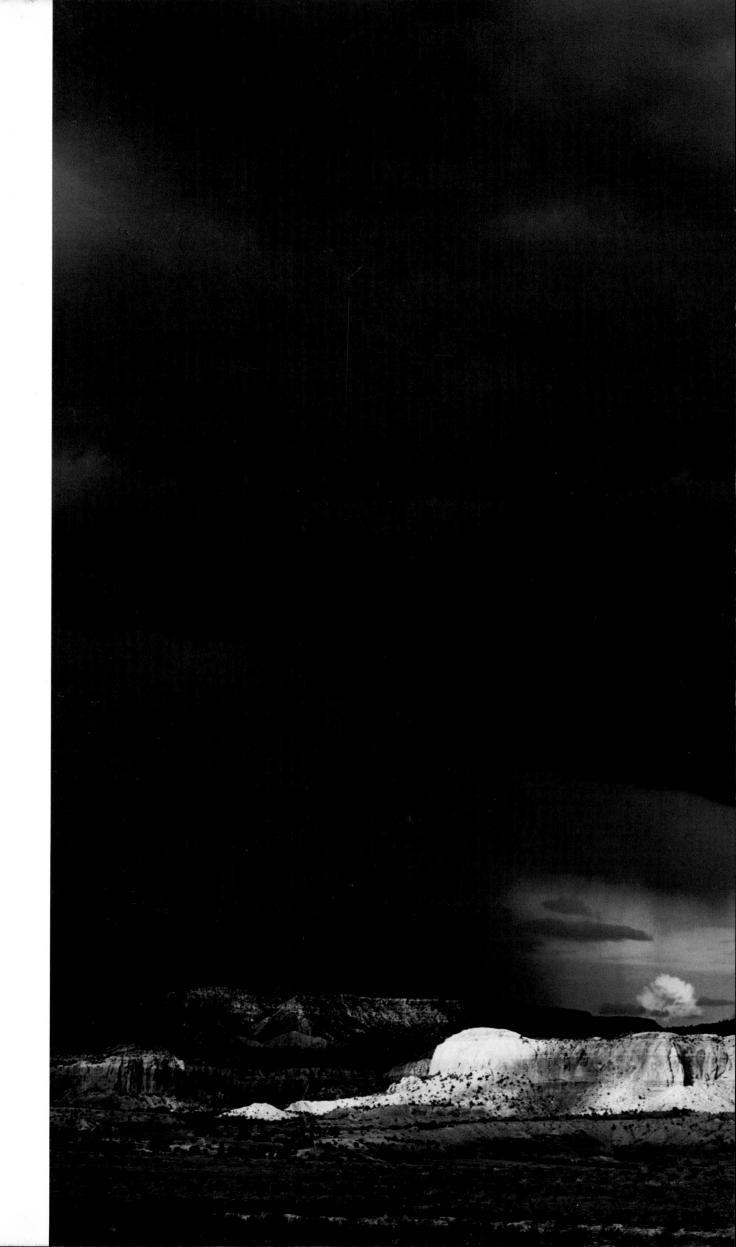

THUNDERSTORM,

NORTHERN NEW MEXICO

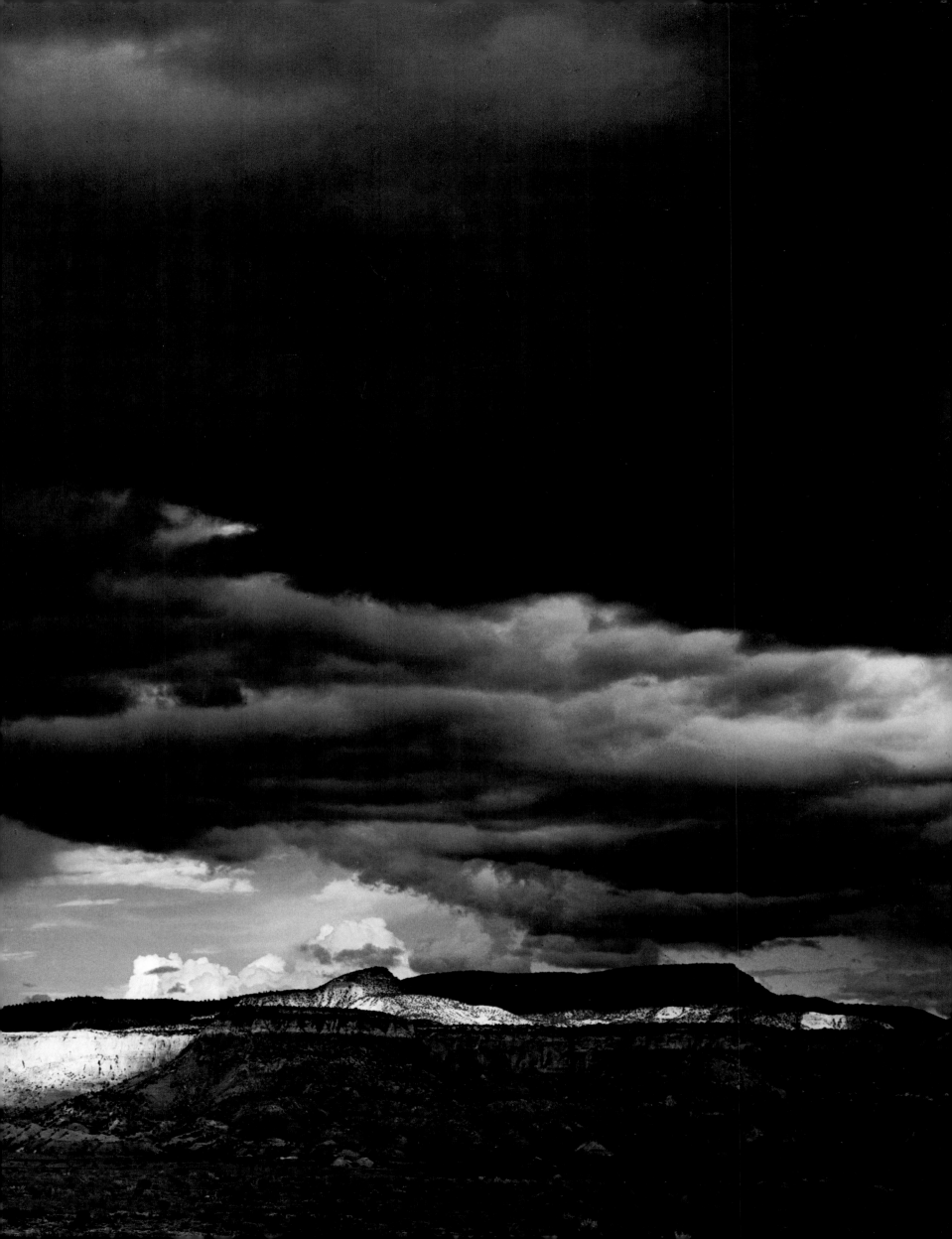

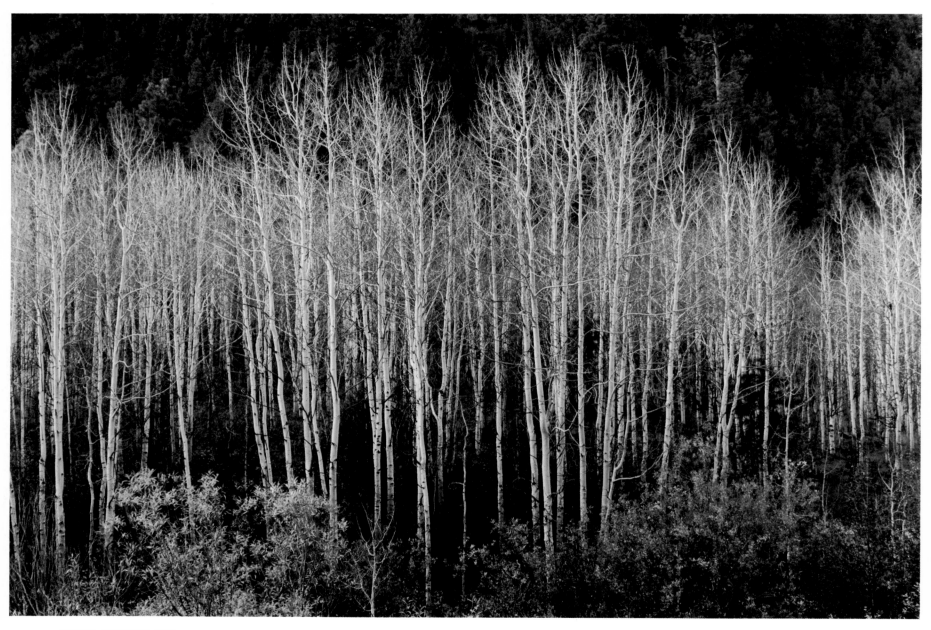

ASPENS, AUTUMN, 1937

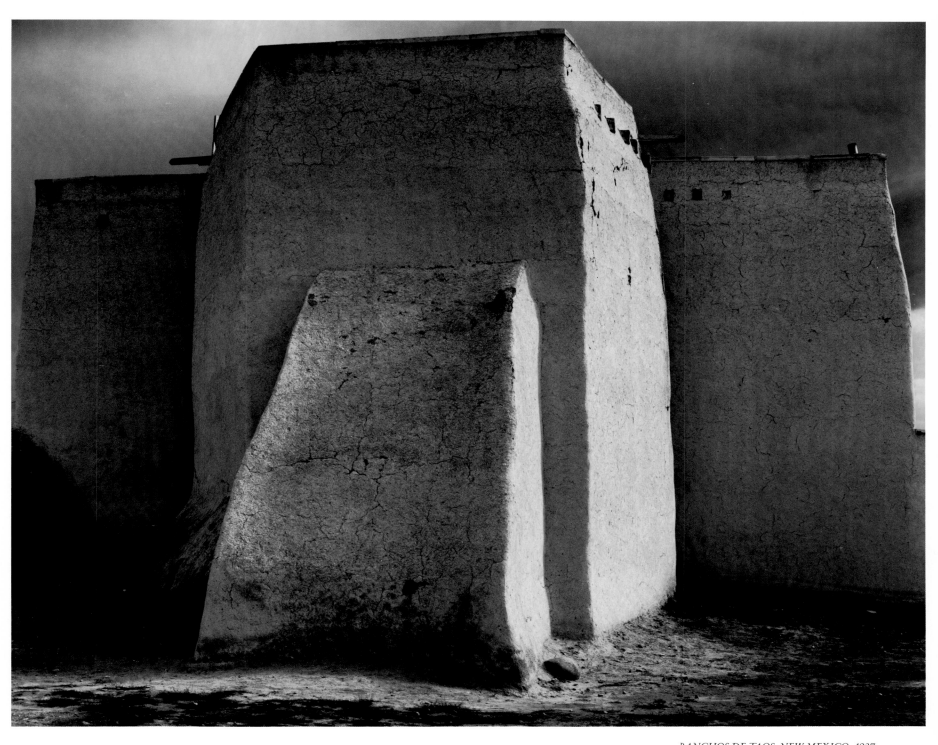

RANCHOS DE TAOS, NEW MEXICO, 1937

10. The Range of Light

Early in December a huge rainstorm hit the Sierra. Slides closed all roads into the Valley. The rivers and waterfalls poured into it until it became a swirling lake carrying away tents, overturning cabins, washing out roads and bridges. Best's Studio, being on higher ground, escaped the flood. Refugees crowded into it. All power and light had failed; they cooked on the hearth in the shop and lit lamps and candles to see by. For days it was impossible to work in the darkroom. When at last the flood subsided, Ansel photographed the sodden litter and wreckage; these records of damage, intended merely to serve as evidence, sometimes attain a curious gloomy beauty. This ability to transform ugliness and squalor is a peculiarly photographic phenomenon, and in Adams it is more marked than in most.

From Edward Weston, whose Guggenheim peregrinations had led him to Taos, came a letter significantly headed, "Ice, snow, cold!" He was applying for an extension of his Fellowship, hoping for a second year during which he could print his hundreds of new negatives. Would Ansel write him a " 'testimonial' as to the quality I am achieving and the importance of my seeing? Though I am, most naturally, personally concerned, I really think that any showing I make will have its effect on the photographers who come after me. And I believe in photography."

Ansel wrote an enthusiastic testimonial and plunged back into his own mixed existence, which consisted just then of such disparate activities as an increasingly exasperated battle with certain obtuse and obstinate lords of advertising—he says now he wasn't using his head about them—working on a one-man show for the University of California, which was to include "photo-mural projects in collaboration with Mr. Eldrige T. Spencer," and composing a score for the forthcoming Parillia Ball. These balls were annual events which Ansel characterized as "wild affairs in the sweet name of charity," and this year the theme was "Europa and the Bull." The Spencers were working on the decor, the costumes, and the papier-maché Bull; the dancers planned to progress through all three ballrooms of the Palace Hotel, and they would need music audible throughout. Would Ansel give some thought to *what* music? Ansel thought of an ancient temple drum in William Colby's Chinese collection. It dated from perhaps the fourteenth century, it stood tall

as a man, and it gave out the deepest resonance, apart from thunder among the granite domes of the Sierra, that Ansel had ever heard. He composed a few tentative bars around this immense instrument which so impressed—and convulsed—the committee that they urged him to do the whole score, all of it in percussion.

Meanwhile letters were coming from Edward Weston. That taste of snow in Taos had awakened his boyhood love of winter; when would there be snow—deep snow—in Yosemite? Snow such as he had longed to work with since he saw Ansel's exquisite trees back in 1933. Might he and Charis and Neil, his third son, who had been promised a trip and hoped it might be to Yosemite, come sleep on the floor, help with the dishes or anything else, and, of course, pay cost plus? "In no other way," wrote Edward, "can we be comfortable."

Ansel replied on January 23 that, while they were welcome, the Adamses' schedule was a mess for a few days—Virginia ill, the cook not well, himself due in San Francisco for the opening of his show, and "no snow worth clicking a shutter at at present." To this he added, "I have had a delightful showdown with the Advertising . . . and am *through*."

"You are the lodestone," wrote Edward. ". . . write me when Ansel, Va., and snow return, and we will leave at once.

"Shall I cheer?—that the adv. is *through*. This should be your great year. Hope I, or we, can play some small part in the starting of your greatest period."

A week or so later, another great storm hit the Pacific Coast; windows blew out in San Francisco, trees fell across the road. In heavy rain the Westons worked their car through the flood-bitten Merced Canyon. Yosemite they found in gray mist above, gray slush below. Ansel and Virginia held out only a hope for snow; it could happen, and it could, as in December, just go on raining. During the night the downpour turned into a blizzard; soon all power and light failed as before. Ansel and Neil went out to shovel off the drifts rising on the roof. The radio became the sole communication with the outside world. For the Westons, the serenity being snowbound can bring—when the house, like Virginia's and Ansel's, is well stocked—was idyllic. For Ansel, deprived of darkroom, car, mail, and telephone, the only solaces were the typewriter, the piano, and now and then pacing

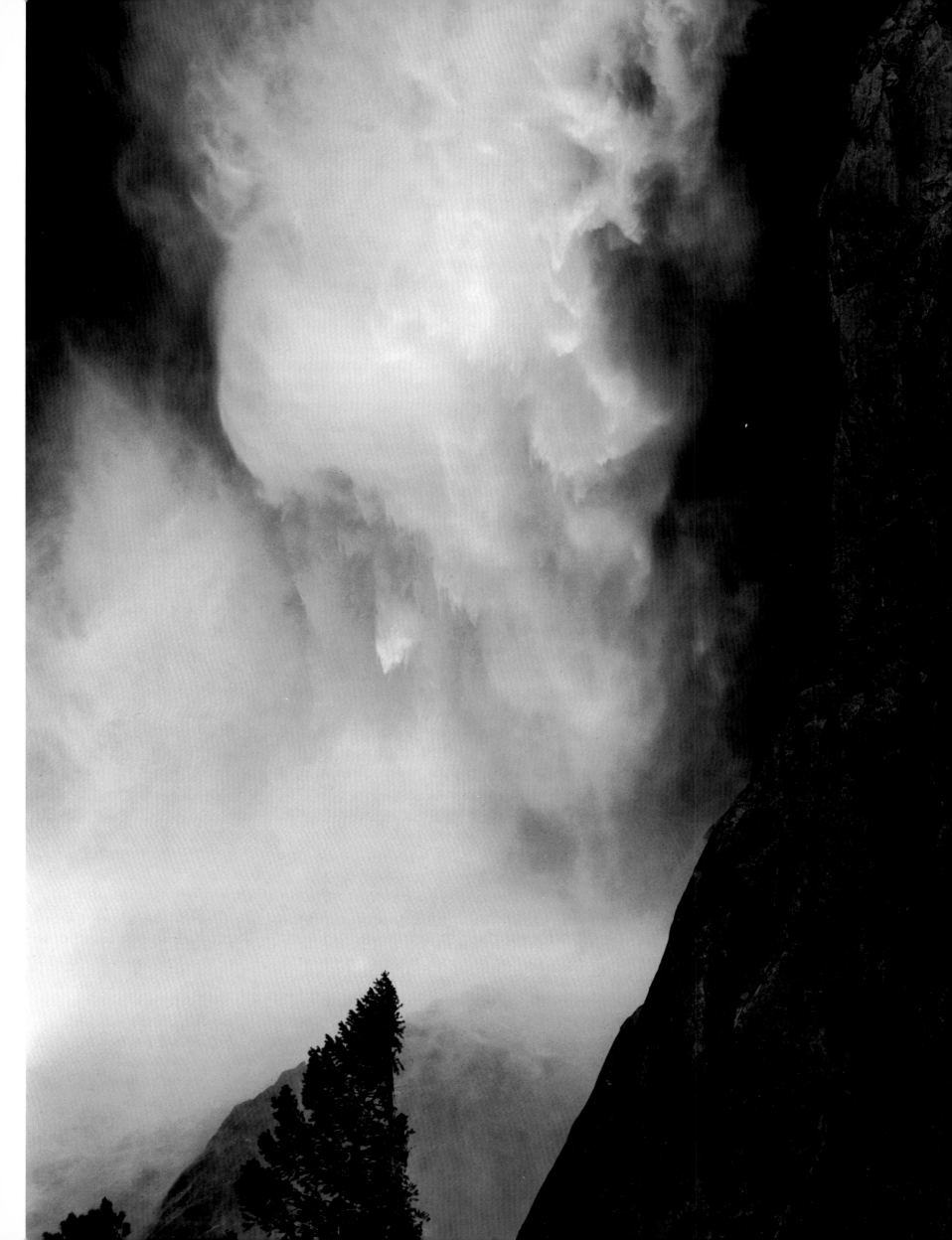

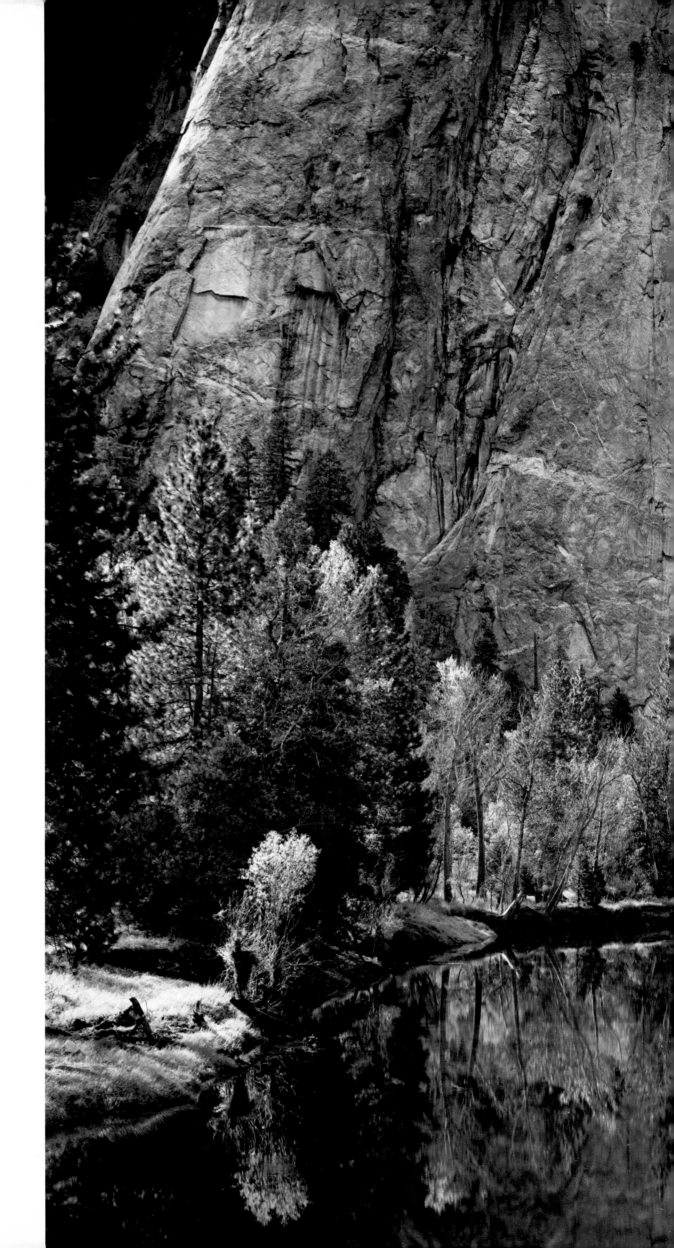

AUTUMN, YOSEMITE VALLEY, 1938

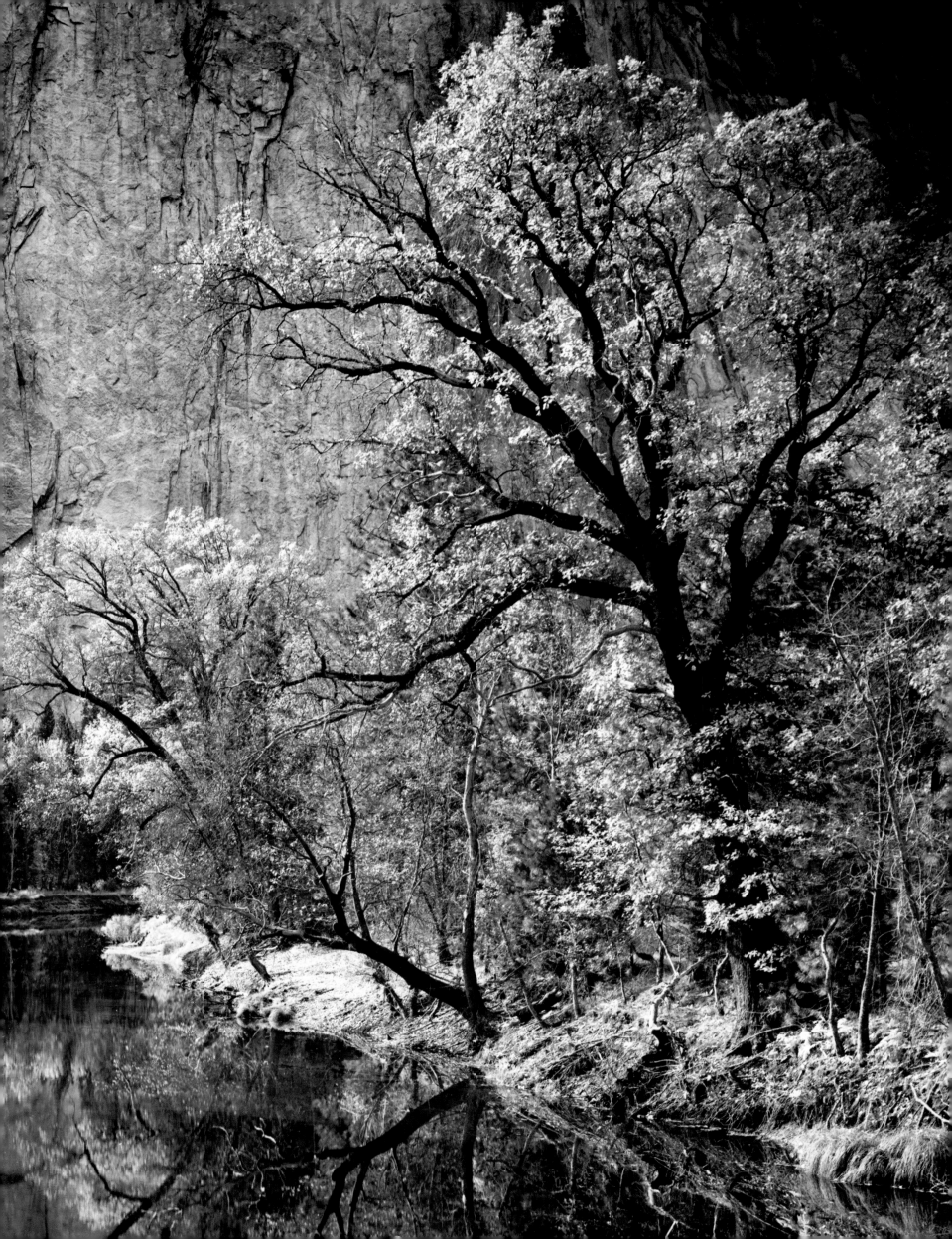

before the fire. The Westons listened sympathetically to his worries and exasperations. But why all the commotion?

Why couldn't Ansel follow Edward's example—simplify? Cut living costs to the minimum and you need earn only a minimum to live. Cut out the fuss and bother of complex tools and techniques such as artificial light, miniature cameras, and enlarging and return to the classic, simple, basic technique of the big camera and the contact print. Leave responsibilities as much as possible to other people; the artist's responsibility is to create. Why couldn't Ansel extricate himself from all these tensions—fighting causes, dashing around the country doing commercial jobs, writing fifteen letters before breakfast, inviting twenty people to dinner, reading scientific publications and science fiction half the night—and concentrate all his time and energy on the great photographs that were in him?

It does not seem to have occurred to any of them that what for a centripetal Edward constituted freedom might constitute prison for a centrifugal Ansel, with his wide-ranging interests, his many gifts calling for unusual opportunities to fulfill them, his astounding speed and energy, and his remarkable imagination from which ideas and projects flashed complete.

When after two days and nights the mists lifted, "and the sun came up in a blue sky, Edward went berserk. Everywhere he looked, there was something to photograph," reported Charis in *California and the West.* Edward would point, Neil and Charis would lunge through deep snow, clearing a path he could follow with his 8 x 10 and film case, and then beat down a circle so hard the tripod legs would not sink. "Edward did cliffs and rocks, the fields and the river, icicles and snowbanks, avalanches, vapory clouds. . . . When he had plowed through the cold white world all day we would return, tired and half-frozen, to the campground de luxe of the Adams's Studio—to hot baths, good food, a roaring fire, and warm comfortable beds."

As soon as the plows could clear the road, Ansel had to leave, though it was all the car could do to grind through the drifts. On March 3 he reported to Edward and Charis, "The Parillia was a great success. My percussion went off with a bang—literally.

"I am so mad that I could not be with you all the time you were in Yosemite. But I want to tell you again what wonderful stuff you got. . . . You caught me in a very trying time and mood—too much to do—too much to think about—too little chance for serious work.

"You and Charis have the faculty of creating vast encouragement just by being around. Thanks—I needed it

badly. You can wave problems in front of me any time—but you seem to be the kind of person that has put problems in their place—in other words, you do not seem to have any at all. You are in a fortunate way, Mr. Weston. That's one reason why your work is so swell."

Edward and Charis decided to go back to Death Valley while awaiting the fateful letter—yes or no—from the Guggenheim Foundation. They urged Ansel to come with them; he *must* come! In Death Valley, they might be able to give him something of what he had given them in the High Sierra, the Owens Valley, and Yosemite. Perhaps too they could give him of their own simplicity and peace of mind. Each day they left hopeful notes of welcome pinned to their tent; each evening, no Ansel. Finally a letter came saying he couldn't make it. "A great blow," wrote Edward, March 23, "But no worse than the wind which I am glad you did not have to buck. In fact, Death Valley has been acting up. One day our tent went over, though well anchored. Maybe it's well you did not come this time. But we must plan another—no excuses will go." A few days later, the long-awaited letter from the Guggenheim arrived, and the answer was yes. Edward had another year for his creative work.

Early in March, Adams received a letter from Beaumont Newhall. First, would Adams like to submit new work for an exhibition of American art the Museum of Modern Art was sending to Paris? And second, what did Adams think of Newhall's plan to establish at the Museum just such a center as that outlined in *Making a Photograph?* To start a collection of great photographs, assemble a library, hold exhibitions, and publish books?

Adams hailed this proposal with excitement, and proceeded to expand his ideas of such a center and how it could function. Then he picked out a few recent things and shipped them off, requesting they be presented "Courtesy of Alfred Stieglitz." His endorsement of the center idea meant much to Newhall, but why the credit to Stieglitz, since the prints did not come from either the Place or Stieglitz' personal collection? "Confidentially," Adams wrote Stieglitz, "he [Newhall] indicated that you were not in sympathy with the work the Modern Museum is doing. That being the case, the problem is two-edged—perhaps you would prefer I did not insist on the acknowledgment. I knew you were not enthusiastic about the exhibit, but I did not know you felt so about the Modern Museum in general. Let me know your attitude at your convenience. . . .

"I feel, from the number of letters I have received from Newhall, that he is trying really hard to do something constructive in his department. I sense that he was given

the job and that he tackled it with enthusiasm, diligence, and with a much higher standard of taste than most undertakings of that kind have approached. I feel that he erred in not consulting you at the very first. I have tried to indicate this basic mistake in my letter to him, and I sincerely hope he will take it constructively. The project is ambitious and of great potential value to photography. With the facilities the Museum has they could do a great job—if they worked on the right track. As a photographer I feel they should be supported and guided. . . .

"I am not telling Newhall that I have sent you a copy of my letter to him. I do not want him to feel that I am 'preparing' any approach or obligating him to consult with you. If he approaches you it should be entirely 'on his own.'" (AA to AS, March 15, 1938)

To Newhall he made a moving statement about Stieglitz: "Too many photographers have forgotten what Stieglitz is, and what he has done for photography. And too many photographers simply do not know about his lifetime fight to maintain the standards of the art in the face of destructive 'popular' developments. In a very definite sense, Stieglitz *is* photography; he has anticipated almost every contemporary phase; and what we are doing today, and the reception of photography as a powerful art form, is built upon the dynamic integrity and insistent courage of Alfred Stieglitz."

Then, Adams tried to state two points: first, the "grave error in the instigation of the 1839-1937 exhibition. Stieglitz should have been the first man to approach . . . I know Stieglitz was not in sympathy with the exhibit, and I have gathered that it was largely because he was not approached as a prime source of information and advice.

"Second, his favorable support of your project is of the greatest importance. In the selection and evaluation of photography he is absolutely supreme. He knows the importance of subtle juxtaposition of print against print; values are accumulative; the significance of sequence and combination is of the greatest importance to him. I feel safe in saying that in all the world no exhibits are hung more beautifully than in An American Place. It is more than just good hanging—it is the composition of *values* and contents and meanings. This goes far beyond the walls of An American Place; it goes right back through the entire perspective of the art and of all arts. And it points the way into the future. It is relatively easy to gather thousands of good photographs; the real task lies in correlating them into a true expression of photography . . . the essence of photographic 'seeing' and revelation.

"You have a magnificent project—and you have the 'plant' to physically effect it. And you have the enthusi-asm to motivate it. What you are beginning now may grow into one of the most important undertakings of its kind. I cannot conceive of any serious photographer not wishing it a vital and complete success." (AA to BN, March 15, 1938)

Stieglitz answered: "My dear Adams: Many many thanks for your letter and for the copy of the letter you sent to Newhall. Both letters are fine. It is almost impossible for a man like Newhall to grasp the spirit underlying all I do and all I have done for the past fifty years or more. I have nothing against the Museum of Modern Art except one thing and that is that politics and the social set-up come before all else. It may have to be that way in order to run an institution. But I refuse to believe it. In short, the Museum has really no standard whatever. No integrity of any kind. Of course there is always a well-meaning 'the best we could do under the circumstances,' etc., etc. Newhall did come to me for some of my prints. I again tried to make clear to him why I couldn't join up with the undertaking. Something happened while he was here which I think was an eye-opener to him. As he left I told him that as an individual I'd look at his work any time he chose—but as an official of the Modern Museum I feared I could be of no use as I felt that in spite of its good intentions the Museum was doing more harm than good. The American idea that always something must be better than nothing I disagree with absolutely. You are right though in letting Newhall have something of yours for Paris. And as for the use of my name, you have my permission, and have had it. But it is good for me to know that there is Ansel Adams loose somewhere in this world of ours. I'm throwing no bouquets, merely stating a bald fact." (AS to AA, April 8, 1938)

To this, Stieglitz was impelled to add: "N.B. Fine as your letter to Newhall is—very fine—I'm afraid the reason you have given him for my not having supported his Photographic Exhibition is not the correct one. The reason was that when he came to me for support I realized that the spirit of what he was doing was absolutely contrary to all I have given my life to. In short that he was doing exactly what I felt was a falsification of values—primarily because of ignorance. Etc., etc.,—I won't go into particulars here. The Catalogue itself was proof that my 'intuitions' were correct."

In the same mail Adams received a reply from Newhall, thanking him for his frankness and spirit of helpful criticism. As for "the most serious gap in the exhibition 1839-1937 . . . I simply want to give you the facts, which you can judge for yourself.

"When the museum asked me to organize the exhibi-

tion I immediately visited Mr. Stieglitz. I asked if he would be good enough to be chairman of an advisory committee as yet unnamed. He declined, on grounds of ill health, to which I was of course sympathetic. I then asked if we might have the honor of dedicating the exhibition and catalog to him, as a slight recognition of his work—provisional, of course, on his entire approval of the contents and presentation of both the exhibition and the catalog. This he declined. I next asked if we might have a substantial number of his works for the show, the selection to be made by himself and presented either by himself or under his direction. This he refused to do on the ground that he could not prepare the prints. Finally I asked if we might borrow from the Boston Museum the splendid collection of his work there, and this he refused to allow, for fear that they might become damaged. He gave his full permission for the use of any of his published material, however. This will explain why he was represented only by his photogravures.

"I cannot tell you how disappointed I was, and still am, that my attempts to enlist the aid of Mr. Stieglitz met with complete and dismal failure. I am fully aware of his position in photography. I am fully in agreement with what you have written about him." (BN, April 8, 1938)

From the moment he read this letter, Adams constituted himself a champion for Newhall and his idea. Stieglitz, he felt, was being blinded by his own prejudices against institutions to the potentials of a person and a project. Stieglitz, of all people, whose life had for forty years been dedicated to just such recognition and affirmation! But Stieglitz was old and ill, and still battling on. Adams put his protest gently:

"There isn't any institution capable of understanding your basis of procedure. With you, everything comes from within—from an Institution, everything has to come from without. No matter what Newhall or anyone else in his position would like to do, he can only do what the 'outside' permits. This 'outside,' being composed of many forces, opinions, and directions, is bound to act as an *average* and not as a personality.

"I think Newhall has a good idea in his photographic project for the Museum—better than any idea I have come across of its kind. In my mind, it all boils down to this—as you are unable to give the time and strength required for such a project someone must do it, as photography is getting more-or-less out of bounds. I feel that when a large plant such as the Museum of Modern Art can turn its wheels in the direction of serious photography that we should all pitch in and make them turn as efficiently as possible on the right track. And institutional

wheels, like autos, can run down hill faster than up hill. Also, like autos, they run on gas." (AA to AS, April 18)

As his own contribution to the "gas," Adams began writing letters to all those he had listed as important for Newhall to consult. "Newhall at the Museum of Modern Art has a swell photographic project," he wrote Weston. "I have been writing him a lot of letters about it. I think you will hear from him soon." The letter to McAlpin led to their meeting and laying the tentative foundations for Newhall's revolutionary plan, a department of photography as a fine art at the Museum of Modern Art.

Stieglitz heard from others who spoke for Newhall—for instance, Lewis Mumford, who had hailed the maligned catalogue, in spite of "the amazing omission" of "the most important modern photographer, Alfred Stieglitz," as "a very comprehensive and able piece of exposition—one of the best short critical histories I know in any language." (*The New Yorker*, April 3, 1937) The catalogue sold out; plans began for a new edition entitled *Photography: A Short Critical History.* Newhall, writing Mumford about the choice for the new title, doubted if any history whose main theme was the development of photography as a fine art could be made without access to the photographs of Alfred Stieglitz. Could Mumford help? Mumford remonstrated with Stieglitz, an old friend: wasn't he being both unfair and unwise?

The most eloquent spokesman, however, was a little portfolio Newhall brought under his arm the next time he came to the Place; it contained a few tiny contact prints on immaculate white mounts.

Stieglitz was touched; perhaps these were not great images, but the sincerity, integrity, and dedication of Beaumont Newhall spoke from every one of them. Yes, he could have a recent photograph for his new edition.

Later that spring Stieglitz became so ill that he did not expect to live. Unfinished business haunted him. Finally O'Keeffe called Newhall. "You *must* come. He's fussing and fretting about that photograph for your book. Of course you won't get it, but come and get it off his mind."

Newhall came and stood at the foot of the bed. "Stieglitz asked which photograph of his did I want for my book? I said, 'Whatever you wish.' He roused himself. 'No, the choice must be yours.' I said I'd like as frontispiece the one that meant most to me—the porch at Lake George, with rain on the grape leaves and mist on the hills. He said, 'Go to the Place. Andrew [framer and matmaker] will get it out for you. Look over others too.'

"Then I asked, 'May I dedicate this history to you?' He said, 'That's not necessary. Again, the decision must be yours.'

"A few weeks later, when Stieglitz was convalescing, I went to the apartment and found him there, all bundled up. He told me I had a mantle to assume, and more or less gave me his benediction to carry on the fight. From that moment on, everything changed." (Interview, 1963)

The other on whom the mantle was to fall was Adams, who was as moved and humbled by the bequest as Newhall. "I wish," he wrote McAlpin, "that I could be half as good as that would deserve. However, I do feel I am one of the very few that feel about photography as he does. What will probably happen is that our group will continue to make photographs as best we can, and the 'leadership' will precipitate itself out of the general solution. I was regretting I could not dash east and see him once more. In fact, I was resigned to a dismal outcome— I felt that he had worn himself out and that the inevitable had happened. But now that he is back on his feet it is entirely possible that he will have many years of active life ahead of him. . . . I have always felt he is sympathetic to my work, and I always appreciated the brow-beatings. But there is a considerable gap between the attainments of Stieglitz and Adams. What I will be at sixty, seventy, and eighty remains to be seen. Probably I will be a photographer!" (AA to DMcA, July 11, 1938)

For both men on whom the demanding mantle was to descend, Stieglitz, risen from near death, was more important than ever. He was a figure legendary even in appearance; Adams once described him, hurling his old black cloak over his shoulder in a moment of fury, as "the mad figurehead of the *Flying Dutchman.*" The one book about him, *America and Alfred Stieglitz*, was an apotheosis published on his seventieth birthday, January 1, 1934. In it, an astonishing parade of great names in the arts, letters, and professions paid tribute to him as prophet, saint, teacher, philosopher, fighter, artist. But each tribute reflected its maker more than his subject; myths echoed on through it, obscuring the facts from which they came. To Adams and Newhall, the book was like a hall of mirrors through which one sought the real Stieglitz in vain. For both of them, the important Stieglitz was *the photographer.* All the other aspects through which the winds of admiration blew were leaves and branches from this mighty root. What were the facts about *the photographer?*

Adams wrote him: "I am anxious to really know all about you and your work in detail—in fact I would like to do a book someday—titled perhaps 'Alfred Stieglitz and Photography.' Your life is so inclusive and complex that I doubt if anyone knows all the pertinent facts and forces. But I think you should be 'gathered together' in one inclusive work—all the stages of your work and your influence on American art. Such a project might interest the Guggenheim Foundation. It would be a grand thing to spend two years pulling you together in a literary sense!" (AA to AS, July 30, 1938)

For Newhall, three thousand miles away, the important thing was an exhibition—the greatest and most comprehensive exhibition of the photographs of Alfred Stieglitz ever held. The book would be a catalogue, with a brief biography, chronology, and bibliography. Through just such retrospectives and catalogues of the work of the towering figures in twentieth-century art—many of whom Stieglitz had introduced twenty years earlier,—the Museum of Modern Art was guiding an ever-increasing public toward an understanding of the new world being created around them in painting, sculpture, architecture, cinema. With a Stieglitz retrospective as its monumental start, the serious study of photography as an art would be nobly launched.

On every side Adams seemed to be involved in the clash of ideals with practicality. He was still fighting for "the vital thread of perfection" in every detail of the presentation of the national parks. On one front he seemed at last to be winning; the problems he had encountered in producing his Sierra Nevada book were now being resolved. Perfection is costly, and after Walter Starr had been repaid his generous subsidy, there would not be much left for Adams. But the book would be as perfect a work of art as he could make it, and he hoped it would be an effective messenger in the cause of conservation.

Concerned with concessions in the parks, and trying to help Virginia develop Best's Studio, Adams found himself still obsessed and infuriated with the curio situation. Originally the curios had been authentic fragments of their environment: Indian relics, specimens of rocks, wildflowers, butterflies, woods, leaves. Of these, since they had to be gleanings from cultures and regions outside the park, there was never a large supply. With the automobile and the ever-increasing millions of visitors, demand for a different type of curio arose, garish, flashing, cheap, and mass-produced to give everybody some souvenir to take home. Gaudy postcards, pillowcases, dolls, pennants, funny hats, and fake Indian jewelry were bad enough, but worse followed: jocular beer mugs and whiskey flasks, ashtrays shaped like miniature chamber pots and other vulgarities, all emblazoned with the name of whatever resort or carnival had ordered them, and destined to litter shelves and window sills, identified until their merciful demise with memories of "Coney Island," "Chicago's World Fair," or "Yosemite National Park." They sold by the millions; almost without exception

concessionaires in every national park placidly sold them, apparently assuming that the public had no taste and that the profit was important to their staying in business.

Ansel and Virginia soon realized, as her father, Harry Best, had before them, that paintings, photographs, photo-finishing, and fine books did not sell in enough volume to net the modest profit that would insure Virginia and the children a living. So they sought out attractive merchandise of different kinds, each genuine and chosen with exacting taste, whether as inexpensive as a pair of silver earrings or costly as the massive ancient Navajo ornaments that are collectors' items. But finding such material took time, energy, imagination, and considerable experience in selling, whereas the abominable curios required only that one shut one's eyes, assume the worst of public taste, and sign an order.

A letter Adams wrote outlining some possible solutions, was brought to the Director of the National Park Service. "Your statement has impressed me very greatly," wrote Arno B. Cammerer, "and I think you have presented some very constructive suggestions. I am wondering if you would consider writing a statement of policy, governing the type of souvenirs and curios, that might be considered by the Department and by the other operators as a practical goal." (ABC to AA, April 4, 1938)

Adams, now familiar with the psychology as well as the problems of those who operate concessions in the national parks, began with a summary of the cultural potentials of the parks, vast "but as yet but slightly developed," in case some operators might have never considered these potentials in relation to business. " 'Public Service,'" wrote Adams, "includes pictures, postcards, and souvenirs just as much as it relates to rooms, meals, stores, garages, etc." Then he focused on the curio and its effects. "The shops selling such 'Curios' cannot be blamed for depreciating the Public Taste and exploiting the Parks. Nothing else exists for them to obtain and sell on a commercial scale, and few of the dealers have the taste, knowledge, or capital necessary to enter a special manufacturing field. Curios have paid them well and enabled them to conduct other phases of their business in a satisfactory way, both to the public and themselves."

Acknowledging that "the American Public seems to have acquired the Curio habit," and that "an immediate change of policy would produce hardship on both visitors and operators," Adams nevertheless maintained, "discrimination exists in almost every class of people, but discrimination is often secondary in the face of relatively low prices and availability." The obvious answer: "good quality curio material in volume production."

Material of appropriate quality, since it did not exist, would have to be created. For California parks, Adams suggested useful objects in natural woods and rocks, decorative collections of pressed leaves, carvings and casts of local animals, insects, and birds.

"Merely licensing commercial factories to produce such material would not be satisfactory unless proper control were exercised. All such material should be designed, executed, and supervised by competent artists and craftsmen. There are many fine artists and craftsmen now under WPA and Treasury Department patronage who could do a magnificent job in this field. For instance, a fine sculptor could design little figures of animals and birds which, on Park Service approval, could be duplicated in quantity in appropriate materials. Descriptive booklets could be designed and compiled from the works of good painters and photographers, etchers, and lithographers. And so on through the entire field of Souvenirs." (Manuscript, dated April, 1938)

This statement was incorporated by the Park Service in their official handbook for operators, but nothing ever happened to his proposal to use the artists in the WPA program who might have produced results as beneficial as the Index of American Design or the series of State Guides. Perhaps if he had persuaded Benny Bufano to make in miniature animals as delightful as those he created for children to ride and slide on beside a public swimming pool, if he had persuaded Edward Weston to get out his Point Lobos photographs—then again, perhaps not. Benny's every move seemed to cause storms of controversy, and Edward's pictures were likely to strike officialdom as "just rocks, old stumps, and dead birds." Again, perhaps the proposal came too late; with the return of prosperity and the obvious menace of war in Europe, the public works projects which had saved thousands from the breadlines were ceasing to be necessary.

The curios remained as bad and as profitable as ever. Adams stuck out his jaw and decided that at least in the matter of booklets there were things he and Virginia could do themselves—an illustrated guide to the Valley, for instance, and a book on Yosemite for children, based on a day in their own children's lives.

Problems of interpretation of a different kind suddenly arose. A book to be called Five American Photographers, of whom Weston, Adams, and Van Dyke were three, had been proposed. A copy of the foreword, by a left-wing critic, was sent to Weston, who discovered that he and Adams, in particular, were being cited as artists who belonged to the past since they had not seen the great light of the Marxian dawn. Edward, whose quiet exterior con-

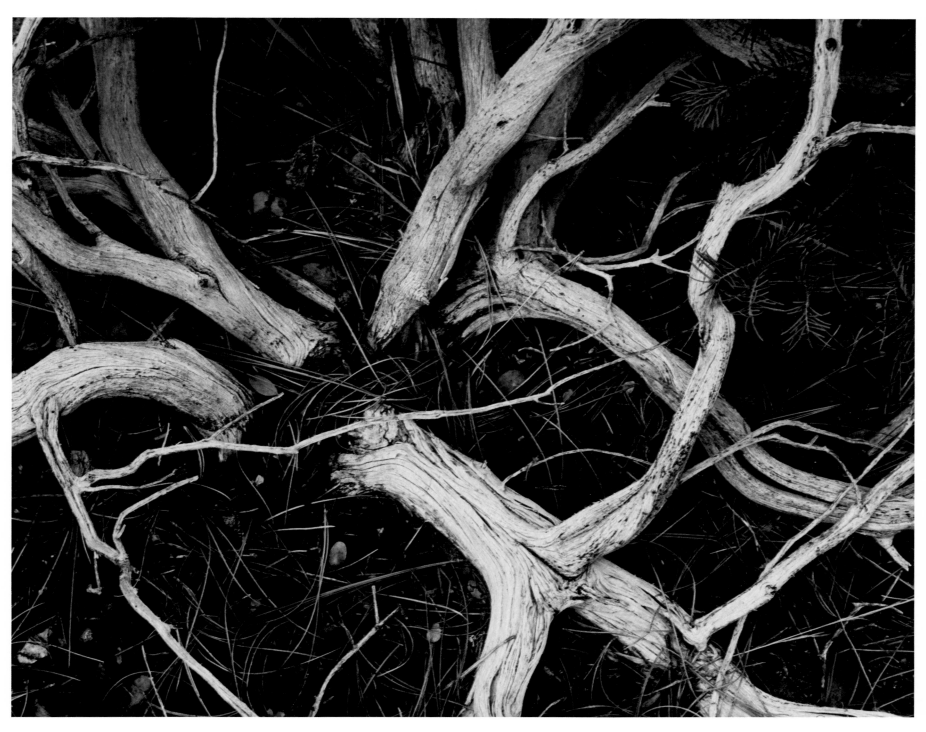

MANZANITA TWIGS, SIERRA NEVADA

FLOWERS AND ROCK, SIERRA NEVADA

cealed a volcano, erupted. He wrote Ansel: "I have re-signed from the proposed book on 5 Amer. Photogs. Read the foreword and could not stomach it. Have written 12 pages (longhand) giving reasons for my withdrawal. I will send you a copy. I don't think you will like the foreword either.

"I'm a bit weary of sitting back and listening to youthful radicals expound. The movement is full of 'escapists' goose-stepping in single file through impenetrable walls built of dialetic materialism (whatever that is)." (EW to AA, April 14, 1938)

Ansel had been worrying about the book too. "I had a small lurking feeling that the foreword would be just as you describe it. The trouble with us, Edward, is that we are narrow—we are dead—we don't know what's going on (and we don't give much of a damn about it anyway). But I would rather have one 'dead' Weston that 1,000 alive Dialectic Goose-Steppers." (AA to EW, April 16)

When Charis returned from Carmel, where her father, the writer Harry Leon Wilson, had suffered a stroke, and went to her typewriter again, Ansel received a carbon of Edward's explosion. "I do not mind," wrote Edward, "faint praise which damns (though I would much prefer to have my work condemned or ridiculed) and I can disregard running commentary on our individual characteristics: 'Van Dyke's air-like purity with morbid lyricism . . . Adams's bright frankness . . . Weston's darkness, ingrown sensuality, stone-like seriousness.' But I do take exception to being grouped as though we all had the same ends, all accepted his summing up of the next great step which would automatically make us functional—'truly contemporaneous.'

"'. . . preference for flat immobile surfaces'. . . What unmitigated nerve! . . . 'air of restraint is fear of emotion' —Have you ever noted an air of restraint or fear of emotion in me? . . . 'in this group is defined a period no longer possible. . . .' My 'faces and postures' period, my heroics of social significance were done about 1923 . . . My industrial period was over by 1933. My façades ('immobile surfaces') were done in Mexico from 1925-27 . . . before I ever heard of Atget. In this latter period are included interiors of peons' huts and tenement houses. . . .

"It seems so utterly naive that landscape—not that of the pictorial school—is not considered of 'social significance' when it has a far more important bearing on the human race of any given locale than excrescences called cities. By landscape, I mean every physical aspect of a region—weather, soil, wildflowers, mountain peaks— and its effect on the psyche and physical appearance of the people. My landscapes of the past year are years in advance of any I have done before or any I have seen."

As Edward read over the foreword, he found more and more to irk him. "Example, his appraisal of Atget. Stieglitz did documents at least as fine in the '90s, and Strand's Blind Girl is finer than anything of Atget's to which it could be compared. Atget was a great documentary photographer but is misclassed as anything else. The emotion derived from his work is largely that of connotations from subject matter. So to 'Nevertheless these five have feeling,' I say, 'Thanks.' I have a deep respect for Atget; he did a certain work well. I am doing something quite different."

To Ansel, Edward apologized "for any unseemly ego expressed. I felt it necessary for emphasis. *You* 'bright frank' maker of socially insignificant photographs! And me, 'dark and sensual. . . .' It's good to know there is another 'bourgeois liberal' in the photographic world. (I'm really handing us a bouquet.)" (EW, April 22)

Ansel responded: "Your reply is magnificent. One of the best statements of an artist's standpoint I have read. It should be published in ten million copies and sent broadside.

"I will help you man the guns any time! . . . Your analysis of what 'Landscape' means to you is masterful. Let me shake your hand!" (AA, April 25)

The next news from Edward was headed "Surprise!" An arrow pointed to a new address in the Carmel Highlands "which is to be permanent. Neil [his son] is building me—or us [he and Charis were now married; on her father's land, they had found a homesite beside Wildcat Creek]—a one-room plus darkroom plus fire-proof vault, house. It will cost about as much as a Ford.

"I have been printing. Have a hundred or so to show you. . . . Have you good news *re* your Lakeside Press reproductions? I may want to spring them on an interested party. I may have a book, or *we* may! Charis's 'log,' my picture postcards." (EW to AA, no date).

Ansel had a chance to see the "picture postcards" when Edward and Charis, on one of their last journeys before they settled down in the new little house to print the results of his Guggenheim, came again to Yosemite in June. And Edward had a chance to see what Ansel still regarded as "proofs" of what he had done in New Mexico on that trip with O'Keeffe and McAlpin the previous fall. Up in the darkroom, they tried out various papers and developers for tone, depth, contrast; Edward was concerned about setting up the simplest, perfect system for printing his thousands of negatives, and to what better authority could he turn who had the subtle perception and sympathetic understanding of an Ansel? They talked about books too, and the problems of reproduction. Afterward Edward wrote Ansel: "You, and *your work*, mean

a lot to me. Realize I have almost no one who speaks my language. And those new New Mexico landscapes—superb! I know the mood you are in, but don't undervalue them. Your problems must, and will work out. Sounds like a cheap Optimist!" (EW to AA, no date.)

After Edward left, engraver's proofs for the Sierra Nevada book began to arrive at Best's Studio from the Lakeside Press. To David Brower they were "the finest I had ever seen. In after-hours' sessions in the Studio there would be a Lakeside proof, trimmed flush, on the piano, and an Adams print beside it. New guests were asked to tell which was print and which was proof. It wasn't easy. It was revealing, among other things, of a man's insatiable desire to see something done better than it had been done before, and to get craftsmen to exceed themselves." (Manuscript notes, 1963).

Ansel reported to Edward: "Got six proofs from Lakeside Press. Simply superb. Best reproductions I ever did see. Now listen:

"Your work is the best going. If you do any book the plates should be correspondingly fine. I think you agree on that. The main problem is whether you want mass production—which means second-rate reproductions, or whether you want limited production with swell plates." There followed, in characteristic Ansel fashion, cost estimates of each alternative.

"All you need," concluded Ansel, "is someone to back you on the production, subsidize you, and amortize the subsidy through the first sales." (AA to EW, July 4)

Over all the figures, Edward shook his head. He regarded Ansel's "headpiece" as "the most remarkable he ever met." (Interview, 1950) But he had had no experience with the manifold techniques of book production and publication. And all he had ever asked of finance, high or low, was to stay one jump ahead of the wolf, and go on making photographs. In his case, he felt, it would be better to let a commercial publisher worry.

Ansel resumed on July 15: "I think that you will find out two things about publishers.

"1. They will always *rush* you and then stall you.

"2. They will propose something *big*, worry very little about actual quality, and then carp about how expensive it is and the probability of limited sale, etc.

"Distribution *is* an important item. But after all distribution to the people you want is the important kind."

"Another thing about publishers," Adams wrote David McAlpin, to whom he was sending "astronomical-size" letters on the same subject, "it is hard to control the quality of reproductions and design—the most econom-

ical procedure is the most attractive to them. Do you realize that a book produced in the regular manner and sold in stores, is subject to the following cost limits:—

"a book selling for three dollars retail
 is sold for two dollars wholesale
 out of which must come

"credit risks
 distributing costs
 agent's fees
 production costs
 publisher's profits
"and finally, royalties to the author or artist. Ouch!!!"

Books. Regional books. Books on photography. Books for conservation. Such a series might solve his problems, both financial and creative. And, as he wrote McAlpin in that same letter:

"The Book idea seems to be my *metier:* not only would I be doing what I could do best, but I am certain that with care and system it would be a profitable course to take. . . . Our place here in Yosemite should about pay for itself this year. Next year it should make a little profit. It is my wife's business and capital, but, of course, I feel quite responsible for making it go. If it once gets going and paying a modest income for my wife and the two kids, I would feel free to step out and concentrate entirely on my own stuff. I only hope I can last long enough for it; I find myself annoyingly tired all of the time, and suffering a descending curve of the creative drive.

"You speak of a book on photography. My first book (*Making a Photograph*) has gone over very well indeed. I gather that about 20,000 copies were sold. This book has filled its purpose; it had some excellent qualities, but I feel that I would like to do something much more complete and representative of my work. Also something which would be a 'lead' to a series."

Adams then outlined many books and continued: "It is hard to stop visualizing things to do! Half of every year I could devote to making a book; as the series increased, the sales would undoubtedly increase.

"Just writing this letter to you about all the possible things there are to do created an enthusiasm. Perhaps I will feel like making some good prints tomorrow! Edward Weston comes up to see me once in a while and tears his hair about my scant production of good stuff and my very large output of advertising tripe." (AA to DMcA, July 2)

Along with these panoramic publishing projects in the letters to McAlpin came plans for a fifteen-day trip through the High Sierra in early September. To Adams it was of the utmost importance that such people as

O'Keeffe, McAlpin, the Rockefellers—and if only Stieglitz and Marin could come too!—should experience the Sierra. He would take them over his favorite trails; they would camp in tranquil meadows and beside bright lakes.

"You know how crazy I am about the Southwest. But I tell you, that for sheer beauty there is nothing like the Sierra. Impress upon O'Keeffe that she will see things she had never seen before. There is no human element in the Sierra—nothing like New Mexico. But there is an extraordinary and sculptural natural beauty that is unexcelled anywhere in the world." (AA to DMcA, *ibid.*)

He succeeded in his persuasions, and the date was set.

On September 6, Ansel wrote Stieglitz: "The Gang is here!—O'Keeffe, Dave [McAlpin], the Rockefellers! We leave tomorrow morning for the high mountains—about fourteen mules, guide, packer, cook, much food, warm bedding, photographic equipment, and great expectations in general.

"I met O'Keeffe at Merced and drove her in to Yosemite Tuesday. She likes our country, and immediately began picking out white barns, golden hills, oak trees. As we climbed through the mountains the scene changed rapidly and as we entered Yosemite she was practically raving—'Well,—really, this is too wonderful.' We came into Yosemite at dusk—a very favorable hour. . . .

"On Thursday I met Dave and the Rockefellers and drove them in via Hornitos, an old mining town near Yosemite. They, too, seem quite touched by the scene. Yesterday we drove to the Big Trees, and had lunch there; later we drove to Glacier Point, where we had supper. It was an incredible moonlight night.

"Today, we are packing, sorting, eliminating, and generally hard at fussing with fussable things. Tomorrow we start, and for fifteen days many of the fussy things will become simple and many of the simple things will be fussy, but we will have a grand time.

"The only regrettable thing is that you are not out here seeing all this with us."

Again the direct simplicity of O'Keeffe's vision had its impact on Adams, particularly in Yosemite. As he watched her look at it, all the old irritations, wearinesses, and stereotypes which had oppressed him seemed to vanish. He could see the Valley as though he too were seeing it for the first time, not as O'Keeffe saw it, but with a new meaning and a new magic for his own vision.

Adams wrote McAlpin (November 4, 1938): "For the first time in a long time I feel happy and healthy and damned enthusiastic. And you and your encouragement started it all. Actually, the trip was wonderful and opened all sorts of vistas. . . ."

But to *what* a schedule he had returned! He wrote Edward: "I am literally swamped. The Sierra Book will be out next month. I have about 2,000 square feet of photo-mural work for the Fair—two exhibitions. There is the possibility of two other jobs coming up along the same lines. I am finishing a large job for a decorator. I have five albums to complete in time for Christmas, and I have to get my Southwest pictures together before the first of the year. Add to this the Christmas festival in Yosemite, the work in Yosemite with the camera, three portraits, two architectural jobs and a book of seventy reproductions for a painter, and you can see I am busy. I am in the position of absolutely having to get all this done before February 15th, as I am headed for New York about that time.

"I have some new prints—best I ever did. Must show them to you. . . ."

So Ansel was back in the same old treadmill. "Adams, my boy," wrote Edward, "I hardly know words strong enough to express my feelings—You can take the 2,000 square feet of photo-murals for the Fair, and stick them up, or rather down, your darkroom sink.

"But cheers for the new prints, the 'best ever.'"

But Ansel insisted: ". . . this particular job is good for me. There is nothing creative about it—nothing that is my own work, nothing that creates a conflict. Just a lot of negatives of various things by other people entrusted to me to technically correlate and blow-up. A purely practical job if ever there was one, but it will net me more than a year of Guggenheim! The trouble with me is, I can't forget anything—I want to be simple but my world won't let me. . . ."

Then he burst forth over a recent affliction: "Walker Evans' book gave me a hernia. I am so *goddam* mad over what people think America is from the left tier. Stinks, social and otherwise, are a poor excuse and imitation of the real beauty and power of the land and of the real people inhabiting it. Evans has some beautiful things but they are lost in the shuffle of social significance." (AA to EW, November 7, 1938)

This book—*Walker Evans American Photographs,* with an essay by Lincoln Kirstein, Museum of Modern Art, 1938 —caused Adams to explode to several favorite correspondents. To O'Keeffe (November 11, 1938): "I think the Book is atrocious. But not Evans' work in the true sense . . . it's the putting of it all in a book of that kind—mixed social meanings, documentation, esthetics, sophistication (emotional slumming), etc. Just why the Museum would undertake to present *that* book is a mystery to me—although I can easily understand their presenting the finer

photographs *as photographs.*" To McAlpin: "... I do not believe the book should be called 'American Photographs' and put out by an Art organization. ... But see what happens—the 'esthetes'... build up a good bit of smoke about a rather damp fire. Afraid of honest sunlight, they draw comparative conclusions on the art value of document and the documentary value of art, and indirectly and vicariously take their petulant jabs at the social order. The result is that true documentation suffers by an anemic plaster of art, and true art gets all mixed up with doctrine and examples and 'facts.' If you remember Stieglitz' early street scenes of New York—they were, first of all, fine photographs. They were so fine that the 'third dimension' of mood vibrated in them. Conclusions on the part of the spectator are inevitable. Hence, they are infinitely better propaganda documents than some self-conscious messenger of decay. I certainly do not like Kirstein's article in the book in question. So glib and so limited! O well. But I still think Evans has made some beautiful pictures."

Then Adams states what were to become for him major themes: "I am very far from being 'Patriotic' but I do resent untruths, exaggerations, false colors in relation to the land in which I work and live. Let us show everything that is false and inhuman, sordid and without hope, without alleviation of the larger fact, and our infection can only widen and deepen and eventually consume us. But, as Dorothea Lange has done in her Farm Security photographs—showing a magnificent moment in the plowing of the land in one picture, and in the next showing a pitiful shack of a migrant family—we can show the good along with the evil.

"If I feel I have any niche at all in the photographic presentation of America, I think it would be chiefly to show the land and sky as the settings for human activity. And it would be showing also how man could be related to this magnificent setting, and how foolish it is that we have the disorganization and the misery that we have. I too could go back into the past for comparisons of points of view. Much of the art of the Renaissance gave man his 'setting'; recall the magnificent bits of landscape in Italian religious paintings. Again, in Dürer, both the exalted and sordid subjects are shown against the earth and sky. They are 'keyed' to reality. 'The Hegelian theory of opposites' of which Kirstein speaks certainly has greater significance than the accidental juxtaposition of a 'For Sale' sign on a delicate pillar. The sign may have been there along with the pillar, but the true significance is just what you choose to make it.

"They are tearing down the old Sentinel Hotel here in Yosemite. It was a swell old building with a wonderful mood about it. The delicate pillars are shattered, a pile of junk is on the porch, a big 'Keep Out' sign is plastered on the wall. I can photograph it to represent the pitiful dissolution of a sound culture,—as an example of the final wrecking of a rundown shack,—as a mere record of work-progress for the engineers,—or as a step toward the improvement of Yosemite. It actually happens to be a good thing it is coming out. But I cite the above just to indicate how very false photography *can* be—false intentionally or unintentionally as the case may be.

"You may wonder why I am blowing up so much about this, and I can only answer by saying that I get annoyed when things go off at tangents." (AA to DMcA, November 4, 1938)

Two or three weeks later, Adam's own book, *Sierra Nevada: The John Muir Trail,* finally arrived, bound in pure white, with fifty rich half-tones tipped in among a luxury of fine paper. Its function, as Adams wrote in the Foreword, was: "... the emotional interpretation of the Sierra Nevada—the revelation of the beauty of wide horizons and the tender perfection of detail. No attempt is made to portray the Range in the manner of a catalogue. A detail of a tree root, a segment of a rock, a great paean of thunder clouds—all these relate with equal intensity to the portrayal of an impressive peak or canyon. ... The majesty of form, the solidity of stone, the eternal qualities of the Sierra as a noble gesture of the earth, cannot be transcribed in any but the richest and most intense expression. Nevertheless, a certain objectivity must be maintained, a certain quality of reality adhered to, for these images—integrated through the camera—represent the most enduring and massive aspects of the world, and justify more than an abstract and esoteric interpretation. I feel secure in adhering to a certain austerity throughout, in accentuating the acuteness of edge and texture, and in stylizing the severity, grandeur, and poignant minutiae of the mountains."

He sent a copy to Stieglitz, who wrote December 21:

"You have literally taken my breath away. The book arrived an hour ago. Such a grand surprise. O'Keeffe rushed over to see it. I had phoned her at once. ... What perfect photography. Yours. And how perfectly preserved in the 'reproductions.' I'm glad to have lived to see this happen. And here in America. All American. And I'm not a nationalist. I am an idolater of perfect workmanship of any kind. And this is truly perfect workmanship. I am elated."

Ansel answered: "I know the book has faults, and I know you and I would probably agree on them. But you

have seen the thing as a whole—its basic intention and quality. I am no nationalist either, but I respond to the very important fact that it was *all* done in this country, and that such things *can* be done in this country at this time....

"Some of my left-wing friends accuse me of bowing to the Rich simply because the book looks so well. It seems that the new order of society is afraid of clean hands. Some people who live in 'functional' architecture (the roof probably leaks) think I have done a stupidly conventional book—where-o-where are the bled pages, the lower-case type blocks, the montage and the spiral bindings with the celluloid covers??? I am thinking of doing an Astronomical Book some day that will be so damn modern that Moholy-Nagy will have a stroke. It might interest you to know that it took us months to find the right type for the title page; the letter chosen is derived from inscriptional letters incised in hard stone (the letters cut in soft stone are more fluent). The Sierra is granite, and the letters have the formal simplicity of carving in such stone." (AA to AS, December 26, 1938)

Georgia O'Keeffe wrote Ansel: "Your book is like a trip in the High Country again."

Francis Farquhar said in review for the *Sierra Club Bulletin:* ". . . here, in bright light and in rare clarity, is to be found the very essence of the Sierra."

David McAlpin presented copies of the book to, among others, the Grolier Club, the University Club, the Union Club, the Metropolitan Museum of Art, and the Museum of Modern Art. I remember the delight on his face when he handed the large and heavy package to Beaumont Newhall. "Now—what do you think of *that?*"

It was pristine, spectacular, dazzling. I remember that first look at it, there in the library of the Museum of Modern Art. The pure whites, the deep blacks, the sharp and intense images beat on my eyes. As I went home I kept seeing, instead of New York City around me, ice on a lake bright under dark cliffs, a stream channeling through granite, new grass springing beside a charred tree.

To some New York intellectuals, especially the "anti-graphic" group, to whom beauty was a sybaritic distraction and nature a sentimentality, the book was too handsome, too luxurious, even inhuman. Lincoln Kirstein, riffling through it there in the Museum library, remarked, "Doesn't anybody go there?"

The Chief of the Forest Service wrote: "I have never seen more extraordinary photographs of outdoor scenery. Although I have not visited the High Sierra country, these pictures give me a feeling of the stupendous beauty of this country such as I didn't think possible while sitting in a remote office.

"These beautiful photographs certainly impress on one the value of the objectives for which you and the other members of the Sierra Club have been fighting for many years—the preservation of the natural environment of the High Sierra." (F. A. Silcox to AA, December 30, 1938)

And from Arno Cammerer, the Director of the National Park Service: "It is one of the most perfectly conceived and beautifully executed books I have ever seen.

"The work of John Muir to bring the wonders of the Sierra Nevada to the attention of the world, so that practical protective measures would be enacted, is fittingly supplemented by the work of your camera." (Arno B. Cammerer to AA, December 28, 1938)

Kings Canyon National Park was finally established by Congress in 1940. Cammerer wrote Adams in February: "I realize that a silent but most effective voice in the campaign was your own book, *Sierra Nevada: The John Muir Trail.* So long as that book is in existence, it will go on justifying the Park."

DEAD TREE, SIERRA NEVADA

GRASS AND POOL, SIERRA NEVADA

FROZEN LAKE AND CLIFFS, SIERRA NEVADA

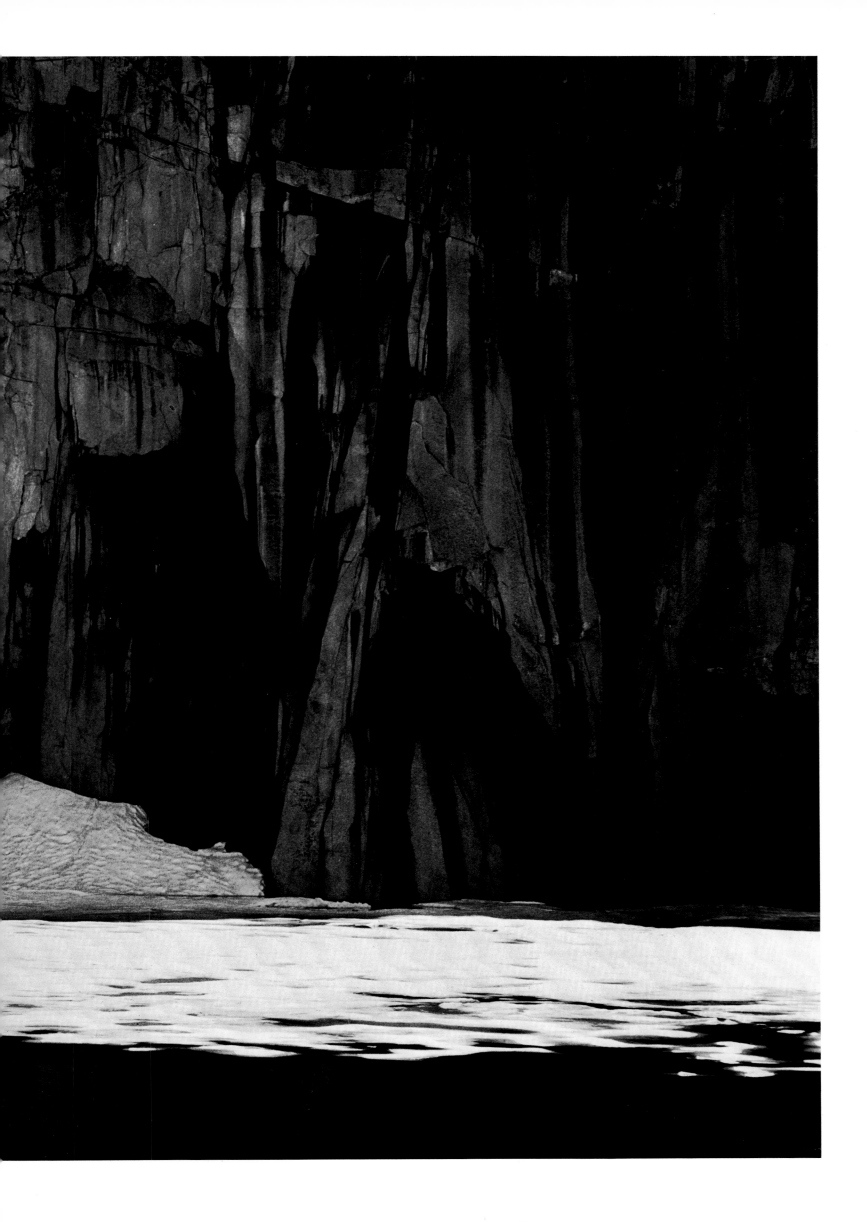

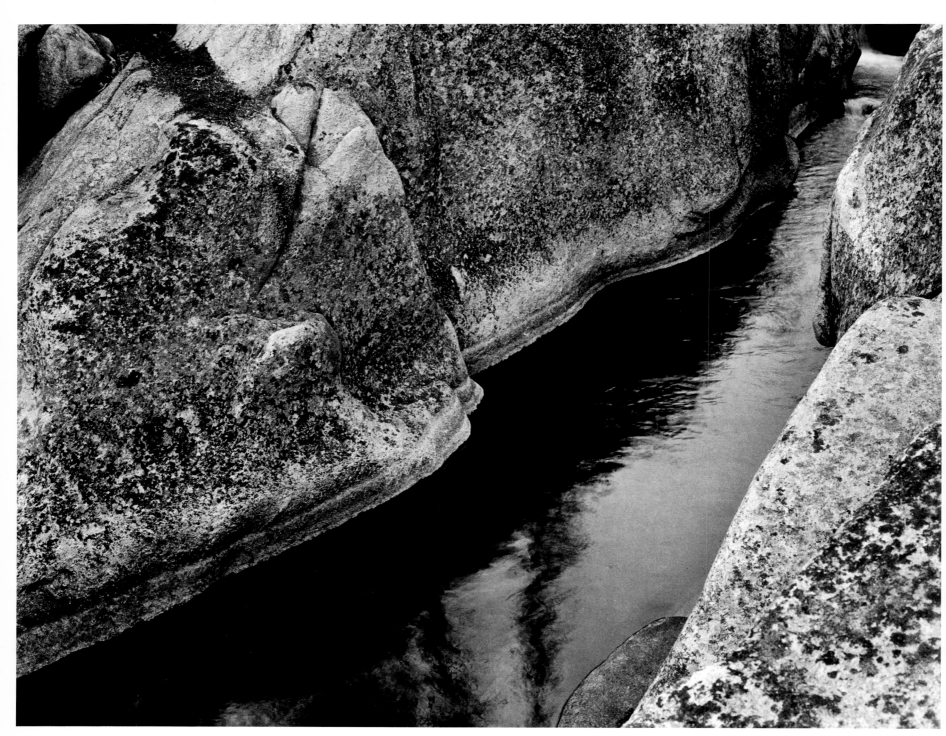

ROCK AND WATER, SIERRA NEVADA

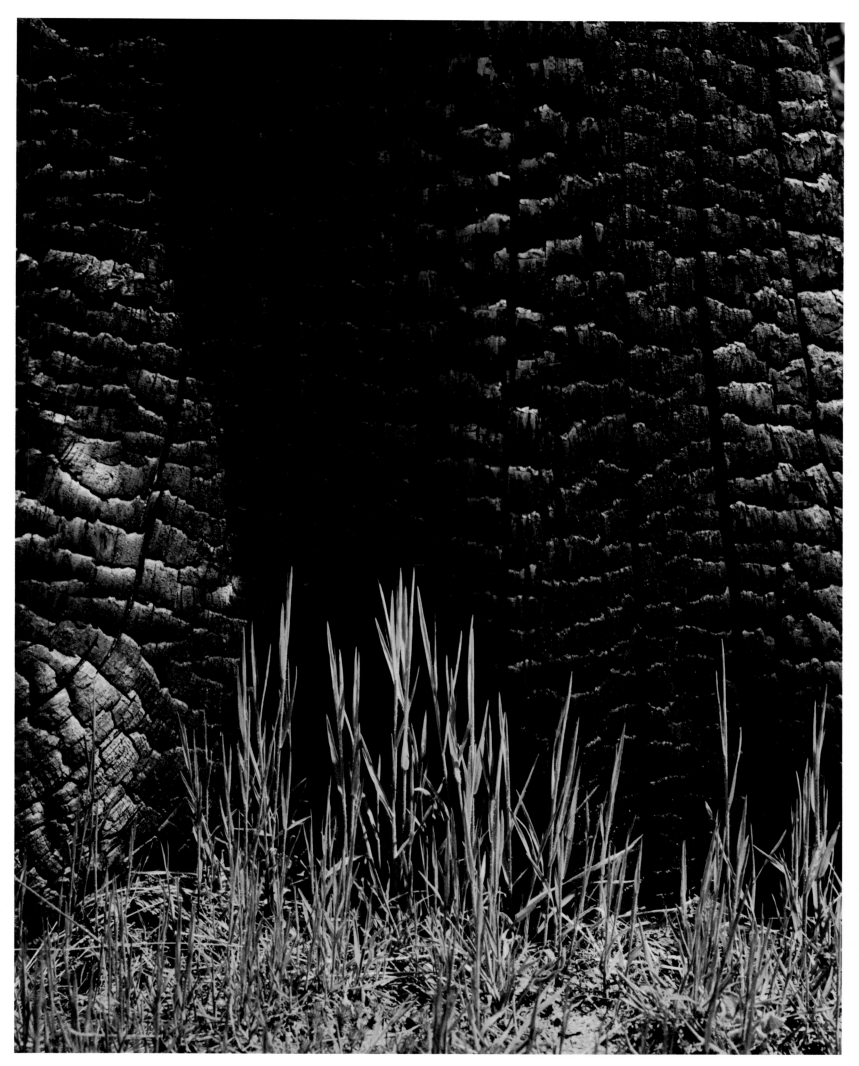

GRASS AND BURNED STUMP, SIERRA NEVADA

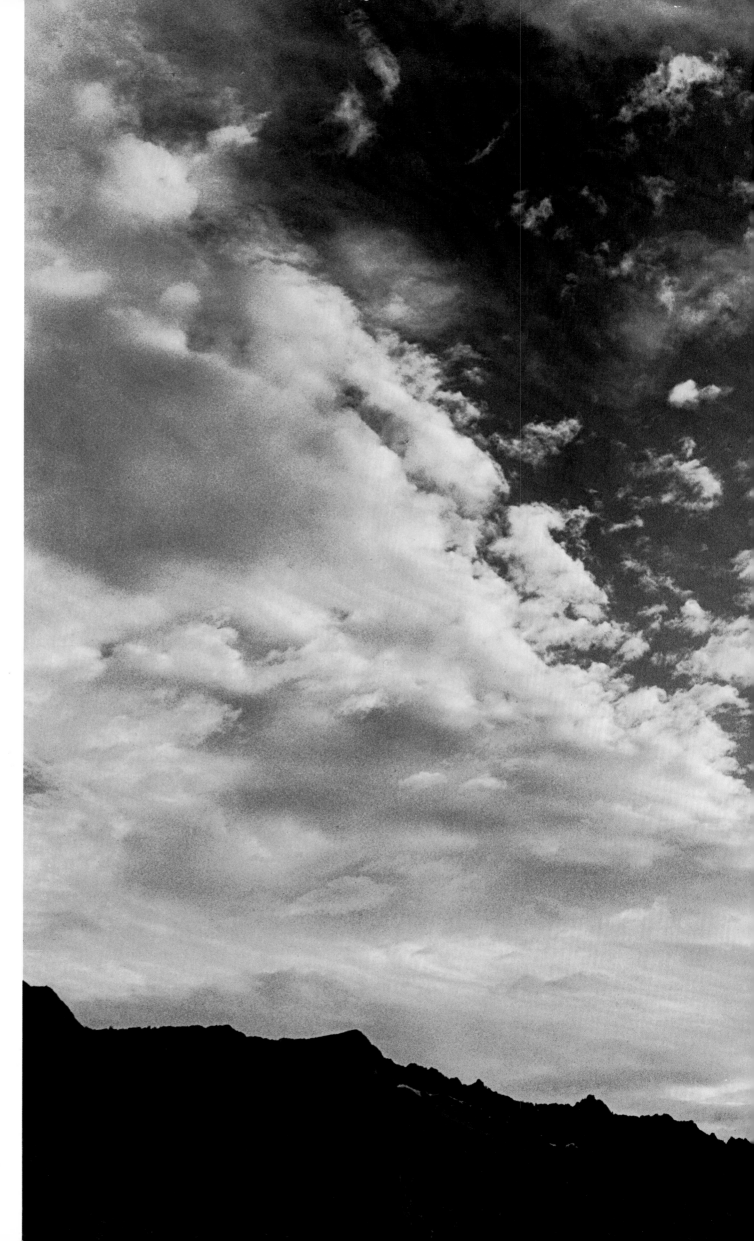

SUNSET, DEVIL'S CRAGS,

SIERRA NEVADA

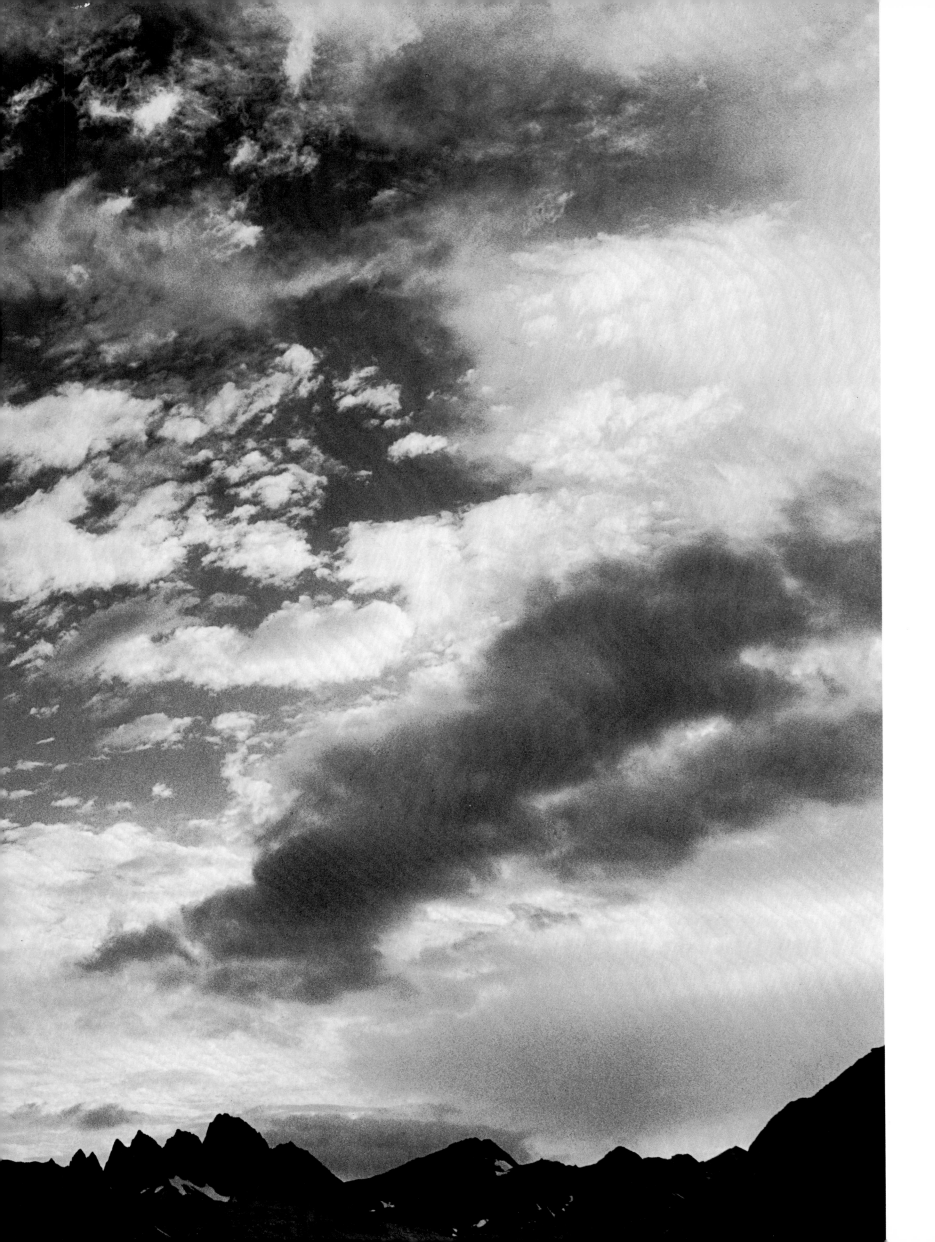

ANSEL ADAMS, SIERRA HIGH TRIP, 1930s (CEDRIC WRIGHT)

FOREWORD TO THE FIRST EDITION

It is hard to tell which shaped the other more—Ansel Adams or the Sierra Club. What does matter is that the mutuality was important. The club provided, by chance, a small building of which a teen-age Ansel Adams could briefly be summer custodian; it provided him for many later summers a group of people who liked mountains as well as he did and who, as he helped lead them along wilderness trails in the Sierra Nevada, learned to see more than they had expected to; and it provided him with a respect that has never ceased growing.

What he brought the growing number of members of the club—and unnumbered people beyond that group—may be nicely epitomized in a postscript Alfred Steiglitz wrote in 1938: "It is good for me to know that there is Ansel Adams loose somewhere in this world of ours." What he brought to the club's purposes was an f/64 clarity in the appreciation of the land and what it means to man. Each place has its own genius. Adams reminds us what the genius of man can see, if he looks insistently enough, of the genius of nature, with which he used to be on good terms, and can again be. As a photographer of great places, he came quickly to discern what did not belong in those places. If something wasn't good on his ground glass, it probably wasn't very good in a national park either, or a forest wilderness. He quickly learned to single out the little and big things that eroded the mood, that intruded on the uniqueness a man visiting a national park ought to have a chance to experience—the uniqueness Adams himself was seeking to interpret with his photographs.

That Ansel Adams came to be recognized as one of the great photographers of this century is a tribute to the places that informed him. It can also bring pleasure to those people whom he instructed and who helped delineate him.

In the recording of this human interplay Nancy Newhall, with subtle selectivity and with a broad knowledge of the world of photographs and photographers, has revealed beautifully how Ansel Adams grew. This is first-hand history and a scholarly work too. In the words of her husband, Beaumont Newhall, who knows and would not say it if he did not know it, "There is absolutely nothing like it in the whole history of photography."

Because Ansel Adams has been the most powerful of influences in the Sierra Club's effort in publishing—an effort to make the story of conservation a widely known story, as far as possible at the reader's expense—I have been fortunately involved in several books and exhibits that have felt the creative force of Mrs. Newhall. In all I have known, she has repeatedly demonstrated an extraordinary sense of what has to happen to make words and photographs work together.

One of the things that had to happen was that the Sierra Club, which like its parent range runs in Ansel Adams' blood, should publish the biography of a man who has meant so much to what the club is for. The Articles of Incorporation say it one way, but mean to say something like this: "We shall seek a renewed stirring of love for the earth; we shall urge that what man is capable of doing to the earth is not always what he ought to do; and we shall plead that all Americans, here, now, determine that a wide, spacious, untrammeled freedom shall remain in the midst of the American earth as living testimony that this generation, our own, had love for the next."

Ansel Adams and Nancy Newhall know this, even as many other photographers and writers do. We hope this knowing pervades and prevails, and we welcome the support of all who want it to.

DAVID BROWER
Executive Director, Sierra Club

New York City
October 31, 1963

PHOTOGRAPHS

Evening Cloud, frontispiece
Moon and Mount McKinley, 8-9
Sunrise, Mount Tom, Owens Valley, 12
Refugio Beach, 14
Rocks, Baker's Beach, Golden Gate, 15
Aspens, New Mexico, 1958, 19
Storm Clouds, Glacier National Park, 20-21
Golden Gate, 1932, 24-25
Charles H. Adams, 26
Vernal Fall, Yosemite National Park, 1920, upper, 30
Cascade, 1920, lower, 30
Francis Holman, 32
LeConte Memorial Lodge, 33
William E. Colby, 34
Burro, photographer's equipment, 35
Cedric Wright, 1927, 37
Grove, Lyell Fork of the Merced River, 1921, 38
Mount Clarence King, 1924, 39
Clearing Storm, Banner Peak and Thousand Island Lake, 1923, 40-41
Monolith—The Face of Half Dome, 1927, 45
Crosses against wall of Penitente Morada, New Mexico, 46
Albert Bender, upper, 48
Robinson Jeffers, lower, 48
Frank Applegate, upper, 49
Mary Austin, lower, 49
Witter Bynner, upper, 51
Bynner's house in snow, lower, 51
Mount Resplendent, Jasper National Park, Canada, 52
Mount Robson, Jasper National Park, Canada, 53
Dust Storm, Taos, New Mexico, 55
Rain dance, San Ildefonso, New Mexico, 56-57
Woman winnowing grain, Taos, New Mexico, 58
Indian, Taos Pueblo, New Mexico, 59
Colonel Charles Erskine Scott Wood, 61
Interior, Penitente Morada, New Mexico, 63
Skiing on Lembert Dome, Tuolumne Meadows, 1930, 64
Mount Winchell, Kings Canyon National Park, 67
Leaf, Frost, Stump—October Morning, Yosemite Valley, 70
Boards and Thistles, 71
Madrone Bark, 72
Rose and Driftwood, 73
Reflection of Unnamed Peak, Lyell Fork of the Merced River, 75
Thundercloud, North Palisade, Kings Canyon National Park, 76
Alfred Stieglitz in An American Place, New York City, 84

R.C.A. Building, New York City, 87
Winter Storm, Yosemite Valley, 88-89
Sutro Gardens, Land's End, San Francisco, 93
Oaks in Snow, Yosemite Point, 94-95
Pine Branch, Snow, Yosemite, 97
Cigar Store, 1933, 99
Carolyn Anspacher, 101
Foujita, 102
Jules Eichorn, 103
Gottardo Piazzoni in his Studio, 104-105
Point Sur, Storm, 115
Ghost Town—Bodie, 116
Courthouse, Mariposa, 118
Thundercloud, Lake Tahoe, 119
Leaves (Screen Subject), 122—123
Fence, Marin County, 127
White Tombstone, Laurel Hill, San Francisco, 128
Picket Fence, Sierra Foothills, 132
Cemetery Path, Charleston, South Carolina, 133
David Brower and Morgan Harris, The Minarets, upper, 138
Edward Weston, Tenaya Lake, lower, 138
Mono Lake, 140—141
Owens Valley, 142
Mud Hills near Abiquiu, New Mexico, 145
Thunderstorm, Northern New Mexico, 146-147
Aspens, Autumn, 1937, 148
Ranchos de Taos, New Mexico, 1937, 149
Upper Yosemite Fall, 151
Autumn, Yosemite Valley, 1938, 152-153
Manzanita Twigs, Sierra Nevada, 159
Flowers and Rock, Sierra Nevada, 160
Dead Tree, Sierra Nevada, 166
Grass and Pool, Sierra Nevada, 167
Frozen Lake and Cliffs, Sierra Nevada, 168-169
Rock and Water, Sierra Nevada, 170
Grass and Burned Stump, Sierra Nevada, 171
Sunset, Devil's Crags, Sierra Nevada, 172-173

Ansel Adams (Nancy Newhall), 3
Ansel Adams, Whitney Portal (Cedric Wright), 17
Ansel Adams, 1905 (tintype, Cliff Photo Galleries), 23
Sermon on the Mount (Cedric Wright), 81
Ansel Adams (Rondal Partridge), 113
Ansel Adams, Sierra Club High Trip, 1930s (Cedric Wright), 174

Place names are in California unless otherwise indicated.
Photographs on pages 17, 81, and 174 are reprinted by permission of Sierra Club Books.